# THE DISCOVERY OF
# CONSTABLE

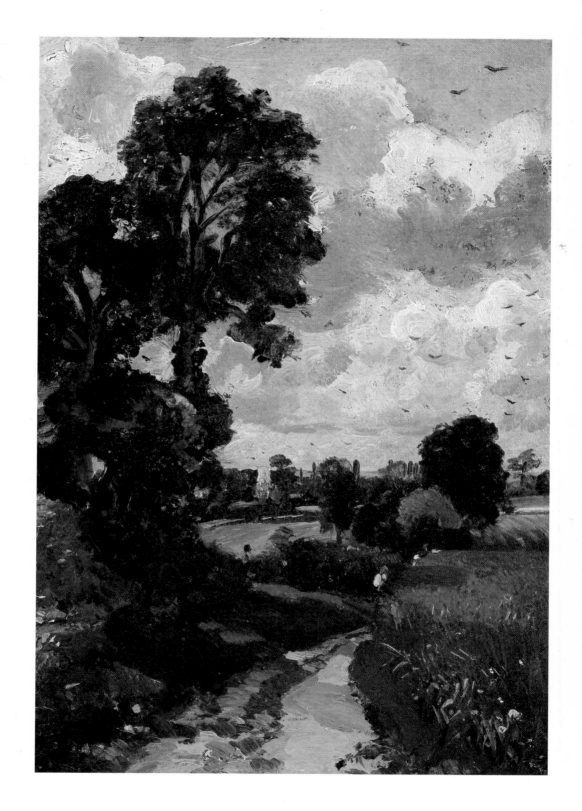

# THE DISCOVERY OF
# CONSTABLE

*Ian Fleming-Williams & Leslie Parris*

**HM**

*Holmes & Meier Publishers, Inc.*
*New York*

First published in the United States of America 1984 by

Holmes & Meier Publishers, Inc.
30 Irving Place
New York, N.Y. 10003

Book design by Geoff Green

Library of Congress Cataloging in Publication Data

Fleming-Williams, Ian
The Discovery of Constable.
Includes Index.
1. Constable, John, 1776–1837.  2. Landscape painting.,
English.  I. Parris, Leslie.  II. Title.
ND497.C7F55 1984       759.2       84-10795
ISBN 0-8419-0980-6

Filmset and printed in Great Britain by
BAS Printers Limited, Over Wallop, Hampshire

# CONTENTS

# INTRODUCTION

'In such an age as this, painting should be *understood*, not looked on with blind wonder' – John Constable

Every great artist has to be discovered. Many are recognized and full acknowledged as such in their own lifetime. Genius, however, is by its very nature exceptional, difficult to evaluate even with hindsight, and full recognition of a great painter has often been the work of later generations. In some cases the discovery of a forgotten or neglected artist and the collecting together of a corpus of his work have taken place over a comparatively short period; in others the process has taken longer. In very few cases has it been as gradual and as complex as it has with Constable.

To only a limited extent was he discovered in his lifetime. For a few years in the 1820s his work was well noticed and highly praised both in London and Paris, but this spell of success was short-lived, and for the greater part of his working life it was rare for Constable's pictures to be greeted with anything more than qualified approval. Unlike Turner, he never managed to establish himself fully in the public eye, and at his death, outside a small circle of relations and friends, there was much uncertainty about his abilities and the nature of his art. His work could only be viewed by the general public at the two main annual exhibitions in London, the Royal Academy and the British Institution, and at occasional shows in the provinces. Between times, his pictures were seen by very few, as his work seldom found a buyer at an exhibition and almost always returned to his studio. The paintings he chose to exhibit represented only a part of his total output and little or nothing was known of the more experimental work, now so highly thought of, the full-size sketches for his six-foot canvases, the oil sketches he painted outdoors, his sky studies, the many hundreds of drawings and watercolours. Of the work of his Suffolk years, the very roots of his art, few even of his closest friends had the slightest knowledge.

Critics and public alike appear to have been unable to make up their minds about the paintings they did see. While able to praise him for the sparkle and freshness in his pictures, they found the work of his early maturity coarsely and carelessly painted, like sketches rather than pictures – for them, an important distinction. Later, he was treated with greater respect, but even then praise was

seldom unqualified. Almost always he was called to account for the manner in which he applied his paint. The general tenor of so many reviews of his later work, puzzlement overlaid by sarcasm, is exemplified by a notice his *Chain Pier, Brighton* received in 1828. 'This', wrote the critic of the *London Magazine*, 'is one of those numberless productions by the same artist under which it might be written — *Nature done in white lead, opal, or Prussian blue*. The end is perfectly answered, why the means should be obtruded as an eyesore we do not understand. It is like keeping up the scaffolding after the house is built. It is evident that Mr Constable's landscapes are like nature; it is still more evident that they are like paint'.

With the critics hedging their bets, and with only a limited amount of his work available for evaluation or re-assessment, it is hardly surprising that, in his own lifetime, Constable's public was so small. To some extent he had only himself to blame for a lack of patronage. He was proud, sensitive, perhaps over-sensitive, to the niceties of the social order, and inconsistent in his relationships with patron or client. He also liked to have his own work around him, and towards the end admirers of his art were sometimes quite unable to persuade him to part with his pictures. On a number of occasions he is known to have bought back his paintings from their owners. Thus, at his death, the greater part of Constable's life-work came into the possession of his children, of whom none were then of age; and in their care — even after a studio sale — for fifty years or more the greater part remained, its very existence hardly known outside the family.

Constable's posthumous reputation grew in an erratic fashion. A controlling factor was the children's watchful care of the collection and then, in the later '80s and the '90s, the rapid dispersal of many hundreds of their father's drawings and paintings. Much of our story is closely linked to the lives of Constable's children and grandchildren and to the decisions they took about the disposal of their inheritance. The publication of an excellent biography early on, Leslie's *Memoirs of the Life of John Constable Esq. R.A.*, played an important part in the awakening of public interest. Of the greatest importance, however, was the changing critical arena into which, at various times, the family released its holdings of his work. In the 1850s, in the context of Pre-Raphaelite painting, Constable was regarded by many as an irrelevant, almost negligible figure, whereas in the 1860s, when looked at in relation to the French school, for some he appeared to be the very father of modern landscape painting. Until well into the present century the pace of Constable's reputation was at least partly geared to his apparent relevance to later developments in the art. The danger here, of course, was that the unique character of his work might be missed. The idea of Constable as a proto-Impressionist, current in the 1930s, depended on a very partial view of his art, a view in which the majority of his early works were hardly taken into account, and his mature, finished canvases were embarrassments that needed explaining away. In addition, Constable was often misinterpreted in what might

seem an even more basic way. Supply and demand being frequently out of phase, and reliable information hard to come by, innumerable paintings and drawings by other artists were misattributed to him, either knowingly or in genuine ignorance. Over-painted originals, imitations and forgeries further confused the already complicated process of his discovery.

The extraordinary complexity of the Constable corpus had been known to academics and accepted as a fact of life by the art market for a long time without ever having been fully explored. Our own interest in Constable was of some years' standing, but it was not until we began on the preparatory work for a major Constable exhibition, the Tate Gallery's celebration of the bicentenary in 1976, and had to choose exhibits from a welter of available material, that we began to sense what a veritable minefield lay ahead. In the exhibition catalogue we were able to discuss a number of the problems involved, but there were many we did not refer to, sometimes because we were then quite unaware of their existence. Various lines of enquiry were afterwards pursued. One of these led to the discovery of the part Constable's youngest son, Lionel, had unwittingly played in the general muddle. But he was not the only one involved. Both peripherally, around the main corpus of accepted work, and embedded deeply within it there was to be found the work of other hands, some clearly recognizable, the remainder less so, but all undoubtedly alien. Authors of some of the work proved to be deserving minor artistic personalities in their own right, but quite a number of the hands evaded identification and could only be tagged for reference with appropriate soubriquets – 'the Scrubber', 'the Wild Man', etc. It was while conducting these enquiries that we began to understand how the confusion had arisen and why the full discovery of Constable had taken (and, indeed, is still taking) such a long time. This book is an attempt to describe what happened and put into their rightful places some of the many characters who have been drawn into the story.

In the first part of the book we describe the emergence of Constable's work and the growth of his reputation in the period from 1837 to about 1937. Much of the material we use here is of a public nature – records of sales and exhibitions, the literature of art – but a good deal concerns the private affairs of the Constable family. For reasons already indicated, the artist's descendants played a major role in the process of discovery; as well as having charge of the bulk of his work, they acted as guardians of his growing reputation. At the same time, however, some of their own artistic activities complicated the problems of identifying his work. The story we have to tell in Part One is therefore twofold, a narrative that moves back and forth between public matters and the occasionally petty affairs of family life.

In the second part of the book we look in more detail at some of the artists with whom Constable has been confused and with whom, in certain cases, there is still some confusion: artists who have stood, or been placed, in the way of his discovery and who themselves have often suffered a lack of due recognition

as a result. Here, we examine and compare closely particular paintings or drawings in order to recognise distinctive features both in Constable's work and in that of his friends, followers and imitators. In this section we discuss former 'Constables' that have been reattributed as the result of our work, and in addition publish for the first time a number of fresh attributions. While the first part of the book is essentially an historical account, the second is therefore concerned chiefly with some of the actual processes of discovery.

For us, these investigations have proved absorbing and exciting. We have had the occasional thrill of instantaneous recognition as the wrapping-paper fell away from a long-lost or quite unknown work. Less sensational, though in its way just as satisfying, has been the day-to-day work on the mass of material available. But it has been from a continual close contact with the art of Constable itself, his actual drawings and paintings, that we have obtained the deepest satisfaction. This appears to be a never-ending pleasure. In our work on Constable one of our chief aims has been to try and clarify our image of him as an artist. At each stage, as he became easier to recognise and we understood him better, our enjoyment only increased. We feel certain that others, perhaps readers of this book, will experience a similar pleasure from a clearer understanding of his art.

# ACKNOWLEDGEMENTS

Many have helped us in the preparation of this book but we are especially grateful to John and Richard Constable for their interest in the project and for allowing us to make extensive quotations from previously unpublished family letters and documents. We are also grateful to Julia Brown, Julian Evans, Chloë Green, Janet Richards and Antony Wood, who advised and encouraged us at various stages in the work. Special thanks are due to Gill, Simon and Katy Parris for their understanding and patience.

The following kindly brought paintings and drawings to our notice or supplied information: John Abbott, Noël Annesley, Osbert Barnard, David Baxter, Attfield Brooks, Peter Brooks, Anthony Browne, Miss N. Demetriadi, Simon Dickinson, William Drummond, Andrew Festing, David Fisher, Peter Folkard, Robin Griffith-Jones, Robin Hamlyn, Eric Holder, Robert Hoozee, Evelyn Joll, Hugh and Charles Leggatt, Maj. Gen. and Mrs H. M. Liardet, E. A. G. Manton, James Martyn, Col. A. T. Maxwell, James Miller, David Moore-Gwyn, Wallace Morfey, Guy Morrison, Felicity Owen, Graham Reynolds, Charles Rhyne, David Scrase, Dudley Snelgrove, Anthony Spink, John Sunderland, Denis Thomas, Mrs J. M. Turner, the Revd A. H. N. Waller, Henry Wemyss and Andrew Wyld.

We are indebted to the many owners who have allowed their works to be reproduced in this volume, and to the National Gallery and the Victoria and Albert Museum for permission to quote from documents in their possession.

Finally, we would like to express our gratitude to David Thomson, without whose enthusiasm and support publication of this book might have been indefinitely postponed.

# LIST OF PLATES

Unless otherwise stated, the artist is John Constable

[xiii]

# ABBREVIATIONS

| | |
|---|---|
| AAC | Alfred Abram Constable |
| BI | British Institution |
| BM | British Museum |
| CGC | Charles Golding Constable |
| Fleming-Williams 1976 | Ian Fleming-Williams, *Constable Landscape Watercolours & Drawings*, 1976 |
| Holmes 1902 | C. J. Holmes, *Constable and his Influence on Landscape Painting*, 1902 |
| Holmes 1936 | Sir Charles Holmes [C. J. Holmes], *Self & Partners (Mostly Self)*, 1936 |
| Hoozee 1979 | Robert Hoozee, *L'opera completa di Constable*, 1979 |
| IC | Isabel Constable |
| JC | John Constable |
| JCC | John Charles Constable |
| JCC I [. . . VI] | R. B. Beckett, *John Constable's Correspondence*, 6 vols, 1962–8 |
| JC:FDC | Leslie Parris, Conal Shields and Ian Fleming-Williams, *John Constable: Further Documents and Correspondence*, 1975 |
| LBC | Lionel Bicknell Constable |
| Leslie 1843 [. . . 1845] | C. R. Leslie, *Memoirs of the Life of John Constable, Esq., R.A.*, 1843; 2nd., revised edition 1845 |
| Leslie 1896 | C. R. Leslie, ed. Robert C. Leslie, *Life and Letters of John Constable, R.A.*, 1896 |
| Leslie 1951 | C. R. Leslie, ed. Jonathan Mayne, *Memoirs of the Life of John Constable*, 1951 (reprinted 1980) |
| MLC | Maria Louisa Constable |
| Parris 1981 | Leslie Parris, *The Tate Gallery Constable Collection*, 1981 |
| RA | Royal Academy |
| Reynolds 1973 (or R.) | Graham Reynolds, *Victoria and Albert Museum, Catalogue of the Constable Collection*, 1960; 2nd, revised edition 1973 |

| Shirley 1930 | Hon. Andrew Shirley, *The Published Mezzotints of David Lucas after John Constable, R.A.*, 1930 |
| Shirley 1937 | C. R. Leslie, *Memoirs of the Life of John Constable, R.A.*, edited and enlarged by Andrew Shirley, 1937 |
| Tate Gallery 1976 | *Constable : Paintings, Watercolours & Drawings*, Tate Gallery exhibition 1976 (catalogue by Leslie Parris and Ian Fleming-Williams) |
| Tate Gallery 1982 | *Lionel Constable*, Tate Gallery exhibition 1982 (catalogue by Leslie Parris and Ian Fleming-Williams) |
| V & A | Victoria and Albert Museum |

# EXPLANATIONS

Measurements given in plate captions are in inches, followed by centimetres in brackets; height precedes width. The artist is John Constable unless otherwise stated. When a work is not reproduced, a reference is given to a recent source where an illustration can be found. Unless otherwise indicated, previously unpublished letters (i.e. those not given JCC or JC:FDC references in the notes) are in the Constable family collection. Where it has been possible to consult the original of a letter or other document, the following signs are used in the transcript: [Landscape] editorial insertion; [?Landscape] doubtful reading; ⟨Landscape⟩ deleted word; ⟨. . .⟩ undeciphered deletion. In such transcripts the original spelling and punctuation are retained, though extra space is left between unpunctuated sentences.

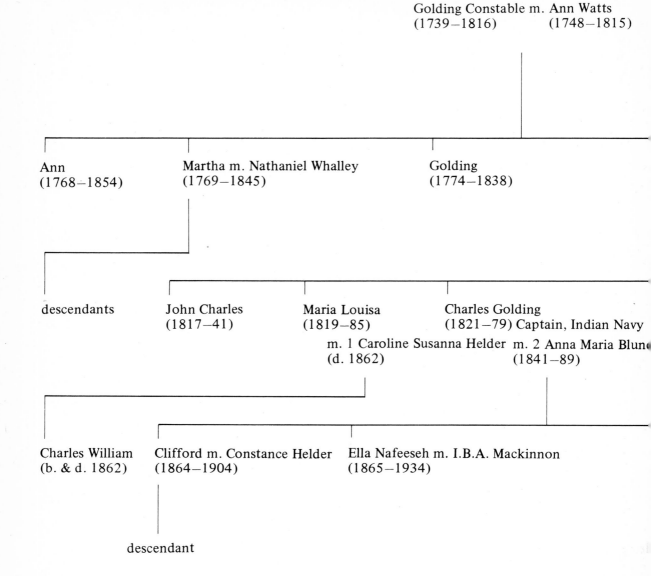

Golding Constable m. Ann Watts
(1739–1816)        (1748–1815)

Ann
(1768–1854)

Martha m. Nathaniel Whalley
(1769–1845)

Golding
(1774–1838)

descendants

John Charles
(1817–41)

Maria Louisa
(1819–85)

Charles Golding
(1821–79) Captain, Indian Navy

m. 1 Caroline Susanna Helder  m. 2 Anna Maria Blun
(d. 1862)                      (1841–89)

Charles William
(b. & d. 1862)

Clifford m. Constance Helder
(1864–1904)

Ella Nafeeseh m. I.B.A. Mackinnon
(1865–1934)

descendant

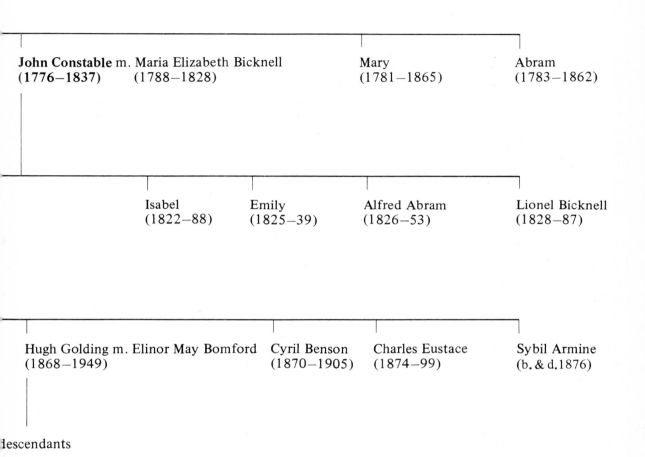

**John Constable** m. Maria Elizabeth Bicknell
**(1776—1837)** (1788—1828)

Mary
(1781—1865)

Abram
(1783—1862)

Isabel
(1822—88)

Emily
(1825—39)

Alfred Abram
(1826—53)

Lionel Bicknell
(1828—87)

Hugh Golding m. Elinor May Bomford
(1868—1949)

Cyril Benson
(1870—1905)

Charles Eustace
(1874—99)

Sybil Armine
(b. & d.1876)

descendants

# PART ONE

# A SECRET COMMITTED
# TO THE PUBLIC

## [1837–1838]

JOHN CONSTABLE's death in his sixty-first year was both sudden and unexpected. On 30 March 1837 he had attended a special meeting of the Directors of the Artists' General Benevolent Institution, the charity with whose work he was most closely involved, to consider an urgent case requiring relief. In the evening he was at the Academy in Trafalgar Square for a General Assembly which had been called to elect a Professor of Architecture in place of Sir John Soane, recently deceased. C. R. Leslie, his friend, biographer and fellow Academician, describes how Constable had afterwards walked part of the way home with him. The night was fine, though very cold.* In Oxford Street Constable had crossed the road to give alms and comfort to a crying beggar child. On their walk he had talked ruefully of money trustingly loaned and subsequently lost. He spoke of this 'with some degree of irritation', Leslie tells us, 'but turned to more agreeable subjects, and we parted at the west end of Oxford Street, laughing. – I never saw him again alive'.[1]

Constable spent the whole of the next day in his painting room at work on *Arundel Mill and Castle* (pl. 1), the picture he intended for his main exhibit at the forthcoming Academy. That evening he went out for a short while on a charitable mission for the Artists' General Benevolent Institution. After a latish supper he returned to a bed he had somewhat unusually asked to be warmed, and – as was his habit – read himself to sleep. It was not long after a servant had taken the candle from his bedside that he awoke in great pain and called out to his eldest son, John Charles, who was preparing for bed in the next room. The pain increased and a neighbouring doctor, Michele, was sent for, but there was little he could do. Constable quickly lost consciousness and, within half an hour of waking, died.†

---

* It had been a bad winter. In a letter to Leslie dated 29 October 1836, Constable had talked of deep snow in Charlotte Street (JCC III, p. 141).

† The exact hour of Constable's death is not recorded. It has generally been assumed that he died before midnight, i.e. on 31 March. Three sources, however – the RA Council Minutes for the meeting of 4 April, the *Gentleman's Magazine* (June, p. 664) and the Letters of Administration – give 1 April as the date of death.

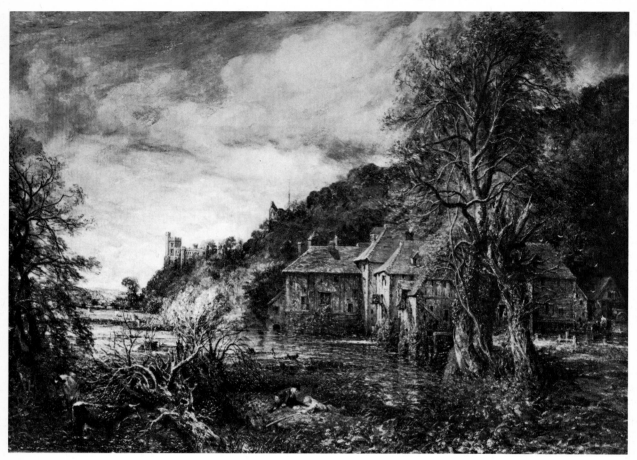

1 *Arundel Mill and Castle*, exh. 1837; oil, 28½ × 39½ (72.4 × 100.3). The painting on which Constable was working on the day of his death.

Leslie describes the events of the following day in his *Autobiographical Recollections*:

On the 1st of April, 1837, as I was dressing, I saw, from my window, Pitt (a man employed by Constable to carry messages) at the gate. He sent up word that he wished to speak to me, and I ran down expecting one of Constable's amusing notes, or a message from him; but the message was from one of his children, and to tell me that he had died suddenly the night before. My wife and I were in Charlotte Street as soon as possible. I went up into his bedroom, where he lay, looking as if in tranquil sleep; his watch, which his hand had so lately wound up, ticking on a table by his side, on which also lay a book he had been reading scarcely an hour before his death. He had died as he lived, surrounded by art, for the walls of the little attic were covered with engravings, and his feet nearly touched a print of the beautiful moonlight by Rubens, belonging to Mr. Rogers. I remained the whole of the day in the house, and the greater part of it in his room, watching the progress of the casts that were made from his face by his neighbour, Mr. Joseph, and by Mr. Davis. I felt his loss far less then than I have since done – than I do

[2]

even now. Its suddenness produced the effect of a blow which stuns at first and pains afterwards; and I have lived to learn how much more I have lost in him, than at that time I supposed.[2]

So inexplicable a death demanded a post-mortem. This was performed by Professor Partridge of King's College, a distinguished surgeon and anatomist, with Michele and another surgeon, George Young, a friend of Constable's in attendance.* No one was any the wiser after the examination: the cause of death remained unexplained.

The artist's two brothers, Golding and Abram, with a few of his closest friends, followed the body on its way up to Hampstead where Constable had buried his wife in 1828. There the small party was joined by others who had known Constable as a Hampstead resident. The service at the graveside was conducted by another friend, the Revd T. J. Judkin, 'whose tears', Leslie tells us, 'fell fast on the book as he stood by the tomb'.[3] As far as we know none of the children was at the funeral. John Charles, still in a state of shock, was too ill to attend. The next boy, the sailor son Charles Golding, was on his second voyage in an East Indiaman bound for Bombay. It may not have been considered an occasion suitable for any of the others, the three girls or the two little boys.

At the time of his death Constable had two houses, No. 35 Charlotte Street, just off Tottenham Court Road, an area much favoured by artists, and No. 6 Well Walk, close by the Heath at Hampstead. He had taken over the lease of the first in June 1822, the former occupant, his old friend and mentor Joseph Farington RA, having died the previous December. No. 35 was an average-sized house for that part of London, comprising a basement and four floors, but at the back there was a large studio† connected to the house by a barrel-vaulted, top-lit passage way, a space used by Constable as a gallery for the display of his works. The house at Hampstead had been taken in 1827, five years later, for the sake of his ailing wife, to enable him to get away from idle callers, his 'morning flies', and to 'unite a town & country life'.[4] To pay for the lease of this house in Well Walk Constable had let off the upper half of No. 35 for a while, keeping for his own use the studio, a large front attic, two parlours and the kitchen. At Hampstead he had felt he was settled for life. 'Here', he exclaimed, 'let me take my everlasting *Rest*'.[5] His prayer was granted; but perhaps rather sooner than he might have wished. After the death of his wife in 1828 he could have let the house in Well Walk go, but in fact there were advantages in having the two houses – Hampstead he said was his home, Charlotte Street

---

* Originally a Brighton acquaintance, George Young, brother of a well-known actor, had coached Constable in the art of public speaking in preparation for his Hampstead lectures. For a time, in the 1850s and 1860s, Young was the owner of *The Hay-Wain*.

† Known to both Farington and Constable as 'the great painting room'. 1820, according to the OED, is the earliest recorded use of the word 'studio'.

his office[6] — and by further letting he managed to keep both on.* From Leslie's account one gathers that Constable and his eldest son had been sleeping in the attic bedrooms of No. 35 on the night of 31 March 1837. In the surviving letters and diaries there is only one further mention of the house at Hampstead and after the funeral it appears to have been in Charlotte Street that with the help of friends the young family began to try and shape a new life for itself.

In their twelve years of marriage Maria Constable had presented her husband with seven children, four boys and three girls. The eldest, John Charles, was nineteen when his father died and still, therefore, a minor, though nominally head of the family. The next in age, Maria Louisa ('Minna' as she was called), was eighteen months younger; rather too young for the role of mother and caretaker she was called upon to play. Charles Golding, the second boy, had celebrated his sixteenth birthday at sea only two days before the death of his father, news of which did not reach him out East until the overland newspapers reached Bombay three months later. Next came the two girls, Isabel, aged fourteen, and the twelve-year-old Emily, in this order the last and first of the seven to die. The last pair, Alfred and Lionel, were ten and nine years of age when their father died. As children they were unruly and mischievous. As we shall see, both were possessed of genuine artistic talent.

By Letters of Administration dated 1 June 1837,[7] Constable's elder brother Golding and Lancelot Archer-Burton were appointed to administer the estate and to act as guardians until one of the children came of age. Archer-Burton was the husband of Constable's cousin Jane Gubbins (daughter of his maternal aunt Mary Gubbins, née Watts). Before his marriage Constable went to stay quite often with his Gubbins relations in Epsom. One would have thought that the artist's younger brother, Abram, would have been a better choice as guardian as he had run the family business after their father's death and had always followed his brother's career very closely, but presumably it had to be Golding, manager of the Countess of Dysart's woodlands at Bentley near East Bergholt, because he was the elder of the two. Jane Archer-Burton had taken an interest in the education of Constable's elder sons in recent years, and had been a help in a number of ways. For a time, in 1833, John Charles and Charles Golding had attended a school at Folkestone because her eldest son, Burton, was there. Her husband, plain Lancelot South of Latton in Essex when she married him, had come into property and changed his name to Archer-Burton; one can only suppose it was because of this, his superior station as a man of wealth, that he had been chosen as the young Constables' main guardian. He appears to have carried out his duties conscientiously enough, if perhaps a little

---

* The last reference to an economy of this sort is in a letter Constable wrote to his engraver David Lucas dated 2 July 1833: 'I have made an excellent let of my first & second floors — but at far too little money —' (JCC IV, p. 401). If there was a tenant occupying the two middle floors of No. 35 at the time of Constable's death, the house did not long remain divided thus.

heavy-handedly. There are echoes of resentment in some of the children's later letters at the treatment they had received from the well-meaning Archer-Burtons. Besides these appointed guardians there were others who willingly lent a hand, Constable's relatives in Essex and Suffolk, for instance, and Maria Constable's married sister Louisa Sanford in Wimbledon. There were friends in London – the Purtons, Johnsons, Pulhams, Leslies, Cooksons and Fishers – as well as in the country: the Atkinsons at Cobham, and at Arundel the George Constables, namesakes only, not relations. But although these and many others were able and willing to help, the mantle of surrogate parenthood and, an even heavier burden, the responsibility for the care of their main inheritance – the many hundreds of their father's paintings and drawings – fell inescapably on the shoulders of John Charles and his sister Minna. To understand the nature of this inheritance and its wider significance, we must consider their father's work as a whole at the time of his death.

The exact number of paintings Constable disposed of during his lifetime is not known. The early history of many of his existing works is obscure, and conversely paintings by him recorded in early sources are frequently not documented further and have not therefore been identified. Altogether, about sixty landscapes can be listed as having been elsewhere than with the Constable family in 1837. Making an allowance for unrecorded transactions, somewhere in the region of one hundred therefore seems a reasonable guess at the total number of paintings (other than portraits) that Constable sold, exchanged or gave away during his working life. Whatever the real figure, it was certainly a small proportion only of his total output.

By and large, such landscapes as Constable had managed to sell or give away were still with their original owners or the owners' descendants in 1837. Some works remained with people he had known in Suffolk, with early friends like Lucy Blackburne,* Peter Godfrey (squire of East Bergholt) and Godfrey's daughter, Philadelphia Fitzhugh. Others were with later, London friends, with intimates such as C. R. Leslie, John Bannister the actor and the amateur artist

---

* Née Hurlock, to whom Constable had given a set of four panoramic watercolour views of the Stour valley as a wedding present in 1800. In our context, the drawings' subsequent story represents a classic case-history. The set remained in the family until it came up for sale at Christie's on 6 July 1934 (4), dubiously attributed to Constable, and was bought by Walker's Galleries for three guineas. Walker's also doubted the authorship and the drawings were unattributed when exhibited by them in 1935. As the work of the Swiss artist M.-V. Brandoin (1733–90), one only of the drawings was bought by the Whitworth Art Gallery, Manchester from the Fine Art Society in 1943. The other three were acquired by the Constable scholar R. B. Beckett, who published all four, correctly attributed, in 1955 ('A Wedding Present from John Constable', *Connoisseur*, CXXXVI, 1955, pp. 16–19). These are now in the Victoria and Albert Museum. A fifth drawing, a replica in the Ashmolean Museum, Oxford of the second of the series, has only quite recently been recognised and published (David Brown, 'A New Constable Drawing', *Master Drawings*, XVII, No. 3, 1979, pp. 278–9). This had come to the Ashmolean in 1934 as the work of a Flemish artist, Pieter Tillemans. Later, A. P. Oppé had thought it English and had suggested John Webber (1752–93) as a possibility.

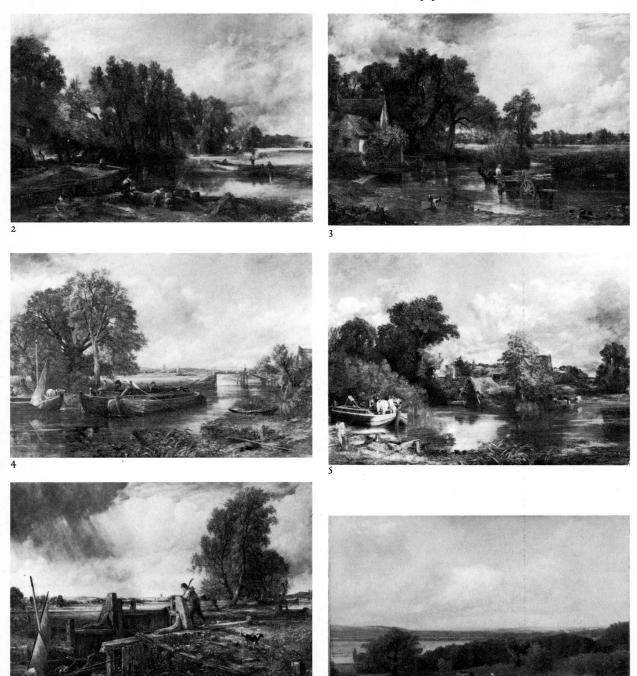

2

3

4

5

6

7

W. G. Jennings. Relatives of Constable's closest friend, Archdeacon John Fisher, owned various paintings of Salisbury and of Dorset subjects. The great *Stratford Mill ('The Young Waltonians')* (pl. 2) belonged to the widow of Fisher's lawyer, J. P. Tinney. With a few exceptions, such collectors as James Carpenter, John Allnutt, James Morrison and Robert Vernon still owned the works by Constable (no more than one or two each) which they had purchased from exhibitions or from Constable's studio.

Where his own work was concerned, Constable had rarely had much to do with dealers, but in the 1820s he had responded to overtures from the Parisian dealers John Arrowsmith and Claude Schroth. As a result, twenty or so paintings, including *The Hay-Wain* (pl. 3) and *View on the Stour near Dedham* (pl. 4), had gone to France. Very few of Constable's paintings had changed hands in England by the time of his death except within the families of their original owners. Those that had were mainly works which Constable himself reacquired. For example, when Fisher found himself in financial difficulties in 1829, Constable bought back *The White Horse* (pl. 5) and a painting of Salisbury Cathedral. In the same year he bought back *A Boat Passing a Lock* (pl. 6) from James Carpenter and presented it to the Royal Academy as his Diploma picture on his election as an Academician. Earlier, he had painted a fresh version of *Ploughing Scene in Suffolk* (pl. 7) for John Allnutt, who was dissatisfied with a new sky John Linnell had added to the original version: Constable took back the latter with remarkably good grace.

In addition to those who owned paintings by Constable, a few others possessed the set of twenty-two mezzotints engraved after his compositions by David Lucas, which had appeared in two editions (1830 and 1833) under the title *Various Subjects of Landscape, Characteristic of English Scenery* – or, for short, *English Landscape*. Constable had closely supervised the engraving of the work and had written an introduction for it setting out his aims as an artist. Neglect and misunderstanding of his paintings had spurred him to produce this epitome of, and apologia for his art. In the short term *English Landscape* did very little to extend the public for Constable's work. Estimates of the number of sets disposed of, whether by gift or sale, range from about forty to rather less than a hundred.*

Leslie said that *English Landscape* was 'a work which, to use the words of Coleridge, was *"a secret committed to the public, and very faithfully kept"* '.[8] In 1837 Constable's art as a whole was hardly less of a secret. By far the greater proportion of his work was still in his own possession when he died. His children and grandchildren subsequently sold or gave away more than 750 oil paintings and

2 *Stratford Mill ('The Young Waltonians')*, exh. 1820; oil, 50 × 72 (127 × 182.9)

3 *The Hay-Wain*, exh. 1821; oil, 51¼ × 73 (130.5 × 185.5). One of the works that made Constable's reputation in France in the 1820s; it only returned to England in about 1838.

4 *View on the Stour near Dedham*, exh. 1822; oil, 51 × 74 (129.5 × 188)

5 *The White Horse*, exh. 1819; oil, 51¾ × 74⅛ (131.4 × 188.3). At £157 10s. this was the most expensive item in the Constable studio sale in 1838. In 1855 it set a record price for a Constable – £630.

6 *A Boat Passing a Lock*, 1826, exh. 1829; oil, 40 × 50 (101.6 × 127)

7 *Ploughing Scene in Suffolk (A Summerland)*, exh. 1814; oil, 20¼ × 30¼ (51.4 × 76.8)

---

* Constable's own account (JCC IV, p. 451, item IV) suggests that 374 impressions of each of the first four subjects were taken. The 1838 sale included 280 sets of the whole work and enough loose impressions to account for another fifty-five sets, making 335 in all. This may indicate that thirty-nine sets (the difference between 374 and 335) had been disposed of by the artist. However, the accounts of the enterprise are too fragmentary for definite conclusions to be drawn. Beckett (JCC IV, p. 414) estimated that Constable sold less than one hundred sets.

sketches and over 1100 watercolours and drawings. The gradual dispersal of this huge collection was a major factor in the growth of Constable's reputation.

Before the business of sorting the collection began in 1837, it was arranged by his friends that Constable should make a final appearance as an exhibitor at the Royal Academy. The main picture chosen to represent him was the *Arundel Mill and Castle* (pl. 1), the painting he had been trying to finish on the day he died. Two smaller works were also submitted.

> I will call on Tuesday afternoon about 3 or 4 O Clock with a caravan to take
> your father's pictures to the Academy [Leslie wrote to John Charles in April]. Mr
> Chalon advises me to take the two small unfinished ones, & if you do not object
> I will do so & hear the opinion of the council whether they had better be exhibited
> or not. I think under all circumstances they will be glad to have them. – Will you
> write on a slip of paper ⟨what⟩ the discription of the large picture for the catalogue
> & if you recollect hearing your father allude to any quotation, any line of poetry,
> as applicable to it will you add that? – I shall be glad also to have the subjects
> of the small pictures if you happen to know what they are. – I think you had better
> ⟨put away⟩ lock up all the loose sketches of which I saw some lying on the floor
> of the painting room.

The *Arundel* was duly hung at the Academy, though no poetical quotation accompanied it in the catalogue. The other two paintings Leslie mentions were not exhibited and remain tantalizingly unidentified.

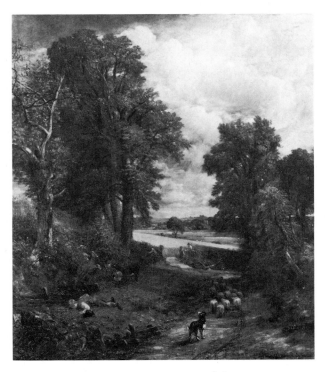

8 *The Cornfield*, exh. 1826; oil, 56¼ × 48 (143 × 122). Presented to the National Gallery by Constable's friends in 1837, this was the first painting by the artist to be acquired by the nation.

The first painting permanently to leave the family after Constable's death was *The Cornfield* (pl. 8), a work the artist had exhibited five times between 1826 and 1835 without finding a buyer. This picture was presented to the National Gallery in 1837 by a body of Constable's admirers, becoming the first, and for the next ten years, the only painting by him in a national collection. The idea of commemorating Constable in this way came from one of his Hampstead friends, the amateur artist William Purton, but it was C. R. Leslie who largely managed the operation. In an undated letter, probably of May 1837, Leslie told John Charles that he planned to bring a small party of fellow artists and friends (Clarkson Stanfield, the Revd T. J. Judkin, E. S. Hardisty, William Carpenter and the two Chalon brothers) to Charlotte Street to see *Salisbury Cathedral from the Meadows* (pl. 9), the picture originally proposed by Purton. Another visit was planned for 22 May 'to determine definitively as to which picture' was to be chosen.[9] The final choice was made on 6 June, as recorded in a circular issued in July by a Committee formed to organise a subscription:

> A desire having been very generally expressed among the admirers of the Works of the late John Constable, Esq. R.A. that one of his Pictures should be made permanently accessible to the Public by being purchased and presented to the National Gallery, a meeting was held at his late residence, on the 6th June when, after a careful examination of the Works of the deceased Artist, now the property of his Family, it was unanimously resolved, that a private subscription should be opened for the purpose of effecting the immediate purchase of the Landscape, called 'The Corn Field,' for the sum of 300 Guineas, (that estimate having been sanctioned by the Administrators to the Estate) and its presentation to the National Gallery.[10]

The committee named in this document was chaired by the aged Academician Sir William Beechey, for long a supporter of Constable, and included pro-

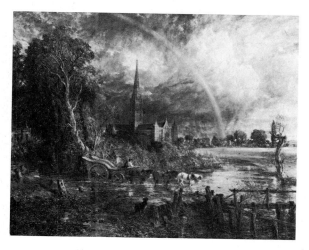

9 *Salisbury Cathedral from the Meadows,* exh. 1831; oil, $59\frac{3}{4} \times 74\frac{3}{4}$ ($151.8 \times 189.9$)

[9]

fessional colleagues and friends of the deceased.* The committee was careful about the sort of image of Constable it was fostering. Leslie says that Purton had originally suggested that *Salisbury Cathedral from the Meadows* should be chosen 'as being from its magnitude, subject, and grandeur of treatment, the best suited to the public collection'. But, Leslie continues,

> it was thought by the majority of Constable's friends that the boldness of execution rendered it less likely to address itself to the general taste than others of his works, and the picture of 'The Cornfield,' painted in 1826, was selected in its stead.[11]

Constable himself thought he had tailored *The Cornfield* more than usual to public taste. 'I do hope to sell this present picture –', he had written to his friend Fisher in 1826, 'as it has certainly got a little more eye-salve than I usually condescend to give them'.[12]

Circulars inviting subscriptions were sent out and interested parties continued to call at Charlotte Street. A letter written to Leslie by one visitor, the miniaturist Andrew Robertson who had known Constable since their student days, strikes a less confidant note than the Committee's declaration:

> I have had this day [21 August] the melancholy gratification, if I may combine such terms, of again visiting the gallery of our lamented friend Constable. The great number of his works left in his possession proves too clearly how little his merits were felt by those who could afford, and ought to have possessed them; and that unless some such a measure had been adopted as that which, to the honour of his friends, has been carried into effect, it is too probable that his works would have fallen into the hands of artists only, for a mere trifle, and remained comparatively buried, till dug up, as it were, and brought to light in another age.[13]

By December 1837 well over a hundred subscriptions of between one and ten guineas had been received from a range of Constable's friends and acquaintances (among them Michael Faraday and William Wordsworth) and the purchase price of £315 reached.[14] The Trustees of the National Gallery formally accepted the painting on 9 December. The following day Leslie sent the news to John Charles, adding that he was delighted that the plan would also prove 'beneficial to your property when the sale of the pictures takes place'.[15]

This reference of Leslie's to a sale of pictures indicates that there was already a scheme afoot to cash part of the children's main inheritance and increase the amount of money available for their maintenance and education. In 1828 Constable and his wife had been left a handsome legacy, said to have been around £20,000, by Maria's father, Charles Bicknell. Rather more than half of this appears to have been invested straightway in annuities for Maria and the children.

---

* William Carpenter, Samuel Cartwright, A. E. Chalon, J. J. Chalon, Dominic Colnaghi, Richard Cook, William Etty, E. S. Hardisty, F. R. Lee, C. R. Leslie, John Murray, William Purton, John Sheepshanks, Clarkson Stanfield and George Young.

But the estimated value of Constable's own estate* and the income from the annuities was evidently not considered enough for the children's needs, and it was therefore decided that part of the collection, including some of the larger and more important canvases, should go to auction. The plan would certainly have met with the approval of Constable himself. He had talked often enough of his works as property belonging to his family, an increase in the value of which he hoped his children would eventually be in a position to enjoy.

It is likely that the elder children were aware of the importance of this great store of their father's work housed under their roof while he was still alive. If they were not already aware of the necessity to keep a watchful eye on the collection when he died, warnings such as Leslie's about putting the sketches away that had been left lying around the studio would certainly have put them on their guard; and if they did not understand everything that was going on around them at first, it was not long before they began to be very careful about lending or allowing anyone to borrow items from the collection. John Charles made a note to this effect in his diary on 2 June 1837: '... NB I must not let any drawings get out of my hands'. When he was away at Cambridge it was on poor Minna that the responsibility mainly fell, and she had a worrying time. In October her suspicions had been aroused about some drawings that George Henry Harrison (1816–46), a pupil of their father's, had been taking home. But it is in a letter written to John Charles the following June that we find her in the most extreme state of agitation and distress; extreme, as the cause was the behaviour of one they had thought to be a trusted friend, James Brook Pulham, son of an old Woodbridge patron and friend of their father.

> I write again very soon for I have a great deal to say. In the first place you have made me a little uneasy concerning M<sup>r</sup> Pulham, how I wish people would not take me in, I am the most wretched person to deal with in matters of this kind, of course I made sure that you had told Pulham to select a great Salisbury† from what he said, & that his reason for wishing to select one in your absence was because he was in a hurry   I am quite vexed when I read that part in your letter about the prints, poor Minna! He also told me that he was going to purchase of us the great

---

* A break-down of the figures given in the Declaration of Constable's goods, chattels and credits (PRO PROB. 31 1368/1081 001219) produces the following. At his death he had £528 18s. to his credit at his bank, Cocks Biddulph. In the Bank of England, £12,000 stood to his name 'per certain Bank Annuities'. He was owed considerable sums: by his brother Abram, £4000, at 5% interest (there later developed a serious row in the family over Abram's repayment, or non-repayment, of his debts to the estate – see p. 56); by his Hampstead doctor, Herbert Evans, £580; by Lancelot Archer-Burton, £512; and by the engraver David Lucas, £50: altogether £6231 5s. 4d. The contents of his two houses were valued thus: furniture etc., £317 9s.; plate and plated ware, £160 13s.; household linen etc., £33 16s.; wine, £43 17s.; 'Books Pictures prints Drawings and other Articles relating to the ffine Arts', £1900 19s.

† The large mezzotint by David Lucas of *Salisbury Cathedral* (Shirley 1930, No. 39, from Constable's 1831 RA exhibit, *Salisbury Cathedral from the Meadows*, pl. 9) was often referred to as 'the great Salisbury' to distinguish it from a smaller print by Lucas (Shirley No. 30) of an oil sketch of the same subject.

Corn Field & Lock* which he has taken away with him    I could not say any
thing because I thought he could not have bought them but with your leave. How
very distressing this is; how guarded I must be when any one comes about prints
& pictures whilst you are away from home. Shall I write or call upon Pulham
    what shall I do, pray tell me when you write, or perhaps you are coming home
soon & could reclaim them for I am sadly afraid he has taken one of the rarest &
best Salisbury with a small rainbow.† I was grudging parting with it the whole
time but as I have before stated I was fully convinced you had promised the said
prints to him. How very responsible my situation is in every respect . . . I begin
to feel the loss of a mother now more than ever as I have not a creature in any degree
living competent or willing to fulfil in the *slightest degree* her situation.‡

John and Minna were doubtless ignorant of the fact that, only three years before,
their father had had words with Pulham over a not dissimilar offence, the borrow-
ing of some of his choicest drawings to copy without asking; in this case with
the remarkably lame excuse that he thought they were by Charles Golding, Con-
stable's second son, a promising young draughtsman, but at that time only just
turned fourteen.[16]

By now, Charles Golding too was anxious about the collection. In the first
letter home after learning of his father's death, he had asked for assurances about
the safety of some of the drawings and sketchbooks. He wrote again on the subject
the following January (1838), in the first letter from Bombay on his return from
China.

I hope those books I mentioned in my last letter were taken care of for me    I would
sooner have them than 100£s    you cannot think how anxious I feel for them yet
I feel a reluctance in asking for any thing. in case that letter did not reach you I
will repeat them I mean the Book of Sketches in the Coutes Indiaman and the two
Brighton sketch books

That August of 1838, when coming up the Channel on his homeward voyage,
he wrote again on the same topic.

I saw in a paper for March 1838 an account of some of my Fathers Pictures advertised
for Sale    I think it was in Pall Mall but I most sincerely hope you were able to
reserve for me the 2 Brighton sketch books and the Portfolio of Sketches made by

---

* Lucas's mezzotints of *The Cornfield* (pl. 8), published in 1834 (Shirley 1930, No. 36), and
of *The Lock*, a replica of the painting belonging to James Morrison (pl. 22), also published in
1834 (Shirley No. 35).

† Possibly an early proof of the large Salisbury referred to in note on p. 11.

‡ Minna's distress is understandable. She had no one in the house to advise her on such matters,
but in dramatising her situation thus, she was surely forgetting one who had made the care of
the family her life's work. This was Elizabeth Roberts, known as 'Bobs' or 'Lady Ribbons',
who had been in service with the Constables as nurse and housekeeper since 1818. She became
deeply attached to her charges and they to her. Many of the children's letters end with fond messages
to her. She is last mentioned in the correspondence by Abram Constable in a letter of 16 February
1862 (JCC I, p. 314), where he calls her 'an old confidential, & as such can never be *replaced*'.

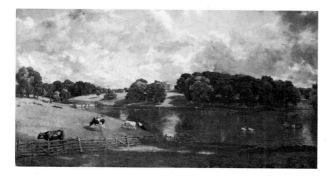

10  *Wivenhoe Park*, exh. 1817; oil, $22\frac{1}{8} \times 39\frac{7}{8}$ (56.1 × 101.2)

him in the 'Coutes' Indiaman* the latter he had really given to me    at the same
Time I hope that you will forgive the indecency of my asking for any thing

Charles had seen an advance notice of the five-day sale of his father's effects
held by Foster & Son at 54 Pall Mall in May 1838. The events leading up
to this important sale, the first dispersal of works from the collection, are reasonably
well documented, with other family matters, in the diaries John Charles kept
in 1837 and 1838. Preparations appear to have begun in January. On the 10th
of that month John Charles noted: 'Mr Leslie & Mr Foster came & made a
cat:[alogue] of the pictures    reserved all the little sketches & 9 pictures.'
Apparently unaided, he then began seriously to tidy up and to try and organize
the many hundreds of pictures, oil sketches, drawings and prints, framed and
unframed, which filled the house: setting the pictures to rights, he called it. He
continued with the task during his next vacation from Cambridge in April.
The full entry for 7 April runs: 'Read some Algebra. Began to set pictures
to rights, to make a cat[alogue] of them & look out some to take to Cambridge.
Burton† called & had tea with us. Mr Field called & dined with us    talked
about his book which he is about publishing.'‡ The work continued on
the 8th and 11th, and on the 12th he was able to record that he had nearly
finished arranging them. On 14 April Leslie came to start varnishing some of
the paintings, beginning with the great *Chain Pier, Brighton*.[17] For some days
John Charles had been feeling very unwell. On the 17th erysipelas was diagnosed
and the boy took to his bed. Though now limited in the part he could play
he was nevertheless able to see visitors and to keep in touch with what was

* In 1803 Constable spent nearly four weeks in an Indiaman, the *Coutts*, captained by a friend
of his father. He made a number of drawings during the voyage. One of the Brighton sketchbooks
Charles had apparently been promised by his father may be the one mentioned in a letter Constable
wrote to Fisher on 17 November 1824, a sketchbook full of 'boats – and coast scenes' (JCC
VI, p. 182).

† Burton Archer-Burton, their second cousin, who had been at school with John Charles in
Folkestone.

‡ Constable's friend George Field, chemist, artists' colourman and author of a number of theoretical
works, published *Outlines of Analogical Philosophy* in 1839.

A CATALOGUE

OF THE

VALUABLE

# FINISHED WORKS,

## STUDIES AND SKETCHES,

OF

### JOHN CONSTABLE, ESQ. R.A.

DECEASED.

Among the FINISHED PICTURES will be found the following GRAND SUBJECTS, all of which have been exhibited at the Royal Academy, and afford abundant evidence of the great genius and unwearied application of this distinguished and lamented Artist :

VIZ.

| | |
|---|---|
| SALISBURY CATHEDRAL, from the Meadows | SALISBURY CATHEDRAL, from the Bishop's Garden |
| HADLEIGH CASTLE | THE GLEBE FARM |
| VIEW ON THE RIVER STOUR | FLATFORD MILLS |
| THE LOCK | BRIGHTON CHAIN PIER |
| VIEW OF DEDHAM, SUFFOLK | THE LOCK AT FLATFORD MILLS |
| THE OPENING OF WATERLOO BRIDGE | |
| HELMINGTON PARK | |

LIKEWISE

A MOST INTERESTING COLLECTION OF

SKETCHES AND STUDIES.

ALSO,

*A few Pictures by Old and Modern Masters.*

Which will be Sold by Auction by

## MESSRS. FOSTER AND SONS

*At the Gallery, 54, Pall Mall,*

On TUESDAY, the 15th of MAY, 1838, and following Day,

AT ONE O'CLOCK EACH DAY PRECISELY,

*BY ORDER OF THE ADMINISTRATORS.*

May be Viewed Three Days prior to the Sale, and Catalogues (at 1s. each) had of H. D. HAVERFIELD, Esq. Solicitor, No. 3, Hart Street, Bloomsbury; and of Messrs. FOSTER, 14, Greek Street, Soho Square, and 54, Pall Mall.

11  Title-page of Constable sale catalogue, 15–16 May 1838. Many important works by Constable were first seen by the public at this sale.

happening. On 23 April the catalogue for the sale of prints arrived. This sale was to be spread over three days – 10, 11 and 12 May. There was a marked increase in the number of callers at No. 35, stimulated perhaps by the notices of the impending auction which had been appearing in the press. Some were old friends of Constable's: Sir Richard Digby Neave, a one-time pupil; the publisher, William Carpenter; Henry Hebbert, who owned a Hampstead view; W. G. Jennings, another of Constable's amateur artist friends; and General Rebow, for whom, in 1816, the artist had painted the finest of his country house portraits, *Wivenhoe Park* (pl. 10). Leslie brought some of his friends. A few of the visitors appear to have been complete strangers, possibly attracted by the

uniqueness of the occasion – the greater part of Constable's life-work assembled together for the last time, stacked and arranged, much of it about to be taken away to the sale-room.

Leslie, a true friend, was there each day to supervise the transporting of the works to Foster's. This took place on 2 and 3 May. On the 4th Leslie came to fetch a few remaining pictures. By now John Charles was better, but still too weak to go out, so it was Mr and Mrs Purton, also very good friends, who took Isabel to the private view at Foster's on Saturday 5 May. John Charles was told the pictures looked very well. By now he was up and about but not fit enough to attend the first of the sales. On the 9th he entered in his diary, 'Mr Leslie came   talked to him about the pictures   I want the Heath & the Arundel Mill. Mr Field called. promised to let him know if we left this house. Mr Leslie dined with us.'

The first sale began at Foster's on the following day, 10 May 1838. Constable had amassed a considerable number of prints of one sort or another and the 530 lots comprised over 5,000 items, not counting the stock of his *English Landscape* mezzotints. Nearly everything was sold. Dealers such as Hodgson, Tiffin, White and Colnaghi were the main buyers. Among the few private buyers was the artist John Sell Cotman. The total for the three days was £648 12s. 6d.[18] Although the majority of the items sold were Old Master prints – Claude 74, Everdingen 219, du Jardin 80, etc. – a number of English works were included. Some of the most interesting of these were forty-eight drawings, sold in six lots, by Richard Wilson, twelve by Gainsborough and forty-one by George Frost, twenty-seven of which were described as 'Drawings in imitation of Gainsborough' (see p. 159). Among the forty framed prints and drawings were several of a picture Constable greatly admired, Titian's *St Peter Martyr* (see pp. 139–40 and pl. 63). One of these, lot 521, was described as 'A copy by CONSTABLE of the drawing of the same subject, by Titian, in the Lawrence Collection; and another by him of the Study of Trees by Titian'. There were other copies by Constable of various sorts. Presumably to test the market for the subsequent sale, a few of Constable's own original works were offered on the second day. The response cannot have been very encouraging. Ten tree studies in black chalk fetched £1 3s., nine 'Highly finished studies' went for £3 3s., and twenty-nine oil studies 'of Clouds and Skies . . . *with curious and interesting memoranda at the backs*' made only £3 11s., or less than half-a-crown each. In addition, the copyright, plates and stock (over 7,000 prints) of Constable's *English Landscape*, including six unpublished plates, were offered but were bought in at £100. Also bought in, at £84, was the plate and copyright of Lucas's large, unpublished print of *Salisbury Cathedral from the Meadows*. The dealer Henry Bohn is reported to have bid £55 for both this lot and the *English Landscape* collection.[19] At a later date he managed to acquire the *English Landscape* plates, which he re-issued in 1855.

The sale of Constable's Old Master and modern paintings and of his own

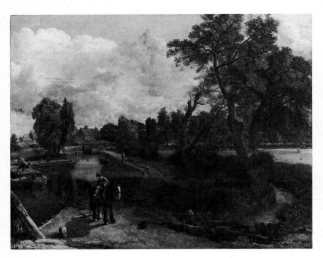

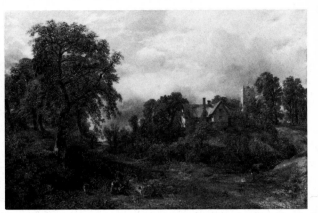

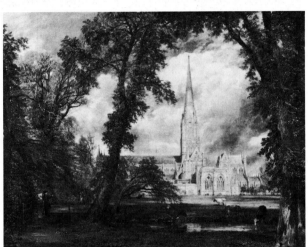

12  *Scene on a Navigable River (Flatford Mill)*, exh. 1817; oil, 40 × 50 (101.7 × 127)

13  *The Glebe Farm, c.* 1830; oil, 25½ × 37⅝ (64.8 × 95.6)

14  *Salisbury Cathedral from the Bishop's Grounds*, exh.1823; oil, 34½ × 44 (87.6 × 111.8)

paintings followed at Foster's three days later, on 15 and 16 May (pl. 11).[20] About a hundred paintings by 'Old and Modern Masters' and nine copies by Constable – after Claude, Ruysdael, Arthois & Rubens – as well as various prepared canvases and other pieces of studio equipment were offered in seventy lots on 15 May. The total for that day was £486 5s. Bought-in lots accounted for a further £35 10s. The following day one hundred and seventy-one paintings and four drawings by Constable (as well as a landscape by Beechey) were offered in eighty-six lots. Twenty-five of the paintings were bought in for a total of £334 19s.* The items sold realised £1763 19s. 6d.

The works offered on this final day, 16 May, were far from the studio scrapings which make up some artists' posthumous sales. A good number of Constable's major finished canvases were included: *Scene on a Navigable River (Flatford Mill)* (pl. 12, Tate Gallery), *Boat-building near Flatford Mill* (Victoria and Albert Museum),[21] *Chain Pier, Brighton* (Tate Gallery),[22] *The Glebe Farm* (pl. 13, Tate

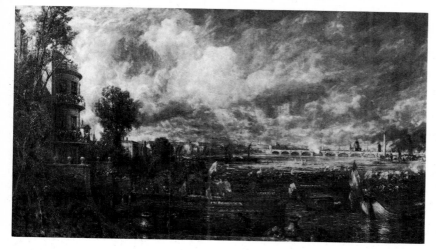

15 *The Opening of Waterloo Bridge*, exh. 1832; oil, 53 × 86½ (134.6 × 219.7)

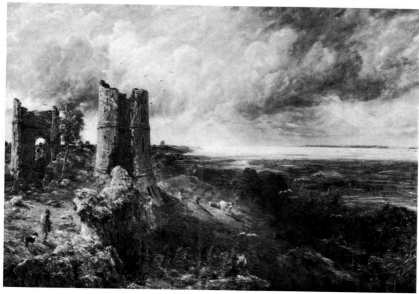

16 *Hadleigh Castle*, exh. 1829; oil, 48 × 64¾ (122 × 164.5). Sold for £105 at the 1838 studio sale.

Gallery), *The Cenotaph* (National Gallery),[23] *Salisbury Cathedral from the Bishop's Grounds* (pl. 14, Victoria and Albert Museum), *The Opening of Waterloo Bridge* (pl. 15), the 1828 *Dedham Vale* (National Gallery of Scotland),[24] *The White*

* This total does not include the amounts paid for lots 38, the full-size sketches for *The Hay-Wain* and *The Leaping Horse* (£14 10s.), and 71, *The Cenotaph* (£42). These were purchased by Purton and Carpenter respectively and are neither marked as 'bought-in' lots nor included in the auction-eer's total of such lots in the V & A copy of the catalogue. However, all three paintings certainly returned to the Constable family sometime after the sale. We have not discovered whether the works were in fact bought in or whether their purchasers subsequently re-sold or gave them back to the family.

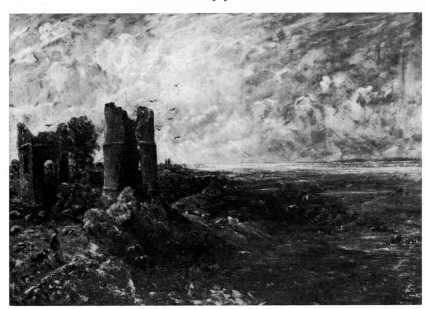

17  *Sketch for 'Hadleigh Castle'*, c. 1828–9; oil, $48\frac{1}{2} \times 65\frac{7}{8}$ (122.5 × 167.4). Sold for £3 13s. 6d. at the 1838 sale.

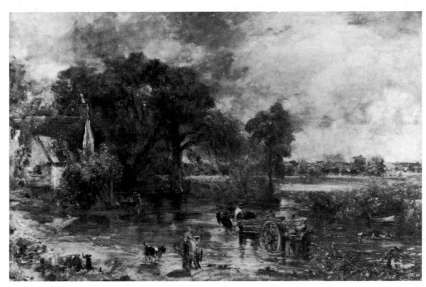

18  *Sketch for 'The Hay-Wain'*, c. 1820–1; oil, 54 × 74 (137 × 188). Bought in, with the sketch for *The Leaping Horse* (pl. 19), at £14 10s. during the 1838 sale. In the 1850s, however, both sketches began to arouse considerable interest.

*Horse* (pl. 5, Frick Collection, New York), *Hadleigh Castle* (pl. 16, Yale Center for British Art), *Salisbury Cathedral from the Meadows* (pl. 9), and so on. At least four of Constable's full-size sketches for his large compositions made their first public appearance on 16 May, those for *Hadleigh Castle* (pl. 17, Tate Gallery), *View on the Stour near Dedham* (Royal Holloway College),[25] *The Hay-Wain* (pl. 18) and *The Leaping Horse* (pl. 19, both Victoria and Albert Museum). Few can have suspected the existence of such works, let alone have seen them before.

[18]

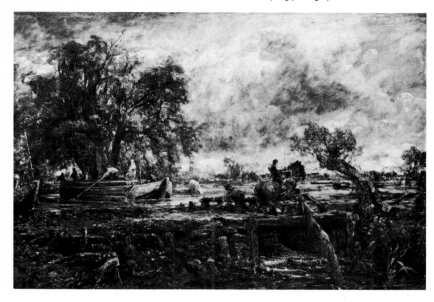

19  *Sketch for 'The Leaping Horse',*
1824–5; oil, 51 × 74 (129.4 × 188)

Many of the smaller pictures and sketches sold on 16 May are impossible to identify from their terse catalogue descriptions, but references to some having been 'painted from nature' suggest that another area of Constable's work previously hidden from the public – his outdoor oil-sketching – was first revealed on this occasion. A number of items described as early works may also have been receiving their first public airing. Perhaps because of the poor price fetched by the twenty-nine examples on 11 May, none of Constable's sky studies appear to have been included and only four drawings were offered.

A sale devoted to the work of a recently deceased artist is often regarded with mixed feelings by the trade. It can be a time for bargains, as a painter's reputation frequently reaches its nadir in the years immediately following his death. It can also be an occasion for the acquisition of unimpeachably genuine work by a particular artist. But the sudden appearance of a large number of drawings and paintings by one individual quickly produces a state of saturation, and knowing this dealers tend to buy somewhat warily. Sale-rooms at such times provide opportunities for long-term investment rather than a quick return, and not everyone can afford to salt away for an uncertain future. Furthermore, it is at such sales that there frequently emerge (as there did at Foster's) new and 'uncharacteristic' examples, material notoriously difficult to sell.

If this is true in the case of artists who have known success, it must have been with even greater circumspection that the trade attended this sale of Constable's, an artist who had experienced comparatively little success in his lifetime and about whom few had as yet made up their minds. With so little in the vendors' favour, with so much unfamiliar material and with such totally strange modes of painting on display, it is hardly surprising that many of the lots on

[19]

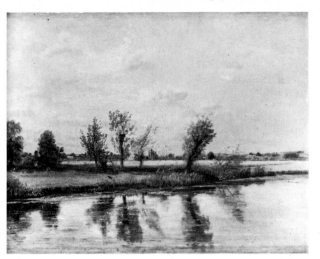

20 *Water-meadows near Salisbury*, oil, 18 × 21¾ (45.7 × 55.3). One of the few works actively competed for in the Constable studio sale.

16 May went for derisive, knock-down prices. Of the full-size, six-foot sketches, the *Hadleigh Castle* fetched £3 13s. 6d., the *View on the Stour near Dedham*, with another unspecified landscape, £12 12s., while those for *The Hay-Wain* and *The Leaping Horse*, offered together, appear to have been bought in at £14 10s.* Small oil studies sold, or did not sell, at a few shillings each. The large, finished paintings naturally fared better though hardly well; most sold or were bought in at between forty and a hundred guineas. The highest price in the sale was achieved by *The White Horse*, which fetched £157 10s. This went to Lancelot Archer-Burton, the Constable children's guardian. Other private buyers included a few who already owned works by Constable, John Allnutt and James Stewart, for example, and friends of Constable who, so far as we can tell, were making their first purchase of his work. These included William Purton, the family solicitor H. D. Haverfield and James Brook Pulham, son of Constable's Wood-bridge friend who not long before had caused Minna so much unease. Charles Birch, Hilditch and John Henry Smith were among those who had probably not been personally acquainted with Constable and who were buying his work for the first time; Smith seems to have been bidding for the great collector John Sheepshanks as well as for himself. The dealer Samuel Archbutt paid £297 19s. 6d. for fourteen pictures, evidently as a speculation since he tried to re-sell thirteen of them at Christie's the following April. His somewhat unsuccess-ful dealings in Constable's work will be described in detail later. Among the better known dealers, W. W. B. Tiffin was the most adventurous, buying six lots, including *Chain Pier, Brighton* and *Hadleigh Castle* (pl. 16). Williams, presumably also a dealer, bought more than Tiffin but confined himself to smaller works. Other dealers bidding included Smith of Bond Street, White, Brown, Morris and Bohn. Leslie and Archer Burton took it in turns to buy in for the

* See, however, note * to page 17.

Constable family works which failed to reach a worthwhile price. It is not clear whether actual reserves were set in advance. John Charles Constable was well enough to attend the sale and to buy three paintings for himself: *View of London from Hampstead Heath*, *The Glebe Farm* (pl. 13), and *Arundel Mill and Castle* (pl. 1), the idea for which had originally been his.

Despite the generally low prices, competition is recorded for at least one painting in the sale of 16 May: lot 50, 'Salisbury Meadows; painted from nature', now in the Victoria and Albert Museum and known today as *Water-meadows near Salisbury* (pl. 20). J. H. Smith, apparently acting for Sheepshanks, paid the comparatively high price of £35 14s. for this smallish and rather untypical painting. The reasons for the interest were extra-pictorial, *Water-meadows near Salisbury* having acquired notoriety because the Selection Committee of the Royal Academy rejected it, in very curious circumstances, when Constable submitted it for the exhibition of 1830.* The collector J. H. Anderdon had tried to buy the picture at the sale and later told Leslie that he 'had been bidding on from ten pounds, hoping to walk off with such a prize, when I heard some one whisper – "Why Sheepshanks is bidding". I was then the last bidder, but I gave way at once to a competitor with such a long purse'. Anderdon says that Leslie then told him, 'You would never have got it in any case. I have tried in vain to obtain it, and have offered in exchange to paint for Sheepshanks anything he liked. But I can't shake him. He clings to it all the more, because he knows it was thrown out by the Academy Council as "a nasty green thing" . . .'.[26]

Even allowing for the lots which the family bought in, the sale on 16 May 1838 probably more than doubled the number of landscape paintings by Constable which had been in circulation at the time of his death. Some new private collectors had emerged, and English dealers were beginning to take a modest interest in Constable's work. Over the next five years the Constable market was to expand dramatically.

* See Tate Gallery 1976, under No. 269, for details of this episode.

# KEEPING UP THE NAME

## [1838–1846]

AFTER the sales at Foster's of May 1838, it was decided that the young Constables should move from Charlotte Street to a smaller house 'more in the country'[1]: to No. 16 Cunningham Place, St John's Wood (pl. 21). This brought them close to their guardians, the Archer-Burtons in Grove End Road, and to within a short distance of Pine Apple Place, where lived the most helpful and willing of their friends, the Leslies. With only Minna and the domestics at home during term-time, the house in Charlotte Street was unnecessarily large, and though the now empty gallery made a splendid play-room for the high-spirited youngsters during the holidays, a more manageable house in a more salubrious area was obviously the right thing for them.

The move took place some time between 8 October and 23 December 1838; on the latter date John Charles wrote from the new address to Osmond Fisher (eldest son of his father's greatest friend), a fellow undergraduate at Jesus College, to explain that he had been called away from Cambridge by a letter from the family solicitor. John Charles had come of age on 4 December and now that he was head of the family, there must have been much legal business to be seen to. It is probable that he also wished to attend a further auction of family things at Foster's on 22 December, this time of their surplus furniture and books. Some of the entries in the catalogue for this sale suggest that they were disposing of items from more than one household, that several of the pieces were from the house in Well Walk. The Archer-Burtons acquired one of the better-quality items, a mahogany secretaire; another, a rosewood bureau with bookcase over, appears to have been bought in by John Charles himself.

Much had been disposed of in the six Foster sales: the books, the many thousands of prints and drawings (with the forty or so portfolios they had been kept in), the surplus furniture and studio equipment (easels, prepared canvases, etc.), around a hundred oil sketches and pictures and all but two of the larger, six-foot canvases. But there yet remained the problem of housing the rest of the collection, the six hundred or so oils and the many more hundreds of drawings, still the greater part of their father's life-work. At Constable's death it had been

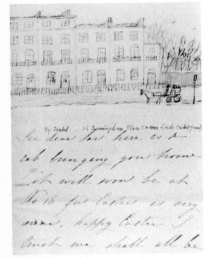

21 Isabel Constable, drawing of 16 Cunningham Place, in a letter to Lionel Constable, 4 March 1842. The small house to which Constable's children moved after his death.

housed under two roofs, No. 6 Well Walk and 35 Charlotte Street with its gallery and capacious studio. Now it had to be fitted into a single house considerably smaller than either of the other two. This, with some friendly assistance, the young Constables succeeded in doing, and despite subsequent adjustments of ownership, here, at Cunningham Place, for the next forty years or so, in hibernation as it were, much of the collection remained: the walls of No. 16, we may suppose, liberally hung with framed pictures and drawings, the attics a storehouse of the artist's more personal and as yet quite unknown works.

John Charles had noted in his diary for 7 April 1838 that he was making a catalogue of the pictures at Charlotte Street and choosing some to take to Cambridge. No such catalogue has survived but we know a little of the history of the paintings he chose for his lodgings (almost the only group to leave the main body of the collection until the 1860s). They were packed up for their journey to Cambridge in July by Wright, a handyman who had worked for the family for many years, and then sent off by carrier. The paintings arrived safely, but only after John Charles had been very much frightened by a rumour that the carrier's waggon had been burned on the road from London. They remained in Cambridge – 'probably the finest collection that ever decorated an undergraduate's rooms', as R. B. Beckett called it[2] – until after John Charles's untimely death: that is, until Osmond Fisher arranged for them to be sent back to Cunningham Place late in the autumn of 1842.

Only two other paintings left the collection. They were the full-scale sketches for *The Hay-Wain* (pl. 18) and *The Leaping Horse* (pl. 19), now both in the Victoria and Albert Museum, the gift of the collector Henry Vaughan. These were too large to be hung at No. 16 and so Leslie, who admired them greatly, arranged for them to be stored at his own house in Pine Apple Place. Here he and his son Robert later cleaned the two sketches of their London grime, and it was while they were there, in Leslie's care, that their originality began to attract the notice of others, of dealers and collectors as well as the artists who called. It was there, at Pine Apple Place, that Henry Vaughan first saw them.

In February 1839, on one of his rare visits to London, Abram Constable, 'uncle Abram', wrote approvingly to John Charles in Cambridge of the new house in Cunningham Place. He had evidently been intending to have a man-to-man talk with John Charles about his responsibilities now he was head of the family. Abram's brother Golding, the children's other uncle, had died the previous March and there was also a need to discuss with John Charles the legacy his uncle had left him. It is likely too that Abram wanted an opportunity to talk to his sailor nephew Charles Golding, about his decision to leave the merchant service for the Indian Navy, an important change in his career, and to see him before he embarked for Bombay.

Charles was just eighteen when he sailed in April of that year (1839) to take up his commission as midshipman. Within two years he was to find himself presumptive head of the family, but it was to be another six before he saw any

of his family again. During that time his departed father and the collection they had inherited would be much on his mind.

None of the Constable children made old bones. Only Isabel and Minna managed to reach their sixties, Lionel was fifty-eight at his death, Charles Golding fifty-seven, Alfred twenty-seven and John Charles only twenty-three. Emily, the youngest of the three girls, died of scarlet fever at the age of fourteen in May 1839, barely a month after Charles's departure for India. John Charles could not bring himself to attend the funeral – there was, he said, nothing he disliked so much as to be present on such occasions. Charles did not hear of his young sister's death until his arrival in Bombay in August. In his first letter home he wrote to say how sorry he was to hear of her death, but that so slender a little thing stood no chance against such a disease. Towards the end of the letter he wrote again of their loss, but this time measuring it against their greater one: 'Poor Emma's death', he said, 'makes scarce any impression after my Father's    I don't think time itself or any thing else can ever help me over that ⟨I can write no more on that subject, I am choked with grief when I think of it⟩ . . . Take care of the sketch books, pictures & portfolios    of course I mean every one in the house – they are like Gold to me Diamonds or any thing else'.[3]

After Emily's death, to avoid contagion the four children at Cunningham Place were farmed out to friends and relations. Alfred and Lionel were taken in by Mrs Susanna Reeve of Well Walk, a friend of their father's, and then sent down to Louisa Sanford (Maria Constable's sister) in Wimbledon. The ever helpful Purtons took Minna and Isabel to spend the summer in the Lake District with some old friends of their mother's, the Speddings, who lived at Mirehouse, overlooking Bassenthwaite Lake. This is no distance from Borrowdale where their father had stayed on his memorable sketching tour in 1806, and the girls managed to find some of the places where he had worked. Isabel was handy with her pencil and sent some little sketches she had made to Charles Golding in Karachi. He recognised the scenes immediately and wrote back to tell them where they would find the drawings their father had made on his tour – in the 'Lake Portfolio' upstairs in the attic, he told them, where he had stowed it after the move. 'Those Lake Sketches', he added, 'will be interesting to you now'.[4]

John Charles had plans in this summer of 1839 for staying with the George Constables of Arundel and with uncle Abram and aunt Mary ('the little old lady of Flatford', as she was now calling herself), but in fact he seems to have spent the greater part of his vacation with the Atkinsons of Silvermere, near Cobham, Surrey, a family who had nursed him back to health after the death of his father two years before.

At Silvermere John Charles found a family even more recently bereaved than his own, the father, William Atkinson, having died in May a few days after Emily. Their shared grief brought them very close. John became deeply attached to Mary, one of the daughters. Before long they were engaged. It was decided,

however, that this should not be made public until he had taken his degree. For some years it had been John Charles's intention to enter the church, and in his last letters from Cambridge he talks of his future plans and of possible curacies. In a letter to Minna of March 1841 he said that it was Mary's wish that he should be ordained as quickly as possible and that he was going to ask Mr Purton whether he knew of any vacant curacies. In his letter he talks of coming home in three weeks' time after the Divinity Lectures. This was written on the 8th. A few days later he contracted scarlet fever on a hospital visit and on the 21st his closest friend, Osmond Fisher, had the melancholy task of writing to tell Minna that John was dead.

Only one of Mary Atkinson's letters has survived in the family archive. It is addressed to Charles Golding, who received it at the same time (November 1841) as he received letters from his sisters and from Haverfield, the family solicitor, bearing the news of John Charles's death. Until he read Mary's letter, Charles had known nothing of his brother's betrothal, and Mary had much to tell him. She also had a number of practical matters to discuss. John and Minna had apparently witnessed many of the deeds of settlement after her father's death and she had now become joint security, with Haverfield, for Minna's administration of his, Charles's affairs. Mary also had a favour to ask. This concerned the collection and is best given in her own words.

> I will now venture to make a request, which is that you will grant me your permission to take charge of one of the beautiful pictures which dear John had in his rooms at Cambridge, until your return to England – dear Minna and Isabel have little room for them to be seen in Cunningham Place, but we have at Silvermere ample room for your father's great talent to be seen and appreciated and there your sisters will I hope often visit us – and it would be the source of the greatest interest to me to be permitted to take charge of one of them. I have a very beautiful but unfinished Sketch of Salisbury which Mr Leslie allowed me to have at the price it was bought in at (with some others[)], at the sale – and I have also two beautiful water colour drawings done by your Father in my Album.*

It is not known whether Charles agreed to loan Mary Atkinson one of the pictures with which John had decorated his rooms, but in a note to Minna of 27 July 1841 from Cambridge Osmond Fisher told her that he had put the pictures safely away, where they would remain until he had heard her brother's pleasure concerning them, so it is clear that now the estate was his, Charles Golding had to be consulted on all such matters. The following July (1842), Charles enquired about the paintings. 'I hope', he wrote to Minna, 'you have got my Pictures to ornament your house'.[5] His use of the possessive adjective suggests that he was already aware of his rights as head of the family.

* Constable made a number of drawings for ladies' albums and some of these are, untypically, signed and dated. Just such an example, *Old Houses on Harnham Bridge Salisbury with the Antient Hospital of St. Nicolas* (1827), came to light recently in one of three albums. See The Haldimand Collection of English Watercolours, Christie's, 18 March 1980 (215).

In her letter Mary Atkinson had quite a lot to say about Alfred and Lionel. It may be remembered that when their father died they were hardly more than children. Now, in 1841, they would be celebrating their fifteenth and thirteenth birthdays, and Mary evidently considered it high time that some thought was given to their futures. It had been John's wish, she said, for them both to have entered the church, but Lionel's inclination and talents seemed decidedly to turn towards engineering and as the training for this profession was much less expensive than for the church she thought that John would have approved of every encouragement to keep him of the same mind. If she could see a way ahead for Lionel, Mary appears to have felt rather less certain about his brother: 'Alfred I fear will never display so much decided talent as Lionel, and for his age is extremely backward'. His disposition, she felt, would be more suitable for a merchant than anything else.

Neither of the boys at this time appears to have been the cause of much satisfaction to their elders, but this is not really surprising. As infants they had known their father's love and had learnt to love him in turn, but they had been spoilt and become very demanding. Together the two high-spirited boys presented a problem. It was therefore eventually decided that they should be educated separately. Alfred was sent to King's College School, where his cousin Burton and Osmond Fisher had been pupils, and Lionel went to board at a school at Wimbledon run by Messrs Stoton and Mayor. This meant that Minna and Mrs Roberts the housekeeper could keep an eye on Alfred, while Louisa Sanford could watch over Lionel's welfare and progress at his school from her home nearby. The arrangement seems to have worked reasonably well. It lessened the strain at Cunningham Place and the boys received an adequate education.

Mary Atkinson had broached the subject of careers for Alfred and Lionel in her letter of 1841, but it was not until October 1842 that, in his breezy way, we find Charles Golding beginning to enquire about his brothers' future: '. . . and those two vixen boys', he writes, 'how might they be getting on. Is any thing settled about a profession yet for Master Antewit'[6] (that being his particular nickname for Alfred). For a time Alfred had entertained the idea of following his brother's example and going to sea. Ships of all kinds, with the rigging carefully delineated, had figured in many of his early letters to Lionel. But he began to have second thoughts about a life afloat in the summer of 1842, when news came through of the death in a boating accident in the Solent of their friend Edward Constable, eldest son of George Constable of Arundel. Charles was more certain what Alfred should not think of becoming than what might best suit him. 'I hardly know what to recommend him to be', he wrote from Bombay, 'but pray tell him not to go into the merchant service nor by any means to be a miller    I should think the wretched state of things with Uncle Abram was an example sufficient to deter any one from wishing to be like him. I should say an Engineer Merchant or Cadet'.[7] While still leaving us in the dark about the state of things at Flatford, a passage in a letter from Alfred to Lionel of

about this time leaves us in no doubt whatsoever what Abram Constable's views were on the subject of a career for his nephew: 'uncle was here on Sunday  we asked him about a Miller  he said that he would not have us. and told me to get to painting and not to think about it'.[8] Both boys had always been fond of drawing. In the earlier correspondence Lionel is perhaps more often referred to as an artist, but Alfred had been able to delight his father at the age of six with a drawing of a polar bear, and the sketches in pencil, pen and wash with which he decorated his letters to Lionel show that he had a natural facility for graphic expression. The decision that Alfred should leave school and study art appears to have been made some time between November 1842, when Minna reported he was still attending King's School but had lately taken to drawing 'to an amazing degree', and March 1843, when Alfred told Lionel he had not missed a day's work at the British Museum and was also busy painting.[9] Further details are contained in a letter of 8 March to his younger brother:

> I only paint now in the afternoon and then not much  perhaps I got to the to[p] of the house and take a peice of sky  I have done a great many lately but I give all my time to drawing  that's the do[d]ge drawing my boy  have you made any sketches yet  if it [is] only a dock leaf it will be useful to you or if you see a peice of fine sky take the shape of the clouds and remember the colors.

When he heard of the boys' plans Charles at first adopted a bantering tone of mock disapproval – 'So the Boys are going to be Artists, only think of that  Oh dear dear what a daubing there will be'[10] – but in fact he was genuinely pleased at the thought of his brothers as painters; somehow, he said, 'one of us ought to keep up the name in the Academy'.[11]

Having drawn from the Antique at the British Museum, Alfred began his art education proper at the school of art in Bloomsbury Street known as Sass's Academy (after its founder Henry Sass), the management of which had recently passed to a one-time pupil, F. S. Cary. Alfred tells Lionel about the school in a letter postmarked 5 May 1843:

> I have been very busy in collecting colors and buying oils and brushes for I am now in oils  I did not tell you that I am now at the Academy all day. and in the afternoon I paint a little  I like the Accademy very much but I am only in outlines  some of the boys are doing the figure  they do it beautifully  the rooms are surrounded with plaster figures and head arms and legs. I will not go on about it as I could fill a sheet about it.

While Alfred and Lionel were thus setting out on their careers as artists, C. R. Leslie was trying to 'keep up the name' in a different way by publishing a biography of his friend: *Memoirs of the Life of John Constable, Esq. R. A. Composed chiefly of his letters*. This appeared in 1843 and in a revised edition two years later. Until Sir Charles Holmes's volumes of 1901 and 1902, Leslie's biography was virtually the only book on Constable, and until R. B. Beckett published his edition of the artist's correspondence in the 1960s it remained the most com-

plete biographical account. In many ways it is still the best introduction to its subject.

Eighteen years Constable's junior, Leslie had first become acquainted with him in about 1817 but the two do not appear to have become close friends for another two or three years. At that time Leslie was establishing himself as a painter of genre subjects, particularly anecdotal scenes from literature and, as he later confessed, 'really knew nothing, or worse than nothing'[12] about landscape painting. Nevertheless, his friendship with Constable continued to grow, becoming especially important to the latter after the death of his earlier friend John Fisher.

It was Fisher who had first had the idea of writing a life of Constable. In 1826 Constable told him that he had been asked to write a paper on art for a local literary journal. Fisher reasoned thus why he should not do so.

> I am doubtful about your Brighton Gazette. You are in possession of some very valuable and original matter on the subject of painting, particularly on the *Poetry* of the Art. I should be sorry to see this seed sown on some unvisited field where it would blossom in forgetfulness: while some theiving author, like a sparrow, would fly off with a sample & take the credit ⟨for the⟩ from you. Throw your thoughts together, as they arise (in a book that they be not lost) when I come to see you we will look them over put them into shape & do something with them. Perhaps we could illuminate the world thro' the *Quarterly*. Pray do not forget to put together the history of your life & opinions with as many of your remarks on men & manners as occur to you. Set about it *immediately*. Life slips. It will perhaps bring your children in £100 in a day of short-commons, if it does nothing else. Besides, *I* have been all along desirous of writing your life & rise in the art.[13]

Fisher died in August 1832 without, so far as we know, having written anything about Constable. A few months earlier, however, Constable had finally taken his friend's advice and begun to 'throw his thoughts together', in the form of a didactic Introduction to the *English Landscape* prints. Later he composed texts to accompany some of the individual plates, and one or two autobiographical asides were introduced in these.

Constable developed his ideas about the history and practice of landscape painting in ten lectures which he delivered at Hampstead, Worcester and the Royal Institution in London between 1833 and 1836. Leslie took fairly complete notes of the 1836 Royal Institution and Hampstead lectures. Possibly the idea of writing some account of Constable was already in his mind. The first clear indication of Leslie's intentions is in John Charles Constable's diary entry for 6 April 1838: 'Called on Mr Leslie he is going to write a life of Papa. promised him all the papers &c. to look at.' John Charles went to stay with his uncle Abram and aunt Mary that summer and Leslie wrote to him there on 22 May:

> I shall feel obliged, if while you are at Bergholt, you will put down for me any anecdotes you may hear from your Aunts and Uncle, of your father's early life as

well as any account you may obtain of your Grandfather & grandmother Constable, of their ancestors, & when the family was first established at Bergholt . . . All these matters will hereafter be interesting to yourself, your brothers & your sisters & a few years may make it difficult, ⟨t⟩ or impossible to preserve them.

John Charles recorded in his diary some of the enquiries he made. On 1 June he 'Went to Mr Dunthorns    talked a great deal about papa    he said he thought he could get me some dates'. On 9 June he 'Wrote some of "the life" ' and again 'Went to Mr Dunthorns who lent me some letters which I think will be very useful'.* Back in London, on 28 July, John Charles noted rather awk⁄wardly that he 'Asked the Miss Fishers to ask ⟨Mr Leslie⟩ Mrs Fisher for some of Mr Fishers letters for Mr Leslie'. The entry 'Wrote some things for Mr Leslie' occurs on 25 July and 21 September.

John Charles's references to writing 'some of "the life" ' and to writing 'things' for Leslie suggest that he acted as more than just a research assistant in the early stages of the book. Unfortunately, none of his material on his father has survived. If John Charles did put together some sort of account of his father for Leslie to see, we might have an explanation for a curious passage in a letter Abram Constable wrote to one of his nieces in 1862. Talking of a Mr Gorman who had come to live at East Bergholt, Abram said 'I had before lent him my Brors. J.C's life, which he lik'd much & better than he did that of C. R. Leslie'.[14] No other reference is known to this alternative life of Constable.

By March of the following year, 1839, a book on Constable had shaped itself clearly enough in Leslie's mind – '*The Life of an Artist*, filled with the most interesting letters on all matters relating to art' – for him to approach Edward Carey of Philadelphia (a relative of his sister) about its publication.[15] By April 1840 Leslie was in the thick of it. 'The truth is', he apologised to a correspondent, 'all my leisure moments have of late been so entirely engrossed in putting together the memoir I have undertaken to write of Constable, that I have scarcely been able to take up a pen for any other purpose. If I live to get through it, I will never write anything of the kind again'.[16] In July things looked brighter: 'with the material I have', he told his sister Eliza, 'I do not hesitate to say I shall make the most interesting life of an artist that has ever appeared'.[17] That summer, Leslie and William Purton visited Suffolk and 'were received at Flatford with the greatest hospitality by Mr. Abram Constable and his sisters, and were accom⁄modated with facilities for exploring what to us was classic ground'.[18] They toured the area with John Charles and his cousin, the Revd Daniel Whalley, visiting Constable's birthplace (East Bergholt House) and the sites at Flatford, Dedham and elsewhere of some of his paintings. The visit was something of a revelation to Leslie, who had come to know Constable only after the latter had himself become an infrequent visitor to Suffolk. Leslie and Purton were

* There was a sad destruction of a Dunthorne/Constable correspondence in the 1920s; see JC:FDC, p. 103 n.

surprised to find that Constable had taken the subjects of so many of his major works from one small area around Flatford. They were startled by 'the resem-blance of some of these scenes to the pictures of them', but also recognised that Constable had often 'rather combined and varied the materials, than given exact views'.[19]

Although the Preface to the first edition of Leslie's *Life* is dated March 1843, the book was probably completed about a year earlier. On 2 May 1842 Leslie asked H. D. Haverfield to have a prospectus printed, adding, 'I am not without hopes of our soon obtaining a sufficient number of names to enable us to go to press'. By 6 August Leslie had found forty-one subscribers and was suggesting to Haverfield that the book should go to press immediately. A specimen of the book had already been got up and Leslie proposed to invite James Carpenter to be the nominal publisher. It had been decided to illustrate the volume with the original twenty-two mezzotints by David Lucas for *English Landscape*. As we have seen, a huge stock of the prints was still with Constable when he died, and over 7,000 had been offered, and bought in, in the sale of 10–12 May 1838. The specimen book mentioned by Leslie in his letter of 6 August has survived[20] and consists of a title-page dated 1842, a Preface, four pages of text and the twenty-two mezzotints. Leslie writes of the latter in this 1842 Preface:

> . . . I will not now enter upon any enquiry into the causes of the cotemporary neglect of the works of so extraordinary an artist. At present, I need only state that the apathy with which these beautiful engravings were received, has enabled me to adorn a volume, chiefly from his pen, with the productions of his pencil.

In an agreement dated 25 February 1843 James Carpenter promised to deliver to Maria Louisa Constable thirty copies of the *Life* as published in return for the prints which had been taken to illustrate the edition: these amounted to 180 sets plus six sets of impressions before the letters. Carpenter and Leslie would therefore have had 156 copies of the book to sell or give away. A list of subscribers now in the Fitzwilliam Museum, Cambridge accounts for about 105 copies, including orders from booksellers and dealers. Tiffin in the Strand took six copies, as did Grundy of Manchester. The published price was three guineas.

Leslie was already thinking of a second edition when he wrote to Francis Darby of Coalbrookdale in May 1843:

> I am delighted to find that I have not been mistaken in my expectations of the interest Constables letters would excite in all who really love nature and appreciate art . . .
> I think it not unlikely that a second edition will be published, without the plates, and of a smaller size, more calculated, in short, for general circulation.[21]

The new edition was published in 1845 by Longman, Brown, Green and Long-mans, at a more popular price, twenty-one shillings in cloth. The format was reduced from folio to octavo and the only illustrations were two lithographic portraits of Constable (by R. J. Lane after Leslie and T. H. Maguire after Daniel

Gardner) and a reduced version of Lucas's mezzotint of *Spring* from *English Landscape*.*

In his Preface of March 1845 to the new edition Leslie tells us that for the first edition he reduced his original arrangement for fear of making the book too long, but that the interest shown in the letters had encouraged him to include much more of the original material. In fact he revised and replanned the greater part of the book. Instead of twelve chapters there were now sixteen. Before, the story of Constable's seven-year courtship had been compressed into one chapter; Leslie now extended it to three. Less fearful now, apparently, of causing tedium, he gave greater weight to Constable's correspondence with John Fisher, the closest friend of his middle years. By cutting less rigorously he kept more of the original colour in his quotations. In all he increased the length of the book by nearly a third.

Since 1845 there have been eight further editions, all based on Leslie's second edition. The book has become a minor classic. In its effective use of the material and in its direct emotional appeal it is perhaps surpassed by no other biography of an English artist. A vast amount of letters and papers had been placed at Leslie's disposal and his choice was of necessity highly selective. Of the fifteen hundred or so letters available he used about three hundred and sixty, more than two thirds of which were taken from the letters Constable and Maria Bicknell wrote to each other before and after their marriage, from the twenty years' correspondence between Constable and John Fisher, or from the letters and notes Leslie had himself received from Constable.

Leslie's main purpose in writing the book was to promote the reputation of a friend and fellow artist whom he admired intensely, a man of genius, he believed, who had received less than his due from the world at large. In this he was remarkably successful. He had a touching story to tell – the young miller, youthful ambition and endeavour, requited love, grandparental opposition, and so on. For his more serious readers he had some of the most profound and moving utterances by a great artist ever to find their way into print. Among the pages of his book there could also be found clearly set out, and again in the artist's own words, the heroic nature of the struggle for recognition. Leslie was successful in another of his aims, to place Constable before the public as an original genius (originality in those days not necessarily being a *sine qua non* of genius) and, moreover, one who had been neglected by reason of his originality. A reviewer of the first edition had said he found it 'refreshing, amid the shoals of common-place people, to follow the course of such a single-minded man, one who, without ranking among the highest, will always be esteemed as an original artist'.[22] In the last chapter of the second edition, a chapter given to Constable's sayings and to a final summing-up, Leslie develops this theme further by comparing Constable with Hogarth, another painter renowned for his originality.

* In some copies only, two further prints were included: Lucas's *Vignette* from *English Landscape* and his mezzotint *Little Roxalana* after a sketch by Constable of Minna as a child.

Though their walks of art were wide apart, yet each formed a style more truly original than that of any of his contemporaries, and this, in part prevented each from enjoying the fame to which he was entitled . . . Constable spoke his opinions openly of the critics; and with point, truth, and freedom, as did Hogarth, of contemporary artists, and each by so doing, made bitter enemies.

On the subject of other artists Leslie had to tread warily. He hints when writing about his editorial policy at material he might have used:

The object I have endeavoured to keep in view throughout the preceeding pages being to give an account of Constable's life and occupations as much as possible in his own words, my extracts from his letters have been necessarily limited to passages relating chiefly to himself; but had not this, and the reserve due to other persons, prevented my quoting these papers more at length, it would be seen that in very many of them his own affairs occupied the least part of his attention . . . Many indeed of his notes and letters have been entirely unavailable to me on this account, excepting in as far as they have added to the high opinion I had before formed of the kindliness of his nature.

The character of Leslie's editing deserves some attention. In both the specimen and published prefaces Leslie plays down his own part in the work. 'The task I have undertaken', he says in the first version, 'has been little more than that of a compiler'. The two title-pages reflect a self-effacing editorial approach: 1842, *Selections from the Letters and other Papers of John Constable, Esq. R.A., Arranged in connection with a Sketch of his Life. To which are added, Notes of his Lectures on the History of Landscape Painting*; 1843, *Memoirs of the Life of John Constable, Esq. R.A. Composed chiefly of his letters.* Tom Taylor, Leslie's friend, thought the biography a model, and found it 'difficult to praise too highly the subordination all through of the editor to his subject . . . the skill with which he left the subject of the biography to tell his own story in letters judiciously chosen'.[23] But though Leslie modestly talks of the work as almost an autobiography of Constable, there is more of himself in the book than these disclaimers suggest. Comparatively seldom is Constable in fact allowed to tell his story exactly in his own words. Leslie's transcripts almost always convey admirably the general sense of what Constable was saying and often the exact wording is transcribed, but seldom is an entire quotation entirely correct. Some examples will indicate the kind of changes he made in his transcripts. In the first, an extract from the Journal kept for his wife in 1825, Constable is talking of the work he and Johnny Dunthorne are doing in the studio.

| *Original* | *Leslie's 1845 edition* |
|---|---|
| we do a deal of painting not going out. I am getting my dead horses off my hands – as fast as I can. I shall do as You say not much mind by little jobs – but stick | We do a great deal of painting, not going out, and I am getting my small commissions off my hands as fast as I can. I will do as you advise, 'not undertake little |

to my large pictures. but I must make my mind easy as to my dead horses – namely =
Salisbury Cathedral.
M^r Carpenters picture.
M^r Ripleys do. – London
M^r Arrowsmith – 3 do.
Mr Mirehouse's picture to be altered. All these are paid for – and one more fortnight will clear them off – how very comfortable I shall then be – Then I am making my last Exhibition picture saleable getting the outline on the Waterloo – &c, &c.

things, but keep to my large pictures.' But I must make my mind easy as to those I have on hand, namely, 'Salisbury Cathedral,' Mr. Carpenter's picture, Mr. Ripley's, Mr. Arrowsmith's, and Mr. Mirehouse's picture to be altered. All these are paid for, and one more fortnight will clear them all off; how comfortable I shall then be. I am making my last picture saleable, getting the outline on the 'Waterloo,' &c.

Leslie's interpolations here are perhaps understandable; they are less so in his transcript of the next passage, a now famous and much-quoted extract from a letter Constable wrote to Maria from East Bergholt on 9 May 1819.

*Original*

Every tree seems full of blossom of some kind & the surface of the ground seem quite living – every step I take & on whatever object I turn my Eye that sublime expression in the Scripture ⟨seems verified before⟩ 'I am the resurrection & the life' &c seems verified ⟨before⟩ about me –

*Leslie's 1845 edition*

Every thing seems full of blossom of some kind, and at every step I take, and on whatever object I turn my eyes, that sublime expression of the Scriptures, 'I am the resurrection and the life,' seems as if uttered near me.

Leslie's editing out of some of Constable's more worldly characteristics was a conscious process, as can be seen by comparing the latter part of Leslie's printed version of a letter Constable wrote him on 21 January 1829 with the original, a letter written under stress only a few weeks after Maria's death and not long before the next Royal Academy Assembly, when he would once again appear as a candidate for election to full membership.

*Original*

I have just received a commission to paint a – 'Mermaid' – for a 'sign' on an Inn in warwickshire – this is encouraging – and ⟨is⟩ affords no small solace to my previous labors as in Landscape for the last twenty years – however I shall not quarrel with the Lady – now – she may help to educate my children –

I have some academical news to tell You but not much – I have little heart to face an ordeal (or rather should I not say – '*run a gauntlet*') in which '*kicks*' are kind treat-

*Leslie's 1845 edition*

'I have just received a commission to paint a *mermaid* for a *sign* to an inn in Warwick-shire. This is encouraging, and affords no small solace after my previous labours in landscape for twenty years. However, I shall not quarrel with the lady now, she may help to educate my children.' He then changes the subject, and after some pleasantry, goes on to say, 'I would not write this nonsense at all, were it not to prove to you, my dear Leslie, that I am in some degree, at least, myself again.'

[33]

ment to those '*insults to the mind*' — which
'*we candidates wretches* of necessity' are
exposed to — *annually* from some 'high-
minded' members who stickel for the
'*elevated & noble*' walks of art — i.e. prefer-
ring the *shaggy posteriors of a Satyr* to the
*moral feeling of Landscape* — but I would not
write this nonsense — at this time or at all
— was it not to prove to *You* my dear Leslie
— that I am in some degree at least 'myself
again —'

There are many expurgations of this kind. Some material was too sensitive
to be handled at all. For example, Leslie quotes letters Constable wrote to Maria
during his long stay with the Beaumonts at Coleorton in 1823, but we hear
nothing of Maria's protests at her husband's protracted absence. It would hardly
have entered Leslie's head to quote such letters from Maria as those of 17 Novem-
ber ('How came you to disappoint me of a letter to day? You said you would
write on Saturday, "your word once passed should never be broken." I begin
to be heartily sick of your long absence') and 21 November ('I shall expect
you at the *end of next week* certainly   it was complimentary in Sir George to
ask you to remain the Xmas, but he forgot at the time that you had a wife').

At the time it was of course not known how much had been edited out
of Constable's letters but some at least felt Leslie had 'painted him *couleur de
rose*'. The artist Richard Redgrave, who said so in his *Century of Painters of
the English School* (1866), also wrote: 'Leslie has just completed his life of Con-
stable, and the world will know Constable only through Leslie's agreeable life
of him. There he appears all amiability and goodness, and one cannot recognise
the bland, yet intense, sarcasm of his nature: soft and amiable in speech, he
yet uttered sarcasms which cut you to the bone'.[24] Of the *Life*, on a later occasion,
Redgrave said that it was 'a picture not so much of that painter as others saw
him, but as clothed with the kindlier nature of Leslie'.[25]

The reactions to Leslie's biography of a few of those who had been close
to Constable are recorded. His children's tutor, Charles Boner, declared that
*he* ought to have written it — 'No one could write such a life of Constable as
I might have done' — and that 'to know all the beauty and sweetness of that
man's mind one must have been with him *always*, as I was'.[26] Charles Golding
Constable liked Leslie's book on the whole:

I think it very successful, the good, quiet, character of poor Papa is kept up
throughout, this is done by the letters &c. You could not have conveyed the feeling
that is expressed in the Book any other way I fancy   It was a very difficult thing
you know, there was very little of a 'Life' to write about   although *we* fancy that
if *we* could only express ourselves we could fill volumes, yet making up a book is
a very different affair.[27]

But he objected to the inclusion of extracts from some of his own youthful letters (which as a junior officer rising in the Service he obviously found embarrassing) and also disliked three anecdotes about his father towards the end of the book which he thought 'silly, common place & altogether very much out of place'.*

Leslie's amiable portrait became the standard image of Constable. The book also became a source of ideas on the subject of art itself. No biography of an artist had hitherto revealed so much of a painter's feelings about his vocation, nor had such a book before contained so many of an artist's thoughts on art so well and so memorably expressed. The sayings are to be seen taking wing from the time of the earliest reviews.† Constable is named with his own words – he becomes 'the natural painter'.‡ His native countryside takes his name and becomes 'Constable country'. The biography achieved for Constable what he had failed to achieve for himself; he became widely known, better known in fact than his paintings. This, after all, is not surprising. In his allotted role as self-effacing editor, Leslie describes and talks about comparatively few paintings in any detail. He passes over much of Constable's output completely. For instance, there is hardly any reference to the vast programme of work done out-of-doors in the earlier years, to the oil studies and the hundreds of pencil sketches. There is also only a passing reference (and then only in the 1843 edition) to a unique feature in Constable's art, his full-size oil sketches for the six-foot exhibition works. These lacunae are surprising when one recalls that Leslie went

---

* The three anecdotes to which Charles Golding took exception were given in the penultimate chapter (XI) on a page headed 'Constable's Sayings and Opinions'.

Constable could not easily resist the temptation of making an unexpected reply, and when Archdeacon Fisher, one Sunday, after preaching, asked him how he liked his sermon, he said, 'Very much indeed, Fisher; I always did like that sermon.' . . .

If Constable had occasion to find fault with a servant or tradesman, it was seldom unaccompanied with a pleasantry, though often a sharp one. To the person who served his family with milk, he said, 'in future we shall feel obliged if you will send us the milk and the water in separate cans.'

A picture of a murder sent to the Academy for exhibition while he was on the Council, was refused admittance on account of a disgusting display of blood and brains in it; but Constable, who objected still more to the wretchedness of the work, said, 'I see no *brains* in the picture.'

†Many were quoted at length by the reviewer in the *Athenaeum* (No. 849, 3 February 1844, pp. 101–2), sayings and remarks now familiar to us, such as 'The world is wide: no two days are alike, nor even two hours: neither were there ever two leaves of a tree alike since the creation of the world; and the genuine productions of art, like those of nature, are all distinct from each other'; 'there is nothing ugly. *I never saw an ugly thing in my life*: for, let the form of an object be what it may, light, shade, and perspective will always make it beautiful'; and 'I shall return to Bergholt, where I shall endeavour to get a pure and unaffected manner of representing the scenes that may employ me. There is little or nothing in the exhibition worth looking up to. *There is room enough for a natural painter*'.

‡Though this, apparently, was not his own spelling of the famous phrase. Shirley (1937, p. 21) and Beckett (JCC II, p. 32) were later to read 'painter' as 'painture', a word taken by some modern commentators to mean 'style of painting'. Unfortunately, the original of Constable's letter to Dunthorne of 29 May 1802, the source of the phrase, is now lost.

through the whole collection when he was making his selection for the Foster sales of 1838 and was therefore probably the only one, outside the family, ever to see entire this greater part of Constable's life-work. The letters themselves are rich in anecdote, opinion and character, but contain little that would enable a reader not already conversant with the subject to visualise the true nature of Constable's work.

The few who had the 1843 edition of the *Life* could at least enjoy the twenty-two mezzotints with which it was embellished. Those who were reading about Constable for the first time in the second edition — that is, the vast majority — had only a reduced version of Lucas's print of the oil sketch *Spring*, and perhaps the *Vignette* to go on. As yet there were not many places where original Constables could be viewed. No. 16 Cunningham Place, with all it contained, was known to only a few. The newly-interested public and the trade which catered for it, had a choice of two courses if they wished to see the work of this neglected genius: to search for original Constables — or for work which *might* be by him — or to become better acquainted with his pictures through engravings. For those who chose the first line of enquiry genuine works proved to be in short supply, some therefore had to be content with examples of doubtful authenticity. There was also only limited satisfaction to be gained for those who turned to the engravings.

In Constable's lifetime only two prints had reached the public at large in any numbers. These were David Lucas's large engravings of *The Cornfield* (pl. 8) and of *The Lock* composition (pl. 22), prints published in 1834 by F. G.

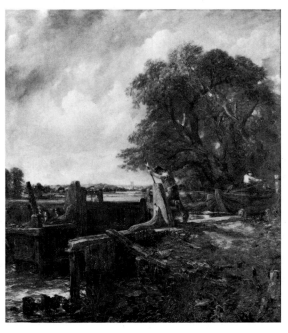

22 *The Lock*, exh. 1824; oil, 56 × 47½ (142.2 × 187.3)

Moon of Threadneedle Street, Printseller to the King. Moon knew his market, and the prints had done well. After Constable's death, in 1838 half a dozen smaller prints from plates that were to have formed an appendix to the *English Landscape* were lettered and published by Moon 'for the Proprietors' – i.e. the family – but Lucas later talked of them as 'exceedingly rare',[28] and it is possible they were never actually issued. Lucas had worked on two other large plates, *Stratford Mill* and *Salisbury Cathedral*, often referred to as 'the large Salisbury' to distinguish it from a smaller mezzotint of an oil sketch of the same subject. The *Stratford* plate belonged to him and he was therefore able to have it lettered for publication. It was issued in 1840 as 'The Young Waltonians', dedicated 'to Every Lover of Angling', with Lucas named as publisher. The date 20 March 1837 had been engraved on the great *Salisbury* plate, but at that time Constable was still working on proofs and he died before this most ambitious of all Lucas's engravings could be published. The steel plate with copyright had come up in the Foster sale of 12 May 1838, but it failed to find a buyer. Re-worked and re-lettered, it was finally published as 'The Rainbow' by Gambart of Berners Street and Goupil & Vibert of Paris in April 1848. Although few had seen the original paintings, through these four large engravings they became Constable's best known works.

The more knowledgeable and, for good or ill, the more enquiring, became acquainted with his work through Lucas's smaller prints, the *English Landscape* mezzotints, and also perhaps through a group of fourteen which Lucas published himself. These, consisting of four earlier plates – two which had been engraved under Constable's supervision and two from the 1838 series – with ten new ones, were issued for subscribers (at six guineas for a bound volume or ten guineas with india paper impressions) with the full title of *A New Series of Engravings, illustrative of English Landscape* or *Mr David Lucas's New Series of Engravings*. Leslie supervised, and the set appeared some time in 1846. In a brief introduction Leslie said that Lucas's 'long and close intimacy with the painter' had given him 'an insight into the principles of Constable's art, and enabled him to imbibe its spirit, to a degree entirely unattainable under less favourable circumstances'. A draft prospectus by Constable's friend George Field also survives.

> Among the objects the engraver has had in view in this publication may be mentioned a wish to guard purchasers of pictures from ⟨the⟩ deceptions that have been practised to a very great extent by forgeries of the works of Constable, ⟨as⟩ the series forming ⟨. . .⟩ a kind of liber veritatis of his works as it is the hope of ⟨Mrs.⟩ Mr. Lucas to ⟨contin⟩ extend ⟨the⟩ his publication ⟨to⟩ so that it shall comprise at least the principal works of the lamented painter.

In practice, neither the original *English Landscape* prints nor Lucas's *New Series* offered any protection to the owners of Constable's paintings. On the contrary, they proved very handy guides for the forger.

# A MODERN PAINTER
# AND HIS MARKET

## [1840–1870]

'THE heart sickens at the list of painters who have died unappreciated, because they devoted themselves to Nature', wrote a reviewer of Leslie's *Life* in the *Art-Union* in 1845: 'after the death of such a one . . . the public, believing in some mysterious excellence in his works, then wake and rise to "investment." Constable is one of those painters whose works are not understood, but only valued at a high price'.[1] Within a few years of the unsatisfactory studio sale of 1838 Constable's work was caught up in a new market in modern British art of which the *Art-Union* itself was one of the chief promoters. Founded in 1839 by S. C. Hall and renamed the *Art-Journal* ten years later, this monthly publication stopped at little in its efforts to turn the cultural aspirations of manufacturers and other possessors of 'new' money firmly in the direction of contemporary painting. Reviewing the progress of the journal's campaign in 1855, Hall looked back to the 1840s, when the art trade was 'almost confined to dealings in "old masters;" the buyers for the most part were wealthy manufacturers and merchants: few of them were then at all conversant with Art: they bought the great names, and thought they had made good investments. It was our duty to show that this was a mistake'.[2] The journal published frequent accounts of rigged auctions, faking and other fraudulent practices in the old master market, taking grim pleasure in quoting such statistics as those it gave for the number of pictures imported to Britain in 1839: of 8000, the journal claimed, 7800 were 'miserable copies . . . chiefly the produce of Flemish youths'.[3] The result was, said Hall, 'to create a very general suspicion and consequent apprehension among manufacturers, &c., that if they bought "old masters" they were more than likely to be taken in; while if they purchased "modern works," the probabilities were that they had expended money to advantage'.[4] But the increased demand for modern British painting soon bred the same corrupt practices that characterised a large part of the old master market. Forgeries of Müller, Etty, Stanfield, Holland, Poole and others went into circulation.[5] In Constable's case, the situation seems to have developed rapidly between 1842 and 1845. In the former year Leslie was still writing rather tentatively of Constable as an artist who 'will not long be

denied his true rank, and that of the highest, in his class of art'.[6] By the following May, Leslie could tell Francis Darby that 'Constable's pictures have so risen in value, that they are now eagerly sought for, and the consequence is there are many forgeries on the market, particularly of his small works, and it is dangerous for any one to buy a picture, professing to be his, unless they are sufficiently acquainted with his style to be safe from imposition'.[7] He also said that he had heard that Lancelot Archer-Burton had recently refused 600 guineas for *The White Horse* (pl. 5); Burton had paid 150 guineas for this in the 1838 sale. The problem of forgeries is mentioned by Leslie in the first edition of the *Life* in 1843: '... I am told some of Constable's sketches have thus been *finished* into worthlessness, and what is a still greater injury to his reputation, entire forgeries have been made of his works. Four of these I have seen, and they are put forth, no doubt, in reliance on the little real knowledge of his style that exists among our connoisseurs'.[8] In the 1845 edition Leslie revised 'four' to 'multitudes'.[9] His son Robert later recalled that spurious Constables were constantly brought to his father by dealers both before and after the publication of the *Life*.[10] Again in 1845, the *Art-Union* warned 'all lovers of Art against the purchase of the atrocious forgeries of the works of Constable, which are commonly procurable from a certain class of dealers who have lived, and do live, upon sordid imitations of the works of good artists. We have only to observe that there is, perhaps, NOT ONE picture by this artist now to be purchased'.[11]

It seems reasonable to suppose that this flourishing trade in imitations was preceded by a rise in the prices paid for genuine pictures by Constable. To be considered worth forging, the small works Leslie spoke of in 1843 as being most often imitated must have ceased to be valued in shillings, as they were in the 1838 studio sale. Not much is known, however, about sales of authentic works in the years between 1838 and the mid-1840s. We can trace or guess the movements in this period of only a few paintings, most of them large. Charles Birch, a Birmingham coal-owner who had bought Constable's 1825 upright *Lock*[12] in the studio sale, soon afterwards acquired the final version of *The Opening of Waterloo Bridge* (pl. 15), which he lent to the Birmingham Society of Arts in 1839. Moseley, presumably a dealer, had paid £63 for it in the sale. By 1843 William Taunton of Worcester had acquired the great *Salisbury Cathedral from the Meadows* (pl. 9), for which Ellis paid £110 5s. in the sale (Ellis may, however, have been acting for him). Some of the works by Constable which John Sheepshanks later presented to the South Kensington Museum may have been acquired by him from dealers who bought them at the sale: the only painting for which someone is known to have been bidding specifically for him is the *Water-meadows near Salisbury* (pl. 20) mentioned in Chapter 1. There appears to be no record of the prices at which such paintings changed hands but it seems unlikely that anyone made much profit from Constable's work until the 1840s. On 20 April 1839 James Stewart, said to be 'quitting his residence', offered at Christie's three works by Constable which fetched no more than 1838 prices: a Brighton Pier

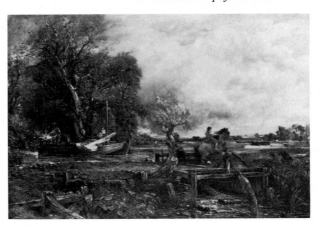

23 *The Leaping Horse*, exh. 1825; oil, 56 × 73¾ (142.2 × 187.3)

sketch and an unfinished 'View from Hampstead Heath' together made £4 and a 'Jacques and the Wounded Stag' £6 10s. The Brighton sketch may have been one of two works bought by Stewart in one lot for £5 5s. in the studio sale.

Profitable dealings there must have been before long but it was the transactions that misfired which attracted most attention. Involved in more than a few of these was a wealthy London builder called Samuel Archbutt, a self-made man who turned to picture dealing on a large scale during the 1830s and 1840s and became one of the first speculators in Constable's work. At various dates in these decades he ran galleries in Regent Circus (now Oxford Circus), Pall Mall ('The Morland Gallery') and King Street, St James's, and also sent large consignments of pictures to the auction rooms. At the Constable studio sale he bought fourteen works for a total of just over £253 and also a 'Guardi' which had belonged to Constable. Among his purchases was a 'River Scene and Horse Jumping', possibly the final version of *The Leaping Horse* (pl. 23). Archbutt made the mistake of trying to resell thirteen of his Constables less than a year later, at Christie's on 13 April 1839, when only three of them found buyers: two oil studies fetched nineteen and twelve guineas and an unfinished *Salisbury Cathedral from the Bishop's Grounds* went for thirty guineas (as against sixteen a year before). The remainder were bought in. This sort of miscalculation appears to have been typical of Archbutt's operations. At another of his sales, at Phillips on 25–26 July 1845, most of the works also failed to reach their reserve prices. Commenting on this sale, the *Art-Union* explained the purpose of reserves and the role of dealers in 'pushing on' bidders or 'becoming amazingly cautious when they fancy the maximum is reached'. In Archbutt's case, however, the *Art-Union* said it was willing to exonerate him from any expectation of obtaining a profit upon his pictures by this method: 'Knowledge of Art he must have had none, as a heap of more wretched daubs and pitiful imitations, with the most exalted names attached, can scarcely ever be met with'.[13] In the 1845 sale a 'Grand Gallery Landscape' said to be by Constable and for which, according to the

[40]

*Art-Union*, Archbutt had paid 600 guineas, was sold or bought in at 130 guineas, while two landscapes by Wilcock or Wilcox, one described in the catalogue as 'in the manner of Constable', were knocked down for nine and fourteen guineas.

The existence of Wilcock (his first name is not given in contemporary reports) had become known the previous month, June 1845, during the course of an action for fraud brought in the Court of Exchequer by Archbutt against another dealer, George Pennell. This was probably the first court action to feature allegedly forged Constables. In 1842 and 1843 Archbutt had advanced sums of money to Pennell against the security of certain paintings, which were to become Arch-butt's property if Pennell failed to repay the loans by the agreed dates. Archbutt became suspicious of the authenticity of some of the paintings, which included several called 'Constable', and sued for the recovery of his money. The action failed because fraud could not be proved and, what is more, Archbutt found his own activities exposed in the same light that he sought to throw on Pennell's. In particular, it emerged that Archbutt had employed an artist called Wilcock to copy pictures, paying him thirty shillings a week and accommodating him in an empty house which he owned. Archbutt's son Robert, called as a witness, said that Wilcock was 'kept to copy: he copied the large "Constable." I don't know to whom it was sold. I don't believe that the copy made by Wilcock was offered for sale as an original. Wilcock left my father's employ to go into that of defendant [Pennell] ever since this action was brought'.[14]

It is possible that Archbutt's artist was George Burrell (or Barrell) Willcock of Exeter (1811–52), who exhibited Devonshire and other landscapes at the Royal Academy (1846–51), British Institution (1846–52) and Society of British Artists (1839–52). Up to and including 1845 his exhibits at the latter institution appeared under the name G. Willcock, with variations on the spelling of the surname. From 1846 he was styled G. B. Willcock both there and at the other institutions. About the same time, between March 1845 and January 1846, he changed his address in London and also began painting Devonshire landscapes, presumably following a return to his native county. The public exposure of the artist whom Archbutt employed occurred during the same period. That this may be more than coincidence, and that Archbutt's artist may have been George Burrell Willcock, is suggested by the fact that Archbutt owned 'A View in Wimbledon Park' by 'Willcock' (Archbutt sale, Phillips, 11 May 1848, lot 19) which could well have been the 'Wimbledon Park' exhibited by George Burrell Willcock at the Society of British Artists in 1842 (No. 446). If Archbutt's man really was G. B. Willcock, the changes he made to his initials, address and subject matter may have been an attempt to turn over a new leaf.

In the circumstances it is not surprising that C. R. Leslie issued such anxious warnings in the mid-1840s to prospective purchasers of Constable's work. In 1844 he had felt obliged to alert the Constable children to someone else whom he took to be engaged in dubious practices. This was George Constable of

Arundel (1792–1878), a prosperous brewer, collector and amateur artist who had been a good friend of John Constable from 1832 until his death. Constable and John Charles stayed with him at Arundel in 1834. The following year Constable took Minna as well as John Charles on a second visit to their namesake. It was on the 1835 visit that Constable made the initial studies for what was to be his final painting, *Arundel Mill and Castle* (pl. 1). After their father's death the Constable children remained friendly with the Arundel family. In a letter probably written in 1843, for example, we find Alfred telling Lionel that George Constable had been 'staying in London for a few days and came up here one or two evenings and talked about Arundel and also asked after you and looke[d] at my paintings and said they were good'. Minna and Isabel must indeed have been surprised when Leslie wrote to them on 27 August 1844:

> You will be surprised at receiving a letter from me; but I write in consequence of having heard from your brothers that you have some expectation of visiting Arundel, and that they are to meet you there. – I must, therefore, acquaint you with circumstances which I ought to have mentioned to you before. – A year or two ago, some small pictures were shown to me, by Mʳ Tiffin, as ⟨your⟩ works of your father, which they evidently were not, – and I told him so. But he said he had an unexceptionable authority for believing them to be genuine, Mʳ Geo Constable *who had seen your father paint them*, at Arundel. – About the same time Mʳ White, of Maddox street, sent some sketches for me to look at, and asked whether ⟨they⟩ I thought they were by your father. They were *wretched imitations*; – one being an enlarged copy from Lucas's engraving of the upright windmill, of which you have the original. – Nobody, in the least acquainted with your father's works, could be imposed on by them, they were so clumsily done; – but White had them also from Mʳ G. Constable who *vouched for their originality*. ⟨About the⟩ Just after I had seen these, I received an invitation from Mʳ Constable to take Mʳˢ Leslie and the children to Arundel. – In answer to this I said I had seen pictures belonging to him, at Tiffin's & Whites, purporting to be your fathers, but that as 'a single glance was sufficient to convince me that *no part of those pictures was painted by him*, I trusted there was some mistake, which I hoped he could satisfactorily clear up.' – He wrote me a short answer merely saying, 'he had received my letter, and with respect to the pictures he should write to Tiffin.' – He did so, repeating that they were painted by your father, but added that he would receive them back, if Tiffin (who had given him some prints in exchange for them) was dissatisfied with them. – Accordingly Tiffin sent back the pictures, and so did White, and I have had no further intercourse with Mʳ Constable – You may imagine how greatly surprised and pained I was by all this. . . .¹⁵

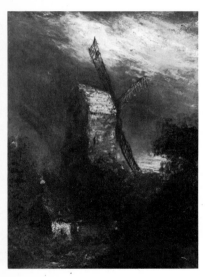

24 George Constable after John Constable, *A Mill near Brighton*; oil, 14½ × 11 (36.8 × 28). A pastiche by Constable's Arundel friend and namesake, who was reported to have passed off such works as genuine Constables in the 1840s.

Although Leslie does not actually attribute the imitations to George Constable himself, there are three copies after Lucas mezzotints among the paintings by George preserved by his descendants, including one (pl. 24) after *A Mill near Brighton*¹⁶ – the 'upright windmill' mentioned by Leslie. The evidence in this curious case seems incontrovertible, yet it is difficult to understand how George Constable came to be involved in such activities. As a prosperous businessman

and local 'figure' (he was Mayor of Arundel in 1837), he can have had nothing to gain and much to lose in passing off his own amateur efforts as Constable's work. It is especially difficult to see how he could have reconciled such behaviour with the respect and friendship he had undoubtedly felt for his namesake. Leslie speaks of the 'warm friendship' which existed between the two men and says that it 'contributed much to the happiness of the last years' of John Constable's life.[17] How, for that matter, could George have continued to call on the Constable children and invite them, and the Leslie family, to Arundel? It is also odd that Leslie felt able to write unreservedly of George Constable even in the 1845 edition of the *Life.*

In 1896 Leslie's son Robert published two brief accounts of the Constable forgeries shown to his father in the mid-1840s.[18] These were nearly all, he said, of 'the extreme palette knife type, or what would now, perhaps, be called "impressionist" examples'. He remembered in particular one batch, comprising 'small oil sketches and one larger finished picture', which a well-known London dealer brought to his father. They had come from 'a gentleman whose name, etc., seemed to guarantee that they were genuine' and who claimed to have seen Constable actually working on some of them. Robert Leslie found on close examination that 'all the unmeaning dabs of paint with which they were loaded, were still soft, showing that they had been painted quite recently. The larger picture was a rather better forgery than the sketches, and the dealer said that Stanfield, who had seen it, had pronounced it a Constable'. Some of the details given by Robert Leslie point to this being one of the batches from Arundel mentioned in his father's letter to Isabel and Minna, though it seems doubtful that a George Constable imitation would have fooled the artist Clarkson Stanfield. In one of his accounts Robert Leslie places the incident 'nearly ten years after Constable's death', i.e. up to four or five years after the George Constable business, but this discrepancy may be the result of faulty memory.

Despite these early crops of forgeries, the market in genuine Constables continued to grow. From 1846 onwards works by Constable appeared more frequently at auction and more substantial prices began to be achieved. *The Hay-Wain* fetched £378 at Christie's on 4 June 1846, when it was sold by Edmund Higginson, who had acquired it around 1838 from a French collection. A Worcester collector, George Oldnall, sold ten paintings by Constable at Christie's on 16 June 1847. These were mainly small works but included the 1811 *Dedham Vale* (pl. 25), which he had bought in 1838 for £25 4s. This, one of Constable's most important early paintings, fetched £52 10s. A later *Yarmouth Jetty*[19] went for £63. Paintings by Constable from the collections of his patron Mrs Hand, Jonathan Peel (the statesman's brother?), the lawyer Ralph Thomas, Sir Thomas Baring (son of the founder of Baring Brothers & Co.) and Constable's actor friend John Bannister also appeared at auction between 1847 and 1849. At Peel's sale on 11 March 1848 James Lennox became probably the first American collector to acquire a Constable when he bought a small

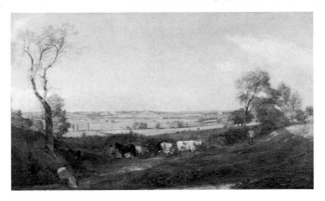

25 *Dedham Vale: Morning*, exh. 1811; oil, 31 × 51 (78.8 × 129.5)

*Valley Farm*,[20] having first been reassured by Leslie that it was genuine and 'a very good specimen'.[21] Henry Vaughan, who later bequeathed an important group of Constables to the nation, made one of his earliest acquisitions on 28 March 1849 at the Bannister sale, where he bought a small picture of Hampstead Heath.[22] One of Constable's most important canvases, *Stratford Mill* (pl. 2), changed hands privately in 1848 when C. F. Huth acquired it from the widow of its first owner, J. P. Tinney, John Fisher's lawyer.[23] William Taunton of Worcester, however, had difficulty in getting an acceptable price for the two major works he owned, *The Leaping Horse* (pl. 23) and *Salisbury Cathedral from the Meadows* (pl. 9), which he bought in at £357 and £441 respectively when he offered them at Christie's on 17 May 1846. Taunton tried again on 29 May 1849, this time accepting £430 10s. from the dealer Thomas Rought for the *Salisbury* but having once more to buy in *The Leaping Horse*, at only 150 guineas. Taunton appears to have sold it privately to Rought soon afterwards.[24] Rought was one of several dealers not present at the 1838 studio sale but active in the following decade: it was he who purchased *The Hay-Wain* in 1846 as well as three items in Oldnall's sale in 1847.

Fairly soon after he bought it at auction, Rought probably sold *Salisbury Cathedral from the Meadows* to Agnew's, from whom it was purchased for £600 in April 1850 by Samuel Ashton,[25] son of the cotton manufacturer Thomas Ashton, with whose descendants it has remained to the present day. From Rought *The Hay-Wain* found its way to another dealer, D. T. White of Maddox Street. Sometime before 1853 White sold the painting to Constable's friend George Young, who lent it that year to a British Institution exhibition. Young, it may be remembered, was one of the surgeons who attended the *post mortem* examination of Constable. By 1853 White had probably also acquired the full-size sketches for *The Hay-Wain* (pl. 18) and *The Leaping Horse* (pl. 19), which he later sold to Henry Vaughan. White presumably bought them from the Constable children through the agency of C. R. Leslie, who had housed these large works ever since the 1838 sale. White appears to have been the first dealer to take a serious interest in Constable's six-foot sketches, and it was while these two examples

were in his possession that the French landscape painter Constant Troyon saw and admired them, probably on his visit to England in 1853. Henry Vaughan said he was told by White that 'Troyon came frequently to see these studies and desired much to become the owner of them had circumstances permitted'.[26]

In 1843 Leslie had reported Lancelot Archer-Burton's refusal of 600 guineas for *The White Horse* (pl. 5). If it really was made, so large an offer would have been unique at the time. Burton Archer-Burton, Lancelot's son, did in fact get £630 for the painting but only when he sold it at Christie's in 1855. This price, the highest so far paid for a Constable, was overtaken a year later when Charles Birch of Birmingham obtained £860 for the 1825 upright *Lock*,[27] for which he had paid £131 5s. in the 1838 studio sale. Birch went to auction four times between 1853 and 1857, one of his sales being occasioned, according to the *Art Journal*, by 'the misfortune of a coal-mine belonging to him having taken fire'.[28] Three major Constables were among the works he put up for sale: *The Lock*, *The Leaping Horse* and *The Opening of Waterloo Bridge* (pl. 15). The latter, as we have seen, was already in Birch's collection by 1839. It was bought in at one of his sales in 1853 for £252 but finally made £609 in 1857. Birch may have purchased *The Leaping Horse* from Rought, who had it from William Taunton in 1849. It was sold at Christie's in 1853 to the dealer Gambart for £393 15s.

A few more sales of the later 1850s and the 1860s are worth noting. With one or two possible exceptions, this was the last period in which paintings appeared on the market from the collections of those who had obtained them directly from the artist. Following their deaths, works from the collections of George Field, C. R. Leslie, John Allnutt and W. H. Carpenter came up for auction between 1855 and 1867. Leslie's sale in 1860 included seventeen sky studies, which fetched just over a guinea each (similar works had made less than half-a-crown in 1838), twelve other oils and twenty-five watercolours and drawings. Surprisingly, the latter fetched more than most of the small oils, White paying the highest price – £74 11s. for a 'Mill at Colchester'. 'Miss C', perhaps Minna Constable, bought two lots, one containing seventeen chalk studies of trees. John Allnutt's sale in 1863 included the *Ploughing Scene*[29] which Constable had painted as a replacement for the original version of 1814 (pl. 7). It made rather less than the painting by Callcott for which Allnutt had intended it to be a companion – £102 18s. as against £325 10s. The sale in 1867 of paintings belonging to Constable's friend W. H. Carpenter, bookseller and later Keeper of Prints and Drawings at the British Museum, did not include his finest possession, the great *View on the Stour near Dedham* (pl. 4), which had been sold before his death. Carpenter had acquired it on its return from France sometime before 1840. *The Opening of Waterloo Bridge* reappeared twice at auction in this period. Henry Wallis, who bought it at the Birch sale in 1857, put it up for auction again in 1858 and had to buy it in at 555 guineas. He tried again in 1861, this time accepting a bid of £464, considerably less than he paid for it. *The Leaping Horse*, another frequent visitor to the sale-rooms after Constable's death,

reappeared in Charles Pemberton's sale in 1863, when White bought it for 365 guineas, and again in an anonymous sale in 1867. George Young retained *The Hay-Wain* long enough for it to make a more respectable £1365 at Christie's on 19 May 1866, nearly £1000 more than Rought paid for it twenty years before. Constable's paintings had by now ceased to be grossly undervalued but they had by no means reached the top of the market. Major works by Turner had been fetching well over £1000 each since the early 1850s and over £2000 from 1860 onwards. In 1867 *Modern Italy*[30] made £3465 in the Munro sale. Landseer's paintings were in a similar price range at this time. *A Midsummer Night's Dream*[31] was sold for £2940 in 1860, *Harvest in the Highlands* for £3097 10s. in 1863 and *Braemar*[32] for £4200 in 1868. Constable's prices were more in line with Leslie's and Linnell's.

As well as appearing in the sale-rooms with increasing frequency during the 1850s and 1860s, Constable's paintings were beginning to reach a wider audience through loan exhibitions. In 1852 the Royal Academy lent the artist's Diploma picture, *A Boat Passing a Lock* (pl. 6), to the British Institution old masters exhibition, to which Burton Archer-Burton also lent *The White Horse*. George Young allowed *The Hay-Wain* to appear in the following year's exhibition. Six paintings by, or attributed to Constable were included in the 1857 *Art Treasures* exhibition at Manchester: Samuel Ashton's *Salisbury* (pl. 9); the Royal Academy Diploma picture; *The White Horse*, lent by its new owner Richard Hemming; the 1825 upright *Lock*,[33] lent by W. Orme Foster, for whom it had been bought in the Birch sale the year before; and two works which have not been precisely identified. In 1862 eleven paintings by, or attributed to Constable were shown in the International Exhibition held at South Kensington. This time the Constable family contributed items from its still extensive collection: *Arundel Mill and Castle* (pl. 1) and a Hampstead painting were lent by Charles Golding and *The Cenotaph*[34] and *The Glebe Farm* (pl. 13) by Minna. Tom Taylor wrote popular handbooks for both this exhibition and the 1857 *Art Treasures*. His appreciative account of Constable made much of the artist's intense feeling for his native scenes but it was rather spoilt by Taylor's own less acute sense of place – East Bergholt became a Sussex village and Constable a lifelong student of 'the quiet Sussex nature'.[35] Henry Vaughan lent a small sketch[36] for Ashton's *Salisbury* to the British Institution in 1862 and Louis Huth sent *Hadleigh Castle* (pl. 16) the following year. The Royal Academy Diploma picture and an unfinished *Glebe Farm*,[37] acquired by Vaughan at Leslie's sale, were included in the *National Exhibition of Works of Art* at Leeds in 1868. When the Royal Academy began its own winter exhibitions of Old Masters in the 1870s, small groups of Constable's paintings became a regular feature.

Just as important for the spread of knowledge of Constable's work were the permanent acquisitions made by museums. *The Cornfield* (pl. 8) had been presented to the National Gallery in 1837. Ten years later the nation acquired its second painting by Constable when Robert Vernon presented *The Valley Farm* (pl. 26)

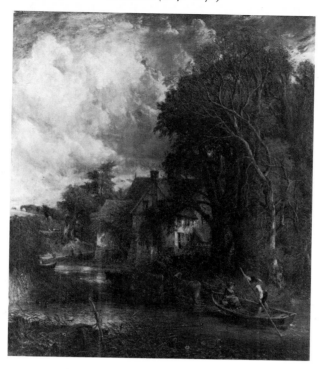

26 *The Valley Farm*, exh. 1835; oil, 58 × 49¼ (147.3 × 125.1). The second painting by Constable to be acquired by the nation, as part of Robert Vernon's gift to the National Gallery in 1847.

to the National Gallery, along with 156 other British pictures. Vernon had bought the work off Constable's easel in 1835 for £300, the largest amount the artist received in his lifetime. Another ten years were to pass before further paintings by Constable entered the national collections. John Sheepshanks's gift in 1857 to the new South Kensington Museum (renamed the Victoria and Albert Museum in 1899) included six works: *Boat-building near Flatford Mill* of 1815, a *Dedham Lock and Mill* of 1820,[38] the *Salisbury Cathedral from the Bishop's Grounds* which Constable exhibited in 1823 (pl. 14), the *Branch Hill Pond, Hampstead* shown in 1828,[39] *Water-meadows near Salisbury* (pl. 20, the picture Sheepshanks had been determined to buy in the 1838 sale) and a Hampstead Heath painting of around 1820.[40] In 1862 Henry Vaughan lent the South Kensington Museum his full-size sketches for *The Hay-Wain* and *The Leaping Horse* (pls 18–19). Except for removal to temporary exhibitions elsewhere, they remained on loan until Vaughan bequeathed them to the Museum in 1900. Two further paintings ascribed to Constable but later reattributed were received by the South Kensington Museum in the Townshend and Parsons bequests in 1869–70. From 1859 until 1876 the National Gallery's British School paintings were also housed on the South Kensington site, in a building erected alongside Sheepshanks's gallery. Confusingly, the latter was known as 'The National Gallery of British Art' while the former remained the 'National Gallery, British School'. For a number

of years, therefore, *The Cornfield* and *The Valley Farm* could be seen in close proximity to the Sheepshanks pictures and to Henry Vaughan's loans. During the International Exhibition of 1862 the number of Constable's paintings at South Kensington was further enlarged and a rare opportunity arose to compare *The Hay-Wain* (lent to the exhibition by George Young) with Vaughan's full-size sketch for it. Although Constable's drawings and watercolours were still largely unknown to collectors, six examples were acquired by the British Museum between 1842 and 1875. Outside London, the first museum to acquire a painting by Constable appears to have been the Ashmolean Museum, Oxford, to which Chambers Hall presented a small oil sketch of Salisbury in 1855.[41]

As Constable's work gradually became better known through exhibitions and auctions, published accounts of him grew more frequent. A series of profiles of 'British Artists: Their Style and Character' which the *Art Journal* commenced in 1855 even took Constable as its first subject. Wood-engravings (three copied from Lucas mezzotints and one from a line-engraving) after *The Leaping Horse, The Lock, The Cornfield, View on the Stour near Dedham* and *Salisbury Cathedral from the Meadows* accompanied a brief text derived largely from Leslie's *Life*.[42] The latter proved a handy source of anecdotes for such rag-bags of the period as James Smith's *Lights and Shadows of Artist Life and Character* (1853) and Joseph Sandall's *Memoranda of Art and Artists* (1871), as well as providing basic information for the biographical dictionaries. Leslie supplemented his main account of Constable in his autobiography, published posthumously in an edition by Tom Taylor in 1860. Some additional anecdotes were included, as well as reflections on Constable's character which are more outspoken than those published in the *Life*. Leslie's account of the events of the day after Constable's death, part of which is quoted at the beginning of the present book, also appeared here for the first time. Some reminiscences of Constable by Henry Trimmer, son of Constable's friend the Revd Henry Scott Trimmer, were published somewhat incongruously in Walter Thornbury's *The Life of J. M. W. Turner, R.A.* in 1862. Two volumes of *Memoirs and Letters of Charles Boner*, the former tutor of Constable's children, appeared in 1871. Although mainly concerned with Boner's later literary and sporting activities in Germany (his best known book was *Chamois Hunting in Bavaria*), the volumes include interesting references to his years with Constable and to his resumed friendship with Charles Golding Constable in the 1860s.

During the period we are considering, Lucas's mezzotints remained more or less the only visual record of Constable's work for those without access to the originals. The mezzotints were made more widely available through Bohn's reissue of forty of them in a single volume in 1855, but either the poor condition of the original plates or the carelessness of the new printing (or both) made this edition a sad travesty of Lucas's and Constable's work. Bohn's short foreword to the volume mentions that the second edition of Leslie's *Life* was also available from him, price 15s. That Bohn, king of the 'remainder' trade, was trying to

sell the volume at a reduced price ten years after its first appearance is a useful reminder of the limits of interest in Constable even at this date.

There was, in any case, a notable voice of dissent from the growing approval of Constable's work, a voice that may in fact have greatly retarded the growth of his reputation. As early as 1844, in the second edition of the first volume of *Modern Painters*, John Ruskin launched an attack on Constable which can still surprise and puzzle admirers of the artist. Far from being upheld as one of those modern painters whose 'Superiority in the Art of Landscape to the Ancient Masters' Ruskin set out to demonstrate, Constable was to be slapped down by Turner's champion as a blundering third-rater.

Ruskin's first reference to Constable, in the Preface to the second edition of *Modern Painters*, Volume 1, is mild enough. Deprecating Claudean idealization of nature, Ruskin preaches the necessity of 'an earnest, faithful, loving study of nature as she is', and adds in a footnote that 'The feelings of Constable with respect to his art might be almost a model for the young student, were it not that they err a little on the other side, and are perhaps in need of chastening and guiding from the works of his fellow-men . . .'.[43] But later in Volume 1 Ruskin returns to Constable's supposed 'unteachableness' and finds a 'corresponding want of veneration in the way he approaches nature herself'. A list of Constable's other defects follows: he has 'a morbid preference of subjects of a low order'; he lacks any ability to draw; his works lack 'rest and refinement'.

> There is strange want of depth in the mind which has no pleasure in sunbeams but when piercing painfully through clouds, nor in foliage but when shaken by the wind, nor in light itself but when flickering, glistening, restless, and feeble. Yet, with all these deductions, his works are to be deeply respected as thoroughly original, thoroughly honest, free from affectation, manly in manner, frequently successful in cool colour, and realizing certain motives of English scenery with perhaps as much affection as such scenery, unless when regarded through media of feeling derived from higher sources, is calculated to inspire.[44]

'Constable's manner was good and great', Ruskin continues in Volume 1, 'but being unable to *draw* even a log of wood, much more a trunk of a tree or a stone, he left his works destitute of substance, mere studies of effect without any expression of specific knowledge; and thus even what is great in them has been productive, I believe, of much injury, in its encouragement of the most superficial qualities of the English school'.[45]

Ruskin can hardly have expected C. R. Leslie to let these remarks pass. Now one of the seniors of the profession, Leslie had served as Professor of Painting at the Royal Academy from 1847 to 1852 and it was in the book he based on his Academy lectures, *A Hand-Book for Young Painters* (1855), that Leslie replied to Ruskin's remarks on Constable. While deploring a method of criticism 'that tends to obscure any of the true lights in Art, in order that one great luminary [i.e. Turner] may shine the more brilliantly',[46] Leslie adopts exactly Ruskin's

method to find fault with Turner's tree painting and then goes on to answer, easily enough, the accusations of Constable's want of veneration of nature and of other art. On the question of Constable's inability to draw, Leslie suggests that Ruskin may never have seen a genuine Constable but have formed his opinions 'from the numerous forgeries of his works in circulation'.[47] Later he makes another interesting suggestion:

> as Constable made a sketch of the full size of every large picture he painted, and as these sketches are complete in effect, though not in detail, they are sometimes mistaken for pictures, and a false notion is therefore conveyed of his Art. It is just possible that some of these may have given to Mr. Ruskin an impression of his want of reverence for Nature, though, considered as a means by which to make his pictures more perfect, they prove the reverse.[48]

Ruskin was not amused by this rejoinder. In the Supplement to his 1855 *Academy Notes* he praises Leslie's paintings highly but points to the *Hand-Book* as 'a perpetual warning to painters advanced in life' not to meddle with things they do not understand.[49] Further observations on the *Hand-Book* appear in an Appendix to *Modern Painters*, Volume 3 (1856). The reader, says Ruskin, may 'suspect me of ill-will towards Constable' but 'I was compelled to do harsh justice upon him now, because Mr. Leslie, in his unadvised and unfortunate *réchauffé* of the fallacious art-maxims of the last century, had suffered his personal regard for Constable so far to prevail over his judgment as to bring him forward as a great artist, comparable in some kind with Turner'.[50] The main text of *Modern Painters*, Volume 3 contains detailed criticism of Constable's drawing. Trees in Lucas's prints of *A Lock on the Stour*[51] and *A Dell*[52] are compared unfavourably with those in Turner's watercolour of Bolton Abbey.[53] In *A Lock on the Stour* Constable bends the principal tree to and fro in a meaningless and wilful manner; he is 'an uninventive person dashing about idly' and produces a 'wholly barbarous' representation of a tree. In the *Dell* he cannot distinguish surface markings from shadows on a tree trunk: there is 'nothing but idle sweeps of the brush'. Ruskin does not apologise for comparing an original watercolour by Turner with prints after Constable because Lucas's mezzotints 'have many qualities of drawing which are quite wanting in Constable's blots of colour'. All the same, Ruskin says he will later compare 'picture and picture', a promise he does not in fact fulfil.[54]

Later in Volume 3 Ruskin again compares Constable and Turner. The former, he writes, 'perceives in a landscape that the grass is wet, the meadows flat, and the boughs shady; that is to say, about as much as, I suppose, might in general be apprehended, between them, by an intelligent fawn, and a skylark. Turner perceives at a glance the whole sum of visible truth open to human intelligence'.[55] Volume 4, also published in 1856, includes further adverse criticism of Constable's tree drawing, this time as seen in Lucas's *Frontispiece*[56] to *English Landscape*. 'Here we have arrived at the point of total worthlessness', says Ruskin.[57]

There was still more to come. In an Appendix to *The Two Paths* (1859) Constable is again attacked, Ruskin expressing his regret 'that the admiration of Constable, already harmful enough in England, is extending even into France'.

> There was, perhaps, the making, in Constable, of a second or third-rate painter,
> if any careful discipline had developed in him the instincts which, though unparalleled for narrowness, were, as far as they went, true. But as it is, he is nothing more
> than an industrious and innocent amateur blundering his way to a superficial expression of one or two popular aspects of common nature.[58]

Finally, in Ruskin's 1871 Oxford *Lectures on Landscape*, published in 1897, the work of Cox and Constable is lumped together and dismissed as 'the mere blundering of clever peasants, and deserving no name whatever in any school of true practice, but consummately mischievous'.[59]

Ruskin's view of Constable appears to have been based on remarkably little knowledge of his works. References to Constable's success with cool colour and to his 'blots of colour' give the impression that Ruskin knew paintings by him but the only works he specifically mentions are three of Lucas's mezzotints as published in the 1843 edition of Leslie's *Life*. At times Ruskin seems to equate these with original paintings. He talks of 'idle sweeps of the brush' in the *Dell* print and complains of 'blackness' as though it were not to be expected in a mezzotint. It is difficult not to feel that Ruskin formed an unfavourable idea of Constable from a hasty look at the *Life*, especially its plates, and then closed his mind to the subject. Possibly, as Leslie suggests, he was misled by forgeries of Constable's work but more likely — another of Leslie's shrewd suggestions — he had 'seen pictures by him, without *looking at* them, which often happens when we are not interested'.[60] As we know, a good number of Constable's paintings were on public view during the 1840s and 1850s. *The Cornfield*, in the National Gallery since 1837, ought by itself to have suggested major qualifications to the views expressed in *Modern Painters*. Among the works by Constable which Ruskin is not likely to have seen, however, were the originals of any of the three mezzotints he discusses, none of these having been exhibited at the time. Ruskin was even less inclined to take Constable seriously after Leslie's remarks in his *Hand-Book*: praising Constable was one thing, criticising Turner quite another. Ruskin's anger also increased as he saw Constable's influence spreading. For Ruskin the next step after Turner was Pre-Raphaelitism. Constable seemed to lead in a quite different direction, to 'the blotting and blundering of Modernism'[61] and even to the modern French school (to the work of Troyon, for example) with its 'deadness of colour' and 'softness of outline'.[62]

Ruskin's opinion of Constable was echoed by William Michael Rossetti, former secretary of the Pre-Raphaelite Brotherhood, in his review of the 1862 International Exhibition. Constable, said Rossetti, 'carried out to the utmost extent the freshness and offhandedness of modern landscape; catching at the obvious general look of things, and doing all so as to be recognised and enjoyed

by the least studious eye which has gazed upon nature. Sincere and not to be called superficial in aim, he has done more than perhaps any other painter to elicit and encourage the mindlessness and slovenly facility of the modern school'.[63] The Pre-Raphaelite painters themselves rarely voiced any opinion of Constable. William Holman Hunt appears to have noticed him only for his prophecy that English painting would be extinct by 1852.[64] Ford Madox Brown declared in 1855 that the landscapes of the now almost forgotten Mark Anthony were 'Like Constable, only better by far'.[65] As late as 1895 John Brett, a protégé of Ruskin in the 1850s, was complaining that 'Constable took so superficial an interest in nature that he never took any pains to study her laws'.[66] However, not all Ruskinians kept their eyes closed to Constable. P. G. Hamerton, a pupil of J. P. Pettitt but better known later in the century as a critic, recorded his initial blindness to Constable in the 1850s and his subsequent change of opinion. Sometime in 1853–4 Hamerton was introduced by Leslie to Constable's children who 'showed me all the sketches of his that remained in their possession. My love for precise and definite drawing made me unable to see the real merits of those studies, though I was not much mistaken in thinking that drawing of the quality I then cared for was not to be found in them . . . I had at that time a mistaken belief (derived originally from Mr. Ruskin and confirmed by Mr. Pettitt) that there was something essentially meritorious in bestowing great labour on a work of art'.[67] As examples of the sort of work he admired at the time Hamerton cites a pen drawing by Millais and a watercolour by J. F. Lewis. In the mid-1860s Hamerton changed his mind and decided that 'Mr. Ruskin's method of study is not such as to lead him naturally to any right appreciation of Constable. Mr. Ruskin draws definite objects with delicate precision and often in outline, nearly always seeking for beauty of line . . . Constable seems to have been constitutionally indifferent to this kind of beauty; he did not see lines, but spaces, and in the spaces he did not see simple gradations, but an immense variety of differently coloured sparkles and spots. This variety really exists in nature, and Constable first directed attention to it'.[68]

Hamerton was one of those observers who by the 1860s were looking at Constable in the knowledge of his revived reputation in France as well as with hindsight of the limitations of English Pre-Raphaelite landscape. 'In France', Hamerton wrote in 1866, 'Troyon and the Bonheurs have looked at him, and all the best modern French landscape is due to the hints he gave. That landscape is now the most influential in Europe; it is even probable that its influence may extend itself to England'.[69] Although the originals were repatriated within a few years, the sensation caused by the exhibition of Constable's paintings in Paris in the 1820s had never been quite forgotten in France. Memories of the event appear to have revived in the 1850s, around the time the Barbizon painters gained official recognition. Constable was claimed as 'the father' of modern French landscape by Delacroix in an article in 1854[70] and as its 'messiah' by Frédéric Villot, reviewing Leslie's *Life* in 1857.[71] Similar tributes were paid

in his *Histoire des Peintres, École Anglaise* (1863) by Théophile Thoré (W. Bürger), who lamented that *The Cornfield* had ended up in the National Gallery instead of the Louvre, where it would have been better appreciated. Around 1858 Delacroix gave Théophile Silvestre an account of his retouching of *Le Massacre de Scio* at the 1824 Salon after he had studied *The Hay-Wain*,[72] while the landscape painter Paul Huet, another veteran of that Salon, remembered Constable's works coming as the sudden realisation of his own dreams.[73] According to Castagnary, writing in 1869, Huet had made copies after Constable which circulated in the Paris studios (presumably a little later than 1824) with dramatic results: '*Ce fut comme si des écailles tombaient des yeux*'.[74] Among those whose eyes were thus opened, said Castagnary, were Charles de La Berge, Jules Dupré and Théodore Rousseau.

Like Hamerton, the brothers Richard and Samuel Redgrave were impressed by this acknowledgement of Constable's role in French painting and remarked upon it when writing a chapter on him – the first serious account of Constable as an artist – in their *A Century of Painters of the English School* (1866). Like Hamerton, they too could see the limitations of recent English landscape painting and the advantages of Constable's practice. The latter 'wholly differed from the new school of landscape painting which arose out of what is called pre-Raphaelism. That system inculcates the exact and literal imitation of parts, gradu-ally merging them into a whole; while Constable viewed his work from the first as a whole, afterwards adding just sufficient detail to give truth of form without destroying the higher qualities arising from generalization. The new system is admirably adapted for study, for the early practice of the young painter; but really fine art ... will never be achieved if literal imitation becomes the end instead of the means'.[75]

It is not surprising that the Redgraves found Constable's late works the most sympathetic. Indeed, what they thought of, by contrast, as 'early' Constable was itself fairly mature work. They cite a Hampstead Heath painting in the Sheep-shanks Collection at South Kensington,[76] now considered to date from about 1820, as an early picture: 'It is a minute and careful study, painted on the spot, and is as perfect in its handling as any work of the new school'. The Sheepshanks *Branch Hill Pond* of 1828[77] is their 'contrasting example': 'In this the details are suppressed, and breadth of colour and light and shade sought after; and it will be allowed that for freshness, a prevailing sense of daylight, and for richness of colour, it is of the two far the finer work'.[78] What Constable was really after, according to the Redgraves, was 'the thorough abstraction of his attention from details' and this he achieved most completely in the six-foot sketches. As we have seen, Constant Troyon much admired the two examples – the sketches for *The Hay-Wain* (pl. 18) and *The Leaping Horse* (pl. 19) – which he saw in White's possession, probably in 1853, and Leslie alluded briefly to such sketches in his 1855 *Hand-Book*. In the Redgraves' fuller account of these two works we see the beginnings of that preference for the large sketch over the finished

picture which became a distinct feature of early twentieth-century appreciations of Constable:

> The canvases are the size of the completed works. The subjects are laid in with the knife, with great breadth and in a grand and large manner. . . . Viewed at a distance, the scheme of the picture is complete, the local truth of colour beautifully felt, and the freshness and daylight are startling.
>
> When Constable had carried his study thus far, and was pleased with the indications it contained, he would leave it without further completion . . . and commence again on a new canvas, endeavouring to retain the fine qualities of the studied sketch, adding to it such an amount of completeness and detail as could be given without loss of the higher qualities of breadth and general truth.[79]

The Redgraves' interest in Constable's technical processes was underwritten by a deep attachment to, not to say patriotic pride in, his subject matter: 'he was entirely English in the subjects he chose – locally English, no doubt, but still purely English. Look at any or all of his pictures and see how England rises before us – England in all her wealth of picturesque beauty – not "trimmed and frounced," not clipped and cropped as the corn-manufacturers disfigure her; but English nature as it holds its own in our rude heaths and ferny commons . . .'.[80] A feeling that Constable's art conveys a genuine English rusticity was also an essential ingredient in Hamerton's appreciation: 'of all the pictures that ever were painted, Constable's pictures are the most thoroughly and purely rural . . . Even in his very manner of work . . . there was a strange and profound harmony with the rusticity of the painter's heart. It may be rude and empirical, as if some farmer endowed with genius had got palette and brushes, and set to work by the light of nature and inspiration, but it is always perfectly clear from the one vice which is out of harmony with rural feeling, for at least it is never superfine. These pastorals are not the pastorals of Florian, but are redolent of the genuine English country . . .'.[81] We shall catch further glimpses of Constable the English rustic (Hamerton's farmer, Ruskin's peasant), although, unlike Constable the father of modern French painting, he is a character who lingers in the popular imagination rather than stalks the literature.

# THE SECOND GENERATION

## [ 1843–1863 ]

WHILE their elders were debating the status of Constable's art, a new generation of family painters was growing up, a generation that, quite unwittingly, was to complicate an already confused situation. When Alfred Constable left King's College School to train seriously as an artist in 1843 he was sixteen years of age. That summer he went down to Suffolk to spend a few weeks at Flatford Mill with his uncle Abram and aunt Mary. Fishing and boating had always been among the main attractions for the Constable children when they stayed at Flatford or Dedham and in his letters to his younger brother on this holiday Alfred wrote mainly about what he called the usual things, the fish he had caught with his night-lines and his adventures on the river.[1] A tailpiece to one of his letters illustrating a tow he had been given downstream to Flatford by one of his uncle's barges (pl. 27) is a reminder of how little the Stour traffic had as yet changed since his father sketched the comings and goings on the river. In another letter Alfred talks of an oil-sketch he had made in the meadows below Fen Bridge, the footbridge his father had crossed so often as a boy on his way to school. Aunt Mary, he said, had very much liked the painting.

This holiday of Alfred's in the summer of 1843 was the last that any of the children were to spend at Flatford, for after a hundred years' occupation, the Constables were shortly to relinquish their holding there. Since the death of old Golding, the father, Abram had run the family business with tolerable success from Flatford Mill where he and his sister Mary had moved in 1819 after the sale of East Bergholt House. From his brothers and sisters, all largely dependent on their share of the profits for a livelihood, Abram had apparently received no complaints. But he had not his father's drive and entrepreneurial flair. As he got older he had been finding the going increasingly difficult and by the 1840s he was a melancholy and embittered man. There had been a wrangle with the Stour Navigation Company Commissioners about a road to replace the fords at Flatford,[2] followed by litigation over a lock-keeper's cottage built by the Company on land owned by Abram beside the lock at Dedham.[3] His refusal to take either Alfred or Lionel into the business does not appear to have

27 Alfred Constable, drawing of a
barge on the Stour, in a letter to Lionel
Constable, 22 July 1843

surprised the children, in view of their uncle's 'wretched state of affairs',[4] but
family ties were stretched almost beyond bearing when he claimed to have paid
them money which the children denied having received. Sadly, there was talk
between the young Constables and their legal adviser of taking the matter to
court.* This small storm in the family's history blew up towards the end of
1845. It was probably no coincidence that within a few weeks Flatford and
Dedham mills, the windmill on Bergholt Heath and Hay Barn (pl. 78), the
farm at the top of the lane above Flatford, were all up for auction.[5]

That summer, in 1846, Alfred was again in Suffolk, but this time staying
at Dewlands, a farm at Higham a few miles above Flatford. Towards the end
of September he went to spend a couple of nights with his aunt Mary. The
mill with the attached house in which she lived with her brother had been sold
in March, but the new miller was not due to take up residence until the following
week. Alfred was left pretty much to himself as they were busy at the mill setting
things out for a further auction that was about to take place, the sale of effects.
In a letter to Lionel he tells of fishing exploits at Flatford and of a picture by
Dunthorne of 'the Old House' – i.e. East Bergholt House – of which Mary
had asked him to make a copy to give a friend. The letter affords us only one
glimpse of Abram in this, his very last week as a miller. 'I showed uncle the
pretty little sketch you did of a little peice of distance with a mill in it', Alfred
wrote, 'he said you had done the mill very nicely'.

After Flatford, Abram and Mary lived together for some years in East Bergholt.

* CGC to IC, 15 February 1846: 'How vexed I was to read in your letter about Uncle Abrams
proceedings, I really could not have fancied he was so bad. I am afraid he is a downright rascal,
I am very glad however that you are in such good hands as Mr Haverfield, if any thing can
be done, he will do it, doubtless. I do not see how Uncle is to gain the day without being able
to produce proof, as to his having paid us. Of course it would be quite useless and indeed mistaken
kindness to leave him alone, or to listen to his empty false talk, I should not hesitate in using
the strictest measures against him, the same as if I had never before heard his name, at the same
time however it will be well to look ahead, if the law expenses are to be borne by us, we should
take care that they do not exceed the amount of the debt, or it would be hardly worth while.'

Then they separated. Abram stayed in the village, but moved to Windmill House where he lived with an old friend, Jacob Mecklenburgh, probably the son of Matthew Mecklenburgh, a millwright of East Bergholt. Mary, to be near her nephew and his family, moved a few miles away to Wenham Magna where Daniel Whalley was rector. Whalley was the son of Constable's married sister Martha, who lived at Dedham. From Mary the Whalleys subsequently inherited a portfolio of very early landscape drawings (see p. 155), but apart from these it is a remarkable fact that neither Abram nor Mary, nor for that matter the other sister Ann (also of East Bergholt), appear to have possessed a single work of a landscape subject by their brother John. On his death in 1862 Abram is only known to have owned one painting by Constable, the portrait of himself now at Christchurch Mansion, Ipswich. Seven portraits were in Mary's possession at her death in 1865: a pair of her and her sister Ann, two each of 'Mr Constable' and 'Mrs Constable', presumably the parents, and one of John Constable himself.

Alfred and Lionel spent the summer of 1846 apart, the former in Suffolk as we have seen, the latter in Somerset. It is likely that this arrangement was not altogether of their own choosing. As boys they had often proved themselves to be unruly when left together and it had been thought advisable that they should go to different schools. Although Alfred, now nineteen years old, was an art student and Lionel, eighteen, at the end of his career at school, they were still a worry to their elders. Two years before, Minna and Isabel had thought of going for a holiday to Paris but instead had opted for a tour of some of the southern counties. Regrettably, Minna had had to report to Charles in India that while she and Isabel were away Alfred and Lionel had once again shown themselves to be 'unsettled wild boys'.[6] This year, 1846, the girls had at last ventured abroad, as far as Boulogne, and it may have been in order to set their minds at rest while they were away that the boys were sent to different parts of the country, Alfred to Suffolk where he was known, Lionel to stay with an acquaintance, a Mrs Nodin, who lived at Ashcott, a village near Glastonbury.

Only a few of Lionel's letters have survived, but in all there are nearly fifty from Alfred to his family, most of which are to Lionel. Of these, the most interesting are the twelve he wrote to 'Lar', as he was often called, during this three months' holiday in 1846. Although a onesided correspondence, from no other source can we learn more of the two brothers at this important stage in their lives. The second letter, dated 31 July, touches on several subjects that are of interest to us. Alfred had his own quite individual epistolary style.

Dear Lar

Thank you over and over again ⟨for nice⟩ for your nice long letter   It was a thing that I very much wanted   you seem to be tolerably comfortable but I quite agree with you about the River it is certainly a great ornament to the Landscape   last Sunday I went and spent the day at Flatford   Uncle was not very well. he has

sold Flatford Mill to Mr John Lot and they have to turn out by the 29 of Septem-
ber    I am so glad you spent a fortnight there    you may never see it again* . . .
I must now thank you dear Lar for your beautiful 2 little sketches    the tree is I
think beautifully done    so is the house    I will certainly send you some little things
only I have not yet done anything small except a study of a few water lilys    I have
been doing a picture of the Harvest men    it is about the size of half those large
sheets of paper    I whent into the field and gave the man a shilling then I sat down
and tryed to do them . . . when I write again I will send you sketches of some of
the things I have done    I think my harvest picture will do for the exhibition but
want it be thought papare
    I have also done a very finished study of a plough    I showed it to the farmer
here    he said it was capital    I hope dear Lar you paint when ever you can    I
know of another picture that I think will do for the Exhibition    it is on the River
Stour and a gentleman here is going to lend me his boat so I shall take my painting
things into the boat and anchor it and then begin to paint    only think of you having
seen the suns rays going off into Perspective    how did it look    I believe it is very
rare    it ⟨it⟩ is painted in the large picture of Waterloo Bidge . . .

Two points will probably have been noted in this disarming letter of Alfred's:
the extent to which landscape drawing and painting dominated his and his
brother's lives, and the fact that they were planning to send in work next year
to the Academy. It is also of interest that Alfred had been wondering whether
the picture he intended to submit would be thought 'papare', i.e. too much
in the manner of their father. Lionel had evidently seen a phenomenon their
father had originally noted – the rays of the sun, by perspective, converging instead
of diverging – and in this letter Alfred remembers having seen the effect in *The
Opening of Waterloo Bridge* (pl. 15).† There are other references to Constable
in the letters. In his previous letter Alfred had talked of his waterlilies, remarking
how well they were done 'in Mr Carpenter's picture' (probably the Huntington
*View on the Stour near Dedham*, pl. 4); had sought for information about the
colours and the tree in a 'Lock' picture they both knew; and had asked Lionel
whether he liked their *Flatford Mill* as well.[7] There are further references to the
*Waterloo Bridge*, or to studies for it. Alfred jokingly talks of outdoing the detail
in 'the Whitehall tree', and describes a sail he had in a boat down the Stour
from Langham, when he had been reminded of 'the boat in the Whitehall    it

* A pencil tree study in the family collection (Tate Gallery 1976, No. 341) inscribed 'June the
5. 1846. Gt Wenham', formerly attributed to Alfred but now thought to be by Lionel, suggests
that the latter may only quite recently have been in Suffolk. There are other allusions in Alfred's
letters to support this notion.

† Leslie comments on this unusual effect in the *Life*. He is talking of Constable's observations
on skies: 'I remember that he pointed out to me an appearance of the sun's rays, which few
artists have perhaps noticed, and which I never saw given in any picture, excepting in his "Waterloo
Bridge." When the spectator stands with his back to the sun, the rays may be sometimes seen
*converging* in perspective towards the opposite horizon' (1845, p. 310, 1951, p. 282). This effect
Constable recorded in a watercolour *View from Hampstead, with Double Rainbow*, BM, L.B.32b,
repr. Fleming-Williams 1976, pl. 42.

is just that sort'.* In a letter dated 31 August he tells of a visit to a gentleman living nearby to see a Gainsborough landscape when he also saw a portrait 'by papa in oils of one of his [the gentleman's] children   I should think very early. only you can see it is papa'. It is likely that Alfred also had his father in mind when he writes of the skies he sees and of the cloud studies he had been making. 'I have been clouding', he writes, 'they have been so very beautiful';[8] and later, 'the clouds here have been very lovely   there was a severe storm here on Saturday night with fork lightning just as you describe it   The clouds where also very splendid on Monday   I tried to do them only mine are very poor'.[9] In his letter of 10 August Alfred talks a lot about his work.

> Thank you for putting some Glass over my stupid little pencil sketch   I have not done many penclings because haveing nothing to set them with they soon all rub out   I have done one of an old tree in your large sketch book   it is only the bowl of the tree   I think it has spoilt you beautiful sketch book   I think you would laugh if you where to see my room   it will soon become quite a gallay [gallery] of pictures   I had two ladies to come and see them a little while ago as they hang about my room   I seem to think they look better than the exhibition pictures of Landscape   I wish you could see my painting room   I have a little table in the middle quite snug   I never touch my pictures indoors . . . I sometimes get up at $\frac{1}{2}$ past 6. begin painting at nine and go to bed at $\frac{1}{2}$ nine or ten   I read in the evenings   I have such nice books Dan lent me   I have found a beautiful ash tree close to an old gate   I mean it do a very very very very finished one of it . . . How goes painting   I hope you paint whenever you can   If you cant paint I hope you pencil   you have a beautiful stile of painting.

From his letters we get a fair idea of the kind of work Alfred was doing that summer, but unfortunately we know very little of what Lionel had been up to in Somerset. Charles Golding seems to have thought he was learning to be a farmer. 'And how does Toby ticklemouse get on', he wrote that August from India, 'I am very anxious to hear of his having settled to some good thing, I suppose though that by this time he is farmering away "Like a good fellow"'.[10] Alfred, he knew, was to become a painter, but in April 1847 he was still imagining Lionel 'talking about "manure" prehaps or "state of crops"',[11] unaware, apparently, of the fact that Lionel too had decided to become a painter, had enrolled at Cary's Academy, and that by then he was hard at work copying plaster casts in the Bloomsbury Street studios.

---

* AAC to LBC, n.d. From the thumbnail sketch in the letter it is evident that Alfred had in mind the small sailing-boat with a man standing up in it which is to be seen in the oil sketch of the subject Isabel gave to the Royal Academy in 1888 (Tate Gallery 1976, No. 176) and which may also be seen in the larger, more finished painting of the *Whitehall Stairs* now in the Cincinnati Art Museum (Hoozee 1979, No. 265). From his talk in the letters of outdoing 'the Whitehall tree' with a 'very very very very finished study' of an ash tree it is probable that in both cases Alfred was talking of the Cincinnati painting, the only one of the series with a carefully finished tree.

Alfred had talked of submitting his harvest picture for the Academy of 1847, but although a work by him was (for the first time) hung in the exhibition that year it rather looks as if he had in fact changed his mind when the time came: perhaps in style it *was* too 'papare'. In the catalogue his exhibit is just called 'Landscape', an improbable title for a harvest scene, and the likelihood of its being of a more straightforward subject is further suggested by references to the picture in a letter to Alfred from a cousin, Jane Anne Luard. Her comments have an additional interest as she herself had known Constable and as a young girl had copied one of *his* copies after Claude.* Her mother, Mrs Inglis, was Lionel's godmother.

> I am delighted with your picture [she wrote, in December of that year, 1847] – it is hung up now in the dining room & looks nicely there – I was not able to see it to advantage in the Exhibition and now that I can examine it, I see that it is of inestimable value. I particularly admire the grass & shadows round the stems of the trees – & the shadow in the road – I think that whole passage is as sweet & true to nature as it can possibly be.[12]

From time to time the boys had been sending examples of their work to Charles in India and in January of this year, 1847, he had received a box of Christmas presents from Cunningham Place which included a painting by Alfred and a drawing by Lionel ('Toby').

> Alfa's little picture [he had replied] is very nice, Abdullah [his servant] took the measure of it, and has gone out to order a little frame, so that I may hang it in my cabin, it is so bright & natural. And Toby's pencil drawing is very clever, so bold, the penciling is quite my Fathers, the sky is so grand & so English.[13]

News that a new generation of Constables had begun to exhibit at the Academy reached Charles in June. 'I am glad Alfa's picture got a good place in the Academy', he wrote, 'how I pray that he & Toby may get on. It is a great comfort though to see Alfa actually exhibiting, this looks as if he was all right, but I remain very anxious about Toby'.[14]

Charles had been serving with the East India Company now for eight years. Promotion had been slow, but after passing the necessary examinations in October he was at last gazetted full lieutenant. There followed a succession of appointments: to the steamer *Medusa* of which he was made captain (March 1846); to the '*Acbar*' (May 1846), the largest steamer in the fleet, as First Lieutenant; and in April 1847, as Second Lieutenant, to the steam frigate '*Moosuffer*'. For some time he had talked longingly in his letters of England and

---

* Jane Anne Luard, née Inglis (b. 27 August 1816), was the grand-daughter of Constable's first cousin Anne Mason of Colchester. There was much cousinly affection between the two families. Correspondence about the loan of the Claude is to be found in JCC I, pp. 278, 282–4. Dated drawings by Jane Luard of the period 1841–62 that came on the market recently show her to have been an enthusiastic and reasonably competent watercolourist.

of leave. Then, quite unexpectedly, after appearing before a board, in October 1847 he found himself in possession of a certificate granting him leave on medical grounds. Within a week he was homeward bound. The last of his letters before reaching England was written from Berlin on 26 December.

With Charles at Cunningham Place, united once more with his brothers and sisters, the correspondence ceases, and for the next two years we know very little of the family story. But this we do know, that quite soon after his return there took place an event, simple enough in itself, but of some importance in the history of the family collection – the division of the great store of their father's work into what was then agreed to be five equal parts, one for each of them. Our knowledge of this share-out derives mainly from a single document. This is a folded sheet and a half of notes in Charles's hand slipped between the pages of the diary he kept in 1864, and written, it would seem, under considerable emotional stress. The document is incomplete. It starts in mid-sentence and tells of a high pitch of frustration and wrath into which he had been driven by what he felt to be the incessant nagging of his two sisters. Not all of it is immediately relevant, but it is better read as a whole rather than in parts and the allusion to the 'sketches' is very helpful. Minna appears to have implied that Charles took advantage of her and her sister's youth at the time of the sharing, though in December 1847 she and Isabel were in fact twenty-eight and twenty-five years of age to Charles's twenty-six.

. . . all love has been quenched in their lonely hearts – . The milk of human kindness has dried up in their breasts long ago.

Ist thing was about the Sketches, which had been most fairly & impartially divided 17 years ago – & now they discovered they had been cheated as much was insinuated when Maria said to me one night at no 16 in the winter of [blank] that 'they were younger then & did not know so much about them' – implying that I took advantage of them then.

2nd The wonders Maria did for me to secure to me the Farms.*

3rd The ⟨. .⟩ Falshoods Maria told about Alfred having framed that sunset over Harrow for her & in [left uncompleted]

4 The cool ⟨. .⟩ and playful little arrangement of dividing all my own prints of shipping amongst themselves ⟨dur⟩ while I was away in India

5 About the division of Alfreds ⟨dr⟩ collection. What Isabel said to me – and how they Kept his best back no doubt†

6 When I gave them the two pencil portraits of themselves by Leslie and asked for the portrait of myself –

7 Battle of the Red Shawl‡

* Farm property in Suffolk, apparently at Newbourn, which Charles had inherited after the death of a great-aunt, Mrs Farnham, daughter of Dr Rhudde.

† See p. 71.

‡ In his letters Charles refers to the purchase of a shawl as a present for one of his sisters.

8th How I used to get pitched into by one and then the other, this was when I
was left in the Room with them – then ⟨I had⟩ the two would open fire at me,
when one was tired or ⟨had no n⟩ could think of nothing more at the moment,
the other would begin at last when this incessant fire of abuse was getting sickening
I used to retire to get a pipe with Lar [i.e. Lionel] and wonder what it was for
and what it all meant. one thing that Minna several times brought up was the trouble
she had been put to (⟨she had⟩ Clayton had called on her two or three times and
she had had a letter or two to reply to or to sign) to get me possession of the farms,
'what were the farms to her she got nothing from them' &c. I ⟨. .⟩ was sorry to
see such a little mind and felt that an affectionate and ⟨spirited generous hearted⟩
good hearted woman would have done that for an absent brother without at all regret⟨
ting it.

At some considerably later date, the following was added by Charles's second
son, Hugh Golding Constable:

> I often heard from my Mother and Ella [his sister] how small minded the Aunts
> were (dear old Lar was alright) & when I lived with them as a ward I found them
> damned difficult. These notes of CGC's confirm, They had been belles & asked
> everywhere & spoilt and besides that they lived in London

This sorry tale of bitterness within the family was not written until 1864, but
as we can see, some of the seeds were sown when the attempt was made to
arrive at a fair and equal sharing of the great mass of their inheritance. Inscriptions
on the backs of oil sketches in the Victoria and Albert Museum and elsewhere
suggest that part of the sharing‐out, at least, took place soon after Charles's return,
between 27 December 1847 and January 1848.*

Charles returned to serve a further term with the East India Company Navy
late in the autumn of 1849. It is from the letters he wrote during the next eleven
years – some fifty or so in all – that we learn most about Alfred and Lionel
and their two sisters. A few of their own letters with a handful from friends
and relations serve to complete the picture.

Only once is there a reference to the acquisition or sale of one of their father's
works. This occurs in one of Charles's letters home (to Alfred, May[?] 1851)
and is of interest as it shows how rife were Constable forgeries at this time, and
how fearful the children now were of being taken in by a false attribution. It
also reveals, significantly, that Charles was by no means certain that Alfred and
the others would be able to tell between the genuine article and a forgery. It
seems that Leslie, on the other hand, could.

---

* See C. M. Kauffmann and John Murdoch, 'Which Constable?', *Burlington Magazine*, CXXII,
1980, p. 436 for details of V & A oil sketches so dated (including corrections to the transcripts
in Reynolds 1973) and L. Parris, 'Some recently discovered oil sketches by John Constable',
*Burlington Magazine*, CXXV, 1983, p. 223 n. 21 for a similar inscription on a sketch now in
the Tate Gallery.

I should like you to buy the Yarmouth certainly,[15] but I fear it would be very high, especially that rascal White would charge ten times as much as he gave for it, still I would always gladly go to 50 or 60 £s but when he had it before he charged 80 I think, if I remember rightly. Whether or no I suppose it will be gone again long before this reaches you but if ever you see it & can get it within these sums you might, only pray be sure, better have Leslie to see it, what a dreadful thing a forgery would be.

Towards the end of his leave, Charles had revisited Folkestone, where he had been at school in the 'thirties, and made his stay an occasion to renew the acquaintance of the Revd Peter Spencer, possibly the Mr Spencer at the school who had helped his father on a visit there with his literary compositions.[16] Alfred, who was too young to have known Spencer in his father's day, is associated with Charles in an inscription on the fly-leaf of a copy of Leslie's Life (ed. 1843) presented to Spencer in London in July 1849 and now in the Tate Gallery. He and Charles received an invitation to go and stay with Spencer and his wife at Temple Ewell, just inland from Folkestone, in September.[17] There is no certainty that Alfred went down with his brother that year, but he was definitely at Folkestone the following one and probably the one after that (1851) as well.

Alfred exhibited a 'Landscape' at the Academy again in 1848, and in 1850 a picture with the title 'Morning on the coast', which could of course have been a Kentish coast scene. In the latter year, for the first time, Lionel too was represented at the RA, in his case by no less than four exhibits: 'Landscape', 'A stormy day', *Tottenham Park* (pl. 132) and 'An ash tree'. He also exhibited at the British Institution this year a painting entitled 'Evening'. News of the boys' success reached aunt Mary at East Bergholt. 'I am wonderfully pleased', she wrote, 'to read of *six paintings* – by the dear young Artists, who inherit name and fame most interesting to us all'. There was also in the exhibition a portrait of Charles, it seems: ' – dear Charles Golding's Picture would attract me with the utmost interest, & I am glad it is [in] the exhibition as he is a Public Character & the[y] would may be glad of it. – he is so clever & gentlemanly – so, that I feel quite a *Plantaget* – when I reflect on my brother's family altogether'.[18]

One of Lionel's rare letters may have been written at around this time. Addressed to Alfred as from 'Lancashire' and dated 5 June, the letter tells of a tour Lionel was making with a companion, Mackay. They had visited Peak Cavern in Derbyshire, spent a day walking about Manchester ('a fine city') and when Lionel wrote had stayed at Bakewell, Glossop, Fleetwood and Broughton. At that point he had not done any sketching. In his letter he talks of having seen Helvellyn covered with snow, but the rest of the tour is unrecorded and we do not know whether they went on to the Lakes. A group of oil sketches suggests that at one time or other Lionel did go there.

1850 is a year comparatively rich in Lionelian documentation. Drawings and oil sketches record a Cornish holiday in July (see pls 45, 145–6), and two long

letters tell of a visit to America. A cryptic reference in a letter Alfred wrote to David Lucas in 1846 suggests that Lionel may have had it in mind to cross the Atlantic for some time, but he appears to have actually sailed for the United States in August. Aunt Mary, who had rather grandiose notions of the family status, obtained for him an introduction from an American lady in Bergholt to her brother in New York, 'where', she wrote, 'a friend at Court may not easily be attained – in the first Class of society'. One can only hope aunt Mary never learned that Lionel actually chose to travel steerage on the voyage. In the first of his two letters, dated 'about Sep^ber 25^th', Lionel tell of his and his companion's plans for their stay after disembarking in New York.

> We first go by steam packet to Albany from that place to Buffalo by railroad, then take the steam boat again and go by the lakes to a place called Chicago   the first lake is lake Erire, then lake Huron and lake Michigan alto gether about 2000 miles   it can be done for less than £3 counting food &c, &c,   Jack expects to get a great deal of shooting and by the accounts I hear he certainly will their being plenty of game wild deer and even bears, horrid. I have not done any sketching on this voyage it being impossible to find a quiet place   I have seen some beautiful effects of sunsets and moon l⟨i⟩ights

His second letter was written some weeks later. Having declined an offer of a job felling timber at £5 a month, work which he did not think 'would quite do' for him, he had left his companion 'Jack' at Milwaukee and was then on a canal boat heading back for New York and home. America, it seems, had not impressed him greatly. Niagara Falls were fine, but the country for so many miles was 'flat, swampy and unpicturesque' and manufactured articles he thought very inferior to the London ones. In a pencilled postscript he announced the date of sailing, 16 November. Two drawings by Lionel made during his tour have survived, both pencil sketches. The first, of 'niagra' Falls, is dated on the back of the mount 'Oct 30^th 1850'. The second, of some shipping (with characteristic attention given to the rigging), is inscribed 'milwakee'.[19]

In the Academy the following year, 1851, there were no fewer than three Constables exhibiting: Lionel, Alfred and, for the first time, Isabel, their sister, with a painting of flowers.* Though it is rather as second fiddle to her older sister Minna (the first lady of the Cunningham Place household) that Isabel (pl. 28) generally makes her appearance in the family story, she nevertheless seems to have occupied a rather special place in her brothers' affections. Possibly this was because she appears to have had a mind of her own and to have seen slightly more of the world than had her sister. Possessing an acknowledged artistic talent, she had for some time attended the 'classes for Females' at the Government School of Design in Somerset House run by Mrs Fanny McIan (wife of the Scottish

---

* Lionel exhibited 'On the coast of Cornwall' and 'Entrance to Looe harbour, Cornwall'; Alfred showed a single work, 'A fisherman's cottage'.

painter R. R. McIan), journeying there each morning by omnibus. It is possibly a tribute to her independent outlook and her judgement that, in 1852, when Charles had to change lawyers and was in need of someone to act for him in some matters of business it was Isabel's offer of help he felt most ready to accept. It was upon Isabel, the last survivor, that there ultimately fell the responsibility of disposing of the bulk of the collection.

1851 and 1852 were uneventful though productive years. In 1851 Minna and Isabel visited Paris, Lionel spent some time in Scotland, and Alfred stayed with friends and relations in Kent and Suffolk. Views of Scotland and Kent were among Lionel's and Alfred's exhibits in the Academy of 1852.* That summer the two brothers were in Devon.

On 22 May 1852 Charles had written asking his brothers for some samples of their work:

> I should be very glad [he told Alfred] if you and Toby would 'throw' in amongst my charts one or two 'bits' of juice    I should like wild bits or coast bits, racey of course – any little bits if in Indian ink would do for me    let them have 'breadth'

'Bits of juice', 'breadth', and in other letters 'racey bits', 'brightness' etc., were all part of a special language adopted by Constable's sons, Charles especially, when writing about their drawings and paintings – in imitation, it would seem, of how they remembered their father enthusing about the art he loved.† Charles's young brothers willingly posted him a parcel of their work, the receipt of which he acknowledged in October.

> I was much pleased with the racey bits sent me    one bit of juice in particular gives me great pleasure    it is Sidmouth bay on a july ⟨day⟩ afternoon but cloudy & a fresh breeze    the sea rolls into the bay quite beautifully and the shadows of the clouds seem to sweep past – the little bit 'Lande rock' is exactly like some of my own bits of Persian gulf    they are all very nice indeed & seem to me to speak a great improvement since I was amongst you – I was glad to see my old chalk rock come to me from East Weir bay –[20]

Charles refers to these sketches again in a letter of 1 February 1853 to Lionel, who, apparently, had left one of his paintings, a coastal subject, with Fyson, a local tobacconist, in the hope that it might attract a buyer.

---

* Lionel showed *Falls of the Tummel* (still in the family collection: Tate Gallery 1982, No. 5), and 'View on the Thames, near Pangbourne, Berkshire'; Alfred another 'Landscape' and 'Hythe Church, Kent'. Isabel exhibited 'Autumn Flowers'.

† Charles's best effort in this vein comes in a letter to Alfred written in the spring of 1851: 'The ship tacking I will draw for you as well as I can and in fact I will, as I said before, "throw in a few bits" combining brightness, colour, breadth, light, tone, richness, raceyness, space, poetry, and in fact throw poor Van der Velde quite into the shade'. Lightness, brightness, racyness, freshness, sparkle, etc. are all to be found in Constable's correspondence with John Fisher.

My sister Isabel described to me a little picture of your painting which Mr Fyson kindly took charge of to give it a chance of being sold. Such a sketch as that, namely a bit of coast with gulls &c. is just such as I want, and I feel very anxious to possess it, so please to ask Mr Fyson for it (if it is still there) and send it to me in the parcel Alfred has to make up for me; I shall be writing to Minna and will tell her to pay you . . . I am frequently looking at those sketches you were so kind as to send me. those about Sidmouth, and Alfas lump of chalk rock lying in East Wear Bay*

Alfred and Lionel each had a picture in the Academy of 1853; the former a view on the Devonshire coast, the latter 'A study'. Isabel did not show again at the Academy. Nor, for very different and in his case tragic reasons, did Alfred.

For some years after the death of their father we get a reasonable picture of the life the Constables led from the letters they wrote each other. But after the 'forties, while Charles was abroad, it is almost entirely upon his letters home that we have to rely for information about the family. In the correspondence, it is thus only in one of his letters that we hear anything about the boating accident on the Thames on 19 November 1853 in which Alfred lost his life. There is no first-hand account of what happened. Charles Golding's second son Hugh, many years later, related what he remembered having heard of the occurrence in a typescript, 'H. G. Constable Esquire, HIS BOOKE OF YARNS',[21] a collection of family stories and anecdotes. 'Poor old Toby', he says, was rowing with his brother Alfred in a home-made dinghy:

> . . . somehow she sank, I forget how, & they swam for the shore. Alfred was a fine swimmer, like his father the artist who twice saved people from drowning. Toby saw that Alfred, in spite of winter gear, was coming on alright but when Toby had got ashore, Alfred had disappeared. These brothers were such pals that they went by the name of Jonathan and David. Toby had a stroke and was for several days nursed in a cottage. The stroke affected his brain a bit and made him simple as a kid in some ways.

The most reliable account of the tragedy will probably prove to be the one given by Robert C. Leslie in a footnote to his edition of his father's *Life*.[22]

> Constable's third son, Alfred, who though he never took up art seriously, was very fond of painting and etching. He was unfortunately drowned by the upsetting of a boat, in which he and his brother Lionel were crossing the Thames just above Goring Mill weir. It was in November, 1853, on a dark, frosty evening, and, though able to swim, he sank before reaching the river bank, overcome probably by cold and shock. His brother Lionel narrowly escaped being carried over the weir, and, on looking round after reaching shore, was horrified to find that Alfred, who was following him, and to whom he had just before spoken, had disappeared.

If Lionel had suffered some sort of stroke through the loss of his brother, it might

---

* East Wear Bay lies just to the east of Folkestone.

partly explain his subsequent abandonment of a career as an artist. In 1855 he exhibited two works at the Academy, 'A barn, in Sussex' and 'Entrance to a wood'. After this there is no further record of his having painted. Instead, he appears to have turned to other interests, fireworks, carpentry, sailing, and to photography, an art in which he had been dabbling for some time.

Some fifty or so of Lionel's photographic prints have been preserved in the Constable family archive.[23] These range from photograms of fern leaves (negative and positive), images obtained by the direct action of light on sensitized paper, to the more conventional salt and albumen prints taken from glass photographic negatives. More than half of the prints are of rural subjects, cottages, mills, churches or bridges; very few being of pure landscape scenery. Two of the views he took with his camera were also subjects for his paintings (pls 136–7). Isabel appears to have been one of his most willing sitters for portraiture (pl. 28).

Charles meanwhile was engaged in the final and most successful phase of his career at sea. Though not such a talented artist as his brothers, from his father he had inherited an exceptionally keen eye and he had already been employed as a draughtsman on a survey of uncharted waters around the coasts of Arabia. In the winter of 1849/50, on his way out from England, he had spent some time in Egypt, and while there had joined Col. James Outram on a survey of the Eastern Desert as a much-needed draughtsman.* The work done on this expedition had earned him the thanks of the Government of India and a warm commendation in Outram's report to the C-in-C. Since then he had worked hard to gain recognition as a cartographer. His efforts were rewarded. In October 1851 he was given a command, the ten-gun brig *Euphrates*, with orders to draw up a large chart of the Bombay waters. There followed the assignment that engaged him for the remaining years of his service, the sounding and survey of waters in the Persian Gulf.

In Charles's letters there is much on British rule to interest the historian. But thoughts of his family and of home were often in his mind and on a number of occasions he writes of his father. From Bushire, towards the end of the Persian War of 1857, for instance:

> I have not yet received definite orders as to what I am to do but I am trying to remain up the Gulf because I like it and better than any other place we have to do with. I should like to have gone with Toby to see the opening of Waterloo

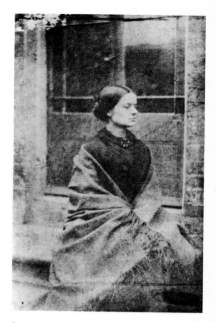

2

28 Isabel Constable (photograph by Lionel Constable). Constable's last surviving child, who made generous gifts and bequests to the nation in 1887–8.

* James Outram (1803–63) had taken the opportunity while in Egypt for his health to write an exhaustive report on the country for the East India Company. Charles quotes from Outram's accompanying letter to the C-in-C.: '. . . thanks to Lt Constable for the valuable aid he gave me in Egypt in surveying & mapping, a very valuable specimen of his handy work being lodged with the Govt . . . I take the liberty to bring Lt Constables Egyptian services to your notice'. Charles also quotes from a letter of introduction he bore to Outram, in which he was described as 'one of the few men who can use both their heads and their hands . . . not only a scientific man, but a beautiful draughtsman'. Outram subsequently had a distinguished career in India; he rose to the rank of Lt-General and was created a Baronet in 1858.

Bridge* — it is a glorious picture — and I can remember more about the painting
of that than almost any other, unless it is the one in the Vernon collection† . . .
I always read about the exhibitions    although I cannot see the pictures I seem to
like to read about them. In the Illustrated News some little time back I was reading
about the notices of the pictures exhibiting at the British Institution and I came to
— 'Caerhun Low water' (547), by Mr. Oakes,‡ is one of the most original landscapes
in the rooms. The surface of the water & the beautiful cloud composition, is very
admirable, and somewhat reminiscent of Constable' — So I frequently see allusions
to Constable. I saw one large book of Coloured plates one day but I forget the title
of it, I know it was about modern painters, giving a specimen of each of their works.
I saw it on a drawing room table when I was out somewhere dining, I think at
Lord Elphinstones,§ & there was the 'Corn Field' with the drinking boy in it,
& a sketch of the life.[24]

For his last survey of the Persian Gulf Charles was given a brand-new schooner,
the *Marie*. This proved to be his last voyage as a serving officer. His time out
East was drawing to a close. The last months were spent ashore working on
his charts, the last weeks packing up. On 28 October 1860 he sailed for England
with a medical certificate granting leave for three years. Within six weeks, after
an absence of eleven years, Charles was back in London. How and where he
lodged is not known, but with No. 16 Cunningham Place so modest a dwelling
there was evident need for him to find a wife and set up on his own. This
did not take long. Noted on a loose page from a diary for August 1861, probably
in Lionel's hand, we have:

> *Tuesday 13*    C G C Married
> I C, M C, G L. M L. & Stiffe went to
> Kew Gardens, Helders in the evening

'G L' and 'M L' were probably George and Mary Leslie, two of C. R. Leslie's
now grown-up children. Lieut. Stiffe had been with Charles in *Euphrates* and
became one of his closest friends. The Helders, near neighbours, were the bride's
family. The marriage was announced thus in *The Times* for 15 August 1861:

> On the 13th inst., at Christ Church, St.Marylebone, by the Rev. Francis Helder,
> and the Rev. Lewis Clayton, Commander Charles Golding Constable, H.M.I.N.,
> son of the late John Constable, Esq., R.A., to Caroline Susanna, daughter of Wil-
> liam Helder, Esq., of Howley-place, Maida-hill.

---

* Presumably Lionel had seen *The Opening of Waterloo Bridge* (pl. 15) when it came up for auction
at Foster's on 27 February 1857 and was bought by Wallis.

† *The Valley Farm* (pl. 26), which Robert Vernon had bought on seeing it in Constable's studio,
'free from the mustiness of old pictures' (JC to Leslie, JCC III, p. 124) in March 1835.

‡ John Wright Oakes (1820–87), ARA, exhibited many views of North Wales.

§ John Elphinstone (1807–60), 13th Baron, Governor of Bombay 1853–9.

For their honeymoon the couple chose to spend a few leisurely weeks on the Continent – Belgium, Germany (in Munich, calling on the by now grey-haired Boner and his sister) and France. The tour ended in Paris and they were well and happy when Charles wrote to Minna on 7 October just before starting back for England. Caroline bore him a son the following year (1862), but neither she nor the boy survived the confinement. Mother and child were buried in one coffin in All Souls Cemetery, Kensal Green, permission for interment having been granted on 12 May.

Charles was on the Continent again when he wrote his next dated letter (14 December 1862), this time in Nice. Despite his recent loss, and an almost prophetic warning from his travelling companion – 'he says if you get a good wife who loves you, she will die, but if you get a bad one, she will live, and kill you, therefore had you not better leave well alone?' – Charles was quite clearly again in the market for a wife. From either Florence or Rome he could have returned with a bride on his arm, perhaps even with an American one, the girl he thought the finest he ever saw, the daughter of Hiram Powers, the sculptor of the then famous *Greek Slave*.[25] But in the end it was from no further than the family right next door in Cunningham Place that he finally made his choice. The wedding took place within two months of his return from abroad. On 30 May 1863, Anna Maria Blundell became the second Mrs Charles Golding Constable.

The main day-to-day events in the subsequent lives of Charles and his family are recorded in the diaries he kept from January 1864 until the month of his death, March 1879.[26] The entries are brief and leave much unexplained, but births, deaths, family occasions, visitors and visits, outings, holidays, exhibitions and sales, the care and ministration of Charles's collection of his father's work, business matters occasionally and Anna's tantrums not infrequently, are all duly noted. No. 16 Cunningham Place, as we have seen, was only large enough to house Charles's brother and sisters and their small domestic staff. For the early part of their married life Charles and Anna lived quite near, at No. 68 Hamilton Terrace. Later, in 1871, they moved away to No. 6 Harley Road, just north of Primrose Hill Park. Five children were born of the marriage and survived childhood: Clifford in May 1864; Ella Nafeeseh in November 1865; Hugh Golding in August 1868; Cyril in 1870 and Charles Eustace in October 1874. A sixth child, Sybil Armine, was born in July 1876 but lived only a month. All but the last-named – and, for some unexplained reason, Cyril – feature regularly in the pedigree of works by their grandfather.

# THE WATCH-DOG

## [1864–1879]

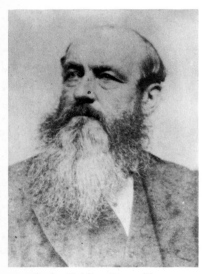

29  Charles Golding Constable

ALTHOUGH now on a captain's retirement pension, for a time there was still work for Charles Golding Constable (pl. 29) to do on the charts of the areas he had surveyed out East and on the book he and his assistant, Stiffe, had written – the official *Persian Gulf Pilot*. But after the publication of the *Pilot* in May 1864, for a man of his lively temperament in the prime of life Charles did not have a great deal to turn to for amusement. More and more, it seems, he therefore began to concern himself with his father and his father's works, those in his own collection and any, genuine or not, which were receiving public notice. With Lionel and Charles Boner he visited the old Hampstead home, No. 6 Well Walk, which he had probably not seen for forty years. He took his family down to Essex and Suffolk. They saw aunt Mary, now astonishingly in her nineties; had a word with Sam Abbot, his grandfather's coachman; and called on old Miss Bowen who, more than fifty years before, had acted as a go-between for the Constables and the dreaded Dr Rhudde.* They boated to Langham and walked up to see the spot from which Constable had painted *The Glebe Farm* (pl. 13). In Hay Barn, the little farm just above Flatford owned by aunt Mary, they found some pictures, and a day or two later went back to fetch them away. Charles even went to see an early work by his father, the altar-piece at Brantham. With his cousin Daniel Whalley Charles also visited one of the properties he had inherited from his aunt Farnham at Newbourn, near Felixstowe. In May 1865 they were down in Suffolk for aunt Mary's funeral, and a few week later were there again, this time to supervise the packing up of Mary's pictures and china. Later that summer he took Boner on a pilgrimage to the scenes his father had painted, to Flatford, Stoke-by-Nayland, Stratford-St Mary, Dedham and to the windmill the family had owned on East Bergholt Common. This was Boner's first visit to the area. Like Leslie on *his* visit in 1840, Boner was surprised by what he found. 'I never could have believed it

* Rector of East Bergholt, grandfather of Maria Bicknell. Rhudde's disapproval of Constable's courtship of Maria was the cause of much unhappiness during their long, seven-year engagement.

possible', he later told Charles, 'that out of such material such grand works could be made. Think only of that puny miserable Lock and then look at the picture!'[1] Yet Charles recalled Boner suddenly grasping his arm and exclaiming, 'Charlie, I see your father in every tree!',[2] an echo perhaps of John Constable's remark when staying at Ipswich in 1799: 'I fancy I see Gainsborough in every hedge and hollow tree'.[3]

An early concern of Charles's was the division of his brother Alfred's collection of their father's work. According to the Diary, Minna and Isabel reacted somewhat strangely when he proposed a share-out: 3 January 1864, 'At Sisters & was abused called most ungenerous for wanting my share of Alfred's drawings &c – ⟨There⟩ They only shew me about £1 worth & say they know nothing of any more!' A year later Charles records his sister as having 'been at Frank [Frank Clayton, their solicitor] about the division of Alfred's sketches'. A conclusion of the unhappy business is noted in the entry for 6 February 1865.

Putting his collection in good physical order was another of Charles's priorities, and during 1865 he sent a number of items to the dealer Hogarth for mounting or framing and, in some cases, cleaning and restoration. Among paintings sent for restoration were the portraits of his father and aunts he had brought home from East Bergholt. In 1867 he himself appears to have cleaned *Arundel Mill and Castle* (pl. 1), which he later sent to Merritt for relining. That year, the Constable family returned to the auction rooms, apparently for the first time since the studio sales of 1838. Charles sold one of his father's *Gray's Elegy* drawings at Christie's on 7 June for £27 6s. and 'two early landscapes' on 11 November 1868 (after having to buy them in at a sale in July because he misunderstood Christie's rules). Thereafter, sales of small groups of works, with Lionel as well as Charles selling, became a regular occurrence for a few years. Charles put up three oil sketches on 15 April 1869 and Lionel another three on 22 May. Six more works from Charles's collection appeared at Christie's on 9 May 1870 and sixteen at Foster's on 5 May 1871. Lionel offered five items at Christie's on 14 June 1873 and eight more on 2 March 1874. Finally, twenty-six paintings and drawings from the family collection appeared at Christie's on 17 February 1877. In all, some seventy works by Constable, mostly oils and the majority actually being sold, were offered at auction by the family between 1867 and 1877. In addition, there were a number of private sales, of which the only record is usually in Charles's diaries. For example, in August 1871 someone called Halsted, acting on Charles's behalf, got £12 from a dealer for an oil sketch of Hampstead Heath (a sunset study painted on 18 October 1820) which had been bought in at five and a half guineas at Christie's on 5 May 1871. Halsted sold two more works for Charles in November and December 1871 and another two in March 1877 for £12. On 2 December 1871 the Revd R. C. Lathom Browne paid Charles 17s. 6d. for seven academy studies, four of which he presented to the South Kensington Museum two years later.[4] As a label still on the back of the picture indicates, Lathom Browne also bought an oil painting from

Lionel in 1874. This was one of several early studies Constable made of the view towards the old Rectory at East Bergholt.[5]

The only large painting Charles Golding Constable disposed of was *Arundel Mill and Castle,* which his brother John Charles had bought at the 1838 sale. This was purchased by the Liverpool collector Holbrook Gaskell in 1878 for £2200, by far the highest price then paid for a Constable. Otherwise the works Charles and Lionel sold in this period were, typically, small oil paintings and sketches, particularly outdoor oil sketches. They were the sort of works that had not been seen much since the 1838 studio sale but which now began to create interest. Two examples, an outdoor oil sketch now called *A Lane near Flatford ( ? )*[6] and a study used for *The Mill Stream,*[7] were etched by R. S. Chattock and published in the *Portfolio* in 1875. Both were probably then already in the posses-sion of Henry Vaughan who, as we have seen, also owned the full-size sketches for two of the artist's six-foot compositions as well as the final version of *The Hay-Wain.* Vaughan was one of the earliest collectors to be interested in Con-stable's small oil sketches, acquiring from Charles's and Lionel's sales in the early 1870s *The Gleaners,*[8] *Epsom*[9] and *The Mill Stream* sketch just mentioned, for which he paid respectively £22 1s., £24 13s. 6d. and £43 1s. In July 1870 he obtained from the dealer Hogarth another of the small sketches (*Dedham Lock*[10]) which, like those, he eventually bequeathed to the nation. Other purchases were probably made by Vaughan directly from the Constable family. Correspondence indicates a visit by him to Lionel in March 1874 and the following month a return call by Lionel and Charles.[11] Charles's diary records another visit from Vaughan on 17 June 1875. Although landscape sketches could now be sold without much difficulty, Constable's cloud studies still aroused little interest. Charles had to buy in, for a total of seven guineas, the seven examples he offered in two lots at Foster's in May 1871. These could be the 'two frames full of cloud studies' he subsequently gave to his friend Walter May.[12]

While Constable's children were thus adding to the number of his works in circulation, paintings which had left the family earlier continued to change hands and to appear in exhibitions. Constable was well represented in the Royal Academy's new winter exhibitions. Six paintings by him were included in the second exhibition in 1871, though on this occasion all but one (Vaughan's *Hay-Wain*) were pictures still belonging to Charles and Minna: *Arundel Mill and Castle, The Cenotaph,* the 1817 *Flatford Mill* (pl. 12), *The Glebe Farm* (pl. 13) and a Hampstead Heath painting. Thereafter, groups of Constable's works appeared at the Academy nearly every winter. The majority were finished paint-ings of his mature years but there were occasional surprises, such as the *View at East Bergholt*[13] of about 1813 lent by the sculptor Thomas Woolner in 1872 under the title 'View near Highgate' and the 1809 *Malvern Hall* (pl. 30) lent by J. H. Anderdon in 1878. In the latter year another group of works still belong-ing to the Constable family, this time to Lionel, was shown. Lionel also lent twelve works by his father to the 1877–8 winter exhibition of the Academy's

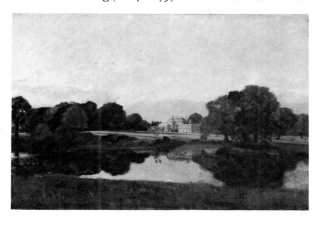

30 *Malvern Hall*, 1809; oil, $20\frac{1}{4} \times 30\frac{1}{4}$ (51.5 × 76.9)

new rival, the Grosvenor Gallery in New Bond Street. Although chiefly famous for its association with Whistler and other non-Academic artists, the Grosvenor Gallery also mounted exhibitions of Old Masters on the lines of the Royal Academy's winter exhibitions. As we shall see, a large and important group of Constables was shown there in 1889. The works lent in 1877–8 were all watercolours or drawings and represented an aspect of Constable's art not much noticed before. A watercolour in Lionel's possession, now in the British Museum and known as *The Farmhouse near the Water's Edge*,[14] had been reproduced as a colour lithograph in Philip Delamotte's book *The Art of Sketching from Nature* in 1871. Although to modern eyes one of Constable's more elaborate, late water-colours, for Delamotte it illustrated 'the powerful suggestiveness, richness, fresh-ness, and simplicity of his style' and was reproduced in the book 'with the greater satisfaction as his water-colour drawings are decidedly scarce'. The works Lionel lent to the Grosvenor Gallery exhibition included other highly finished water-colours, such as the *Old Sarum*[15] which had been exhibited by his father in 1834, but there were also two pencil drawings which were probably among those reproduced later in 1878 in an article about Constable by Frederick Wed-more in the French journal *L'Art*.[16] Wedmore illustrated the paintings of *The Cornfield* and *Admiral's House* (pl. 139) but devoted his other five reproductions to pencil drawings, among them an 1821 study of a barge on the canal near Newbury,[17] a large drawing of ash trees (pl. 31) used in *The Valley Farm* and an 1834 drawing of Cathanger near Petworth.[18] Such drawings, four belonging to Lionel but one already in the collection of J. P. Heseltine (whose notable collection of English drawings, including many Constables, was sold at Sotheby's in 1920) would have been as much a revelation to English as to French readers at this time. The works lent by Lionel to the Grosvenor Gallery exhibition certainly made a strong impression on Mrs Charles Heaton, who wrote of them thus in her continuation of Allan Cunningham's *The Lives of the Most Eminent British Painters* (1880):

[73]

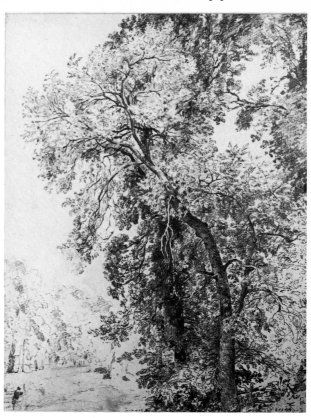

31 *Study of Ash Trees*, pencil, 13 × 9⅜ (32.8 × 23.8). One of the first drawings by Constable to be published, in a French magazine in 1878.

Constable's studies and water-colour drawings, some of which were lately exhibited at the Grosvenor Gallery, though of extremely rapid and apparently careless execution, reveal even more strikingly than his finished works his power of seizing a transient effect, and conveying the impression it had made upon his mind to that of others.[19]

After the sale of *The Hay-Wain* in 1866 none of Constable's major works came to auction for a number of years but lesser paintings sometimes reappeared with alarming frequency. Of the three works attributed to Constable which were sold from Edwin Bullock's collection at Christie's on 21 May 1870, a *Weymouth Bay* (probably the picture now in the Louvre[20]) turned up again in Joseph Gillott's sale on 26 April 1872, fetching £735 as against £535 10s. in Bullock's sale, and surfaced again the following year at a Paris auction. Another Bullock picture, *Child's Hill, Hampstead* (probably the painting currently on loan to the Whitworth Art Gallery, Manchester[21]), made £787 10s. in 1870, £1050 in John Hargreaves's sale on 5 June 1873 and was then bought in at £934 in Albert Wood's sale on 13 June 1874.

Fresh batches of forgeries also began to appear on the market or at exhibitions

in the late 1860s and 1870s. Charles Constable set himself up as a watchdog, noting in his diary various 'shams' he had seen and on occasion writing letters of complaint about them to *The Times*. The first sighting he noted was on 17 October 1866 when he called on 'a M$^r$. Nell to see a forgery of Constable'. A more serious case came to light in June 1869 when Foster's attempted to auction what they called 'three Grand Rural Landscapes, which show how truly this great English Painter could delineate the sunny meadows and refreshing streams of Dedham's rich pastures, and Sarum's fertilising valley'. The works, said to have been painted 'by express commission' and never to have been publicly exhibited, were entitled 'Dedham Lock', 'Salisbury' and 'On the Stour'. Each measured six feet in length by over four feet in height. With these Foster intended to sell 'An Italian Landscape' attributed to Turner and described in equally flowery terms. Charles Constable viewed the pictures on 14 June in company with his brother Lionel: 'Went with Lar to Foster's', he noted in his diary, '& saw 3 pictures each 6 feet long said to be by my Father but they were all forgeries'. Others who viewed the works told George Redford, art sales correspondent of *The Times*, that Foster's room 'had an unusually strong smell of varnish. Suspicions were immediately aroused on coming before the pictures attributed to Constable. The Turner was under glass, but the Constables were not, and this led to more than one person feeling the lumps of paint, and discovering that they were soft'.[22] Charles and others spoke to Foster, who agreed to cancel the sale. Charles then wrote the following letter to *The Times*, where it was published on 22 June 1869 under the heading 'CAUTION TO PICTURE COLLECTORS':

> Sir, – I went among many others to see three large paintings, each six feet long, which were advertised for sale by auction at Messrs. Foster's gallery on the 16th inst., and called in the catalogue 'Magnificent pictures by John Constable, R.A.'
>
> I think the public are greatly indebted to Messrs. Foster for declining to sell these pictures after the doubts expressed by myself and others. It now occurs to me that I might do a little good if I warned those wishing to purchase a Constable that there are a greater number of imitations about than usual. For one genuine picture offered for sale there are six sham ones. I have seen them at auctions, at dealers, and in the houses of gentlemen who have been imposed upon, and I have come to the conclusion that there is a manufactory for them somewhere. They are nearly always made up from the mezzotinto engravings by David Lucas from my father's pictures. But these imitators seem not to know that Constable's works are each known to artists and admirers, and are catalogued, and cannot be repeated without detection, notwithstanding the variations artfully introduced; moreover, it has not occurred to them that Constable could draw, and was also a colourist.

Charles's claim that his father's works were all catalogued can only be described as a bluff. The first attempt at a proper listing was not made until 1902, in an appendix to Charles Holmes's book on the artist, and there must have been

a good number of genuine works which even Charles Golding Constable had never seen.

George Redford quotes some doggerel verse which circulated at the time of the Foster sale but the only clue it seems to offer to the identity of the forger is that he was originally a marine painter and that he was employed by 'a man from across the sea'.[23] M. H. Spielmann, writing of the episode in 1904, said rather unhelpfully that 'it would not be difficult to give the name of the clever painter (a painter of original talent, curiously enough, in this case)' who was responsible 'but he is dead now, and no one ever cared to challenge him on a charge which was openly talked of and universally believed. In the artistic circle it has been no secret for many a year'.[24] The pictures themselves were destroyed in a fire at the Pantechnicon warehouse on 13 February 1874. Fortunately, a letter from Charles to Minna Constable has survived which tells us the name of the painter. From Felixstowe on 30 September 1870 Charles wrote:

> I met John Absolon the water colour artist, who does pretty pictures of figures in sunny landscapes, I was talking to him about those great forgeries which Forster declined to sell you remember, he told me that they were painted by James Webb. James Webbs studio would be a queer place to visit*

Captain Constable went into action again in 1874 when he spied a number of fakes in the International Exhibition held at South Kensington. In the Fine Arts section four artists had been singled out for special treatment – Wilkie, Constable, Roberts and Egg – but they were, said a reviewer in the *Art Journal*, 'so feebly represented that we are compelled to pronounce the effort a misrepresentation to those who have little or no knowledge of what these artists have produced. . . . Probably Constable is the worst represented as regards the quality of the works exhibited'.[25] Charles appears to have hoped that his friend the journalist Tom Taylor would comment on the Constables in *The Times* but, as Taylor explained in a letter to Charles on 16 July, 'The reason why I did not write anything upon the "sham" Constables, is that I was not asked by the Editor of the Times to take up the pictures of the International Exhibition, & in the Times it is always (entre nous) correct to *not* volunteer, but to be content with doing the work assigned one. I have learnt this by long experience. Any protest from you against the forgeries which discredit your father's name ought to & will command attention . . . Write directly to the Times'. This Charles did on 3 August, enclosing, as Taylor advised, a covering letter to the subeditor William Stebbing. The latter replied by return that he was 'particularly pleased to aid in rescuing the reputation of an Artist whom I so much honour as your Father from having to support the burden of spurious pictures'. Charles's letter appeared on 4 August under the heading 'BORROWED PLUMES':

* For Webb, see pp. 241–3.

Sir, — At a recent meeting of the Council of the Society of Arts it was resolved to consider the desirability of holding International Exhibitions of Art in the various manufacturing centres of the kingdom.

I am inclined to suggest that some system might be adopted to prevent, as far as possible, spurious works from being received into these Exhibitions. I make this remark as I am suffering from the discredit and injustice done to my father's reputation as an artist from seeing numerous pictures now being exhibited in the London International Exhibition wrongly attributed to John Constable, R.A. I consider it, therefore, my duty to point out the 'shams,' 16 in number, described in the catalogue as follows:— Fortytwo, 'The Embarcation of George IV. from Whitehall on the occasion of his opening Waterloobridge;' 52, 'Effect of a passing shower;' 55, 'River Scene;' 59, 'Young Waltonians;' 91, 'Hartlepool;' 92, 'Dedham;' 96, 'View of Birkenhead;' 107, 'The Chimneypiece in the Councilchamber of the Palais de Justice at Bruges;' 134, 'The Horse Farm;' 160, 'Landscape;' 172, 'The Water Mill;' 176, 'The Valley of Stour;' 185, 'Brighton Beach;' 190, 'A Dell in Helminghampark;' 194, 'Landscape, with church;' 207, 'Landscape, with church.'

Charles's letter provoked further correspondence, most of which has been overlooked by modern commentators. On 13 August *The Times* published a letter from a Mr J. W. Barnes of Durham, who wrote to defend the attribution of the *Helmingham Dell*, No. 190 in the exhibition. 'This picture or sketch', he wrote, 'now the property of Sir Henry Thompson, was purchased as an undoubted Constable in 1839, by the late William Bewick for Mr. William Davison, of Hartlepool, in whose possession it remained until recently'. Barnes cites a letter published in Bewick's *Life and Letters* in which Bewick told Davison, 'You were lucky to get hold of the sketch of Constable's, and in a frame it will be delightful'.[26] Barnes does not give the date of the letter, which in fact is 23 November 1845: the reference is therefore not easily reconcilable with the picture's supposed purchase in 1839. Barnes also suggests that at the time Bewick acquired the picture there could not have been 'the least motive for making a factitious Constable, since the originals realized comparatively little' and that nobody but Constable could have painted a picture which is 'almost identical' to Lucas's print of *Helmingham Dell*. But, as we have seen, there was already a considerable trade in fake Constables by 1845 and Lucas's prints were much used as a source. Without further knowledge of the painting itself, it seems quite likely that Captain Constable was right to doubt the work.

On 18 August *The Times* confused the issue when it published information received from the owner of another version of the *Helmingham Dell*, Colonel E. W. Scovell, who had sent in details of the impeccable provenance of his picture, now in the Johnson Collection at the Philadelphia Museum of Art (pl. 32). The newspaper misattributed this provenance to the work lent to the International Exhibition by Sir Henry Thompson, with the result that Captain Constable has ever since been blamed for doubting a perfectly genuine work by his father. Far from writing to *The Times* to meet 'the unwarranted aspersion

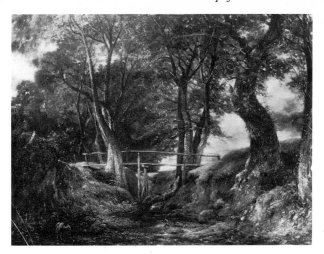

32 *Helmingham Dell*, 1825–6; oil, 27⅞ × 36 (70.8 × 91.5). Misattributed to F. W. Watts during Constable's lifetime (see p. 209) and the subject of further confusion in 1874.

on his picture' (as R. B. Beckett put it),[27] Col. Scovell was probably trying to lend support to Captain Constable's original complaint. A further notice of information received from Scovell appeared on 20 August. In this he was quoted as saying that the picture 'is now in the room whence I write (Blackwater, Hants)'. *The Times* did not spell out its mistake but this second note clearly indicated that Scovell was not talking about the picture on loan to the International Exhibition.

If Captain Constable's judgement of the 1874 exhibits is to be doubted, it must be in connection with quite another work, as the following letter from its owner, Wynn Ellis, makes clear. The letter appeared in *The Times* on 31 August.

Sir, I beg you will allow me a small space in your valuable paper respecting another of the 'Borrowed Plumes' at the International Exhibition.

The picture No. 134, erroneously called in the catalogue 'Horse Farm,' instead of 'Home Farm,' was purchased by me at the sale of the pictures of Mr. G. Morant in the year 1832. Shortly after this purchase Mr. T. Boaden Brown, the dealer, asked me to accompany him to call on Mr. Constable, R.A. My recent purchase was soon talked over. Mr. Constable, remarking that the picture was always much valued by him, and taking me into his studio, showed me a much larger picture, in every respect the same subject, and expressed his desire to give the larger one for mine; I told him that I had so placed the picture in the country (where it has always remained) that I preferred to retain it.

Mr. Brown was intimate with Mr. Constable and frequently saw him, and Mr. Constable again and again pressed upon him to effect, if possible, an exchange of the pictures, thus showing his appreciation and attachment for the work. Mr. Brown is fortunately alive, and, though from a local affection unable to leave his room, is in possession of all his faculties, and can confirm all that I have stated.

Being allowed to examine the painting (still at the Exhibition), I find on the back

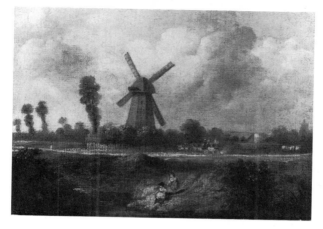

33 Formerly attributed to John Constable, *Barnes Common*, oil, $9\frac{7}{8} \times 13\frac{7}{8}$ (25.1 × 35.2). Bought for the National Gallery as a Constable in 1879 for £37 16s.; now discredited.

of it the name of 'G. Morant, Esq.;' also Mr. Phillip's sale number 44,2282, and further, in Mr. Constable's handwriting, 'The Glebe Farm, J. Constable, A.R.A.' Mr. Constable was made R.A. in 1829, so the picture was painted before that year.

Messrs. Phillips have kindly referred to their books, and state that the painting was bought by me at the sale of Mr. G. Morant's pictures in May, 1832, as lot 44, and called 'A View at Dedham, Essex,' painted for the proprietor. Further proof is not needed.

The three other pictures of mine condemned with the 14 have, I fear, been relined and cleaned, so that, all dates and marks being effaced, I may be unable to prove their truthfulness, as in the case of No. 134; but I have shown that Captain Constable does not know his father's best and, by himself, most valued productions, and is not competent to designate 'shams' 14 pictures which have been sent, not for sale or verification, but for the amusement and gratification of visitors to the Exhibition.

Wynn Ellis was right about his *Glebe Farm.** We know from other sources that Constable sold the first version of the picture to George Morant at the British Institution in 1827, and that a larger version had been painted by the time of the visit to Constable's studio described in Wynn Ellis's letter. This larger version, now in the Tate Gallery (pl. 13), was the one Minna owned and which she lent to the RA winter exhibition in 1871. It was also the one Lucas had engraved for *English Landscape.* Charles obviously had no idea that his father had painted an earlier version. There is no evidence, however, that he made other mistakes on this occasion. Two of Wynn Ellis's remaining three exhibits, 'Hartlepool' and 'View of Birkenhead', were almost certainly wrong, since Constable is not known to have visited either of these places. The same is true of the picture lent by the Duke of Westminster, the positively outlandish 'Chimney-piece in the Council-chamber of the Palais de Justice at Bruges'.

* Possibly the picture now in the Detroit Institute of Arts; the identification is discussed in Parris 1981, under No. 37.

Charles Constable's warnings did little to stem the flow of doubtful paintings. His diaries show that from 1874 to 1878 he saw at least eighteen pictures which he considered shams, apart from the International Exhibition items. At the Munro of Novar sale on 6 April 1878 there were, he noted, '3 J. Constables so called. Lots No 12, 13, and 14   No 12 Stratford S$^t$. Mary Suffolk 12 in. by 19., sold for £325 that was a sham. No 13 Hampstead Heath 12 in by 19 in sold for £483. It was a nice little picture and I should think that half of it was my Fathers work. No. 14 "Ploughing" 10 in by 14 in £304..10..0 This was a very bad copy of the "Spring" [the Lucas mezzotint after Constable] and was not worth 5 shillings'.

Charles Golding Constable died suddenly on 18 March 1879, before the 1879 auction season got into its stride. It would have been worth having his view of the large *Stoke-by-Nayland*[28] sold for £777 from Jonathan Nield's collection on 3 May and now at Chicago – a picture still debated by some scholars. And Charles would surely have had something to say about *Barnes Common* (pl. 33) and *A Cornfield with Figures*,[29] which were bought for the National Gallery at the Anderdon sale on 30 May. The first 'Constables' that the Gallery actually purchased, both were in fact falsely ascribed and were to prove very misleading. But Charles had remained on watch until the end. 'After he retired', wrote his son Hugh, 'he was greatly disliked by certain people for perpetually exposing shams. He died during the time he was the principle witness in exposing ⟨one of the⟩ a case where a large picture had been sold as a Constable by a Celebrated dealer'.[30] No other member of the family took on Charles's role of watch-dog. By making extensive gifts to the national collections, however, his sister Isabel was to find a more permanent way of protecting their father's reputation.

— *CHAPTER SIX* —

# DIVISION AND DISPERSAL

[1879–1900]

CHARLES GOLDING CONSTABLE's death, to be followed within a few years by those of Minna, Lionel and Isabel, initiated the last major phase of the division and dispersal of the family collection. Between 1879 and 1899 more than 500 oils and 1,000 drawings and watercolours left the family, a massive unloading that helped both to create and to satisfy an increasing demand for Constable's work, but one that also introduced problems of a sort that had not been encountered before.

In his Will,[1] made on 8 March 1875, Charles requested his two Trustees, his brother-in-law Joseph Wagstaff Blundell and William Caton Thompson, to 'take and keep a note . . . of the names of any of my children on the back or any part of the pictures and to each childs share shall the pictures . . . belong'. Unmarked pictures and drawings were to be divided among the children by the Trustees themselves and the works were to be handed over on the coming of age or marriage of the children. The Will was proved on 5 May 1879, Charles's personal estate being sworn as 'under £16,000', but was then contested, for reasons which remain unclear, by Benson Blundell (Charles's father-in-law) on behalf of the children: Clifford, Ella, Hugh, Cyril and Eustace. Judgement was given for the defendants, Charles's Trustees, in the Chancery Division of the High Court on 31 July 1880:[2] by this judgement the trusts of the Will were to be performed, though various enquiries about the estate were also directed to be carried out. It seems possible that Charles never actually got round to inscribing the names of his children on the pictures (certainly, the authors have never seen such inscriptions) and that this had something to do with the litigation.

As Charles's children were all minors at the date of his death, the pictures stayed together for the time being in any case. His widow Anna offered them as a loan to the South Kensington Museum in March 1880 and one of the Museum officials noted[3] that they would probably remain there during the minority of Captain Constable's children. Before accepting the loan the Museum took advice from one of C. R. Leslie's sons, George Dunlop Leslie, RA, who confessed that he had not seen Captain Constable's collection for a long time

[81]

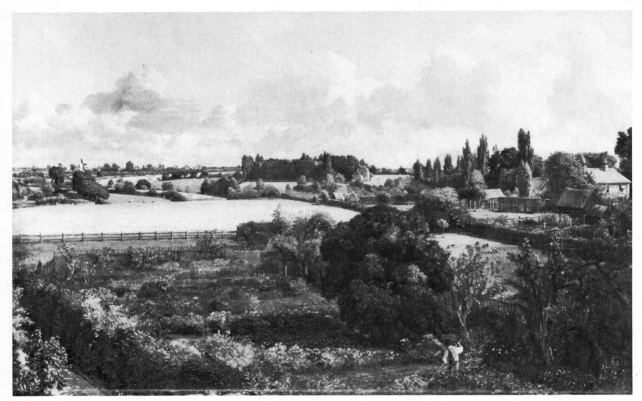

34 *Golding Constable's Kitchen Garden,* 1815; oil, 13 × 20 (33 × 50.8). This kind of early, closely observed work was not generally known or appreciated until comparatively recently.

'as we did not like his wife' but who said that there was no doubt that the 'pictures & sketches are all perfectly genuine & If I recollect very fine' and that 'some of the marine water colour sketches of coasts at Suffolk & Brighton with fishing boats are perhaps the finest things Constable ever did in my estimation & very little known to the public'. The works, duly collected by the Museum on 6 April 1880, comprised fifty oils, including a portrait of Constable by R. R. Reinagle, eighty-one watercolours and drawings and a box of '38 sketches and small engravings': at her request, this box was returned to Mrs Constable on 10 January 1882. The oils included a handful of finished paintings (among them the pair now at Ipswich of the gardens of East Bergholt House – see pl. 34 – and a Hampstead Heath painting dated 1830, probably the one now at Glasgow[4]), but were mainly small studies, with a strong showing of Brighton and other marine subjects and also of cloud studies. Brighton and Folkestone subjects were also well represented among the watercolours and drawings. As we have seen, Captain Constable had always regarded his father's sea paintings and drawings as peculiarly his own and most of them had fallen to him in the 1847–8 division of the family collection.

Mrs Constable's loan to the South Kensington Museum was the largest collection of Constable's oil studies and drawings yet seen in public but it is difficult

to find evidence that it was much noticed. Even at this late date it would seem that the French sometimes paid more attention to Constable than his compatriots did. It was probably Mrs Constable's loan that Ernest Chesneau had in mind when he wrote of Constable in his *La Peinture anglaise* (1882; first English edition 1884): 'His style is rich and impetuous. His studies, exhibited at the South Kensington Museum, give the impression of an energetic brain and impulsive execution. He is a poet whose nature is roused to ecstasy by stormy elements; although not blind to tranquil beauty, it is life and movement which stir the depths of his soul'.[5]

The loan to South Kensington came to a premature end following a visit by Mrs Constable to the Museum on the evening of Saturday 6 January 1883, apparently her first visit since the works were hung. Mrs Constable complained, quite without justice it would seem, that she had been promised a separate room for her exhibits, that a separate catalogue of them had also been promised and that the frames had been damaged. She said that if she did not receive a letter by seven o'clock the following Monday saying that these matters would be put right, she would withdraw the pictures. Similar complaints followed in a letter on 17 January, when Mrs Constable also expressed her 'utter disgust' at finding that 'two shams' had been hung with her pictures. An internal memorandum identifies these as two works lent by the collector J. C. Robinson, formerly superintendent of the South Kensington art collections and by this time Surveyor of the Queen's Pictures. By May 1883 a solution acceptable to all parties had been found: the collection would be transferred to the Edinburgh Museum of Science and Art (now The Royal Scottish Museum). Mrs Constable and F. J. A. White, whom she referred to as her secretary, spent two evenings sorting the items in June, when it emerged that twenty-nine of the oils and fourteen of the drawings were Mrs Constable's personal property.[6] 'I found M^rs Constable a very difficult lady to deal with', noted the official who attended these sessions. The Edinburgh loan commenced on 3 July 1883. Most of the items remained there until 27 June 1887. Those noted as Mrs Constable's own property, however, were returned to her on 27 October 1886, probably following her second marriage that year to Edward Ashcroft.[7]

The works returned from Edinburgh in 1887 were all auctioned at Christie's on 11 July that year as the property of the late Captain Constable and were sold 'pursuant to an Order of the High Court of Justice' arising out of the 1880 litigation mentioned earlier. That the works were sold rather than divided among the children (two of whom had now come of age) again suggests that Captain Constable never made the specific bequests he had planned and also that the Trustees felt unable to make a division themselves. The twenty-one oil paintings and studies in the sale fetched sums ranging from ten guineas for an 1822 cloud study (now apparently a marketable sort of work) to an exceptional £1050 for the 1830 *Hampstead Heath*. The comparatively early, closely observed views of Golding Constable's gardens (see pl. 34), not the sort of Constables

in general favour at this time, made only £52 10s and £48 6s. The buyers were predominantly dealers but two of Captain Constable's children purchased a watercolour each: Hugh a Brighton scene for £15 15s. and Clifford the *Netley Abbey by Moonlight* which is now in the Tate Gallery,[8] for £21 10s. 6d. Altogether there were sixty-seven drawings and watercolours in the sale. A further sale on 23 June 1890 appears to have consisted largely, perhaps entirely, of those items from Captain Constable's collection which had become the property of his widow, Mrs Ashcroft, who had died in 1889.

Some of the works sold in July 1887 were soon on view again, in an impressive *Loan Exhibition of Works by Gainsborough, Constable, and Old Suffolk Artists* held at Ipswich Art Gallery in October that year.[9] At the July sale Agnew had bought extensively for Cuthbert Quilter, wealthy businessman, art collector and MP for the Sudbury division of Suffolk. Among his acquisitions at this sale and shown again at Ipswich were the two views of Golding Constable's gardens, *West End Fields, Hampstead*,[10] the larger of the two versions of the double portrait of Ann and Mary Constable[11] and Reinagle's portrait of Constable, as well as several drawings. Another major contributor to the exhibition was Sir (as he had now become) John Robinson, two of whose Constables had provoked Mrs Constable in 1883. Robinson lent at least twenty-two items, apparently mainly drawings. The exhibition also included a few loans from Isabel Constable, *Gillingham Mill* from Louis Fry,[12] Woolner's so-called *View near Highgate* (which we met in the 1872 RA Winter Exhibition) and many others. Altogether, at least forty-seven works by, or attributed to, Constable were shown.

Sometime after their brother Charles's death, and certainly by 1885, Minna, Lionel (pl. 35) and Isabel moved from Cunningham Place to a larger house in nearby Hamilton Terrace, presumably to provide a home for Charles's children. An article published in the *Spectator* after Isabel's death in 1888 gives a charming if not entirely accurate picture of the last years of the trio.

35 Lionel Constable

> In Hamilton Terrace the sisters and brother spent a few quiet years surrounded by their pictures, pets, and flowers, and although growing more and more retired in their habits, giving a welcome to a few old and intimate friends. With compassion for every form of suffering, the Constables were very pitiful to animals; their house was a refuge for the destitute, in the shape of neglected birds, hunted cats, and strayed dogs . . . It was a sad break-up of the little party when, three years ago, Lionel's wife, who had long been ailing, died after a short, sharp attack of illness; and the shock brought on Lionel – who had a slight attack of paralysis after the sudden death of his brother Charles – a second and more severe stroke. From that time he became a confirmed invalid, and died on the eve of the Jubilee. This youngest of the Constables could never make much use of his considerable share of artistic talent, from the state of his eyes; one having been destroyed in boyhood from the blow of a stone, the sight of the other was rendered so precarious, that he was advised to work it with great caution; but he did paint and photograph a little for amusement. Very fond of and indulgent to children, Lionel Constable was regarded as a sort

of good genius by his niece and nephews, and there must be others who remember the delight of going out with their kind friend 'La,' . . .[13]

As is now known, Lionel in fact made considerable use of his artistic talent as a young man, though by the 1880s he may have been disinclined to talk much about his work; his sight seems unlikely to have been quite so impaired as the article suggests. No other reference is known to Lionel having married and there may have been a confusion in the writer's mind with the death of Minna, which had in fact occurred about 'three years ago', on 17 April 1885.

Minna's estate, valued at £10,183 10s. 3d., passed to Isabel and Lionel. In turn, Lionel, who died on 20 June 1887, left his estate (valued at £9654 9s. 8d.) to Isabel, apart from bequests of £100 each to his niece, his nephews and a few others. Included in his estate were freehold properties at Felixstowe and East Bergholt and the lease of No. 18 Waterton Street, Harrow Road.[14] After Lionel's death, therefore, what remained of the family collection was concentrated in Isabel's hands.

According to the *Spectator* article, Minna, Lionel and Isabel agreed during their last years together that 'the most important examples' of their father's work 'should eventually become national property'.* As we have seen, there were at this time two institutions describing themselves as national collections of British art, the National Gallery and the South Kensington Museum. Isabel may not have felt entirely sympathetic towards the former. Her nephew Hugh said that she had asked the Director of the National Gallery, Sir Frederick Burton, to remove the two spurious Constables that had been bought in 1879 – *Barnes Common* (pl. 33) and *A Cornfield with Figures* – but that he refused.[15] If Isabel was rebuffed in this way, she apparently bore the Gallery no grudge when she came to distribute her collection. Possibly Henry Vaughan's gift to the National Gallery of *The Hay-Wain* in 1886 helped to restore her faith in that institution as a suitable repository for her father's work. At any rate, it appears to have been to the National Gallery that she made her first approach. Writing to Sir Frederick Burton on 18 October 1887,[16] she offered to present *Hampstead Heath with the House called 'The Salt Box'*,[17] *East Bergholt House*[18] and *Hampstead Heath with Harrow in the Distance* (pl. 36). The offer was accepted. When the pictures were sent to the Gallery shortly afterwards, Isabel added to them one of the palettes her father had used.[19] Three more paintings were offered and accepted the following year, 1888: *Gillingham Bridge, Dorset*;[20] Constable's earliest surviving exhibition picture, *The Church Porch, East Bergholt* (pl. 37); and *Admiral's House, Hampstead* (pl. 139). These six were nearly all finished paintings. The bulk of Isabel's collection, however, consisted of oil sketches and drawings and these

* However, Lionel made no bequests to the nation in his Will. Had Isabel predeceased him, the residue of his estate would have passed in the first instance to his nephew Clifford, according to a codicil Lionel made to his Will on 28 November 1885.

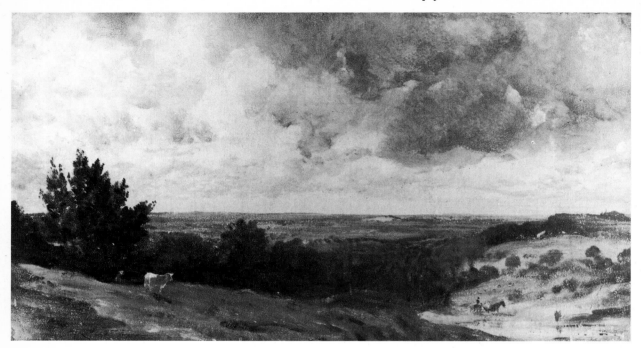

36 *Hampstead Heath with Harrow in the Distance*, c. 1820–22; oil, $6\frac{11}{16} \times 12\frac{5}{16}$ (17 × 31.3). In 1891 this was the most frequently copied modern painting in the National Gallery, beating Landseer's *Dignity and Impudence* into second place.

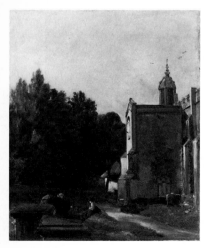

37 *The Church Porch, East Bergholt*, exh. 1810; oil, $17\frac{1}{2} \times 14\frac{1}{8}$ (44.5 × 35.9)

she appears to have thought more suited to the South Kensington Museum. The Museum had always had an educational bias and may have seemed to Isabel the most appropriate home for works that revealed Constable's methods of study rather than his public face. Isabel's friendship with one of the Museum's two Assistant Directors, R. A. Thompson, may also have played a part in her decision to present so large a collection to South Kensington. The 'Landscape Sketches' which she offered the Museum, in a letter to Thompson on 29 December 1887, amounted to ninety-two oils, 295 drawings and watercolours and three sketchbooks; a few miscellaneous items were also offered, including Daniel Gardner's portrait of Constable and some prints, letters and books.[21] This magnificent collection ranged over the whole of Constable's working life, with oil studies dating from 1802 to the 1830s and drawings and watercolours from 1796 to 1836. There were one or two imbalances but generally speaking it was a remarkably even spread of Constable's more private work.

Isabel's gifts continued in 1888. In February she gave forty-five drawings and watercolours to the British Museum. The same year the Royal Academy received fifteen oil studies, mainly of Hampstead and Brighton subjects. The Academy already had Constable's Diploma picture, the horizontal version of *The Lock* (pl. 6), and was to receive a still more important gift in 1889 when Mrs Dawkins presented *The Leaping Horse* (pl. 23). In May 1888 Isabel made a Will[22] in which she left five more paintings to the National Gallery and an additional three paintings and two watercolours to the South Kensington Museum. These

bequests, which took effect on her death on 13 August that year, comprised the most important works in her collection and she asked that they be described as the gift of Minna and Lionel as well as herself. To the National Gallery went *Scene on a Navigable River (Flatford Mill)* (pl. 12), *The Cenotaph*,[23] *The Glebe Farm* (pl. 13), *Hampstead Heath with a Rainbow*[24] and *Harwich Lighthouse*.[25] The South Kensington Museum received *Trees at Hampstead*,[26] *Cottage in a Corn-field* (pl. 61) and *A Watermill at Gillingham, Dorset*[27] and the two major water-colours *Old Sarum*[28] and *Stonehenge*.[29]

Isabel's gifts and bequests had a dramatic effect on the extent of her father's representation in the national collections. The National Gallery's Constable collection rose from three paintings (discounting the two mistakes of 1879) to fourteen, the South Kensington Museum's from six paintings and five drawings* to ninety-eight paintings, 300 drawings and three sketchbooks, and the British Museum's from ten to fifty-five drawings. Perhaps more importantly, the character of Constable's representation changed. The majority of the paintings given to South Kensington were studies and sketches. Previously these had not been represented at all in the national collections, which had examples only of Constable's public work, the pictures he painted for exhibition and sale. Constable's work in watercolour and pencil was now also represented for the first time in all its variety.

Almost immediately the new material began to have an effect on Constable's reputation. Until 1893 the *Annual Report of the Director of the National Gallery* published figures for the number of paintings copied in the Gallery. In the decade preceding Isabel's benefactions Constable usually came about halfway down the list of modern artists most frequently copied, with between three and six copies being made annually from *The Cornfield* (pl. 8) and fewer from *The Valley Farm* (pl. 26). Following Isabel's gift of six new works in 1887–8, Constable rose rapidly up the list. Although the total number of copies of modern paintings made in 1888 in any case showed an increase on previous years, one of Isabel's pictures, a little study of *Hampstead Heath with Harrow in the Distance* (pl. 36), achieved equal fourth place in the league that year, being copied no less than thirteen times, a figure only surpassed by three works by Landseer. *Hampstead Heath with Harrow in the Distance* was the smallest and sketchiest of the paintings Isabel gave to the National Gallery and in this, no doubt, lay its especial attraction at this stage in the development of Constable's reputation. For comparison, *The Cornfield* was copied ten times in 1888, *The Valley Farm* nine times and *The Hay-Wain* eight times, while nine copies were made of Isabel's *Gillingham Bridge* and seven of her *Admiral's House, Hampstead*. The following year, 1889, *Hampstead Heath with Harrow in the Distance* was copied sixteen times and rose to second

* As well as the four academy studies given by the Revd R. C. Lathom Browne in 1873 (see p. 71), the Museum had acquired a sepia drawing called 'Stoke-by-Nayland' (Reynolds 1973, No. 331); this was purchased from Hogarth & Sons in 1876.

place behind Landseer's *Dignity and Impudence*[30] (18 copies). Isabel's *Harwich Lighthouse* appeared on the list for the first time with fourteen copies and another twelve were made of *Gillingham Bridge*. The latter work was the most frequently copied Constable in 1890 (eleven times) but the Harrow sketch was back at the top in 1891, when the sixteen copies taken from it made it the most copied modern picture of the year, beating even *Dignity and Impudence* into second place.

Isabel had requested that the works she gave to South Kensington should not be copied, but critical enthusiasm for this part of her gift — composed, as we have said, mainly of Constable's oil studies and sketches — was not lacking. To the critic of the *Standard* the 'large series of this really great man's studies, shown to-day, and henceforth, at South Kensington, are, for purposes of estimate and inquiry, the complement of what is at the National Gallery':

> It is possible to see now, not only a few — a very few — of his most deliberate and ordered efforts — Constable *en grand tenue,* so to say — but to appreciate the variety, such as it was, of his moods, and to be sure what it was that he chiefly cared for, and how it was that he pourtrayed it . . . . And though it is not likely that South Kensington can show anything so complete as the 'Hay Wain,' vividness, force, decisiveness will never go any further than in the comparatively small pictures of 'Salisbury Cathedral,'[31] standing like oxydised silver amidst the greenery of the trees of the Close, and of the pageantry that attended the opening, by King George IV, of Waterloo Bridge.[32] Modern taste is extremely in favour of such studies 'from the life,' faithful and brilliant transcripts of the thing of the moment — Nature caught in the very act.

But the writer also thought that Isabel's gift to South Kensington would act as a corrective to those 'would-be connoisseurs and the younger students' who tended to assign to Constable 'undue importance, by exaggerating the range, if not precisely the height, of his attainment'.

> If a person wishes to be considered very advanced in his taste in Music, the god of his idolatry, in this present year, has, of necessity, to be Brahms. The qualified in Literature, as much in Chicago as in Cambridge, must swear by Mr. Browning. And, in Art, the intelligent young painter, fresh from Parisian studios, is apt, while falling foul of everything else that is English, to be absolutely hysterical in his admiration of Constable.[33]

If the *Standard* critic was correct in his assessment, Constable's reputation had been running ahead of actual knowledge of his work, a phenomenon we discussed earlier in this story when talking of the influence enjoyed by Leslie's biography of the artist.

P. G. Hamerton, whose conversion to Constable in the 1860s was noted in Chapter 3, surveyed the new works at South Kensington, the British Museum and the Royal Academy in an illustrated article in the *Portfolio* in 1890. Like the critic of the *Standard*, he found that Constable's sketches made a particular appeal to contemporary taste; this he attributed to an increased public awareness

of the processes of art. Only ten years before, Mrs Heaton, in her continuation of Cunningham's *Lives*, had expressed the view that 'Constable's art, in truth, will always have more value for the student, than for the general observer, who will be apt to be offended at its somewhat careless dash in execution, and its little attention to detail'.[34] Hamerton could now be more sanguine:

> Of late years . . . the conditions of artistic study have come to be more generally understood. The public has been brought much nearer to artists, it is much better informed and more intelligent about artistic matters than it was when Constable worked from nature. The reproduction of sketches by photographic processes, and especially the revival of etching, have taught people what to look for in rapid work, and what it is unreasonable to expect.[35]

The francophilia noted by the *Standard* critic had also long been a factor in Hamerton's expectations of Constable. Impressed in the 1860s by Constable's influence on French painting, Hamerton now tended to see Constable almost as a French artist:

> These oil studies remind one of French *pochades*, and, in fact, almost all Constable's sketches have a French air; the reason being, not that Constable imitated foreign art, for he was British to the backbone, but because he is the father of genuine nature-study amongst French landscape painters, and they have been led into his ways of study, which have now become almost universal amongst them.[36]

The sort of French painting English critics had in mind when they looked at the 'new' Constables is not altogether clear. Although he was certainly familiar with Impressionism by this time, Hamerton mentions only the earlier Barbizon painter Diaz in his 1890 article. Specific comparisons between Constable's sketches and Impressionist landscapes appear to date only from about 1900.

As well as her gifts and bequests to the nation, Isabel Constable made a number of specific personal bequests of works by her father:[37] eight oils went to her nephew Clifford, fourteen to Hugh (together with five watercolours and drawings) and seven to her niece Ella. Sir Bradford Leslie, second son of C. R. Leslie, also received an oil by Constable, as did Isabel's executor Francis Stephen Clayton. Sister Mary (Marie Catherine Le Coq) of the Convent of Bon Secours, Haverstock Hill, Hampstead, who had nursed Lionel at the end of his life, was given an oil sketch by Constable and 'some by Lar', i.e. Lionel. On the back of the work by John Constable, a study of poplar trees by a river, Isabel wrote of Sister Mary, 'I believe She was sent as a ray of light to me — may Our Heavenly Father reward her'.[38] Some gifts were made by Isabel before she died. Her friends R. A. Thompson, of the South Kensington Museum, and Alice Fenwick received several especially fine oil studies.[39] Mrs Fenwick's '*Stoke-by-Nayland*' of 1816 is illustrated as our frontispiece.

Even after these personal gifts and bequests, Isabel's collection was still an impressive size. A selection of the residue of her pictures was included in the

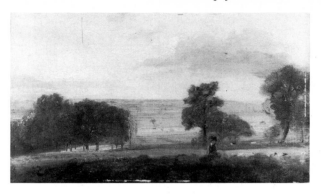

38 *Dedham Vale with a Shepherd*, 1812;
oil, $5\frac{7}{8} \times 9\frac{7}{8}$ (14.9 × 25.1). A work
published for the first time in 1983.

Grosvenor Gallery's exhibition *A Century of British Art (Second Series) from 1737
to 1837* in 1889. On view were eighty-nine oil sketches lent by Isabel's executor
(though apparently including a few already mentioned among the specific
bequests in her will), two more lent by Mrs Fenwick and a further two by
J. W. Knight. Elsewhere in the exhibition were examples of Constable's more
finished work lent from other sources, including the Morrison *Lock* (pl. 22),
the 1826 *Gillingham Mill*[40] and one of the versions of *Yarmouth Jetty*.[41] The cor-
responding Grosvenor Gallery exhibition of the previous year, 1888, had included
the finished version of *Hadleigh Castle* (pl. 16), the *Arundel Mill and Castle* (pl.
1) which Holbrook Gaskell had bought from Charles Golding Constable, Ash-
ton's *Salisbury Cathedral from the Meadows* (pl. 9) and the 1828 *Dedham Vale*
which is now at Edinburgh.[42]

Most of the works from Isabel's collection which were shown at the Grosvenor
Gallery in 1889 went to auction at Christie's in 1891 and 1892, together with
other examples which had not been exhibited. Forty-one oils were offered on
28 May 1891. Although described in the catalogue as having been 'Exhibited
at the Grosvenor Gallery, 1889, as the Property of Miss Isabel Constable,
deceased', they were in fact offered for sale, Christie's records show, by one E.
Colquhoun. This was Ernest Alfred Colquhoun (1851/2–1930), a friend of
Isabel's and sometime Manager of the Legal and General Life Assurance Society.
It is not clear whether he was acting on behalf of Isabel's heirs or had actually
purchased the collection from them. If he was not in fact the owner of the works
offered for sale, he soon became the possessor of nineteen of them, which were
bought either in his own name or that of 'Bourne'. A number of these, which
included some of the more expensive items, are still with his descendants and
remain comparatively unknown. Among them is a delightful little study of Ded-
ham Vale dated 21 October 1812 (plate 38) and a very fine cloud study of
6 September 1822. The other buyers were mainly dealers: Wigzell, Colnaghi,
Shepherd, Gooden and others. Prices, ranging from 5s. to just over £500, were
low, no doubt because of the quantity of material on offer. There was considerable
variation in price for small landscape sketches, an early Flatford Lock study

making £105[43] but only £8 10s. being bid for the now well-known *A Lane near East Bergholt with a Man Resting* of 1809.[44]

The second sale of works exhibited at the Grosvenor Gallery, with a large admixture of works not shown on that occasion, took place at Christie's on 17 June 1892. This time E. A. Colquhoun was not involved. Over ninety oils were offered, many in lots of two or three. In addition, there were about 230 drawings and watercolours and a huge collection of prints. Shepherd, Dow-deswell, Leggatt, Agnew, Gooden and Boussod were among the dealers bidding for the oils, which again fetched modest sums from a few shillings up to £472 10s. for a 12 × 19 inch 'Hampstead Heath, looking towards London' which Lionel had lent to the RA Old Masters exhibition in 1878. Agnew's paid £81 18s. for a small study now called *Harnham Ridge from Archdeacon Fisher's House, Salisbury,*[45] which they sold the following year to the National Gallery of Ireland; this was the first Constable acquired by the Dublin gallery. The drawings and watercolours ranged from copies after Raphael made in 1795 to watercolours of the 1830s. The artist and collector Charles Fairfax Murray bought extensively in this part of the sale and later gave many of his purchases to the Fitzwilliam Museum, Cambridge. Prices for drawings and watercolours were more often in shillings than pounds. Comparatively high prices were paid, however, for early proofs of Lucas's large mezzotints: £42, for example, for a *Salisbury Cathedral*[46] and £39 13s. for a *Vale of Dedham*.[47]

These two sales of the residue of Isabel's collection gave dealers a good oppor-tunity to stock up with examples of Constable's smaller works at very reasonable prices. Dowdeswell, for one, was able to show large groups of Constable oils in his *Early English Masters* exhibitions in 1891, 1892 and 1893. His December 1892 show included thirty-one works by or attributed to Constable, many of which had come from Isabel's sale earlier that year, while the *Art Journal* reckoned his 1893 collection 'one of the most interesting little exhibitions which has been held in London for a long time. There are several Constables, quite delightful in character and, although not important in size, charming in quality'.[48] Because there was now a taste for his small, informal pieces and a good supply of them, Constable became collectable in a way that had not really been possible before. During the 1890s and early 1900s several extensive collections of his smaller works were assembled, sometimes by men who also collected in other fields where the artefacts were small in size, 'charming in quality' and available in some num-bers. The doyen of such collectors was George Salting (1835–1909), who in 1865 inherited a fortune estimated at £30,000 a year, his father having owned sugar estates and sheep farms in Australia. Salting was an omnivorous collector, buying oriental ceramics, English miniatures, Italian bronzes, jewellery and much else besides paintings. His rooms in St James's, said the dealer J. H. Duveen, resembled 'an overcrowded antique shop'.[49] Charles Holmes recalled visiting him there one winter morning:

Salting had not yet got up, but he insisted on my climbing, boots and all, on to the very bed in which he was lying, so that I might look closely at a Constable which hung above it, near Crome's marvellous *Moonrise on the Yare*. Finally he rose, a strange figure with his long gray beard and crumpled nightgown, to show me some particular treasure. I feared the old gentleman would catch cold, so insisted upon retiring to the sitting-room till he had splashed in his saucer-bath, and got some clothes on. When he had done the honours of the things visible, he proceeded to reveal things hidden. Plunging into a drawer full of collars and handkerchiefs he pulled out a paper parcel. It contained a magnificent necklace which he hastily popped back, to rummage again until he found underneath the ivory which he wanted.[50]

Although Constable was only one of Salting's many interests, he bought, and often resold, a good number of examples, usually through Agnew's. Twenty-eight paintings attributed to Constable were included in an exhibition of the Salting collection mounted by that firm in 1910 and from these the National Gallery chose fifteen under the terms of Salting's bequest to the nation. One of Salting's earliest and most important acquisitions in this field was the superb 1809 *Malvern Hall* (pl. 30) which he bought at the Anderdon sale in 1879. Most of his Constables, however, were acquired in the 1890s or early 1900s and several can be traced to the family sales of the period.

The wealthy American lawyer John G. Johnson (1841–1917) also counted Constable among his many collecting interests. Like Salting, he was buying small oils by the artist in the 1890s and early 1900s, his first Constable acquisition being an 1810 study of the Stour at Flatford[51] which he bought in 1891 soon after it appeared in the Isabel Constable sale of that year. His main interest during this period was early Italian and Flemish painting but his Constables often have that 'peculiar imaginative intensity and intimacy' which his friend Roger Fry, writing of two early Flemish works acquired by Johnson in 1907, found to be 'the real note' of his collection.[52] Twenty-two oils by or attributed to Constable were among the works Johnson left to his native Philadelphia on his death in 1917 and which are housed today in the John G. Johnson Collection at the Philadelphia Museum of Art. Others who formed extensive collections of Constable's smaller works at this time were James Staats Forbes, the railway manager and uncle of the painter Stanhope Forbes, and Alexander Young, both of whose collections were acquired by Agnew's, in 1905 and 1906 respectively. In 1903 Forbes was said to own fifty-nine works by Constable.[53]

Several of Constable's major canvases came to auction in the mid-1890s and went to collectors whose interest in the artist was perhaps less obsessive. Richard Hemming sold *The White Horse* (pl. 5) at Christie's on 28 April 1894 for £6510. It was bought by Agnew's, who sold it to the American banker J. Pierpont Morgan. C. F. Huth sold *Stratford Mill* (pl. 2) on 6 July 1895 for a record £8925. Agnew's were again the buyers and the picture went to another banker, Sir Samuel Montagu. The new American interest in Constable, exemplified in different ways by Johnson's and Morgan's purchases, grew rapidly. As we

shall see in a later chapter, by the early years of the twentieth century British collectors were finding difficulty in competing for the more important items that came up for sale. In the meantime, however, a fresh supply of smaller works was becoming available and to this we must now turn.

# THE THIRD GENERATION

## [1890–1900]

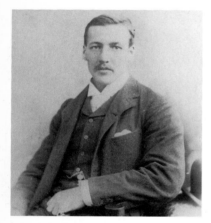

39 Clifford Constable

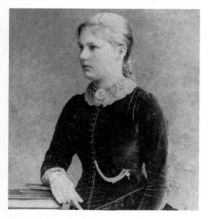

40 Ella Constable

IN the 1890s Constable's grandchildren began to add to the considerable number of works by the artist which had come onto the market since the death of their father, Charles Golding Constable, in 1879. The five surviving children of Charles's marriage to Anna Blundell had been made wards of court on their mother's remarriage in 1886. Their aunts Minna and Isabel Constable and Harriet Blundell were appointed guardians, together with a Revd Kidd. For a few years (and probably from before the time of the remarriage) Minna, Isabel and Lionel's house in Hamilton Terrace became the children's home when they were in London. The eldest, Clifford (1864–1904, pl. 39) went to naval schools at New Cross and Southsea but failed to get into Dartmouth because of bad eyesight. Instead he trained in the Thames Nautical Training College ship *Worcester* off Greenhithe and then served in the merchant navy, chiefly in Indian waters, reaching the rank of 1st officer. He married Constance Helder and had a son, Lionel Golding (1890–1974).[1] Ella Nafeeseh (1865–1934, pl. 40) was educated in London, Margate, Rugeley and Berlin, where she was offered a post as drawing-mistress. Her brother Hugh described her as a fairly good watercolourist and a good linguist and said that her interests included botany, stamps and photography. In 1888 she married Ivan Bailie Alister Mackinnon and spent some years in India where Mackinnon was in the Hooghly Pilot Service. Hugh Golding (1868–1949, pl. 41), who played the largest role in dispersing what remained of the family collection, went to schools in Margate and London and trained as an engineer at Crewe (1885–9). In the words of his son, 'He made a special study of naval history, designed and built several boats, and travelled all over the world painting, mostly seascapes'.[2] His early travels included a voyage to South America in 1885 with his uncle Joseph Blundell and a world tour shortly before his marriage in 1892 to Elinor May Bomford. The couple made their home in Ireland until 1921 or 1922 and both of them exhibited at the Royal Hibernian Academy. They had two children, Arrahenua Ella (1893–1966), born in New Zealand, and John Hugh (1896–1974). Charles's third son, Cyril Benson (1870–1905, pl. 42) was educated at Ipswich, Bloxham School, Banbury

and the Royal Naval School, New Cross. He then entered the merchant navy, ending up as a 4th officer. Hugh Constable described him as a 'Fisherman Carpenter. & Remarkable romancer'.[3] He is said to have disgraced himself by marrying a stationmaster's daughter at Gravesend. The youngest son, Charles Eustace (1874–99, pl. 43) was educated at Margate, Langley near Maidstone and at Laxton School, Oundle. He was an officer in Her Majesty's Submarine-Mining Militia Service and in 1896 served as a trooper in the Matabele War under the British South African Company. He died in New Zealand from wounds received in this war.

41 Hugh Constable

All five children inherited works by John Constable, mostly small oils, drawings and prints, from their father or from their aunt Isabel. By 1900 the greater part of this inheritance had been sold. Ella made an abortive attempt to sell some of the pictures she had been given to the National Gallery in December 1888 but was told, reasonably enough, that 'as there are now 16 examples of Constable in the Collection the latest additions being those generously bequeathed by your late Aunt, Sir Fred. Burton does not feel disposed to add to the number by purchase'.[4] The main transactions of the 1890s can be summarised as follows. A large collection of *English Landscape* prints belonging to Clifford Constable was included in the first of the two Isabel Constable sales at Christie's on 28 May 1891. Six oils, over a hundred drawings and watercolours and another large group of prints were sold anonymously at Christie's on 30 November 1892 by F. J. A. White, whom we saw acting as Anna Constable's secretary in 1883; presumably he was now acting for one or more of the grandchildren. Nineteen oils inherited by Clifford from Isabel were sold at Christie's on 23 June 1894 together with five belonging to Cyril. Eustace sold sixty-nine oils and about 200 drawings (including a sketchbook) at Christie's on 16 April 1896. Sometime in the 1890s Ella sold a number of works (probably forty-six oils and twelve drawings) through Leggatt's to Henry Newson-Smith, whose son sold them at Christie's in 1951.

42 Cyril Constable

The family sales of the 1890s reached a spectacular climax when Hugh and Clifford sold a large collection of paintings and drawings to Leggatt's in 1899. These were shown in an historic exhibition mounted by the firm in their Cornhill gallery in November that year with the title *Pictures & Water-Colour Drawings by John Constable, R.A.* Although it came more than sixty years after the artist's death, Leggatt's exhibition was the first to be devoted solely – or so it then seemed – to Constable's work and it aroused considerable interest. The market for small oil paintings and sketches was now firmly established and could stand even this large influx of fresh examples – ninety-eight oils and 112 watercolours and drawings. About seventy per cent of the exhibits were reported to have been sold on the opening day.[5] As *The Times* reviewer observed, 'with the increasing admiration for his pictures there has arisen a strong demand for these slighter efforts'. The *Daily Telegraph* critic enthused over Leggatt's 'large and exceedingly interesting collection of the great master's sketches in oils . . . . One never tires

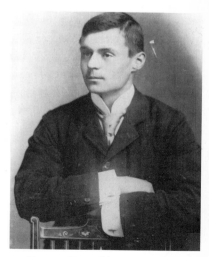

43 Eustace Constable

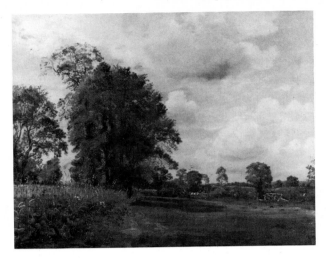

44 Lionel Constable, '*Near Stoke-by-Nayland*', oil, 14 × 17½ (35.6 × 44.5). Before 1978, a work considered by many to be central to an understanding of the art of John Constable.

of these wonderfully fresh and vivid notes'. Some observers were struck by what the *Manchester Guardian* called 'the variety of manner which marks the exhibits'. In fact, one of the surprises of the show, said the *Guardian* writer, was 'its constant suggestiveness of the styles of other men'; Linnell, Stark, Creswick and Corot were names that came to his mind. To the *Daily Mail* reviewer, familiar only with Constable's 'thunder-clouds and rain', it was 'a genuine surprise to find, among this most interesting collection, peeps of brilliant blue skies, of sunlit landscape, and of gay colours'.

Some of this variety, we now know, was due to the unsuspected inclusion in the exhibition of paintings by Lionel Constable and possibly by other hands as well. The following paintings by Lionel, some of which do indeed have 'brilliant blue skies', can be identified among the exhibits: Nos 5 and 67, two versions of *A Bridge on the Mole* (pl. 136, and ex-Carstairs Collection); Nos 66 and 52, two paintings of views said to be near Keswick (Yale Center for British Art;[6] the other known only from description); No. 62, '*On the Stour*';[7] No. 71, '*Cottage on the Stour, Flatford*';[8] and No. 40, which is probably the Tate Gallery's '*Near Stoke-by-Nayland*' (pl. 44). Other paintings now identified as by Lionel were shown, though their catalogue numbers have not been established. Of the remaining exhibits which can still be identified, some do not appear to be by either John or Lionel. An example is 'Brighton Downs', No. 64 in the 1899 exhibition, which could only be catalogued as 'Constable' when it reappeared at Sotheby's on 14 November 1976. One painting, larger than the others, was singled out for special treatment in the catalogue of the exhibition: No. 1, 'Hampstead, Stormy Noon'. This can be identified as the Branch Hill pond composition in the McFadden Collection at the Philadelphia Museum of Art,[9] a painting that at best seems only partly the work of a Constable.

Other works by Lionel changed hands under his father's name at this time.

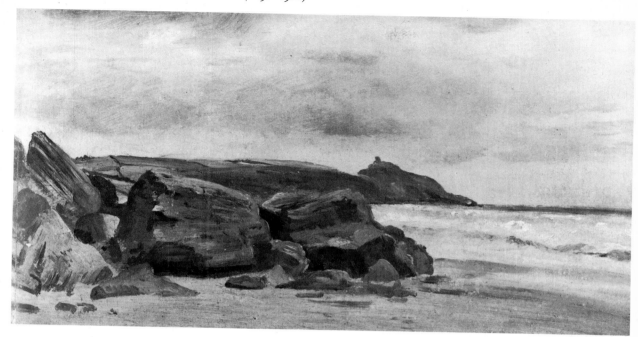

45 Lionel Constable, *Rame Head, Cornwall*, 1850; oil, $7\frac{1}{16} \times 13$ (18 × 33). Attribution of this sketch to Lionel was assisted by the identification of the subject as a headland in Cornwall, a county never visited by John Constable.

There were at least two paintings by him in the group mentioned above as having been sold by Ella to Henry Newson-Smith: *An Old Barn*[10] and an oil study of the '*Near Stoke-by-Nayland*' subject now in a private collection. A number of small sky studies in the same group may also be by one of the Constable children. Newson-Smith was sold at least one drawing by Lionel, again of the '*Near Stoke-by-Nayland*' composition.[11] Sometime before his death in 1904, Clifford Constable sold Lionel's *The Way to the Farm*[12] to Leggatt's, as their label on the back records. Hugh Constable appears to have disposed of several Lionels in 1905. *Rame Head, Cornwall* (pl. 45) and *An Ash Tree* (pl. 46) bear his handwritten labels, dated 22 November 1905, describing them as works by John Constable which he had inherited from Isabel. *On the Sid near Sidmouth* (pl. 47) at one time carried a similar label, this time naming Ella as an intermediate owner.

The fact that such works had come direct from the Constable family was seen as a guarantee that they were the authentic productions of John Constable. Besides this, it was thought they looked right. The items in Leggatt's exhibition were given specially printed labels recording their purchase by the firm from one or other of the grandchildren, the actual name being inserted by hand. But, as the critic of the *Morning Post* wrote on that occasion, 'The pictures bespeak their own authenticity, and do not need the additional credential implied in the fact that they were purchased from Constable's family'. The possibility that other members of the family had produced works which might have been confused with John Constable's was inconceivable at this time.

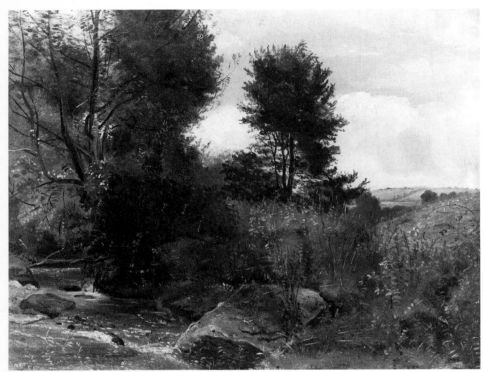

47  Lionel Constable, *On the Sid near Sidmouth*, *c.* 1852; oil, $9\frac{3}{8} \times 12$ (23.8 × 30.5). A painting with many examples of Lionel Constable's characteristic brushwork.

46  Lionel Constable, *An Ash Tree*, oil, $15\frac{1}{2} \times 11\frac{3}{4}$ (39.4 × 29.9)

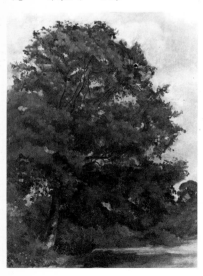

To what extent were Hugh, Clifford, Ella and their younger brothers aware of the true situation? During the 1880s, as we have said, they looked on No. 64 Hamilton Terrace as their home and Ella actually lived there with her aunt Isabel for a few years. The house was liberally hung with examples of their grandfather's painting but none of them appears to have taken much interest in their artistic inheritance until they needed to sell things after Isabel's death to finance their own careers, travels and marriages. They may have been completely unfamiliar with Lionel's work. He had after all, given up painting in the 1850s and does not seem to have talked about his work at the end of his life. His pictures probably lay parcelled up with his father's smaller works, the majority of which were still unframed at this time. We do know, however, that Isabel could distinguish between her father's work and Lionel's and that she knew where to lay her hands on examples of the latter: it will be remembered that she bequeathed paintings by Lionel to his nurse, Sister Mary; Isabel's will is annotated to show that these were in fact given in her lifetime. But such knowledge may have died with Isabel. A reasonable case could be made out for Constable's grandchildren simply being unable to tell what was what amidst the huge residue of Isabel's estate.

[98]

On the whole, this appears the correct explanation. There is, however, a document in the family collection which shows that it is not the entire story. Entitled 'Rambling "Tales of Grandpapa" just as they happen to come into my head', this is a miscellaneous collection of reminiscences put together by Hugh Constable in the early 1930s.[13] It includes an account of a visit he paid with his son to the 1933–4 winter exhibition of the Burlington Fine Arts Club. In this we hear of the dubious activities of the dealer Joseph Cahn.

> 5th Jan 1934 I went with John to the private view of the 'English School' at the R.A. but before that I was at the Fine Arts Club where they had a show mostly Constables lent by Sir M. Sadler and T. W. Bacon. Small things. unimportant but interesting . . . 7 I noticed as by Lionel or as utterly 'Wrong Uns' several were entered as having belonged to me    I only recognised one N.º 41 a study of a large tree. I always considered it a Lionel (the branches at the top for instance were so like Lionel) but I suppose I fell to a good offer by Joe Cahn or was tired (I was up the whole night going over sketches with him at Monaloo C.º Cork. as he wanted to get a train soon after breakfast)    I see Cahn's influence (who is dead) and another dealer (Myers) near Bond Street, who may be alive. In all these ⟨sales⟩ J.C. shows. Salting had several Lionels sold to him. These 2 dealers got a lot of Lionels & Alfreds paintings mainly from Clifford Ella & Cyril who knew very little about J.C. and anyhow we were all very young.

It appears to have been in 1905 and in London rather than Ireland that Hugh sold the picture that became No. 41 in the 1933–4 exhibition. This, the 'study of a large tree', can be identified as Lionel's *An Ash Tree* now at the Yale Center for British Art (pl. 46), which has the following label on the back describing it as a work by John Constable:

>         this Study of                                    measuring
>           A large tree. hedge & part of field  15½ × 12 [. . .]″
>                                         by J. Constable R.A.
>     was inherited by me from my aunt Miss Isabel
>     Constable    daughter of the artists
>                                         Hugh Constable
>         London 22.11.1905          (Grandson of the artist)

A separate note by Hugh survives with further comments on the 1933–4 exhibits. Of the other works stated in the catalogue to have come from his collection, he thought that No. 3, *Morning – Clouds before the Sun*,[14] 'must be Toby', while against No. 18, *Approaching Night*,[15] he simply placed a question mark. He also noted as by Lionel No. 59, *Green Trees and Meadows*, which was said to have come from the collections of Charles Golding and Eustace Constable.

In his 1934 notes Hugh gives the impression that he was reasonably familiar with Lionel's style by the time he sold *An Ash Tree* in 1905 – he talks of the branches being 'so like Lionel'. One might suppose from this that other works

by Lionel which Hugh sold at this time, for example *Rame Head, Cornwall* (pl. 45), were knowingly so sold. But Hugh may have been writing with hindsight about these matters. By about 1930 he had undoubtedly developed powers of discrimination which he is unlikely to have possessed at the beginning of the century. Like his father, Charles, it was only in later life that Hugh devoted much thought to such questions.

What is certain is that the dealer Cahn put considerable pressure on Hugh to authenticate doubtful pictures obtained from other sources. Two letters survive from Hugh to his wife describing meetings with Cahn in London in April and July 1907. The first took place at the house of the painter and collector James Orrock in Bedford Square. Hugh was asked to vet a large painting of Flatford Lock which Cahn was selling to a German called Gossler and which Cahn and Orrock accepted but which the Constable expert Charles Holmes did not.

> I could taking it as a ⟨general⟩ whole say alright and particularly the middle [Hugh wrote to his wife on 12 April] but I dont like a few parts    that however is not what they want. If I saw it in a shop I should say a picture by J.C but foreground left unfinished and done up by someone else    however as I am no more certain one way than another I am saying I consider it alright.

On the second occasion, in July, Hugh was shown a *Branch Hill Pond, Hampstead Heath*, a large 'Young Anglers' (presumably a copy of *Stratford Mill*, pl. 2) and a large painting of trees and cattle. This time he refused to authenticate any of the works. Cahn had composed a letter about the 'Young Anglers' which Hugh considered

> might lead some to think I thought it quite right, and he said that he expected 3000 & on anything over 900 he got I was to get 5 p.c. & ⟨that⟩ he also infered that there would be no more jobs unless I came in    I said – give me your copy of letter & I will consider it and send you what I think I can honestly say but he tore it up. It really seemed to me an honest enough letter *in a way* but not wholly so & being jolly sick of the swine I came away.

The following day, Hugh was asked to write something about the Hampstead Heath picture.

> I wrote 5 different letters but because I said I was inclined to think it was real and formed this inclination by the light & shade & by touches in the colouring and would not effuse he said it was not an opinion at all. Then I tore every thing up & told him to shoot his £10.10 & stop thinking I was McKinnon    I saw ⟨of⟩ a letter of that particular swines to show he sold pictures – he got from his wife – to Cahn in 1904

This last date is heavily underlined in the original. Mackinnon, it will be recalled, was Ella's husband. It is not known which paintings he sold to Cahn in 1904.

Hugh himself was in touch with Cahn by 1899. Messrs Leggatt's own copy of the catalogue for their Constable exhibition of November that year has inserted in it a receipt showing that Cahn paid Hugh £1250 on 20 May 1899 for what was to become item No. 1 in the exhibition, the 'Hampstead, Stormy Noon' we have already discussed. The receipt was made out at Hugh's home at Monaloo in Ireland, perhaps on the occasion of that all-night session Hugh recalled in 1934. Quite what arrangement led to Cahn's painting being subsequently included in Leggatt's exhibition is not recorded. Of Cahn himself almost nothing is known. He is not listed in contemporary directories of art dealers. A family tradition that he was a German spy and was shot in the Tower of London during the First World War appears to be wishful thinking.

The paintings by Lionel Constable which Hugh and the other grandchildren sold around the turn of the century were rapidly absorbed into private collections, including those of Alexander Young, George Salting, Charles Gassiot, the American John G. Johnson, and, in Paris, Charles Sedelmeyer. By 1910 the Heinemann Gallery in Munich also had examples. When Salting left his pictures to the National Gallery in 1910, the nation unwittingly acquired its first examples of Lionel's work: 'Near Stoke-by-Nayland' (pl. 44) and *Leathes Water*.[16] In his 'Rambling Tales' Hugh Constable spoke also of Alfred's work, which even today remains largely unidentified.

> I have seen 2 – I think 3 – Constables in the Guildhall from the Salting Collection* which are by Lionel or Alfred Constable   They used Antwerp blue & treated briars in a different way to their father. My wife who has copied John, Alfred, & Lionel's pictures† so that it is nearly impossible to tell the originals knows each style directly but either the wonderful critics dont know or else something else.

Unfortunately, neither Hugh nor his wife chose to enlighten 'the wonderful critics'. With the exception of a small group of paintings in the family collection that somehow managed to preserve their true identity, Lionel's work remained concealed until the late 1970s; Alfred's, as we have said, is still a mystery.

But the 1890s Constable collector could – and often did – do far worse than add a few Lionels to his pack. There were plenty of pictures which had never been anywhere near the Constable family. Charles Holmes counted six imitations and one painting by F. W. Watts among the twenty-eight works attributed to Constable in Salting's collection when it was exhibited at Agnew's in 1910.

---

* There are no Constables from Salting's collection in the permanent collection of the Guildhall Art Gallery and none appears to have been temporarily exhibited there. Possibly Hugh wrote Guildhall in error for Tate Gallery. One of the two Constables given to the Guildhall by Charles Gassiot in 1902 is, however, now thought to be by Lionel (Tate Gallery 1982, No. 23).

† Two copies by Hugh's wife, Elinor May, of paintings by John are still in the family collection: one after a Branch Hill Pond composition and the other after the little *Elder Tree* presented to the Municipal Gallery of Modern Art, Dublin by the Princess of Wales in 1905 (Tate Gallery 1976, No. 189).

Two works accepted by Holmes on that occasion are rejected today and two more are the paintings by Lionel mentioned in the previous paragraph. A high proportion of John G. Johnson's Constables are no longer taken at face value. Holmes's comments on a group of James Staats Forbes's Constables, exhibited at the Grafton Gallery in 1905, suggest the variety of unauthentic and misattributed works available to collectors of the period. The seven works in question comprised, in Holmes's opinion, one wholly genuine Constable, one finished by another hand, a Wilcock or a Watts, a copy after Lucas, a James Webb, a 'poor imitation of Müller' and 'a modern sketch painted at least half a century after Constable's death'.[17]

Perhaps the most spectacular collection of unauthentic Constables formed at this time was that of James Orrock (1830–1913), whom we have already met in the company of Joseph Cahn. Orrock was originally a dentist but turned to collecting and dealing around 1866; he was also an artist himself. Although he made extensive collections of furniture and porcelain, British painting of the eighteenth and nineteenth centuries was his greatest interest and Constable his particular hero: 'It is his wont to say, "I am a Constable man"', wrote his biographer Byron Webber.[18] For Orrock, Constable was most true to himself in his late work and especially in the oil sketches in which he used the palette knife. In an essay in the *Art Journal* in 1895 Orrock rhapsodized over Constable's 'brilliant knife operations', his 'masculine and muscular' handling and his 'force, dash, and brilliancy'. Constable 'seemed born for a palette-knife painter', he wrote, and was 'only happy when he was carrying out his unconquerable idiosyncrasy'.[19] The metaphors Orrock used for Constable's late work – drawn from the fields of music, soldiering, athletics and electrical lighting as well as surgery – may have left his readers a little confused but there can have been no doubt about the personal commitment. As it happened, Orrock owned one of the best examples of Constable's late palette-knife painting, *Cottage at East Bergholt* (pl. 48), now in the Lady Lever Art Gallery, Port Sunlight, but most of his other Constables were hopelessly wrong. There were, after all, comparatively few genuine works of this sort available. Two of Orrock's examples were reproduced in colour in *Constable's Sketches in Oil and Water Colours* (1905) by his friend Sir James D. Linton, whose other plates, all black-and-white, were drawn exclusively from the Victoria and Albert and British Museum collections. It is intriguing that Orrock could see no essential difference between the *Cottage at East Bergholt* and the grotesque *Valley Farm* reproduced as Linton's frontispiece (pl. 49). Of the twenty-four oils and nine watercolours attributed to Constable in Orrock's sale at Christie's on 4–6 June 1904, Charles Holmes accepted without reservation only four oils. Of the general system of cataloguing employed by Orrock, he observed that 'the presence of a well-known name was in a good many cases only a general indication of authorship'.[20] About sixty works attributed to Constable were among the hundreds of paintings Orrock sold to the Lancashire soap king W. H. Lever, later Viscount Leverhulme. Practically

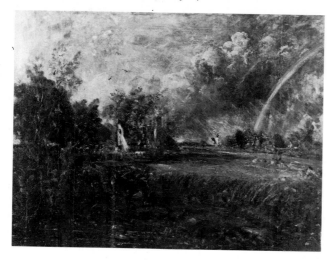

48 *Cottage at East Bergholt*, 1830s; oil, $34\frac{1}{2} \times 44$ (87.6 × 111.8)

all were disposed of as unauthentic by Leverhulme's executors after his death in 1925 or later by the Trustees of the gallery he founded at Port Sunlight.[21]

Ironically, it was Orrock's genuine *Cottage at East Bergholt*, together with a dubious version of *Salisbury Cathedral from the Bishop's Grounds* (lent by E. L. Raphael and now at Newcastle),[22] that one of C. R. Leslie's sons, G. D. Leslie, RA, chose to attack when it appeared in the Royal Academy winter exhibition of 1893. The *Athenaeum* of 14 January that year published a letter to an unnamed friend in which Leslie called Orrock's picture 'mere palette scrapings' and talked of its 'senseless and clumsy workmanship':

> Very early in life I was taught to appreciate the beauty and style of a Constable, and my father pointed out to me over and over again, when I was copying one of this master's pictures, the great characteristic of his occasionally rough execution, namely, that every bright dab of light or dark, though it might, at first sight, seem rough, invariably has *intention*, as well as exquisite emphasis and gradation, sharply contrasting at one part and melting in another. . . . No one knows better than yourself how numerous and impudent are the forgeries of 'Constables.' It is most significant that it is invariably his rougher style and deft touchings with the palette-knife which are imitated by the scoundrels who follow the audacious trade in question. Picture buyers are always ready to be imposed upon by those rude scrabbles of the coarser sort, perhaps the coarser the better, which are so rife nowadays.[23]

A sarcastic reply from Orrock appeared in the next but one issue of the paper, with a threat of legal action appended as a postscript:

> Mr. Leslie's condescension in explaining to the world of art the 'intention of Constable in his bright dabs of light or dark' is deeply instructive, especially to those landscape painters who may to some extent fancy they are in sympathy with that master's work. Let us hope, however, they may be pardoned if, even after such a

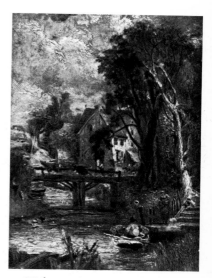

49 Unknown imitator of Constable, *The Valley Farm*; as reproduced in J. D. Linton, *Constable's Sketches . . .*, 1905. The publication by 'experts' of such crude imitations as the work of Constable did not make it easier for the public to distinguish the genuine article.

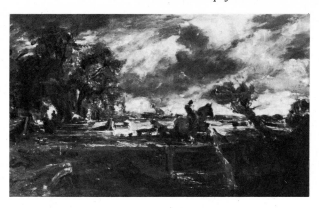

50 Robert Leslie after John Constable, *The Leaping Horse*, oil, $7\frac{1}{2} \times 11$ (19 × 28)

training as Mr. Leslie has had 'early in life,' some of them may fail to discover any traces in that artist's own schoolgirl pictures of that masculine manner which in Constable he so much 'appreciates'![24]

G. D. Leslie apologised but did not retract his opinion of the picture. His brother Robert kept up the attack on spurious Constables in his new edition of his father's *Life* which Chapman and Hall published in 1896. This was a handsomely produced edition, illustrated with reproductions of the Lucas mezzotints and of various paintings and drawings, including a copy by Robert Leslie of the *Leaping Horse* sketch (pl. 50).[25] Some new footnotes were added to the 1845 text, one of them giving an account of Alfred Constable's death. In his Introduction Robert Leslie looked back to his schooldays with Alfred and Lionel and recalled the 'many happy hours' he had spent among their father's works, with which he had become more intimate, he thought, than with his own father's pictures. Like his brother, he felt able to speak with authority on questions of authenticity.

> During the fifty years which elapsed between Constable's death (in 1837) and [Isabel's] bequest of his pictures to the nation, any work of his that chanced to change hands, at first slowly, but afterwards very rapidly, rose in value; and many imitations of his pictures have during this interval been sold, and even publicly exhibited. One marked feature of all these productions being founded upon the mistake, that in order to manufacture an authentic Constable, it was only needful to load so many square feet of old canvas with unmeaning dabs of paint, clumsily laid on with something like a small trowel.[26]

'I should not be surprised', Robert concluded, 'if the number of forgeries now greatly exceeded that of his genuine pictures'.[27]

Where, then, could collectors and others interested in Constable turn for reliable information on his work? Despite the justness of their general complaints about forgeries, Leslie's children were not infallible in particular cases. Nor could Constable's grandchildren, intent on selling the remains of the family collection,

be impartial in these matters. The literature had not kept pace with the market: Leslie's biography, still the most complete account of Constable available, had never been intended as the sort of detailed guide to the artist's works that was now required. The Constable collection at the Victoria and Albert Museum, comprehensive though it now was, had still to be arranged and catalogued in an instructive way. This was the state of affairs that faced Charles Holmes, some of whose opinions we have quoted in this chapter, when he was asked to write a small book on Constable in 1899 or 1900. By 1902 he had virtually established modern Constable studies.

# SCHOLARS AND COLLECTORS

## [ 1900–1930 ]

THE literature on Constable between the publication of Leslie's *Life* in 1843–5 and the end of the century had not amounted to much. The only book to appear on the artist during this period (apart from the new edition of the *Life* in 1896) was a slight volume coupling Gainsborough and Constable by George Brock-Arnold in 1881. Brock-Arnold's biographical account derived from Leslie while a brief chapter on Constable's works was mostly taken up with a discussion of Ruskin's attack on the artist. The eight wood-engraved illustrations include a memorable *Hadleigh Castle*, printed back to front and mis-titled 'Osmington, near Weymouth'.

During the same period there had been a number of articles on Constable as well as chapters on him in general books on English art. Some of the more interesting of these shorter pieces — by the Redgraves, Hamerton, Mrs Heaton and others — we have already quoted. Although these writers recognised Constable's importance as an innovator and acknowledged his influence on subsequent French painting, none of them had seriously attempted to place him in the history of art or, being chiefly interested in his late pictures, had examined the internal development of his work. With more immediate interests in play — whether getting back at Ruskin or using Constable to justify post-Pre-Raphaelite landscape styles — and with comparatively little of Constable's work on permanent display before 1888, these more measured approaches were hardly conceivable until towards the end of the century.

Charles John Holmes (1868–1936), who was to put the study of Constable on a new footing, spent most of the 1890s as a publisher's assistant, notably with Ricketts and Shannon's Vale Press. During this time he also taught himself to paint and took up art journalism. The success of his first book, a small volume on Hokusai (1899) published by the Unicorn Press in Laurence Binyon's *The Artist's Library*, led to him being asked to contribute a volume on Constable to the same series; this appeared in 1901. Holmes had evidently been interested in the artist for a few years before this. In his autobiography, *Self & Partners (Mostly Self)* (1936), he recalled sketching in the Stour Valley in 1894 or 1895,

trying to 'find good subjects which [Constable] had overlooked, and which I could therefore misuse without seeming to be a mere imitator'.[1] In the 1890s he also acquired one or two paintings in the sale-rooms attributed to Constable.

Holmes said in his autobiography that he devoted to his 1901 *Constable* 'an amount of time disproportionate to its length, visiting Constable's haunts, and making voluminous notes'.[2] The book is certainly short — forty-two pages of text and twenty-four illustrations — but it reveals an unusually thorough knowledge of the works by Constable then available as well as a firm belief in the need to understand their chronology. Most of Holmes's examples (and his illustrations) were taken from the Victoria and Albert Museum collection, which at this date was still displayed, he said, 'without any regard either for sequence or decorative effect'[3] and which had still only been catalogued on topographical lines. Holmes also referred to works in the National Gallery, Tate Gallery, British Museum, Royal Academy and a few private collections and to Constable's altarpieces in the churches of Brantham ('though it is not worth while going there to see it'[4]) and Nayland. For Constable's very earliest works he had to rely on what he had seen in Leggatt's exhibition in 1899.

The chronological sequence of Constable's work which Holmes outlined from these examples was remarkably accurate. It also drew attention to works or groups of works whose significance had not been recognised before, for example the Derbyshire drawings of 1801,[5] the 1802 *Dedham Vale*[6] and the Lake District watercolours of 1806.[7] Holmes was, however, misled by the two spurious paintings in the National Gallery (he used *Barnes Common*, pl. 33, to mark the end of Constable's first period) and by some of the things he had seen in Leggatt's exhibition, including Lionel Constable's mountain oil studies which he took to be the product of John's visit to the Lake District.

As well as sketching the course of Constable's development, Holmes attempted to place him in the history of landscape painting, concluding, perhaps rather too neatly, that Constable stood 'at the parting of the ways between the old masters and the moderns':

for he was the first to prove that a landscape might be a good picture, and also be really like nature. The aim of his great predecessors had been to make noble compositions, with just as much resemblance to nature as was convenient. The aim of his successors has been to get a sincere likeness to nature, while pictorial quality seems too often to be regarded as a subordinate matter.[8]

Holmes soon afterwards had an opportunity to expand his ideas on Constable's place in art and to make more use of the detailed information he had assembled on the artist's paintings and drawings. Laurence Binyon passed on to him a commission he had received to write a large work on Constable. The book Holmes produced, *Constable and his Influence on Landscape Painting* (1902), was to remain a standard work for over half a century. Its most lasting feature was

the 'Chronological List' of paintings, watercolours and drawings which appeared as an appendix. Holmes said of this that it was

> a mere foundation, but it has been carefully arranged to give as much help as possible to those who, having sketches or pictures of their own, would like to find out some-thing about them, by comparing them with other examples whose date is known. The List includes only two or three works which I have not personally examined during the last few years.[9]

The list omits undated watercolours and drawings made after 1806 but still manages to include over four hundred items. About twenty private collections are represented in addition to national and other public holdings. Some of the works seen by Holmes in Leggatt's exhibition in 1899 are listed, as are a few items which passed through the sale-rooms in 1902. Details of works exhibited by Constable, whether or not traced by Holmes, and of places visited by the artist are given under each year.

Holmes's list was a remarkable achievement for its time and was only super-seded in 1960 when Graham Reynolds's *Catalogue of the Constable Collection in the Victoria and Albert Museum* appeared. In this Reynolds paid tribute to Holmes's book as 'the only sustained attempt so far to suggest a chronological dating for Constable's work'.[10] Holmes's list is still useful today. Some of the works known to him have since been lost sight of and his brief comments on them are their only record. This is not the place to analyse the list in detail but it is worth noting that several major pictures were unknown to Holmes at this time, including the 1811 *Dedham Vale* (pl. 25) and *The Mill Stream* (pl. 51). Among later works which he knew only from engravings were *Chain Pier, Brighton*,[11] *Hadleigh Castle* (pl. 16) and *Arundel Mill and Castle* (pl. 1). He found, as have all his successors, especial difficulty in reconstructing Constable's early work, and his account of these years was confused by his acceptance of paintings by Lionel Constable and by other hands. It is interesting to see what Holmes made of Lionel's Lake District oil studies in the main text of his book. After writing of the watercolours and drawings John Constable made on his 1806 tour of the Lakes, Holmes says:

> He made a certain number of studies in oil, not very numerous, which differ so utterly from the drawings that they might well be mistaken, even by an expert, for the work of another hand. In these studies, whose thin, smooth, careful painting contrasts strongly with the broad sweeps of the brush in the water-colours, the real tones and hues of the yellow grass, the dark patches of pine-wood, the pale purples of the hill-sides, and the clear blue of the sky are rendered with remarkable truth. The effect is far less powerful than that of the water-colours, but almost makes up in sincerity (considering the period at which it was produced) for what it lacks in artistic force.[12]

Holmes was equally sensitive to the unusual character of other works which

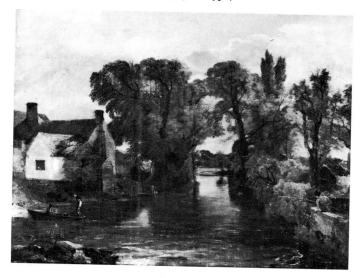

51 *The Mill Stream, c.* 1814; oil,
28 × 36 (71.1 × 91.5)

have since been identified as Lionel's, including *A Bridge on the Mole* (pl. 136),
which he found 'singularly modern-looking'.[13]

The main body of Holmes's 1902 volume consists of a survey of Constable's
life and work and of his place in the history of art. Unlike some previous writers
on Constable, Holmes was not primarily interested in the six-foot sketches or
the late works. He tried to give a balanced account of the whole of Constable's
output, finding the early works interesting for the 'alternation between tradition
and nature'[14] they revealed and the late works important because they anticipated
Impressionism. At this time, however, Holmes was unsure of the value of
Impressionism and had doubts about the merits of Constable's late works:

> there is undeniably a certain lack of sensitiveness for beauty of workmanship and
> material, for which additional brilliancy and contrast do not always compensate. In
> sketches such as Mr. Orrock's [*Cottage at East Bergholt*, pl. 48], that are frankly
> nothing more than sketches, the freedom of the handling has the charm of spontaneity
> to excuse it. In the case of works more deliberately executed, this line of defence
> has to be abandoned . . .[15]

For Holmes, Constable's best work was produced in the 1820s and his finest
achievement, 'a landmark between the art of the Past and the art of the Present',
was the finished version of *The Leaping Horse* (pl. 23), which perfectly combined
and balanced Constable's 'peculiar excellences'. It was fresh without being raw,
detail was suggested without being either scamped or too fully realised, the hand-
ling hit 'just the happy mean between force and shapeliness', with impasto still
clearly related to form, and the design was grand and truly inventive. In few
other works, Holmes thought, did Constable achieve such a balance. *The White
Horse* (pl. 5) and *The Hay-Wain* (pl. 3) were flawed for him because their designs
were 'too scattered'. Under Holmes's gaze *The Hay-Wain* falls to pieces. It is,

he says, 'merely an aggregate of circumstances which suggest pleasant summer weather'. It lacks emphasis and is not worthy of a six-foot canvas.

> This lack of proportion of thought to scale, this diverting of the attention by details that are really irrelevant, this tendency to all-round compromise, instead of concentrated emphasis on some single fact, explains why Constable is not a great designer.[16]

It is difficult not to feel that Constable is still being made to fight other people's battles. In *The Leaping Horse* Holmes's Constable seems to be steering the sort of mid course between tradition and modernity that Holmes aimed for in his own painting. Holmes's mountain and industrial landscapes are notable, too, for their emphatic designs and 'emphasis' is the key-note of the lectures he delivered at Oxford as Slade Professor of Fine Art from 1904 to 1910.[17]

We have called Holmes's 'Chronological List' the most lasting feature of his 1902 volume. Two other appendices to the book deserve mention. One contains a reprint of the catalogue of the Constable studio sale, the first time this important document had been made available since the sale itself in 1838. The other is a useful discussion of forgeries of Constable's work, concluding with some practical advice to collectors. Prospective buyers of very early or very late works, or replicas of engraved compositions, should consult an expert, Holmes says. Works purporting to be from Constable's mature years should be avoided if they include 'a definitely brown tree among green trees', if they are glazed all over with brown, if they have uniformly rounded clouds, if they are signed 'J.C.' or if they depict 'barges that are lop-sided, windmills that couldn't go round, or locks that couldn't be opened without causing a flood'.[18] Holmes was particularly interested in the question of forgery and at one time thought of writing a book on 'Forgers and Forgeries of the British School'. In his autobiography he recalls finding several signed works by James Webb in a private collection in Oxford which were identical in technique to imitations of Constable and Turner he had seen. Webb, it will be remembered, was the artist said to have been responsible for the imitation six-foot Constables which Foster's tried to auction in 1869. Holmes once offered five pounds for a Webb 'Constable' priced at ten pounds in a shop in Shaftesbury Avenue, 'saying that was enough for an imitation'. The shopkeeper replied that if he knew that, he ought to know that 'Jimmy Webb is worth eight pounds in the trade, any day'.[19]

Holmes's career after 1902 left him little time for further Constable studies. He was co-editor of the newly founded *Burlington Magazine* from 1903 to 1909, Slade Professor at Oxford from 1904 to 1910, an active painter (exhibiting at the New English Art Club), Director of the National Portrait Gallery from 1909 to 1916 and then Director of the National Gallery until 1928 (being knighted for his services in 1921). Nevertheless, he published several articles on Constable, including one in 1907 on the rediscovery of the 1811 *Dedham Vale* (pl. 25)[20] and another in 1908 on the lessons to be learned from a study of

the catalogues of the British Institution, which he had overlooked when writing his two books on Constable.[21] He also wrote the Introduction to a new edition of Leslie's *Life* published by Everyman's Library in 1912 and in 1921 published a short book on Constable's early drawings, to which we shall return later.

Holmes's volumes of 1901 and 1902 marked the beginning of a brief spate of works on Constable, five books appearing between 1903 and 1905. First in the field was Lord Windsor, who had been working independently of Holmes and who finished writing *John Constable R.A.* (1903) as Holmes's second volume appeared. The latter had been aimed at a limited audience. Only 350 copies were printed, though they apparently sold quickly, and the production was lavish, the book measuring a gigantic 15 × 12 × 3 inches and being illustrated with seventy-seven photogravures. Windsor produced a smaller and more popular work. His approach was biographical with extensive quotations from the artist's correspondence and only brief asides on selected pictures. In two concluding chapters Windsor discussed Constable's forerunners (not always relating them very clearly to Constable and including some unexpected names – Cotman, Cox and Müller, for instance) and gave an 'Appreciation' of the artist, partly in the words of Constable's French admirers and partly in reply to Ruskin's criticisms. Windsor seems to have had little to add himself. A painting in his own collection which he reproduces, entitled 'A Deserted Mill', appears to be the sort of pastiche of late Constable that Holmes and earlier writers had warned against and it makes one wonder just how closely he had looked at Constable's works. Where Windsor's book did break fresh ground, however, was in his publication of new documentary material. By purchase, he had become the owner of much of the correspondence Leslie had used when writing his *Life* – letters from Constable to Fisher, George Constable, Dunthorne, and others, and also letters to Constable from his family at Bergholt. While basing his account largely on Leslie, Windsor was therefore able to introduce unpublished letters and to quote more fully from some that Leslie had abbreviated or 'improved'. This was something of a sore point with Holmes, who regretted that he had not been able to add much to Leslie's narrative himself:

> A batch of Constable's letters indeed was offered to me, of which Leslie had made but little use, but the price asked was more than the whole payment I was to get from the publishers. I think Lord Plymouth [i.e. Windsor, as he then was] after-wards acquired them for his book on Constable. Judging from the single glance at them which I was allowed, these letters were very different in general tone from the polite extracts given by Leslie. Constable's outspoken and contemptuous com-ments upon his contemporaries not only helped to explain the tardiness of his acceptance by them, but would have infused some liveliness into my text.[22]

In addition, Windsor published for the first time some of the annotations David Lucas had made in his copy of Leslie's *Life*. He also reprinted the various texts that had accompanied the *English Landscape* prints and a number of contemporary

newspaper accounts of Constable, notably of the lectures he delivered at Worcester in 1835.

*John Constable* by Arthur Chamberlain, published in the same year of 1903, was a very modest affair, relying on Leslie for its biographical account and Holmes's 1902 book for its general opinion of Constable. Unusually, however, Chamberlain devoted one of his eight illustrations to a Constable portrait, *James Lloyd*.[23] M. Sturge Henderson's *Constable*, published in 1905 and re-issued in 1911, was a more detailed study but was again based largely on Leslie and Holmes and also on Lord Windsor's book. The illustrations included some of Constable's pencil drawings, which hardly make an appearance in other books of the period. Although disfigured, as we said in the previous chapter, by colour reproductions of two of Orrock's least happy acquisitions, Sir James Linton's *Constable's Sketches in Oil & Watercolours* (1905) provided the largest body of illustrations to date of Constable's less formal works: forty-seven oil sketches in the Victoria and Albert Museum and seventeen watercolours in the same collection and the British Museum; they were not, however, arranged with any regard for chronology.

The audience for whom these more popular books were intended could now also indulge its interest 'on the spot', and at the turn of the century we see the onset of a still flourishing rural industry, the pilgrimage to Flatford and 'the Constable Country'. Sturge Henderson tells us that Cook's added 'A Visit to Constable's Country' to their list of tours in 1893 and, he adds, 'the fact reveals the admiration entertained for the artist by our Continental and American visitors'.[24] The Great Eastern Railway Company also arranged tours of the area, with coaches meeting the London trains at Colchester. A booklet written for the Company by Percy Lindley, *A Drive through the Constable Country* (?1902), reassures the traveller that he 'need not be a collector – a single picture runs into thousands – or even an admirer of Constable'.[25] Admiration and some knowledge would seem to have been an advantage, however. At Flatford, says Lindley, 'you seem to recognise actual bits from his sketches and studies now at South Kensington. You recall one sketch* perhaps, in particular':

> You are looking at sundown from the edge of a cornfield, which drops into the hollow. The facing slope is in transparent shadow. The corn sheaves, and the tired workers going down the field path, cast long shadows over the stubble. A plough-man with his team follows the track under the hedge to the farm in the dip.
>
> It is the quiet close of the day. In the waning light Dedham Vale stretches far away, beyond the dark upland and the willows by the river, to the tower of Stoke, and the church and hill of Langham. As you recall the sketch, you seem to hear the contented caw from the dark line of rooks straggling home, and the lark's vesper song as it drops into the silence of the valley.[26]

---

* *Autumnal Sunset*, V & A (Reynolds 1973, No. 120), though Lindley is actually recalling David Lucas's mezzotint of the subject (Shirley 1930, No. 14), which differs in details

At the end of what has been a rather cosy outing, 'the brake meets the express which reaches town in nice time for dinner'.

> So closes a pleasant day in this cheerful Constable country, a country of cornfields and sloping river banks; of water-mills, old locks and still backwaters; of spacious valleys and sparkling distances of woods with gray church towers; and sunlight and shadow playing over all.[27]

Pilgrims who questioned the natives might feel themselves getting closer to the master. T. West Carnie tells us in his book *In Quaint East Anglia* (1899) that he interviewed a man outside East Bergholt church who 'was as communicative as he could be':

> His father used to grind the colours for Constable, and his uncle originally sat for the figure of the boy drinking water in the picture of 'The Cornfield.' 'You can just see the corner of the field through yonder, sir.' I asked if there were any of the master's works still in the village. 'Well, yes, sir, at the white house down the hill there there's one of the church; and I had one or two myself, but took no note of them.' 'What has become of them?' I asked. 'Well, sir, one I exchanged with a doctor for another picture, and one painted on tin the Misses Constable gave me a sovereign for when they came down here. You see, I set no value on them, and they had been lying among a heap of rubbish and old papers; and I think there's another somewhere about still, but, bless you, sir, I couldn't lay my hands on it if I tried ever so hard.'[28]

Although he had written about Constable as early as 1878 (see p. 73), Frederick Wedmore did not visit the Constable country until 1899. He related his journey (a sentimental pilgrimage on which he 'found Constable') the following year in the *Pall Mall Magazine* and again in the introduction to his book *Constable: Lucas: with a Descriptive Catalogue of the Prints they did between them* (1904). However, the main purpose of Wedmore's book, as its title indicates, was to provide a catalogue of David Lucas's mezzotints after Constable. There was a flourishing market for English mezzotints at this time and interest in these was consequently high. Holmes had written about them in *The Dome* in 1900[29] and in his 1901 book had described *English Landscape* as 'the most magnificent series of landscape mezzotints ever produced'.[30] E. E. Leggatt of Messrs Leggatt arranged a comprehensive exhibition of the prints at Gooden & Fox in 1903 and Wedmore published an article on them in the *Nineteenth Century* the same year.[31] In his 1904 volume Wedmore supplied the first detailed list of published states and some account of the trial proofs he had seen. There was now great competition for the latter – 'those transcripts summary and magnificent', Wedmore called them, 'for one or other of which a ten- or twenty-pound note may to-day be held, quite reasonably, to be an insufficient ransom'.[32] He foresaw that the comparatively neglected published states 'will have, henceforth, to be collected more seriously'[33] because of the rarity of proofs. Even in this limited and fairly well documented area, all was not quite what it seemed. Trial proofs

could not be faked but some of the published, lettered prints had been converted into 'unlettered proofs' either by leaving the lettering un-inked before printing or by erasing the lettering after printing.[34] And at least one of Lionel Constable's mezzotints had become confused with Lucas's work for his father: *A Shower*,[35] reproduced in Holmes's 1902 book and catalogued by Wedmore as his No. 44.

The quantity and variety of new Constable literature in the early years of the twentieth century suggests a quickening of interest at several levels, the extremes of which are oddly represented together in Wedmore's book on the prints. Museum collections of Constable's work were also expanding at this time. Henry Vaughan's bequest to the National Gallery in 1900 included twelve oils by or attributed to Constable, ranging in date from the 1809 *Epsom* sketch[36] to the unfinished *Glebe Farm* of about 1830[37] which had once belonged to Leslie. Only one of these works now seems at all doubtful – *Summer Afternoon, After a Shower*.[38] Vaughan also bequeathed to the Victoria and Albert Museum the two six-foot sketches, for *The Hay-Wain* and *The Leaping Horse* (plates 18–19), which had been on loan from him to the Museum since the 1860s. The fifteen oils selected for the National Gallery in 1910 from George Salting's bequest were a more mixed bunch, including (as we have said) two works by Lionel Constable and also two other paintings which no longer appear to be John's work. But when they were good, Salting's Constables were very good: *Salisbury Cathedral and Archdeacon Fisher's House from across the Avon*,[39] *Weymouth Bay*,[40] *Malvern Hall* (pl. 30) and the portrait of Maria Constable.[41] In addition, Salting left twelve drawings to the British Museum. With other recent gifts, the Museum's collection of drawings by Constable now stood at well over one hundred. In the same year, 1910, the Fitzwilliam Museum, Cambridge received from John Charrington an extensive collection of Lucas mezzotints formed by Sir Henry Theobald, together with correspondence between Constable and Lucas and a number of drawings. Paintings, not all genuine, were acquired by the Walker Art Gallery, Liverpool (1881 and 1892), Glasgow Museum and Art Gallery (1896), Bury Art Gallery (1901), the Municipal Gallery of Modern Art, Dublin (1905), Manchester City Art Gallery (1909) and by other public galleries.

Few British collectors, however, let alone galleries, could now afford the prices fetched at auction by Constable's more important works, which tended to go instead to American collections. The 1826 version of *Salisbury Cathedral from the Bishop's Grounds* (cf. pl. 14), sold by Stephen Holland on 25 June 1908, was bought by Knoedler for £8190 and sold to Henry Clay Frick.[42] Holbrook Gaskell's *Arundel Mill and Castle* (pl. 1) fetched £8820 on 24 June 1909 and went via Knoedler to Edward Drummond Libbey of Toledo, who gave it to the Toledo Museum of Art in 1925. Sir Frederick Mappin's large but rather odd *Stoke-by-Nayland*[43] – which we saw fetching a comparatively modest £777 in 1879 – made £9240, a new Constable record, on 17 June 1910 and was acquired then or later by Mr and Mrs W. W. Kimball of Chicago, who gave

it to the Art Institute of Chicago in 1922. By now Constable's prices were in the same league as Turner's, although very good Turners still fetched more: Holland's *Mortlake Terrace* and Gaskell's *The Burning of the Houses of Parliament* both made over £13,000.

Major Constables next appeared in the Beecham sale on 3 May 1917 and sooner or later (their histories are incomplete) also found their way into American collections: another version of *Salisbury Cathedral from the Bishop's Grounds*,[44] which made £6510, was in the collection of Edward Harkness by 1931 and was later bequeathed by Mary Stillman Harkness to the Metropolitan Museum, New York; the very late sketch *On the Stour*,[45] bought in at £6300 but offered again in 1918 and sold then for £4200, was bought by Duncan Phillips in 1926; the 1825 *Branch Hill Pond*,[46] sold for £2520, was later acquired by Mrs Weyerhaeuser of St Paul, Minnesota and ultimately went to the Virginia Museum of Fine Arts. The finished version of *Hadleigh Castle* (pl. 16) was apparently already in America when Holmes published his 1902 book, though its exact whereabouts was unknown.

When the City of Leeds Art Gallery mounted its *Loan Exhibition of Works by and after John Constable, R.A.* in October 1913, the Chairman of the Gallery Committee singled out such exports as the major problem the organisers had faced: 'so many important works by Constable have been exported to the United States during recent years', wrote Alderman Willey in his foreword to the catalogue, 'that comparatively few remain in private possession in this country'. Another problem had been the perennial one of fakes:

> Constable's landscapes have been extensively forged, and unfortunately these forgeries are to be found in several public galleries as well as in numerous private collections. It has been the first aim of the Committee to exclude from this Exhibition all doubtful pictures. . . .

The Leeds exhibition was the first loan exhibition ever to be devoted solely to Constable's works. The idea of mounting it had come from Professor Michael Sadler, educationist, collector of modern (i.e. post-Impressionist) art and at this time Vice-Chancellor of Leeds University. The organiser was another protagonist of modern art, the gallery's curator Frank Rutter. Charles Holmes lent his support and performed the opening ceremony. The result was an interesting mixture of works from Isabel Constable's gifts to the National Gallery (eight oils), from Sadler's own collection (twelve oils, nine watercolours and drawings) and from other public and private collections. With a large collection of Lucas mezzotints and other prints lent by E. E. Leggatt, the exhibits reached a total of 132 items. The aim of the exhibition, wrote Arthur Willey, was 'to illustrate both the development and the range' of Constable's art. Although Holmes said in his opening address that he was 'very glad to see that the promoters had included specimens of Constable's art from the time when he was a boy of twenty to the end of his life',[47] the coverage was actually rather patchy. Any 'development'

must have been difficult to grasp. The order of the exhibits appears to have been haphazard but even if rearranged according to the dates assigned them in the catalogue the exhibits would not have produced a very satisfactory idea of Constable's growth. Visitors were invited to believe, for example, that three years after painting *The Bridges Family*[48] in 1804, Constable produced *Brook, Trees and Meadows* (as it was then known) and that two years later, about 1809, he painted both *Dawn at East Bergholt*[49] and what is now called *Dedham from near Gun Hill, Langham*.[50] The first and last of these four, both now in the Tate Gallery, do seem to date from 1804 and circa 1810 respectively. The second work, however, is Lionel Constable's *On the Sid near Sidmouth* (pl. 47), probably painted in 1852, while the third, now at Anglesey Abbey, is generally thought today to date from about 1800. The omission of any landscapes of the period from about 1810 to 1817 can only have added to the mystery. Beginning with the *Flatford Mill* of 1817 (pl. 12), a reasonable sequence of works, largely borrowed from the National Gallery, was then shown: *Harwich Lighthouse*,[51] *Hampstead Heath with the House called 'The Salt Box'*,[52] the Royal Academy's *Leaping Horse* (pl. 23), two versions of *The Glebe Farm*, Ashton's *Salisbury Cathedral from the Meadows* (pl. 9), *Hampstead Heath with a Rainbow*[53] and *The Cenotaph*.[54] By this time it would have been difficult seriously to misrepresent such paintings — generally they were large works of Constable's mature and late years, which had always been comparatively well documented and which in most cases had been presented to the nation by Isabel Constable. But as we have seen, early works and undocumented small paintings and sketches presented considerable problems. At least five of the paintings Michael Sadler lent to the Leeds exhibition were by Lionel Constable and there were also some oddities in a group of small works borrowed from Dublin. However, the organisers appear to have been remarkably successful in keeping forgeries at bay. They also showed great initiative in putting on the show at all: no comparable exhibition was to be mounted until 1937.

The idea put forward in the Leeds catalogue that few important works by Constable remained in English private collections was not quite true. A considerable number of paintings, some of them major works, were still in English hands. The difficulty was in locating them or even knowing of their existence. Private collections were very incompletely represented in the list of works Charles Holmes had published in his 1902 volume. 'It was not easy', he recalled in his autobiography, 'for a totally unknown clerk to get access to pictures in private collections; and, as Sir Charles Tennant remarked when he showed me his treasures, "You are a very young man to be writing a book." '[55] Beginning his work on Constable at the end of the 1890s, Holmes had also come on the scene too late to keep track of the hundreds of works sold at auction, not least by the Constable family, during the boom period of the 1880s and 1890s. For one reason and another, therefore, Holmes's list omitted a considerable number of privately owned works, some of which were important: the 1811 *Dedham Vale* (pl. 25, which he caught

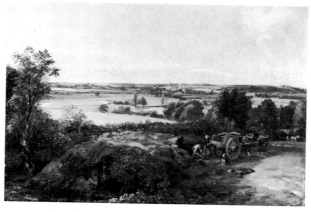

52 *The Stour Valley and Dedham Village,*
1814; oil, $21\frac{3}{4} \times 30\frac{3}{4}$ (55.3 × 78.1)

up with in 1907), *The Mill Stream* (pl. 51, Henry Yates Thompson from 1888 to 1941), the 1814 *Valley Farm*[56] (Arthur Sanderson until 1908), the 1814 *Ploughing Scene in Suffolk* (pl. 7, Miss Atkinson from 1891 to about 1941), the 1814–15 *Stour Valley and Dedham Village* (pl. 52, James McLean from about 1885/1900 onwards), the two paintings of Golding Constable's gardens (pl. 34, Cuthbert Quilter by 1903 and until 1936), the 1816 *Wivenhoe Park* (pl. 10, at Wivenhoe until about 1905), the 1817 *Cottage in a Cornfield* (pl. 60, Ionides family from about 1890 onwards: see pp. 137–8), the *Hampstead Heath*[57] of about 1820 which later went to the Fitzwilliam Museum (Walter Holland until 1915), and so on, up to *Chain Pier, Brighton*[58] (Sheepshanks family from 1838 to 1948) and the full-size sketch for *Hadleigh Castle* (pl. 17, Smith family from 1838 to 1930). These paintings reappeared in no particular order, some almost immediately but others not for a considerable time. Lesser works not mentioned by Holmes included many which were later to assume importance because, being firmly dated, they helped establish the chronology of Constable's development. Typically these lesser items were oil studies which had appeared in the family sales of the 1880s and 1890s and they generally took even longer to come into view again; indeed, they are still being rediscovered today.

The aspect of Constable's work chiefly affected by this comparative ignorance of works in private hands was his early development, up to about the year 1817. This was also the period that C. R. Leslie had known least about, and it was not one that other nineteenth-century writers and collectors had shown much interest in either. In 1866, it may be remembered, the Redgraves had described a Hampstead Heath picture of about 1820 as an early work and compared its 'minute and careful' handling to Pre-Raphaelite painting. Later, Orrock had talked of Constable's late years as his 'Constable-period',[59] as though all else was irrelevant. Writing of the 1810 *Church Porch, East Bergholt* (pl. 37) in the *Dome* in 1900, Holmes observed that 'were it not for the fact that it is labelled with Constable's name, not one person in a thousand would associate it with him. It is hard to conceive anything more utterly unlike the spotting and splashing

[117]

with which his name is usually connected'.[60] Since then more had been dis-
covered about Constable's early work but not enough to make a convincing
reconstruction possible. When Holmes returned to the problem in 1921 in a
slim, privately published volume entitled *Constable Gainsborough and Lucas, Brief
Notes on Some Early Drawings by John Constable,* he actually confused the issue
further. In his previous writings Holmes had noted the influence of Girtin in
the watercolours Constable made in Derbyshire in 1801 and more strongly in
the Lake District watercolours of 1806. By contrast, he had seen Constable find-
ing his own style in some of the oil studies attributed to this period – the 'modern-
looking' studies that were actually by Lionel Constable. Having studied a group
of drawings in the collection of H. W. Underdown, Holmes now had an
explanation for the character of Constable's drawing style in the same period.
The decisive influence here was Gainsborough; indeed, so closely did Constable
follow Gainsborough that it was not always easy to tell the two artists apart.
In the second half of our book (pp. 160–2) we show that some of the drawings
Holmes used to demonstrate Gainsborough's influence on the young Constable
were in fact by the Gainsborough follower George Frost and that because of
Holmes's authority in these matters other Frost drawings were subsequently
attributed to Constable. For some time to come early Constable remained an
odd animal, partly himself but with prominent features borrowed from Lionel
Constable, George Frost and others.

Nevertheless, Holmes's hybrid was at least the product of serious thought about
the problem of Constable's origins and early development. Other Constable
studies of the 1920s showed little awareness of such problems. E. V. Lucas's
*John Constable the Painter* (1924), a lavishly illustrated volume with a chatty text,
carelessly included pastiches and copies as well as what appears to be a fine
early painting by F. W. Watts among its 'Constable' plates. Lucas usefully
quoted from the Farington diary, a major contemporary source of information
about Constable and other artists, excerpts from which had first been published
in the *Morning Post* during 1922 and 1923. But he made elementary mistakes
about Constable's work, confusing *The White Horse* (pl. 5) and *The Leaping
Horse* (pl. 23), for example, and thinking that a small oil sketch in the National
Gallery, *Dedham from near Gun Hill, Langham,*[61] was the 'Dedham Vale: Morning'
which Constable exhibited in 1811 (pl. 25) and which Holmes had correctly
identified as long ago as 1907. Lucas was also given to making such puzzling
observations as that in *The Church Porch, East Bergholt* (pl. 37), 'we find more
direct or easily-distinguished foreshadowings of Barbizon than in the epoch-
making *Hay Wain* of thirteen years later'.[62] In his *Constable* (Paris 1926, English
edition 1927) André Fontainas reproduced some doubtful works in the Louvre
apparently in ignorance of Percy Moore Turner's pertinent remarks on them,[63]
also made in 1907, which had already passed into the Louvre's official catalogue.
Among other reattributions, Turner had proposed James Webb as the artist
of *The Rainbow* (pl. 153, a pastiche of *The Glebe Farm*) which John Wilson

had presented to the Louvre in 1873 and F. W. Watts as the artist of *The Cottage*, purchased by the museum the same year. One of Fontainas's oddest illustrations can only be the result of his having obtained the wrong photograph: over the caption intended for the Victoria and Albert Museum's *Water-meadows near Salisbury* (pl. 20) he reproduced what appears to be a painting by Hobbema.

After its bright start at the beginning of the century the Constable literature had reached a low point. The sale-rooms were only slightly more interesting. Two paintings of Malvern Hall which had descended from the Countess of Dysart appeared in the Suckling sale on 23 July 1924 and were bought quite cheaply (£800 and £980) by Knoedler; both went to American collectors and one is now in the Sterling and Francine Clark Art Institute, Williamstown, Massachusetts.[64] A smallish but important variant of the design finally used for *The Opening of Waterloo Bridge* was sold from the collection of Helen Nightingale by Foster's in July 1928 for £1785, having been in her family, unknown to Constable scholars, for about fifty years. It was bought on behalf of Mary Hanna of Cincinnati, who gave it to the Cincinnati Museum in 1946.[65] A large version of the final composition had fetched £2415 in Sir J. Robinson's sale on 6 July 1923; this is the painting now in the Fairhaven Collection at Anglesey Abbey[66] – the final canvas (pl. 15) stayed in the Tennant family until the 1950s. Another high price for the period was the £2310 paid on 20 May 1927 for Mrs Raphael's *Salisbury Cathedral from the Bishop's Grounds*.[67] Later acquired by the Laing Art Gallery, Newcastle, this version is generally rejected today. The Ipswich Museums made a very good purchase on 15 February 1929 when they paid £189 for an important oil study of Willy Lott's House, dated 1816 and probably later used for *The Hay-Wain*. After Constable's death it had belonged at different times to three artists: C. R. Leslie, Thomas Churchyard and B. W. Leader.

The most important Constable transaction of the 1920s, however, was the private sale of the 1822 *View on the Stour near Dedham* (pl. 4), the fourth of Constable's great series of six-foot river pictures. This was sold to Henry Huntington in 1925 by the trustees of the estate of T. Horrocks Miller, whose father, Thomas Miller, had acquired it around 1850. Rarely seen during its time in England, from now on the painting was only to be seen in its new home, the Henry E. Huntington Art Gallery, San Marino, California, the terms of whose foundation prohibited the loan of the work elsewhere. The same restriction was to apply to *The White Horse* (pl. 5) after its acquisition by the Frick Collection, New York in 1943. The export to America in the period 1890–1930 of many important pictures by Constable, especially these two key works, increased the already considerable problems faced by anyone trying to form a comprehensive, first-hand idea of the artist's work. Even today few people have actually seen all six of the large river pictures that make up the core of his achievement: *The White Horse, Stratford Mill* (pl. 2), *The Hay-Wain, View on the Stour, The Lock* (pl. 22) and *The Leaping Horse* (pl. 23). Nobody is likely ever to have the opportunity of comparing them side by side.

[119]

# A HUNDRED YEARS ON

[ The 1930s ]

THE 1930s saw a return to the scholarly investigation of Constable and his works that Holmes had initiated at the beginning of the century. In 1930 the Oxford University Press issued the Hon. Andrew Shirley's *The Published Mezzotints of David Lucas after John Constable, R.A.*, a more complete and more detailed catalogue than the one Wedmore had produced in 1904. Shirley distinguished, and described more fully, many more states among both trial proofs and published prints than had his predecessor. He also illustrated at least one state of each print together with the oil painting or sketch upon which he thought it had been based – Wedmore's catalogue was unillustrated. In addition, Shirley tried 'to collect and print all the documents and letters relative to the subject',[1] few of which had been published before. The letters included those between Constable and Lucas which John Charrington had presented to the Fitzwilliam Museum in 1910. Shirley aimed at literal transcripts: for the first time Constable's voice was heard practically unedited. Among other new documents published by Shirley were Constable's drafts for the letterpress to *English Landscape* which the Constable family had preserved. Shirley's catalogue remained the standard reference until Osbert Barnard produced a revised list of the published states of *English Landscape* in 1970 in the form of a duplicated typescript. No comparable revision has yet been published of Shirley's account of the trial proofs (or progress proofs, as he called them) or of the prints outside the original twenty-two *English Landscape* subjects.

The publication of Constable's correspondence continued the following year with an edition by Leslie's grandson Peter Leslie of *The Letters of John Constable, R.A. to C. R. Leslie, R.A.* This provided the most complete text so far available of Constable's letters to Leslie and, like Shirley's handling of the correspondence with Lucas, it was notable for its attempt at an accurate transcript of the documents. The full publication of Constable's correspondence, the extent of which was unsuspected at this time, was to be a major factor in the further identification and dating of his works but there was still much to be discovered by simply looking more closely at particular areas of Constable's activity and collating the

available material. Although it contained only eight works, the Paterson Gallery's *Exhibition of Cloud Studies by John Constable, R.A.* in June 1928 drew attention to one such area, Constable's 'pure' sky studies of 1822. The catalogue usefully illustrated each item and copied the inscriptions on the back of the works. An article by Shirley in the *Connoisseur* in 1933[2] focussed on another neglected area, Constable's life drawings, and touched on the more important question of Constable's portraiture, a large and unexplored body of work that Shirley was to investigate more fully in publications of 1937. The lessons to be learned from studying the provenance of Constable's works were suggested by H. Isherwood Kay in another article published in 1933. Kay managed to discover where *The Hay-Wain* had been between its appearance at the Paris Salon of 1824 and its loan by George Young to the British Institution exhibition of 1853. It had, in fact, remained in France until about 1838 before returning to England. But, as Kay said:

> The absence of definite knowledge of the whereabouts of the picture during these thirty crucial years, when if ever it could have worked directly upon the rising generation in France, has made possible the most extravagant claims on the part of out-and-out devotees of Constable and equally sweeping denials on the other side.[3]

Kay also identified the other large work by Constable shown in Paris in 1824 as the Huntington *View on the Stour near Dedham* (pl. 4), not, as Holmes had thought, *The Leaping Horse* (pl. 23).

A curious volume published in 1932, Herbert Cornish's *The Constable Country A Hundred Years after John Constable, R.A.* is an indication of the increasing fascination felt by many people not so much for the pictures Constable painted as for the places where he worked. As we saw earlier, the pilgrimages to Constable country were well under way by 1900. By the 1920s visitors had perhaps fewer expectations. 'You make your way to the bridge, wondering if you can spot just where he sat to paint the Mill and what changes it will show after all these years', wrote 'A.B.W.' in *The Times* of 7 September 1921, ' — and you come upon a tent marked TEAS AND ICES'. 'You think at last', he continued, 'you have found the true point of view. But doubts arise, and you choose another site. Finally, you give it up in despair', having forgotten what Constable's painting of *Flatford Mill* (pl. 12) looks like and realising, too, that the vegetation has changed — realising, even, that 'you could never at any time have seen the scene the painter saw, because you and he are different persons'. By the 1920s Flatford Mill and more especially Willy Lott's House were in any case in a bad state of repair. Various schemes were put forward to restore and find new uses for them; T. R. Parkington of Ipswich finally bought the two buildings in 1927 for presentation to the nation. This 'saving of Flatford' is one of the themes of Herbert Cornish's 1932 volume but it is difficult to say what much else of it is about. The language is esoteric, perhaps to be understood only by some secret society of Constable Countrymen. Thus East Bergholt is frequently

53 Eleanor M. Gribble, illustration to *The Constable Country . . .* by Herbert Cornish, 1932

54 Eleanor M. Gribble, illustration to *The Constable Country . . .* by Herbert Cornish, 1932

referred to as 'The Little-Mother Place' while Ipswich becomes 'The Foster-Mother Town'. There are, however, some interesting illustrations, photographs of the area as well as reproductions of paintings by artists working there in the 1920s. The text is helped along with drawings by Eleanor M. Gribble (pls 53–4), one of them showing the ghost of Constable walking past the 'Constable Tea Gardens' at East Bergholt. These occupied the site of Constable's birthplace, East Bergholt House.

At some remove from these local affairs, there was much debate in the 1930s about the relative merits of Constable's sketches and finished pictures. This debate was connected with the older one about Constable's relationship to French painting. We have seen how English appreciation of Constable was encouraged in the 1860s by the knowledge that his works had exerted an influence on Barbizon painting. The Barbizon artists became very popular with certain English collectors and critics from about 1870 onwards and Constable was sometimes seen through their eyes, as it were, rather than vice versa. Thus Hamerton, writing in 1890, could describe an oil study by Constable of a Brighton windmill as 'in spots like the execution of Diaz'.[4] E. V. Lucas was inclined to look at Constable in this way as late as 1924. To him the Tate Gallery *Stoke-by-Nayland* sketch[5] was 'very French' and 'visibly full of the seeds of Barbizon', while 'Diaz, Rousseau, Daubigny and Dupré' were 'all foreshadowed' in *A Lane near Flatford*[6]. In *Admiral's House, Hampstead* (pl. 139), wrote Lucas, 'I always seem to see Corot'.[7] By about 1900 English critics were ascribing to Constable a still more important role, as a precursor not only of the Barbizon school but also of Impressionism. Whether or not a direct influence on the Impressionists was claimed, there was again a tendency to see Constable's work through French eyes. Here, for example, is Charles Holmes in his 1901 book on the artist:

> The *Study of Tree Stems* [pl. 55] might almost come from the hand of Manet, so brilliant and natural is the blaze of the sunlight, so frank is the treatment of the cool shadows. . . .
> In certain other sketches Constable went still further, and by a loose tremulous handling caught the effect of atmospheric vibration, which was rediscovered many years later by Monet and Pissarro.[8]

Manet was a favourite comparison. 'Constable suggests our contemporaries, and the best of these, Manet above all', wrote Julius Meier-Graefe in his *Modern Art*, published in an English translation in 1908.

> Things like this little *Coast Scene* [a Brighton oil sketch in the Chéramy collection][9] are the first evidences of that conception of Nature we call Impressionism, and give indications of everything that Manet brought into the same domain.[10]

Works by Lionel Constable were unwittingly brought into these comparisons. Meier-Graefe thought the *Bridge on the Mole* (pl. 136) in Alexander Young's collection had 'a striking affinity with Corot's broad manner, which was adopted

55 *Study of Tree Trunks*, oil, $9\frac{3}{4} \times 11\frac{1}{2}$ (24.8 × 29.2). Admired in the early 1900s for its resemblance to the work of Manet.

by the Impressionists'.[11] In the 1930s Constable was being linked to still more recent developments in French art. In a *Listener* article of 1937 entitled 'Constable, Prophet of Impressionism', Kenneth Clark was reminded of Matisse by some of Constable's Brighton beach studies, while in other works he found a 'transcription . . . almost as free as in the latest Cézannes'.[12]

From the 1860s onwards Constable's work was likely to be seen in terms of what had been happening recently in French art. Constable seemed continuously relevant, always modern, though there were some who did not agree.* However, it was only Constable's oil sketches, ranging from the small outdoor studies to the full-size sketches for his six-foot compositions, that could go on being 'updated' in this way. Although the studies and sketches given to the nation by Isabel Constable in 1887–8 had been admired by the critics who noticed them, such admiration had not been at the expense of Constable's more finished work. Nor had Holmes in his 1901 and 1902 books sought to elevate one type of work over the other. In his influential *Modern Art* (1908) Meier-Graefe, however, expressed a clear preference:

> That which places Constable's so-called finished pictures beneath the sketches, is the painter's respect for an obsolete guild prescription. It is no cheap respect, consciously speculative, but rather a slight fetter of instinct. Perhaps it was unavoidable.

* For example, R. H. Wilenski in his *English Painting* (1933, p. 213): Constable 'has nothing to offer to the student of to-day – except the warning furnished by his elaborated pictures'.

In his sketches Constable ventured upon things which we can readily believe required a new generation to make them into pictures.[13]

By 1921 Charles Holmes was reaching a similar conclusion, aware that his generation was 'becoming perhaps just a little impatient' of the finished pictures: 'the time is not, I think, far distant, when Constable's greatness will be seen to rest far more upon his brilliant sketches and studies'.[14] In his *Landmarks in Nineteenth-Century Painting* (1927) Clive Bell suggested that Constable's sketches were 'perhaps, the most brilliant and characteristic part of his output' but he could still speak well of the finished works, finding in them some of the characteristics of the sketches: 'the quality of his studio-pictures, if you look closely into them, will be found often as broken, exciting, and modern as that of a Renoir'.[15] Roger Fry's *Reflections on British Painting* (1934) contains some sensitive accounts of Constable's small outdoor sketches, nearly every one of which, he said, 'is a discovery – a discovery of some moment when the tones and colours reveal themselves as suddenly brought together in a new and altogether unexpected harmony'.[16] But Fry deplored the time Constable spent 'elaborating those great machines which were calculated to produce an effect in the Academy exhibitions. The habit of making these was entirely bad. They were almost always compromises with his real idea'. 'Fortunately, however', continued Fry, 'he frequently did full-size studies for these pictures, and it is to those and to the sketches that we must turn to find the real Constable'.[17] However, Fry did not go quite so far as R. H. Wilenski, who in his *English Painting* of 1933 proposed a complete reclassification of the full-size sketches:

> His real contribution would be more obvious if the so-called sketches were labelled simply *The Hay Wain* or *The Valley Farm* and the so-called pictures painted from them were labelled *Elaborated Version of The Hay Wain* and *Elaborated Version of The Valley Farm*.[18]

Although not often expressed in such an extreme form, the contemporary view of Constable – through eyes 'dilated by half a century of impressionism' as Kenneth Clark later conceded[19] – generally favoured the full-size sketches over the exhibition canvases. One curious consequence of this bias was the response to the discovery of the full-size sketch for *Hadleigh Castle* (pl. 17). This had remained until 1930 in the family of the man who had bought it (for £3 13s. 6d.) in the 1838 studio sale. Between 1930 and 1935 it was in the trade, ending up with Percy Moore Turner, a dealer who had played an important role in introducing Impressionist and Post-Impressionist painting to England (many of Samuel Courtauld's pictures came through him). *Hadleigh Castle* was purchased from Turner by the National Gallery in 1935 but had already been talked about with interest before this. Charles Holmes mentioned it in his introduction to Peter Leslie's edition of *The Letters of John Constable, R.A. to C. R. Leslie, R.A.* in 1931:

It is a brilliant piece of palette knife work, anticipating quite curiously the style of Mr. Wilson Steer, and so broadly and freely handled as to explain Constable's hesitation about sending it to the Royal Academy, at the moment when, as he puts it, 'I am still smarting under my election.' In a period when brushwork in general was sober, smooth or 'pretty' such vigorous scrapings and slashings and loadings of pigment must indeed have seemed chaotic and revolutionary . . .[20]

In the absence of any other large painting of the subject, and with his own eyes now 'dilated by impressionism', Holmes readily assumed that the newly discovered work was the one Constable had exhibited in 1829. He made the same assumption when he published the painting in 1936, in an article which reveals just how welcome an addition to Constable's oeuvre it was at this time:

although the studies and smaller works at Trafalgar Square and Millbank undeniably illustrate the ways and means whereby Constable endowed us with new vision as regards landscape, the larger paintings there, the *Haywain* and the *Cornfield*, are still weighted by the relatively staid, static tradition from which he broke free. . . . Moreover, these large and rather heavy pictures being connected in our minds with Leslie's too carefully Bowdlerized record of the painter as a quiet young student and a devout, devoted British paterfamilias, have encouraged, nay, forced us to think of Constable as one far too mild and *bourgeois*, either to have deliberately started a great artistic revolution, or to have carried it through to complete victory. The man has seemed just a little unworthy of his achievement. For such conquests over massed, inert humanity, the pedestrian and domestic virtues are not enough. Exceptional daring, extraordinary vigour are also needed, and it is well for our national credit that these qualities in Constable's art should be made manifest to all beyond doubt or dispute.

No work by Constable on a considerable scale, not even the magnificent *Leaping Horse* in the Diploma Gallery at Burlington House, conveys so directly the impression of masterful tremendous energy as does this *Hadleigh Castle* . . .[21]

'We may be proud and thankful', Holmes continued, 'that Trafalgar Square now possesses this convincing proof' of Constable's 'modernity' and 'power'. One can see how attractive the idea must have been that Constable had actually regarded such a picture as his final statement of the subject. If this notion had caught on, the idea that Constable's finished paintings were only elaborated replicas would have seemed to have been vindicated. But this was not to be. Discrepancies between the provenance of the National Gallery's *Hadleigh Castle* and what was known of the history of the exhibited version were soon found and the conclusion correctly drawn that the latter work (pl. 16) was still missing.

The exhibitions and publications of 1937, the centenary of Constable's death, reflect many of the attitudes and interests we have traced so far in this chapter. Leslie's *Life* was republished this year in an enlarged edition by Andrew Shirley, a valuable addition to the documentation of Constable's life. In his new edition Shirley included letters not used by Leslie, indicating their presence by indentation, and 'corrected and amplified' many of the letters already in the work.

New biographical material and comments on works of art were also added in
indented paragraphs, thus more or less preserving the original text while adding
considerably to it. Chronological lists of works were given at the end of each
chapter and there was a lengthy introduction which included separate sections
on imitations of Constable's works and on his portraiture (a neglected aspect
which Shirley also wrote about in the *Burlington Magazine* in 1937). The twelve
colour and 217 black-and-white reproductions made the volume easily the best
illustrated account of Constable so far available. Altogether Shirley's book con-
tained an impressive amount of information and it tended to supersede Sir Charles
Holmes's great volume of 1902 as the standard work on the artist, though Shirley
acknowledged that he had largely followed Holmes in his chronology of Con-
stable's oils. In fact, understanding of the chronology of Constable's work had
not advanced much since 1902. The particular problems of reconstructing Con-
stable's development in the years up to about 1815 have already been noted.
It is true that Fry and others had recently looked at some of Constable's early
outdoor oil studies with new enthusiasm but historical investigation of them had
lagged behind. In his account of this period Shirley offered much the same sort
of compound of genuine works, works by Lionel Constable and works by
unknown hands that we have seen before, only this time it was still more confused
by extraneous pictures which had turned up in the 1930s. Taking up Shirley's
account in 1805[22] we find him still accepting *Barnes Common* (pl. 33) as an
example of Constable's debt to the Dutch school. He then immediately goes
on to talk of a version of *Dedham from Langham*[23] then belonging to Messrs Vicars,
which today appears to be a copy from Lucas's *Summer Morning* mezzotint[24]
but which Shirley regarded as the study from which the print was finished.
Next come two modern-looking works, *Trees on Rising Ground* in Michael
Sadler's collection, the colouring of which is 'fresh almost to the point of crudity
in the blue sky', and F. Hindley Smith's *Hilly Landscape*,[25] described by Shirley
as an 'astonishing piece of modernism' but not accepted today. This brings Shirley
to the years 1808–10 when Constable 'was sketching in a style that remains
"modern" after a hundred years. *The Country Road*[26] and *The Way to the Farm*
[Lionel Constable][27] are admirable instances of bright colour, broad brushwork,
and severely censored detail'. Shirley was in advance of general thinking, however,
in his rejection of the Tate Gallery's *Leathes Water*,[28] though it is odd that he
accepted the very similar *Keswick Lake*,[29] then in Sadler's collection and now
at the Yale Center; both are now given to Lionel. Having accepted a number
of bright, modern-looking works as belonging to the years before 1809, Shirley
faced a problem: how to explain what he saw as an earlier influence, that of
Girtin, in the *Malvern Hall* of 1809 (pl. 30). We can only assume, he says,
that 'something in the scene stirred a memory which seduced him from his ordi-
nary practice'.[30]

Shirley again tackled Constable's early work in a *Burlington Magazine* article
of 1937 which centred on Sir Hickman Bacon's collection. His first example,

56 Attributed to Pierre-Henri de Valenciennes, *Italian Landscape*, oil, $4 \times 8\frac{1}{2}$ (10.2 × 21.6). In 1937 thought to be a Constable of around 1800.

an Italian landscape study in oil (pl. 56), presented a similar problem of assimilation and once more a diversion from usual practice had to be hypothesized. We know, says Shirley, that later in life Constable 'was familiar with J. R. Cozens's work, owned some drawings himself, bought another for Fisher, and called him the greatest genius that ever touched landscape. But now comes an early sketch that can hardly be anything but a translation into oil of a Cozens watercolour'. Shirley argues that it dates from about 1800 and concludes that 'As there has been no suggestion that Constable was interested in Cozens's work at this time, it has a certain documentary value besides its charm'.[31] Very little was known in 1937 about the many other artists besides Constable who made outdoor oil studies in the eighteenth and early nineteenth centuries. Later research was to suggest that the Bacon sketch was painted in the 1780s by the French artist PierreHenri de Valenciennes.

Whatever its limitations, Shirley's attempt to reconstruct Constable's development had the merit of including works from sources other than the familiar national collections. The exhibition which he helped Percy Moore Turner organise at Wildenstein's Galleries in Bond Street in April and May 1937 had the same shortcomings and virtues. Entitled *A Centenary Memorial Exhibition of John Constable, R.A. His Origins and Influence*, this included 136 paintings and drawings attributed to Constable and, to demonstrate his place in the history of art, thirtynine works by other artists, ranging from Rubens to Cézanne. As we would expect from his commitment to modern French art, Turner emphasised Constable's role as a forerunner of Barbizon, Impressionist and PostImpressionist painting. Turner saw the direct line of descent ending with Seurat but the name he seems to have wished to leave most firmly impressed on visitors' minds was that of Cézanne, to whom he devoted some triumphant, if irrelevant, concluding paragraphs.

If Turner's notes told one little about Constable, the exhibition itself was valuable in bringing forward a number of unfamiliar paintings and drawings by the artist. One or two of these were important early dated oil sketches, such as the 1804 *Stour Estuary*[32] later acquired by the Beecroft Art Gallery, Southend and the 1809 *East Bergholt Church*[33] now in Mr Paul Mellon's collection. *Apollo* magazine found the drawings especially revealing: 'It is likely that the range, dexterity and sensitiveness of this section will come as a surprise to many, for

his drawings are not too frequently seen'; the magazine also noted the representation of 'other sides of his activity, that are generally unrecognized', such as his portraiture.[34] But in retrospect the greatest surprise is that so few of the exhibits were actually by Constable at all. At most only half the oils would today be accepted as his and a good many of the drawings would also be rejected or doubted. George Frost, Lionel Constable, F. W. Watts and Thomas Churchyard were all unwittingly represented, the first two quite well; the majority of the doubtful items, however, still lack convincing names.

The Wildenstein exhibition included none of Constable's more important canvases. These were committed to the larger *Centenary Exhibition of Paintings and WaterColours by John Constable, R.A.* at the Tate Gallery, which was planned to open in April but actually ran from May to August 1937. The slim catalogue of this exhibition is probably not much consulted today because most of the exhibits were familiar and undoubted works by Constable which are now better documented elsewhere: by contrast, the Wildenstein catalogue remains a fascinating index of past confusions and still unresolved problems. But there can be no doubt that the large Tate Gallery exhibition gave a more complete idea of Constable as an artist. The 150 oils included many of his major productions, from the 1811 *Dedham Vale* (pl. 25) through *The HayWain* (pl. 3) and *The Leaping Horse* (pl. 23) to Lord Ashton's *Salisbury Cathedral from the Meadows* (pl. 9). There was a generous showing of small oil studies as well, the majority – over eighty – lent by the Victoria and Albert Museum. All but a handful of the hundred or so drawings and watercolours on view also came from the V & A. Inevitably there were a few doubtful items but by and large the Tate was able to show an impeccable assembly of works because they were drawn almost entirely from the national collections. Apparently it was felt sufficient simply to gather these riches together. An unsigned introduction to the catalogue actually states that the pictures 'are here to speak for themselves'. The writer offers little in the way of guidance or explanation, except to suggest that Constable's prime concern was with the rendering of light as a means of conveying the transitory aspects of nature. In the exhibition itself no attempt seems to have been made to show the development of Constable's work or even to point connections between related pictures. If the hanging followed the catalogue order, there was indeed an odd mixture of periods and types of work. But to many it must have seemed enough. Reviewing the exhibition on 6 May, *The Times* critic took exception to the colour of the walls but otherwise thought the exhibition did 'full justice' to Constable: 'the representation of the artist in all his moods, phases and stages of execution is complete and overwhelming in its effect'.

In this first 100 years after his death, what, we may ask, had been discovered about Constable. How complete really was the picture? Although much had come to light, in fact a good deal of his work was still hardly known. Several of his most important canvases still figured only fleetingly in the literature. Of

Constable's series of six-foot river scenes – today regarded as his finest achievement – only *The Hay-Wain* and *The Leaping Horse* were at all well-known: *The White Horse* (pl. 5) and *View on the Stour* (pl. 4), in America since 1894 and 1925 respectively, tended to be left out of account, as to a lesser degree did the two examples still in English private collections, Lord Swaythling's *Stratford Mill* (pl. 2) and Charles Morrison's *Lock* (pl. 22). None of these four pictures was in the Tate Gallery exhibition, the first two because their guardians were prohibited from making loans. In his 1937 edition of Leslie, Shirley had to rely on Charles Holmes's memory of *View on the Stour* for his comments on its surface characteristics and he was unable even to illustrate *Stratford Mill.* Many of the finished paintings of Constable's earlier years were still unknown to specialists. With the idea of Constable as a proto-Impressionist still very prevalent, they may not have seemed worth searching for. The two paintings of Golding Constable's gardens (see pl. 34), now at Ipswich and regarded as among the finest works of Constable's Suffolk years, were sold at auction on 26 June 1936 for £945 and £1155 but made no appearance in the exhibitions or publications of the centenary year. They were almost the only important paintings by Constable sold at auction in the 1930s.

By 1937 no round-up had been attempted of the hundreds of oil studies outside the collection given to the nation by Isabel Constable. Although instrumental in promoting Constable's reputation at the end of the nineteenth century, the group at the Victoria and Albert Museum had also inhibited further enquiry by its very size: who would have thought that much more was to be discovered about this aspect of Constable's work? In his *British Painting* of 1933 C. H. Collins Baker, enjoying a rare transatlantic position as both Head of Research in Art History at the Huntington Library and Art Gallery and Surveyor of the King's Pictures, referred briefly to one of the major caches of oil studies outside the V & A, those in the Johnson Collection at Philadelphia, but Constable scholars did not follow up the lead at the time. Constable's drawings were becoming better known. In addition to the collection shown at Wildenstein's in 1937, the British Museum put on an exhibition of its large (and more reliable) holding as its contribution to the centenary celebrations. But perhaps a more telling indication of the state of knowledge in this area was the neglect of Constable's two sketchbooks of 1813 and 1814 in the Victoria and Albert Museum, the former containing more than a hundred drawings, the latter some seventy or so studies. These are probably the most important single items in his whole output as a draughtsman, containing as they do the germs of many of his major compositions (see pl. 143). Shirley illustrated not one page from either sketchbook in his 1937 volume and did not even list the 1814 book in his chronology. Before he published *Hadleigh Castle* in the *Burlington Magazine* in 1936, Charles Holmes asked the V & A authorities to look for the 'little book of hasty memorandums' Constable said he filled on his visit to Hadleigh and other places in Essex in 1814 but of which, wrote Holmes, 'no part . . . appears

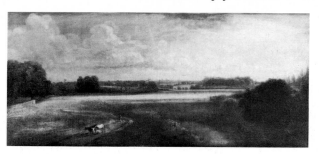

*57 View from Golding Constable's House,* oil, 13 × 29½ (33 × 75). A very early work exhibited for the first time in 1976.

to have survived'. Yet leaves from this sketchbook, including the drawing of Hadleigh Castle upon which Constable's paintings of the subject were based, had been in the Museum since 1888. What is equally odd is that nobody seems to have looked through the intact 1814 sketchbook for such drawings either.

Since 1937 interest in Constable has expanded on all fronts. Private and public collectors, exhibition organisers, art historians and publishers have devoted their energies to him as never before. One of the results of this activity has been the rediscovery of many paintings which were not generally known forty or so years ago. Hardly a year now passes without the appearance of new or hitherto untraced work. In forming our ideas about the artist today we can take into account, as Holmes and Shirley could not, such works as the early *View from Golding Constable's House* at Downing College, Cambridge (pl. 57), *Old Hall, East Bergholt* of 1801 (his first securely dated landscape in oils),[35] the *Flatford Mill* exhibited in 1812,[36] *The Mill Stream* (pl. 51), two versions of *Ploughing Scene in Suffolk (A Summerland)* (pl. 7), the miniature 1815 *Brightwell* (pl. 58), *The Stour Valley and Dedham Village* now at Boston (pl. 52), *Wivenhoe Park* (pl. 10) and its companion *The Quarters, Alresford Hall*,[37] the first versions of *Cottage in a Cornfield* (pl. 60) and *Dedham Lock and Mill*[38] and the final version of *Hadleigh Castle* (pl. 16), as well as a host of oil studies and drawings that were unknown in 1937. We can now also leave many things out of account. Having a clearer idea of what Constable painted and how he painted it, we can more readily detect the copies, pastiches, and works by other painters, including the artist's own children, that blurred Constable's image in the past.

Not only is more of Constable's work known today. Its chronology and internal relationships are also beginning to be better understood. Two catalogues compiled in the 1950s made great advances in this ordering of the artist's work: Graham Reynolds's chronological *Catalogue of the Constable Collection* in the V & A, first published 1960, and R. B. Beckett's draft catalogue of all Constable's work, arranged on topographical lines, which was completed about the same time but never progressed beyond typescript. Much has been done in this direction since. We can now follow in detail the development of many of Constable's pictorial ideas, watch him — to take a simple example — first making a pencil memorandum in a sketchbook, then returning to sketch the same subject in oils and, possibly many years later, taking up the idea again on a large canvas

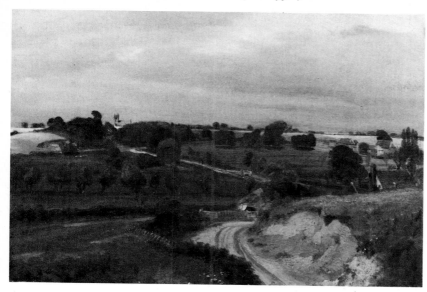

*58 Brightwell Church and Village*, 1815; oil, $6\frac{1}{8} \times 9$ (15.5 × 22.8). Sold at auction in 1978 as 'English School'.

in the studio, perhaps with the aid of preliminary studio sketches. The function of particular drawings, sketches and paintings becomes clearer once their place in such sequences is grasped or, indeed, if no such place can be found for them. Gradually we are learning what Constable was trying to do with his material.

The fuller publication of the artist's own writings has proved an essential aid to this kind of enquiry. In particular, R. B. Beckett's magnificent six-volume edition of *John Constable's Correspondence*, published by the Suffolk Records Society between 1962 and 1968, provides a mass of new documentation which has assisted the identification and dating of Constable's work and helped to clarify his methods and aims. It also supplies the material for a more complete idea of the man himself. His family background, his relations with his wife and children, his friendships and enmities with other artists and his dealings with patrons are all shown in a clearer light. In recent years Constable's intentions as an artist and his character as a man have also been illuminated by specialized studies of the topography of his works, his understanding of contemporary meteorology, his knowledge of poetry and artistic theory and his political ideas. The intellectual make-up of 'the natural painter' has come to be seen as more complex than was once thought.

It should not be imagined, however, that Constable now stands fully revealed or perfectly comprehended. It may be some time before the diverse researches of recent years add up to a new and more convincing general account of the artist. Such fundamental questions as how and why he painted in the way he did have in any case hardly begun to be answered. Nor is a complete reconstruction of his oeuvre as yet within sight. For example, of the one hundred or so works Constable exhibited at the Royal Academy between 1802 and 1837 —

[131]

the works, presumably, he set greatest store by – no more than about half have been certainly identified. No exhibited landscape before 1810 is known for certain today. The missing works in this period include six Lake District subjects shown at the RA in 1807 and 1808 and five, some no doubt the same as the RA exhibits, shown at the British Institution in 1808 and 1809. There is also no trace of a five-foot picture of Borrowdale which, on Farington's advice, Constable decided not to exhibit in 1809 or of the largest picture he said he had so far painted, the 'Wood Scene' of 1815. The unidentified or missing works are not restricted to Constable's early years but extend right up to the 1830s. In addition, uncertainty still exists about the authenticity of known paintings. At the time of writing, the most comprehensive catalogue available of Constable's oils is Robert Hoozee's *L'opera completa di Constable* (1979). The main body of this catalogue includes forty-nine works, out of a total of 565, against which Dr Hoozee feels obliged to place a question mark but which he finds sufficiently convincing for them to be kept out of a separate section of 'doubtful works', a section already containing sixty-nine items. Some of the paintings questioned by Hoozee are accepted by other Constable scholars, who in turn question some of the works fully accepted by Hoozee. A long-awaited catalogue raisonné by Graham Reynolds and Charles Rhyne is now nearing publication. This will undoubtedly be a landmark in Constable scholarship. It remains to be seen which of the outstanding problems of attribution the catalogue will resolve and which will require further attention.

# A CASE-HISTORY:
# 'COTTAGE IN A CORNFIELD'

THE history of a number of Constable's paintings has been given in this first part of our book, but so far only fragmentarily, reflecting their periodic appearances in sales and exhibitions. Before we come to the second part, and the problems of distinguishing his work from that of other artists, it might perhaps be helpful if we considered one case-history of discovery in greater detail.

Occasionally a work is discovered or recognised in an instant. This was the case when the Fenwick oil sketches were brought to the Tate Gallery in April 1981 (see Frontispiece), and when another unknown study, *Anglers at Stratford Mill* (pl. 59), was unwrapped for inspection at Christie's counter the following year. Sometimes it takes rather longer. *Brightwell* (pl. 58) was catalogued as 'English School' and sold for under £50 when it came up for auction in one of the smaller London sale-rooms in June 1978. William Drummond, a discerning dealer, became the next owner for an equally modest sum, thinking it a lovely little picture, but at the same time entertaining no high hopes for it. His realisation of what he had in fact bought began to dawn some months later when he saw a mention of an oil painting of the subject by Constable in the parish church at Brightwell itself. Within a few weeks researches had born fruit: the work proved to be a fully documented painting commissioned by a Suffolk parson which Constable had executed in the summer of 1815; a rarity the Tate Gallery was subsequently very pleased to acquire.

More often, however, the process of discovery proceeds at a slower pace, with the gradual advance of knowledge, and the case we have chosen, one of mistaken identity and of the final emergence of two paintings when it was originally thought there was only one, probably gives a better idea of the way in which most Constable discoveries are made.

Constable exhibited two pictures of a cottage in a cornfield: a smallish one in 1817 and 1818 (with framed measurements of 19 × 17 inches) and a rather larger one (framed measurements, 34 × 30 inches) in 1833 and 1834. Both have now been identified. The first is a recently 'discovered' painting of the subject, the *Cottage in a Cornfield* now in the National Museum of Wales at Cardiff

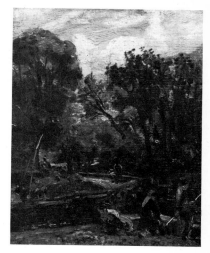

59 *Anglers at Stratford Mill*, 1811; oil, $7\frac{7}{8} \times 5\frac{3}{4}$ (18.7 × 14.6). A recent discovery, unknown until 1982.

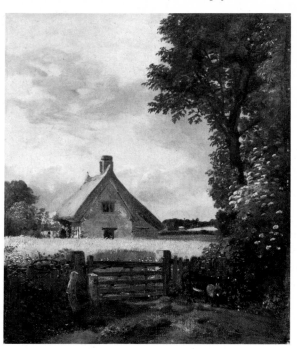

60 *Cottage in a Cornfield*, exh. 1817; oil, 12⅜ × 10⅜ (31.4 × 26.4). New to scholars when it was published in 1978.

(pl. 60); the other is the comparatively well-known version in the V & A (pl. 61). In neither case has the identification been achieved without difficulty. This is because the Cardiff picture passed into private ownership and obscurity in 1818 and did not re-enter 'public life' (and only then through something of a cloud) until 1978; and because the V & A *Cottage in a Cornfield*, for long the only known version, was for many years thought to be the exhibit of 1817/18. It was Leslie who made the initial mistake about this larger version. But he can hardly be blamed for it, the picture being so plainly the work of a period earlier than 1833, the year it was shown at the Academy. How did this come about?

For some years prior to 1833 it had been Constable's aim to have a major painting ready each April for the Academy. In 1831 and 1832 he had shown two of his largest paintings, *Salisbury Cathedral from the Meadows* (pl. 9) and the big *Waterloo Bridge* (pl. 15). Often, in the weeks immediately preceding sending-in day, we hear of him working at his easel at great pressure in an endeavour to have the current picture ready because he had been late in making a start. This year, 1833, was no exception. On 22 January, with little more than two months to go, he told Leslie that he was contemplating a half-length (i.e., a vertical canvas suitable for a half-length portrait) for his 'Sercophagi',[1] the subject he eventually titled *The Cenotaph*.[2] Work was evidently under way when his brother Abram wrote from Flatford on 15 February approving of his choice of such a canvas.

[134]

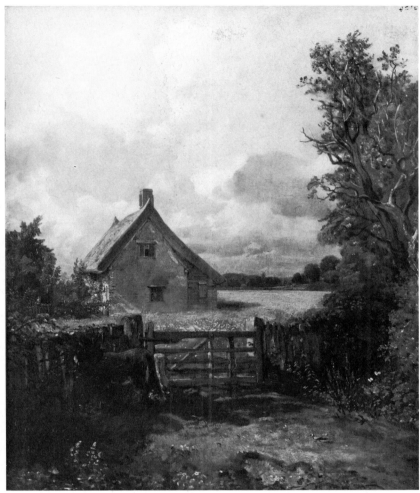

61 *Cottage in a Cornfield*, exh. 1833; oil, $24\frac{1}{2} \times 20\frac{1}{4}$ (62 × 51.5)

I am glad you are going on so well with your Pictures for next Exhibition, & think you will accomplish them. I am certain a middling siz'd Picture well finish'd, tells better than very large ones, & are more disposable – I think your House Picture will be beautiful, a faithful representative of *'9 o'ck in the morning, in* [ *? summer*]'³

The house picture, a work that was to cause much heartache, was *Englefield House*,⁴ a commissioned portrait of a country seat which Constable had already been working on for some months. In the event, this, with its architectural detailing – 'the windows & window frames & chimneys and chimney pots are endless'⁵ – took longer than Constable had anticipated and it was not until 27 March, with only a couple of weeks to go, that he was able to report for the last time that he had 'almost done' the picture.⁶ To achieve this, he had had to lay *The Cenotaph* aside; there had not been time to complete both. This meant that *Englefield*, by default, had become his main exhibit, the painting by which he would

have to 'stand or fall'. From his subsequent touchiness about the merits of the picture one gathers that he was not altogether happy about the way things had fallen out. As well as a large painting, Constable habitually exhibited a group of smaller, supplementary works. There was a short-fall here as well this year and to make an adequate showing he had to resort to an unusual, somewhat desperate measure, to the re-vamping of an unfinished, much earlier canvas. This was the V & A *Cottage in a Cornfield*, a work begun years before, possibly as early as 1815. Constable was clearly uneasy about the impression his exhibits would make. It was reported to him that certain artists – Wilkie, Landseer, etc. – were strong; 'Constable', he told a friend, 'is weak this year'.[7]

Leslie cannot really be blamed for confusing this exhibit of 1833 with the much earlier one. Stylistically, he had judged aright. But the mistake once made, because it *was* justifiable, took a long time to rectify.

The *Cottage* returned from the Academy of 1833 unsold, and failed to find a buyer when it was shown at the British Institution the following year.[8] It was next seen in public as lot 52, 'Cottage in a Corn Field', in Foster's sale of the artist's effects in 1838. Here the work again failed to attract much attention and it was bought in for the family at twenty-six guineas. Leslie, though, paid it the compliment of a special mention in his *Life*, and perhaps because of this *A Cottage in a Cornfield* was one of the paintings Lucas chose to engrave and to publish in 1845. In 1888, with four other works by Constable, it was bequeathed to the V & A by Isabel, with a request that all five should be described as the gift of her sister Maria Louisa, herself, and of her brother Lionel. Holmes, in his chronological list of Constable's works (1902), while recording a *Cottage in a Cornfield* as an Academy exhibit of 1833, accepted Leslie's statement that the V & A version had been the BI exhibit of 1818 and probably the Academy *Cottage* of the year before. He did, however, refer to a related drawing, a pencil study 'made about 1815'.

The first clues leading to the eventual identification of the two *Cottages* were published unknowingly in 1937 by Andrew Shirley in his new and enlarged edition of Leslie's *Life*. After Leslie's reference to the 1818 BI *Cottage in a Cornfield* Shirley gave the catalogue dimensions – '1 ft. 7 in. by 1 ft. 5 in.'[9] – unaware, it seems, that these were the outward measurements of the frame and that the V & A picture, unframed, was larger, $24\frac{1}{2} \times 20$ inches, and therefore could not have been the BI exhibit. In addition, Shirley published a letter to Constable from a dealer, Allen Woodburn, containing references to the selling of a *Cornfield* after the BI show in 1818.[10] It was Jonathan Mayne in *his* edition of Leslie (1951), who first pointed out that though Leslie's description exactly fitted the V & A *Cottage*, and though the painting seemed to belong to the year 1817/18 stylistically, the measurements in the BI catalogue ruled out the possibility that the painting could have been the exhibit of that year.[11]

Proof that this *Cottage* was in fact the RA exhibit of 1833 was finally provided in 1960 by Graham Reynolds by means of a label inscribed by Constable at

some date after May 1832, a label that had formerly been attached to the back of the work. Reynolds also offered an explanation for the anachronistic character of the picture, suggesting that the meaning of a phrase in a letter Constable wrote not long before sending-in day – 'I have brushed up my *Cottage* into a pretty look' – could be that he had been retouching an earlier painting for the exhibition.[12] This has now been accepted as the most probable course of events. In addition, Reynolds increased the likelihood that a different *Cottage in a Cornfield* had been sold in 1818, by drawing attention to the letter quoted by Shirley in his edition of Leslie and, in connection with this, by quoting Farington's report of 3 April 1818 that Constable had sold two of his landscapes, one of them for twenty guineas. At the same time Reynolds published the related drawing Holmes had listed. This was an undated pencil sketch of the cottage in its cornfield (an item in Isabel's bequest to the V & A), which came from a sketchbook used by Constable in the summer of 1815, a drawing the artist certainly appears to have used when painting the Cardiff version of the subject (pl. 62).[13] Five years later, in 1965, R. B. Beckett made a further contribution by publishing a letter from a Mr Venables to Constable dated 26 March 1818[14] along with the letter from Allen Woodburn of 25 March[15] which Shirley had included in his 1937 edition of Leslie. Venables's letter had been written during negotiations for the sale of a picture. It is now generally agreed that the negotiations must have been for the sale of the smaller *Cottage in a Cornfield*, that these must have been successfully concluded and that Venables finally purchased the picture for twenty guineas, the sum mentioned by Farington.

62  *Cottage in a Cornfield*, 1815; pencil, $4 \times 3\frac{1}{8}$ (10.2 × 7.8)

Both the V & A *Cottage in a Cornfield* and the related drawing were shown at the Tate bicentenary exhibition in 1976.[16] In the catalogue entry for the painting the compilers summarized what was known about the two exhibits and published the documentary evidence from which it had been concluded that another, smaller version of the *Cottage* had been exhibited in 1817 and 1818. 'We do not know', they said, 'what became of this work, or even, with any certainty what it looked like'. This smaller version of the *Cottage in a Cornfield* was also referred to in the catalogue entry for the pencil sketch. Constable, it was pointed out, had used the drawing for the *Cottage in a Cornfield* exhibited in 1833 'and possibly for the untraced work called "A cottage" shown at the R.A. in 1817'. It was this entry, with the little reproduction of the drawing beside it in the margin which led to the 'discovery' of the Venables *Cottage in a Cornfield* (pl. 60).

After Mr Venables's presumed purchase of the picture in 1818 nothing is known of the painting's history until it was bought from Leggatt's in about 1890 by Alexander C. Ionides,[17] eldest son of the well-known benefactor C. A. Ionides (1833–1900), whose bequest of pictures, pastels, drawings and prints to the V & A included paintings by Botticelli, Poussin, Rembrandt, Delacroix and Degas. Alexander Ionides was not a collector on the scale of his father, but he nevertheless acquired a number of fine drawings and paintings. The *Cottage in a Cornfield* was not the only Constable in his possession at the

[137]

time of his death in 1933. From Alexander Ionides the *Cottage* passed to a grand-daughter, and with her it remained, unknown to scholarship only because it was of a modest size and the family were unaware of its importance in the story of the artist's career. And there it might have remained, had not 'experts' spoken disparagingly of it and had not a member of the family noticed the reproduction of the drawing (pl. 62) while turning the pages of a copy of the Tate catalogue of 1976.

The family had always considered their little *Cottage* to be a genuine Constable. But in recent years their confidence in the work had been somewhat shaken: first by a representative of the art trade who said it was only of mediocre quality, and then by a visitor, reckoned to be an authority, who confidently pronounced the trees on the right-hand side of the picture to be the work of a student. It was perhaps the resultant state of uncertainty about the work that caused the owner's brother in 1978 to notice the illustration in a copy of the Tate catalogue and to read with interest that the drawing was possibly a study for an untraced painting of the subject exhibited at the Academy in 1817. The Tate was contacted; the picture seen. Recognition was immediate. Without the slightest doubt, this little 12 × 10 inch painting was the missing picture, the Venables *Cottage in a Cornfield* (pl. 60).

It is perhaps not without significance that it was the right-hand screen of trees in the picture in particular that had been questioned. For in this part of the painting there are passages that are not at all characteristic, passages that in a sense *were* painted by a student. If the two pictures and the drawing are compared it will be noticed that there are a number of minor differences, changes in the foreground, in the cottage garden, in the quality of light, and possibly in the nature of the crop. Quite the most marked difference, however, is the treatment of the trees on the right-hand side. In the drawing we see a rather untidy but familiar kind of tree. In the V & A version (pl. 61) we have a screen of leaves and branches painted with less conviction than the rest of the work and in a style strongly reminiscent of Gainsborough's early Dutch manner. In the Cardiff picture the screen bears not the slightest resemblance to either. Here it is composed of a tree of no recognisable species, with motionless outspread leaves, its lower trunk hidden by indeterminate russet fruit and foliage and by an elder bush with flowering heads, as the artist himself once described it, 'fore-shortened as they curve over the round head of the tree'.[18]

In Leslie's *Life* we hear that Constable had 'brushed up' his *Cottage* for the 1833 Academy. In fact Constable wrote 'licked up',[19] but the meaning is the same, he had obviously been retouching or reworking the picture for the exhibition. Only one part of the V & A painting, the 1833 exhibit, is stylistically inconsistent with the remainder, the patch on the upper right hand side, an area left bare when the sky was put in and then over-painted with leaves and branches. It must surely have been here that the picture was most in need of licking up. If it was this part, as we strongly suspect, that received treatment in 1833, then

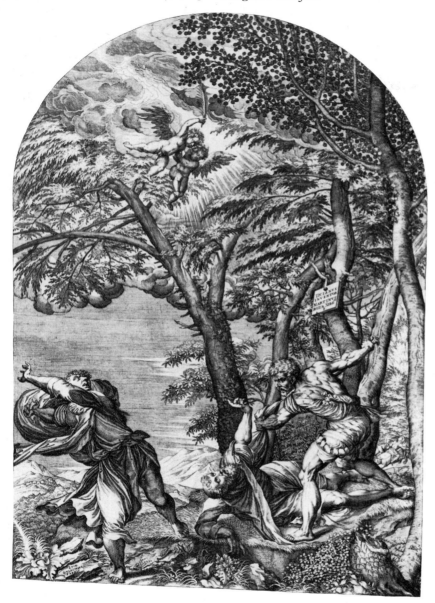

63 Martino Rota after Titian, *St Peter Martyr*, engraving, $15\frac{5}{16} \times 10\frac{9}{16}$ $(39 \times 26.8)$

the trees on the right-hand side of the Cardiff picture, the picture of 1817, must have been painted when Constable had not previously solved the problem of providing a satisfactory side-screen for his composition. The vigorously drawn young oak, or whatever it was, in the pencil sketch of 1815 evidently would not do. For an answer, Constable, it seems, turned to Titian. Pls 64 & 65 are details from the tall tree in the Cardiff picture and from an engraving by Martino Rota of Titian's *St Peter Martyr* (pl. 63), a painting greatly admired by Con-

[139]

64  Detail from pl. 60

stable.* Resemblances of twig and leaf such as those we see here are not coinciden-
tal. Constable, we know, owned a copy of this engraving and it is patently
obvious that the leaves and twigs in his *Cottage* (pl. 64) were taken from the
print. There is further evidence that Constable had the *Peter Martyr* in mind
when working on his little picture. In a lecture he gave at Hampstead Constable
talked at length about Titian's picture and from the notes Leslie took at the
time we learn that Constable pointed out the 'elder bush, with its pale funereal
flowers, introduced over the head of the saint'.[20] The flowers must have been
plainly visible in the oil-copy of Titian's painting that Constable borrowed to
illustrate his lecture. But one can also make out the elder's characteristic upward-
facing blossoms in the engraving, just behind the trunk of the central tree. If
the form and shape of the leaves and twigs in Constable's tree derive from Rota's
print, it can hardly be doubted that the engraving was also the source of the
idea for the elder bush, sited in Constable's picture almost as Titian had placed
it in his composition, at the foot of the main tree.

* *The Martyrdom of St Peter* was painted by Titian for SS. Giovanni e Paolo in Venice. Constable
can only have known it from copies, though the original was seen by many English artists who
visited Paris in 1802. It was destroyed by fire in 1867.

Lots 518–522 in Foster's sale of 12 May 1838 consisted of engravings of the 'Peter Martyr'
by Rota, Le Febre, Zuliani and two other unnamed engravers; 'A copy by CONSTABLE
of the drawing of the same subject, by Titian, in the Lawrence Collection; and another by him
of the Study of Trees by Titian'; and 'Another drawing, in pen and bistre, of the 'Peter Martyr'.

The painting is often referred to in the Correspondence. In December 1836 (JCC III, p.
145) Constable talked of setting three models for the students at the Academy Schools the following
March: 'I have concluded on the three figures in the "Peter Martyr", for I am determined to
sift that picture to the bottom.' On 27 February 1837 (with four weeks to live) he relieved Turner
as Visitor in the Life Academy and set the model to pose as the first of the three figures from
the *Martyrdom* – that of the assassin.

[140]

65  Detail from pl. 63

It is ironic that it was this part of the *Cottage in a Cornfield*, the trees and bushes, to which exception had been taken and which had been pronounced the work of a student. When making these disparaging remarks the visitor had been so near to the truth. He had sensed that there was something odd about the right-hand side of the picture, but had not realised that he was looking at a transplant from the Veneto. In a sense he was also right to call it the work of a student, for in painting thus Constable was tacitly acknowledging Titian as his master. The error was in failing to recognise the painting for what it was, the picture Constable exhibited at the Academy in 1817, along with *Wivenhoe Park* (pl. 10), *Flatford Mill* (pl. 12) and the portrait of his greatest friend, the Revd John Fisher.[21]

Thus the history of these two paintings to date. So far so good. An interesting story perhaps, but as yet an incomplete one. There remain some important questions to be answered. What prompted Constable to paint two pictures of that cottage with its cornfield? When and where did he paint them? What part did the drawing play? Were both, neither or was just one painted from it? At present we have firm answers to none of these questions. For future studies we can, however, lead off with a clue.

The cottage on the edge of the cornfield appears to have been a brick dwelling with a wooden lean-to attached at the back. When Constable painted the V & A version he took a very close look at the rather quaint way in which the junction of the cottage and the lean-to had been effected, and in his picture gave a very convincing account of the awkward in-filling under the thatch where the lean-to over-rode the cottage gable (pl. 66). This degree of scrutiny was neither called for nor possible on the scale he was working when he made his small drawing, but if we look at the lean-to as he has described it with his pencil we see a

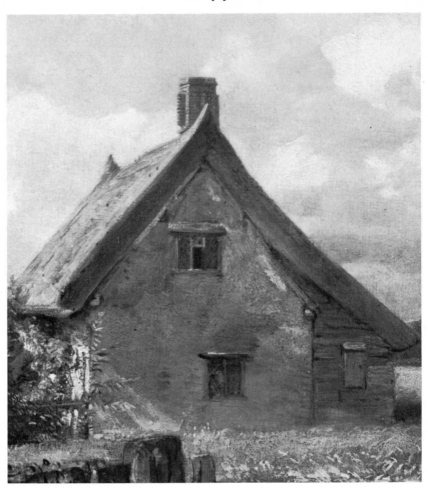

66 Detail from pl. 61

different kind of structure suggested: a roof, thatched down over the end of the gable to match the eave on the other side, with an attached, slightly less thick thatch over the lean-to. It was this mode of thatching and attachment, not the one in the V & A *Cottage*, that Constable chose to depict in the Cardiff version. Although the thatch on the Cardiff lean-to is thicker than in the drawing, there is agreement between the pencil sketch and the Cardiff painting on this point, but not between them and the V & A *Cottage*.

What does this signify? Was the drawing made after the V & A version, and had the cottage been re-thatched in the interval? How did Constable obtain such detailed information for his V & A *Cottage*; from another drawing or direct from the building while at work on the picture? Had he only the drawing to work from when he painted the Cardiff *Cottage*, and was the drawing, because of its small scale, in fact misleading about the roofing, so that he had to fudge the Cardiff thatching, to imagine how it might have looked? There is plenty

[142]

here for debate. The possible sequence of events we at the moment favour is that the drawing was done in 1815, probably in July*; that the V & A painting was started, on the spot, a few days later;† that it was put aside unfinished because the trees (as in the drawing) lacked the necessary pictorial character; and that the Cardiff *Cottage in a Cornfield* was painted in London early in 1817 from the drawing alone, as the other canvas (probably with much else) had been left behind at Bergholt the previous September when Constable left Suffolk to get married.‡

* A drawing of wheatsheaves inscribed '15 Augst 1815. East Bergholt' from the same sketchbook (R. 140) tells us when they were harvesting that year.

† The green, unripened corn commented on by Leslie (1843, p. 24; 1951, p. 72) suggests a date in July rather than August for the picture, in view of footnote* above.

‡ Constable and Maria were back in London from their honeymoon by 10 December 1816, so he could have started work on the *Cottage* before the year was out.

# —PART TWO—

IN the historical survey given in Part One we saw how drawings and paintings by other artists were from time to time mistaken for works by Constable. From the middle of the last century to the present day there has been hardly a decade when such mistakes have not been made. Sometimes the confusion has been deliberate: we have mentioned the faking and forgeries of the 1840s, the paintings Constable left uncompleted that were 'finished into worthlessness', the further forgeries that appeared on the market in the 1860s and 1870s. But in general deliberate forgeries appear to have been greatly outnumbered by the host of works wrongly attributed to him, in the execution of which there was not the slightest intention to deceive: the copies that students young and old have been making ever since there were originals in the national collections available for study, the drawings and paintings by admiring imitators and followers, the works by unknown hands hopefully but mistakenly attributed by subsequent owners. We shall conclude with a short section on a few of the forgeries and less innocent imitators, but most of the second part of our book is devoted to artists who were quite unaware of the confusion their work might be capable of causing. These fall into one of three fairly distinct groups:

a Early acquaintances upon whose style Constable attempted to model his own – J. T. Smith, Sir George Beaumont and R. R. Reinagle.

b Early sketching companions who both influenced and were in turn influenced by Constable – George Frost and John Dunthorne senior.

c Those who copied, imitated or were in some degree influenced by him – his friend John Fisher, his assistant John Dunthorne junior, the younger professional F. W. Watts, three amateurs, W. G. Jennings, George Constable of Arundel and Thomas Churchyard, and the artist's youngest son, Lionel.

These artists are discussed more or less in the order in which their work is historically connected with Constable's.

There are others we shall not be discussing whose works are known to have been confused at one time or another with Constable's – Thomas Stothard, Peter DeWint, Dr William Crotch, Perry Nursey, W. J. Müller (see pl. 67)

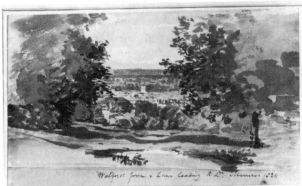

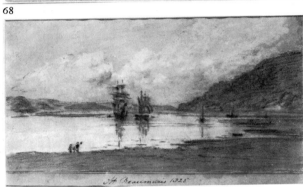

68

69

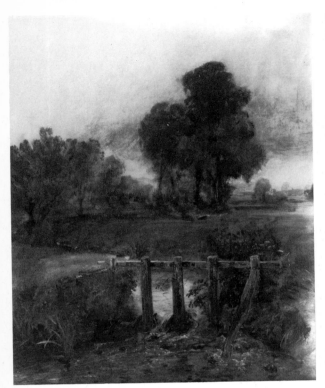

67 William Müller, '*Landscape near Dedham*', oil, 22¾ × 19½ (57.8 × 49.5). Until comparatively recently, attributed to Constable.

68 T. Clark (?Agostino Aglio), *Watford from a Lane Leading to Dr Munro's*, 1824; watercolour, 5 × 8 (12.7 × 20.3). From a large batch of drawings and watercolours that appeared on the market as Constables in the 1960s. Some are still in circulation as such.

69 T. Clark (?Agostino Aglio), *Beaumaris*, 1825; chalk and watercolour, 6½ × 11 (16.5 × 28)

and even Thomas Gainsborough. Besides these there are several whose work we know less well but whom we should perhaps keep in mind for future investigation: the artist sometimes referred to as T. Clark or Clarke (who in turn may have been confused with Agostino Aglio), by whom there passed through the sale-rooms in the 1960s a great many attractive watercolours and chalk drawings catalogued as 'John Constable R.A.' (pls 68–9); friends such as John Jackson, William Purton, the Revd T. J. Judkin (who exhibited 20 landscapes at the Academy between 1823 and 1849) and John Fisher's wife, Mary; the engraver David Lucas and his nephew George; the young pupils G. H. Harrison and John Chase, the second of whom exhibited at the Academy between 1834 and 1870; copyists such as C. R. Leslie's sister Ann and his son Robert.

# JOHN THOMAS 'ANTIQUITY' SMITH

*Born 23 June 1766; died 3 March 1833. Son of Nathaniel Smith, sculptor, chief assistant to Joseph Nollekens, R.A. Trained as an engraver. Earned a living for some years as a drawing master at Edmonton. Exhibited landscapes at RA, 1787 and 1788; married in latter year. 1796, met Constable at Edmonton. 1797, moved to London; published* Remarks on Rural Scenery, *illustrated with his own etchings. 1798, at East Bergholt with the Constables. Became portrait draughtsman and topographical engraver. 1807, published* Antiquities of Westminster; *1815,* Antient Topography of London. *1816, appointed Keeper of Prints and Drawings at the British Museum. 1828, published* Nollekens and his Times, *which has been called 'the most candid, pitiless and uncomplimentary biography in the English language'.[1] Friendship with Constable cooled when latter moved to London. He and later his widow were given assistance in their last years by Constable.*

The first professional artist with whom Constable became acquainted, J. T. Smith played an important part in the events that led up to his final choice of a career. Their correspondence shows that for rather more than two years, while learning the family business in obedience to his father's wishes, Constable was almost openly Smith's pupil. Smith supplied him with plaster casts of anatomical and classical figures, sent him drawings to copy — some of them in turn copies from artists such as Hobbema and Waterloo; instructed him in the art of etching; sent him books, and gave him advice, including the recommendation at one stage that Constable should attend to his father's business. It is likely also that during his stay at Bergholt as the guest of the Constable parents in the autumn of 1798, Smith interceded on their son John's behalf. As R. B. Beckett has suggested: 'It may not be without significance that within three months or so of Smith's visit to East Bergholt Constable had obtained his father's permission to go up to London to study art.'[2]

Smith's manner of drawing became Constable's prime stylistic source during those years before he began his art training proper. The older man's influence is to be seen in Constable's earliest known group of landscape drawings, the eleven rather scratchy pen and ink sketches from a dismembered sketchbook in the V & A, one of which, a view of a cottage and the church at Horton

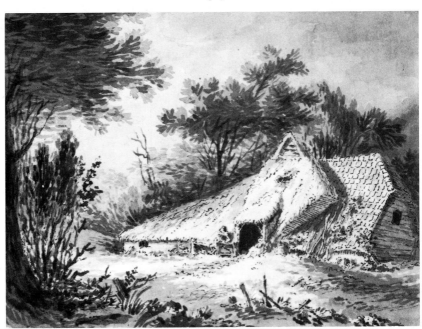

70  J. T. Smith, *Near Deptford*, pen and wash, $4\frac{1}{4} \times 5\frac{1}{2}$ (10.8 × 14)

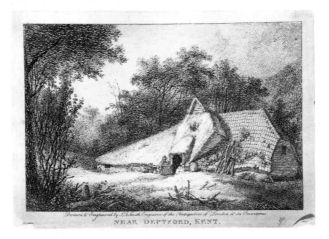

71  J. T. Smith, *Near Deptford*, published 1797; etching, $3\frac{5}{8} \times 5\frac{3}{16}$ (9.2 × 13.2)

St Mary, is dated 1796.[3] Whenever possible Smith avoids drawing a profile with a line. If he is using the etching-needle he will indicate the edge of a form by a change in the density of his shading or his little touches, that is by a tonal or textural change. An example of this is his treatment of the outline of the sloping thatched roof of the barn in both the drawing and the etching, *Near Deptford, Kent* (pls 70–1), an illustration for his *Remarks on Rural Scenery*. When profiles are unavoidable the lines Smith draws are shaky, intermittent, and readily break off into series of little touches wherever possible. This characteristic, or mannerism, suited Constable and he adopted it wholeheartedly, for at that stage

[148]

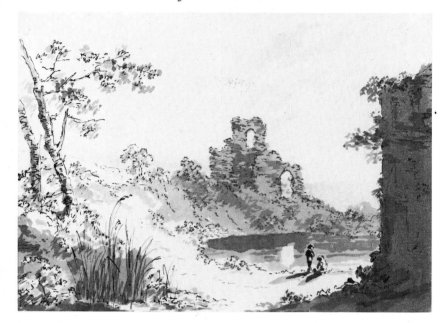

72 *Landscape with a Ruin by a Lake*, pen and wash, $5\frac{3}{8} \times 7\frac{1}{8}$ (13.7 × 18.2). Constable attempting to draw like his friend J. T. Smith.

he was inexperienced, visually inarticulate, and naturally diffident and uncertain. Almost all the drawings in Smith's manner in the Whalley portfolio, the largest cache of early drawings by Constable (see p. 155), are of invented scenes, possibly because they were drawn in the evening after a day's work in the counting-house or one of his father's mills. *Landscape with a Ruin by a Lake* (pl. 72), in pen and wash with a little tinting in the sky, and the *Cottage by a Stream* (pl. 73), a rather bolder pen and ink essay in rural decrepitude, both from the Whalley portfolio, are typical examples. In the latter Constable is not only doing a Smith subject and imitating his pen-work, he has also adopted Smith's method for painting foliage, a build-up of small, increasingly dark touches of monochrome wash, a directional bias in the touches signifying different species of trees.

In those early years Constable made a number of formal, carefully executed topographical drawings in monochrome or watercolour. Two are of local churches, *Stratford St Mary* and *Little Wenham*.[4] A third, *Chalk Church*, was drawn after visiting Kent in 1803.[5] One of the most ambitious topographical works of Constable's career belongs to this period: the four, twenty-inch-wide panoramic views of the valley of the Stour that he did as a wedding-present in 1800.[6] In none of these drawings has he attempted to extend himself stylistically beyond the influence of Smith. There are visible signs of a change, however, of Constable developing and adapting Smith's calligraphy, in some of his less formal studies from nature: in the Yale Center's *A Rural Cot*, dated 179[8?];[7] in Miss Sadie Drummond's delicate pencil and wash drawing, *Cottage among Trees*; and in the beautifully drawn pen and wash sketch, *Cottage by a River*, inscribed on the reverse 'Hadley 1798' (pl. 74).

[149]

73 *Cottage by a Stream*, pen and wash,
$6\frac{5}{8} \times 8\frac{1}{16}$ (16.9 × 20.5)

In the Witt Collection at the Courtauld Institute of Art there is a pen and wash copy by Constable of a drawing made by Smith of a well-head, a sketch the latter made during his Suffolk visit of 1798. It is inscribed, 'Well on the Road from E.B. to Ips$^{ch}$ done in a gig by J.T.S. & this my copy from it'.[8] Another memento of Smith's visit has remained with the Constable family collection. This is a pen and wash drawing by him of a staircase. Sometime after Smith's death in 1833 Constable wrote the following on the backing paper: 'drawn by the late J T Smith the stair Case into the Room over the South Porch – E Bergholt Church – Suffolk – done 1798 – or 9 –'. In both cases, for the identification of authorship we rely entirely on Constable's inscriptions. Without them, so limited is our knowledge of their work at this time, either drawing could have been the work of either Smith or Constable. It is not improbable that there are uninscribed drawings of this period by the two men, besides those we know, that await identification.

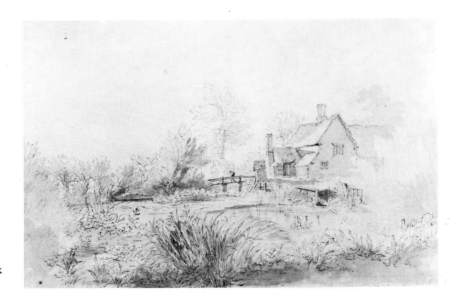

74 *Cottage by a River*, 1798; pencil, ink
and wash, $11\frac{1}{2} \times 17\frac{1}{2}$ (29.2 × 44.5)

# SIR GEORGE HOWLAND BEAUMONT, BART

*Born 6 November 1753 at Dunmow, Essex; died, 7 February 1827. Son of George, 6th Baronet and his wife Rachel, née Howland. Educated Eton and New College, Oxford. Was taught drawing by Alexander Cozens at Eton, by John Malchair at Oxford. 1778, married Margaret Willes of Astrop. 1779, exhibited A View of Keswick at RA; became regular Honorary Exhibitor, showing in all thirty-six works. 1782–3, made Grand Tour. 1787, stayed with mother at Dedham, first of several such visits. 1794, exhibited landscape of Dedham. 1795, probably the year in which Constable was introduced to Beaumont. Acquainted with most of the better-known painters and sculptors and by this time widely acknowledged as collector, patron, landscapist and arbiter of taste. Befriended Constable in his early years in London. Formed close friendship with Wordsworth. 1808, Coleorton, Leicestershire, became his country home. 1820s, friendship with Constable renewed. 1823, offered his collection of Old Masters to help form National Gallery; that autumn Constable spent six weeks at Coleorton.*

After the death of his step-father in 1787, Beaumont stayed with his mother at Dedham on a number of occasions before her move back to Dunmow in 1797. On his visits there Beaumont made a number of pencil and wash sketches. Among those listed are views of Dedham taken in 1790 (pl. 76), 1791, 1795 and 1796; Langham, 1790 and 1796; and the mill at Stratford St Mary. It was Beaumont's habit to carry his favourite Claude, *Hagar and the Angel*, around with him in a box specially made for it. This, on one of their first meetings, he showed to Constable, the first Claude the young artist had ever seen. It seems likely that the baronet would also have shown Constable examples of his own work, including some of the drawings he had done around Dedham.

Beaumont made his collection of Old Master and modern works available for Constable to study soon after his arrival in London in 1799, and the latter made copies of at least two of the baronet's pictures, a Wilson and the Claude *Hagar* now in the National Gallery. Leslie tells us that Beaumont also showed Constable the thirty or so Girtins he possessed 'which he advised Constable to study as examples of great breadth and truth'.[1] Girtin's influence on Constable did not take effect for some time; more immediate was that of Beaumont himself. After seeing a painting by Constable, a commissioned view of Old Hall, East

[151]

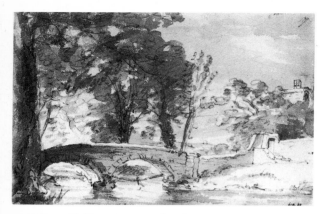

75  *Bridge at Haddon*, 1801; pencil and wash, $6\frac{3}{4} \times 10\frac{1}{4}$ (17.1 × 25.9)

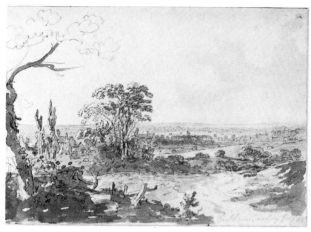

76  Sir George Beaumont, *View of Dedham*, 1790; pencil and wash, $6\frac{1}{2} \times 9$ (16.5 × 22.9)

Bergholt,[2] in July 1801 Farington recorded in his diary that Constable's manner of painting the trees was 'so like Sir George Beaumont's that they might be taken for his'. That autumn Constable made a three-week tour of Derbyshire. Among the drawings Isabel bequeathed to the V & A are twelve of the pencil and wash sketches he did on this trip.[3] As Iolo Williams pointed out as long ago as 1953,[4] some of these are extremely close in style to Beaumont's own manner. The *Bridge at Haddon* (pl. 75) is a more forthright work than Beaumont's well-schooled *View of Dedham* (pl. 76), but the handling is similar — the rapid pencilling and the loose washes — and out of context it would not be difficult to confuse the Derbyshire drawing and others like it with one of Beaumont's.

After their initial kindnesses Beaumont and his wife rather lost interest in Constable — Lady Beaumont was heard to remark that 'he seemed to be a weak man' — and for some years they saw little of him. Their attitude changed when he was elected ARA in 1819 and began to exhibit his big landscapes. In 1823 Constable was invited to visit them at Coleorton. Originally it was intended he should stay a fortnight or so, but their friendship took a new turn and in the end it was nearly six weeks before Constable could tear himself away. Most of the day was spent with Sir George in his painting room; in the evenings the baronet or his wife read aloud or they looked through his collections of prints and drawings. Constable and his host also appear to have amused themselves by making drawings for each other. Sir George drew a sketch on the back of a printed invitation to the Royal Academy banquet of that year (Private Collection). On the printed side Constable wrote: 'This drawing was done at Coleorton by Sir G. Beaumont ⟨and presented to me⟩ one Evening, and was presented to me by Himself Nov.ʳ *1823.* while I [was] on a visit there J.C.'. In addition, Constable copied some of Beaumont's drawings. Two have already

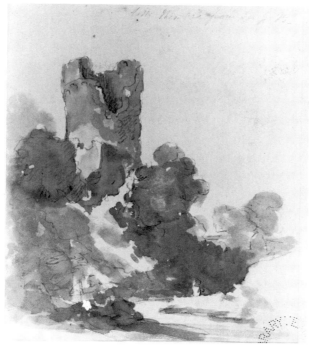

77 John Constable after Sir George Beaumont, *A Ruined Tower*, pencil and wash, $8\frac{15}{16} \times 7\frac{3}{8}$ (22.7 × 18.7)

been published: *Boy Riding through a Wood*, inscribed 'East Bergholt Tuesday Aug 5 1790' and in Constable's hand, 'Coleorton; 23$^d$ Oct. 1823';[5] and *Landscape with Windmill*, inscribed on the verso 'From a drawing by Sir George Beaumont, Bart Done at Coleorton Nov 1, 1823 J.C.'.[6] Neither of these are recognisably by Constable (one would hardly expect them to be), and, while undoubtedly correct, their attribution rests entirely on the inscriptions. Pl. 77, *A Ruined Tower*, is of a drawing in the Exeter album* which, with another of an old house on the verso, is again attributable to Constable only on the basis of the inscription. This, in Constable's hand, reads, 'both these are from Sir G. B$^t$'. Without this inscription, or some other external evidence, it would not have been possible to identify either as the work of Constable.

In distinguishing between drawings by Constable and Beaumont we therefore have a somewhat unusual situation. Twice in his career, but for very different reasons, Constable tried to draw in Sir George's characteristic style. So far as we know this has not as yet created much of a problem. If unknowingly their work has been confused it will doubtless have been on a limited scale. Only in the Exeter album are there known to be drawings about which there might be some degree of uncertainty.

* An album bequeathed to Exeter Public Library by Mrs Edward Fisher in 1897 and, following its rediscovery by Professor Michael Pidgely, transferred to the Royal Albert Memorial Museum, Exeter (No. 99/1978); it contains eighty-seven pages of drawings, mostly by Constable, of which several are of some importance.

# RAMSAY RICHARD REINAGLE

*Born 19 March 1775; died 17 November 1862. Son of Philip Reinagle (animal, portrait and landscape painter; ARA, 1817; RA, 1822) and his wife Jane, neé Austin. Eldest of eleven children, most of whom are listed as exhibitors of one sort or another. Pupil of his father, who for many years worked for Allan Ramsay on replicas of his Royal Portraits. Maintained himself as artist on travels abroad (Holland, Germany, Italy, Switzerland) between 1793 and 1797. Exhibited at RA from 1788 (not from the age of nine as he sometimes boasted) to 1857. Associate Old Water Colour Society and President in 1812. Elected ARA, 1814; RA, 1823. Prolific exhibitor: Continental and English landscapes, portraits, sporting and marine subjects, rustic genre, etc. 1848, compelled to resign from the Academy after exhibiting another's work as his own.*

A veritable Baron Münchausen in the several accounts he gave of his life, Reinagle bragged of his early association with Constable in characteristic fashion when writing to W. H. Ince in 1846: 'M^r Constable was taught by me the whole Art of Painting. When his Father, who was a rich Miller at Bergholt in Suffolk, dismissed him his house [quite untrue] for loving the Art as a profession, I received him into my house for 6 months, & furnished him every thing he wanted – even Money.'[1]

The facts as we know them are that Constable met Reinagle soon after his arrival in London in February 1799 to study art at the Royal Academy Schools (with an allowance from his father); that Reinagle spent part of that summer with Constable and his family at East Bergholt; and that later in the year they were sharing lodgings. For a time, a relatively short period, the two appear to have been close friends, but their aims and outlook on art proved incompatible, Reinagle looking 'only to the surface & not to the mind'[2] and speaking a language whose source was 'not in the heart'.[3] By 1801 Constable had moved out and was living on his own. Reinagle made an effort to maintain their friendship but Constable was unwilling. 'Mr. R – wanted me to dine with him today', he told his East Bergholt crony, John Dunthorne, 'but I declined it, this would be reviving an intimacy which I am determined never shall exist again, if I

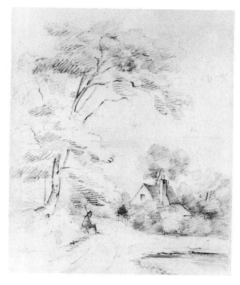

78 *Hay Barn, Flatford*, pencil, $9\frac{1}{4} \times 7\frac{1}{4}$
(23.5 × 18.4)

have any self command. I know the man and I know him to be no inward man'.[4]

A record of this short-lived friendship has made its own small contribution to the prevailing uncertainty about the artist's early work. When Constable's last surviving sister, Mary, died in 1865, she left a number of her possessions, including a portfolio, to her nephew, the Revd Daniel Whalley, Rector of Great Wenham, a Suffolk village not far from Bergholt. The contents of the portfolio, two oil paintings and early drawings by both Reinagle and Constable, were preserved by Whalley's stepson and eventually parcelled out between six members of a subsequent generation. Over a century later, in 1971, one of the six 'parcels' came under the hammer in a provincial sale-room.[5] This group consisted of seven drawings by or possibly by Constable, six by Reinagle (two signed and dated, two correctly attributed to him and two misattributed to Constable), a small oil on a panel (possibly by Mary herself) and a few Lucas prints from the *English Landscape Scenery*. With generous help from the owners of the remaining parcels it has been possible to identify the other drawings known to have come from the Whalley portfolio — nineteen Constables and twelve Reinagles in all — and to attempt an assessment of the group as a whole.

All the Reinagle drawings are in pencil, and all are of imagined or recollected scenes of rural life (pls 79 & 81). All are drawn in an easy, self-assured manner with the pencil moving unhesitatingly over the paper, writing out, as it were, well-tried formulas for the objects represented, for the trees, buildings, animals etc. All appear to have been drawn at about the same time, conceivably to entertain when he was staying at East Bergholt House in the summer of 1799.

The drawings by Constable in the portfolio all belong to the period at the start of his career just before the turn of the century when he was most susceptible

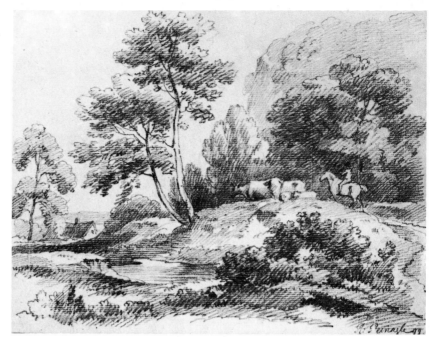

79 R. R. Reinagle, *Landscape with Cattle and Drover*, 1799; pencil, $7\frac{9}{16} \times 9\frac{1}{2}$ (19.2 × 24.2)

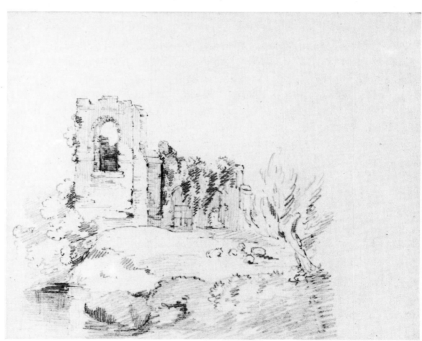

80 ?John Constable, *Ruined Church with Sheep*, pencil, $7\frac{1}{2} \times 9\frac{7}{16}$ (19.1 × 24)

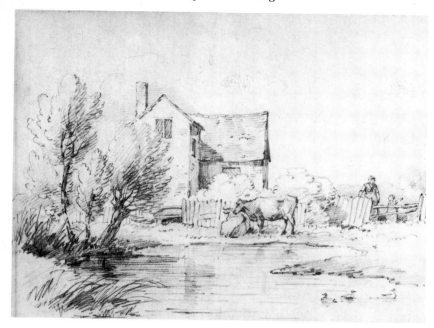

81  R. R. Reinagle, *Cattle by a Pond*, pencil, $7\frac{1}{4} \times 9\frac{1}{4}$ ($18.4 \times 23.5$)

to the influence of others. The majority show most clearly the influence of J. T. Smith (see p. 147), but in a few cases he is to be seen attempting to imitate his newer friend's more dashing, rhythmic way of drawing. How far short he fell of Reinagle's standard of accomplished pencil-work may be appreciated by comparing his *Hay Barn, Flatford* (pl. 78) with Reinagle's signed and dated *Landscape with Cattle and Drover* (pl. 79). In general a drawing or painting by a Constable follower or imitator is to be distinguished from an original by weaknesses of handling or comprehension in the former. With the Whalley group and with some other early works by Constable the reverse is the case, he is the imitator and it is his work which is weaker in execution and understanding. This inversion of what might normally be expected has led to a number of incorrect attributions.

With a certain amount of supporting evidence it is possible to identify drawings such as the *Hay Barn, Flatford* as the work of Constable, but among those that came on the market there are two or three about which it is less easy to make up one's mind – the *Ruined Church with Sheep* (pl. 80), for example. Whoever drew this was obviously familiar with the Smith-like inventions discussed on p. 149 and yet at the same time was plainly attempting to use the Reinagle formulas: compare the pollarded willow in pl. 80 with the more skilfully delineated tree in *Cattle by a Pond*\* (pl. 81) by Reinagle. The *Ruined Church with Sheep*

---

\* This drawing was attributed to Constable in the sale of November 1971. The attribution held when it appeared for a second time in a London sale-room. Reattribution followed upon its appearance in an advertisement in 1979 which gave the drawing's full provenance. The work was sold as a Reinagle when it came up for auction for the third time, in May 1981.

could well be by the slowly-learning Constable, on the other hand it could just as well be by someone else, a member of the family circle, for instance, making a similar attempt.

As far as we know it is only with the contents of the Whalley portfolio (that is with drawings) that there has been any difficulty in distinguishing between the work of Constable and Reinagle. There may of course be other Reinagle-influenced early Constables that have not been identified as such, but if so there are unlikely to be many, the friendship being so short-lived and Constable's rejection of Reinagle and all he stood for so wholehearted.

# GEORGE FROST

*Born, possibly, at Ousden, Suffolk, but christened at nearby Barrow, 22 February 1745; died 28 June 1821. Began as builder, his father's trade, but moved to Ipswich and found employ as confidential clerk at Blue Coach Office. Remained in this post until retirement aged about seventy. Little known of his life, but active for much of it as spare-time landscape draughtsman, topographer and drawing master. 1797, referred to as a drawing master in letter quoted by Constable when writing to J. T. Smith. October 1803, sketched Orwell at Ipswich with Constable. Letters by him to Constable have survived dated September 1807, May 1810, June and August 1818. In 1814 the* East Anglian *published a drawing by him of 'The Market Cross and Shambles, Ipswich, in 1780'. 1818, Elizabeth Cobbold alluded to him complimentarily in a poem published in* The Suffolk Garland. *In 1820 a caller found him making a copy of Gainsborough's* The Mall, *which, with other Gainsboroughs, he owned. June and July 1821, Abram Constable reported Frost's illness and death to his brother.*

From the time of the earliest notices of George Frost, he has been recorded as an admirer of Gainsborough. 'An ardent admirer', the obituarist of the *Gentleman's Magazine* called him in 1822, 'and a close and correct imitator of the productions of his countryman, the celebrated Gainsborough'. Since then he has been generally recognised as the author of a large number of drawings 'in the manner of Gainsborough', some of which have been identified as copies but which might quite easily be mistaken for originals.

Also recorded, since Redgrave's entry in his *Dictionary of Artists* of 1874, was Frost's friendship with Constable. Leslie must surely have known something of the association (he was after all largely responsible for the cataloguing of the Foster sales in 1838, in the second of which there had featured over forty of Frost's black chalk drawings), but he makes no mention of it in his account of Constable's early career in the *Life*. Charles Holmes had also seen the entries in Foster's catalogues, but Frost does not seem to have registered with him either and he appears to have been quite unaware of him as a recognisable artistic personality. In the event, this proved unfortunate.

In 1921, some years after the appearance of his magisterial *Constable and his Influence on Landscape Painting*, Holmes privately published a further, much slighter

work, *Constable Gainsborough and Lucas*, to introduce what was thought to be an important group of early drawings by Constable. In all Holmes discussed and illustrated fourteen drawings, all of which belonged to the one owner, said to be H. W. Underdown, an otherwise almost unknown collector. All were in black chalk. All but the last had been given plausible titles, 'View near Sud-bury', 'Near East Bergholt', etc. Four were justifiably so called: two because they bore a convincing inscription and the others because they portrayed familiar views of Flatford or Dedham Vale. The remaining titles were the merest inven-tions and might just as well have been drawn out of a hat. Holmes found fault with the names of two, 'A Dell near Petworth', and 'View near Petworth', pointing out that they could not be of that area as Constable only visited it towards the end of his life, and saying he thought it more likely that they were of Helmingham Park. Several of the drawings are at present unaccounted for and are only known from Holmes's illustrations, but with the knowledge now available of Frost it is clear that while Holmes was probably correct in accepting the attribution to Constable of some, in at least five cases he was wrong, having mistaken Frost for Constable.* With little or no knowledge of Frost's work this is understandable, but it was a pity nevertheless, for the main theme of his book, Constable's debt to Gainsborough, found ready acceptance, and as Gainsborough-like Frosts were not in short supply there began to accumulate a body of work in pencil or chalk similar in character to those Holmes illustrated which was also assumed to have been drawn by Constable in the years around the turn of the century.

The readiness shown by collectors and dealers to accept Holmes's endorsement of the Underdown attributions is at this remove perhaps rendered more credible if one remembers that at the time he was in an almost unassailable position as Director of the National Gallery and the foremost authority on Constable. His manner of presentation must also have carried a good deal of weight. The follow-ing is a fair example of his informal yet confident style of writing. The drawing he is dealing with is No. 4 in the book, '*View near Lavenham*' (pl. 82), a drawing now thought to be either a George Frost of an inferior quality or a copy of one of his drawings by a pupil.†

> Here we find more mature and capable work again [Holmes writes]. There is a general resemblance to Gainsborough still in the way in which the chalk is handled, both in the tendency to diagonal strokes in the foliage to the right, and more particu-

---

* Holmes, op. cit., 1921: No. 2, *View near Sudbury*; No. 3, *View near Long Melford*; No. 5, *View near Nayland*; and No. 12, *Near East Bergholt* (a study of a horse) are undoubted Frosts. No. 4, *View near Lavenham*, pl. 82, seems more like the work of a Frost pupil.

† Although a number of 'Frosts' may well be by pupils, only one such has yet been identified: William Trent (fl. 1820), a farmer of Washbrook Farm, of whose work Mr P. R. Downing, the Antique Shop, Felixstowe, held an exhibition in 1976. Mr Downing was told by a visitor to the exhibition that his great-great-grandfather had been taught by Frost and that Frost, Trent and Constable were said to have sketched together on occasion.

82 ?George Frost, '*View near Lavenham*', chalk, $12\frac{1}{4} \times 10$ ($31.1 \times 25.4$). One of the drawings attributed to Constable by Holmes in 1921 and accepted as such until quite recently.

larly in the treatment of the pollarded trunk to the left, which might actually have come straight out of a drawing by Gainsborough himself. But the difference between the two men emerges clearly when we examine the trees to the right. The ramification of Gainsborough's trees is free and fluent and graceful, but tends always to become a trick of hand. Constable's work, if in appearance more awkward, has far more of the character and the caprice of Nature. It is evidently based upon a searching study of the personality, the individual characteristics of the tree that the artist is studying, and not upon any sort of personal shorthand for rendering foliage in general. Yet if we recognize that we are dealing here with a more searching naturalism than Gainsborough's, we must also see that we are dealing with a less experienced hand. The horse in the foreground is hardly larger than the clump of burdock leaves to the left, and in proportion to the rest of the objects in the sketch would hardly be two feet high! It was a long time before Constable was able to rid himself of this fault. In his picture of 'Keswick Lake' exhibited at the Royal Academy in 1807 which hangs before me as I write,* the cattle look like pigs rooting under the trees. The sketch with which we are dealing is, of course, much earlier in date, and was probably executed about the year 1802.[1]

The attribution of this kind of drawing to Constable was given the final seal of approval when a group consisting of two Holmes had reproduced (one being the '*View near Lavenham*') with three others was shown in Wildenstein's *Centenary Memorial Exhibition of John Constable* in 1937.† All six were plainly

* Now National Gallery of Victoria, Melbourne; repr. Holmes 1902, p. 32, and exhibited Tate Gallery 1976, No. 79 (as *Lake District Scene*). Hoozee (1979, No. 602) places it in his section of doubtful works.

† No. 86, *View near Lavenham* and No. 93, *View near Long Melford*, repr, Holmes, op. cit., 1921. No. 85, *Landscape, with Man and Cart*, repr. *Studio*, CXXXIX, 1950, p. 24. No. 97, *Road through a Wood*, 'signed: J. Constable'. No. 101, *Freston Tower*.

by the same hand and now it is not so very difficult to see that all six are by Frost, but at the time the attributions appear to have stood unchallenged and it was not long before these and other similar drawings began to find their way into public collections. The only recorded dissent at present known is the one word 'Frost' which Constable's grandson, Hugh Golding Constable, pencilled in his copy of the Wildenstein catalogue against the entry for the first drawing in the exhibition, *Landscape with Man and Cart*. Less like Gainsborough and less obviously the work of Frost were three further drawings in the Wildenstein show, a *Windmill* (which had been presented to the Cooper Art Gallery, Barnsley in 1933), and two ploughing scenes, one of which (owned by P. M. Turner) was reproduced in the edition of Leslie's *Life*, edited and enlarged by Andrew Shirley, which was published in that centenary year, 1937.[2] In the later 1940s and 1950s misattributed Frosts of this type continued to make their appearance and to be accepted as the work of Constable. A few were exhibited as such and gained additional respectability from their catalogue entries.

Meanwhile, Frost himself began to receive a certain amount of attention: initially as a follower and imitator of Gainsborough; then as one of the draughtsmen whose work could be confused with that of Constable; and finally as a minor artist worthy of interest in his own right. His great-nephew Frank Brown had published a book on him in 1895, *Frost's Drawings of Ipswich and Sketches in Suffolk*, but perhaps because it had been locally printed in Ipswich the work appears to have received little or no notice until Mary Woodall published her pioneer work on Gainsborough as a landscape draughtsman in 1939. In her book, *Gainsborough's Landscape Drawings*, Miss Woodall presented and illustrated Frost as the only one of the imitators of Gainsborough's Suffolk manner to emerge as an individual personality. Her knowledge of him as an artist was based on an examination of three sketchbooks or albums, two of which are still available for study in the Ipswich Museum. Although one or two of the drawings she had examined in the albums seemed to be copies of one sort or another after Gainsborough, and some suggested Gainsborough in general outlook, the majority, Miss Woodall pointed out, were not really much like his work in style and would never have been confused with it. In the passage that followed it may be seen how the false trail laid by Holmes resulting from his failure to detect a hand other than Constable's among the Underdown drawings, was capable of leading others astray. 'Frost', Miss Woodall wrote, 'appears also to have made drawings in imitation of Constable, who was a friend of his,* and there is a group of rather large drawings in black chalk which occurs in all the Ipswich sketch books which is extraordinarily close to the sketches by Constable in black chalk, done about 1806;† other small sketches in pencil by Frost are also very close to Constable'.[3]

---

* Brown, op. cit., p. 16, states that Frost was 'on intimate terms of friendship' with Constable.

Shirley, writing in his edition of Leslie's *Life* (1937) about artists whose work could be confused with Constable's, said in passing that it was 'important to mention the work of George Frost', but the notion that there existed a real problem in distinguishing between Frost and Constable only appeared in print for the first time in 1952. This was in the chapter in Iolo Williams's *Early English Water-colours* devoted to the non-professional draughtsmen. 'Almost every group or section of the English watercolour school had its amateurs', he wrote: 'In East Anglia, for instance, there was George Frost of Ipswich (1754 [sic] − 1821), an admirer of Gainsborough and a friend of Constable, to whom (as "early examples") are sometimes falsely attributed the best of Frost's black chalk draw-ings of trees, farmhouses, churches and the like.' Williams further warned his readers that drawings by Frost were occasionally called Gainsborough by over-optimistic owners; that Frost himself taught amateurs; and that some 'Frosts' were in fact by his pupils.

Frost himself and his working association with Constable received little serious attention, however, until the 'sixties, when there appeared Vols I and II of R. B. Beckett's *John Constable's Correspondence*, and an important article on Frost's draw-ings by John Hayes in the quarterly, *Master Drawings*.[4] In the former the relation-ship became an historical reality with the publication of several references in the family letters and two letters from Frost to Constable.[5] In the latter, the main object of which was to establish more clearly stylistic distinctions in the work of Frost and Gainsborough, the then available sources for a full study of Frost were set out for the first time.

Towards the end of his article Hayes turned to the question of Frost's relation-ship with Constable, and discussed some of the apparently interrelated drawings which had been attributed to them. Believing that the Underdown drawings were all by Constable, Mary Woodall had commented on the similarity between them and some of the Frosts in the Ipswich albums, and to account for this had assumed that Frost, the lesser artist, had imitated the more talented Constable. Hayes took the opposite view, and advanced the theory that in fact in the year 1802 it was Constable who had imitated Frost, 'from whom (though far surpass-ing his master in sensitivity) he learnt the art of massing, and of disposing light and shade'. This was an important step, and Hayes very properly illustrated his point by reference to a drawing which must surely be by Constable, the *Mill on the Banks of the River Stour* in the V & A (pl. 83).[6] When the article was written a certain impetus had recently been given to the study of Frost by the appearance of two large batches of his drawings on the market. The first of these, two hundred and forty-two sketches, came from an album once owned by Frost's friend and obituarist, the Revd James Ford. The second, consisting of one hundred and sixty-five drawings, all of which bore the collector's mark

† In a footnote Miss Woodall here refers to plates 2−5 in Holmes's 1921 book (four of the five Frosts that Holmes had illustrated and written about as Constables) as examples of Constable's sketches in black chalk.

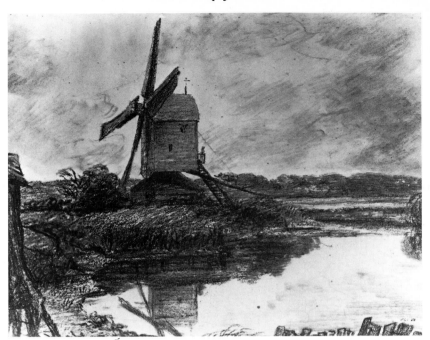

83 *A Mill on the Banks of the River Stour,* 1802; chalk and charcoal, $9\frac{1}{2} \times 11\frac{3}{4}$ (24 × 29.8)

of William Esdaile (1758–1837), had been acquired by Colnaghi's. This new mass of material presented a much more comprehensive picture of Frost's range and capabilities, but it was as yet rather soon for it to have had much effect on the conventional view of Constable's early output that had originated with Holmes, and when making his point that Constable had copied Frost, Hayes mistakenly chose to compare one of the drawings that had just been on the market, *Wooded Landscape with Horse,*[7] with a Holmes 'Constable' of the identical subject, the fictitiously named *View near Lavenham* (pl. 82).

In his book on English watercolours, Iolo Williams had remarked that the best of Frost was sometimes attributed to either Gainsborough or Constable.* This is all too true, and Hayes himself appears have fallen into the same trap in his choice of a drawing to mark the conclusion of this early phase of Constable's work. In its forty or so years of recorded history the drawing in question has had various titles, but is perhaps best referred to as *Hilly Track through Trees* (pl. 94), the name given to it in the catalogue of an exhibition of Constable drawings and sketches at the Huntington Art Gallery in 1961.† This Hayes believed to be a work individual to Constable which could never be confused

* He might have included John Crome, to whom a group in the Norwich Museum had been attributed until it was questioned by Dr Miklos Rajnai. See John Hayes, *The Drawings of Thomas Gainsborough,* 1970, text vol., p. 72, n. 48.

† *John Constable, Drawings & Sketches,* No. 4. First mentioned in print in Shirley 1937, p. 33, as *Road through Wood* (then Coll. P. M. Turner).

with anything Frost produced.[8] In our view the drawing is clearly by Frost and shortly we shall be giving our reasons for the attribution.

The dispersal of the drawings from the Ford album and many of the Colnaghi group must very largely have been the cause of the sharpening of interest in Frost manifest in the 1970s. There were three exhibitions of his work: two in 1971 to mark the anniversary of his death — at the Minories, Colchester (shared with Thomas Churchyard), and the Northgate Gallery, Ipswich — and one in 1974 at Gainsborough's House, Sudbury. Among the exhibits chosen for the Sudbury show were two watercolours, one by Constable (dated 5 October 1803, from the V & A) and the other by Frost, which Michael Rosenthal (one of the organisers) had recognised as being of an identical scene, warehouses and shipping on the Orwell at Ipswich, a view that in all probability the two men had taken at the same time. This was a most helpful discovery.[9]

Evidence of a further change of attitude towards Frost in the 1970s is to be found in an article by Denis Thomas, 'George Frost and the Gainsborough tradition', which appeared in the October 1971 issue of the *Connoisseur*. In this, for the first time in print, and then only in the form of a mild enquiry, the issue was raised of Holmes's acceptance of the Underdown attributions. 'We may wonder in passing', Thomas asked, referring to the '*View near Lavenham*' (pl. 82), 'whether the qualities he refers to in his description do not properly belong to Frost rather than to Constable'.

Very little has been written about Frost since this article and at present it is not possible to say how much notice has been taken of Thomas's lead. But from recent sale catalogues and from the subsequent history of some of the items they list one gathers that drawings hitherto accepted as early Constables, especially those in black chalk, are now regarded with a greater degree of circumspection.* A comparison of one or two early drawings by Constable with a few by Frost, and a look at some in need of reappraisal may help to clarify the nature of this particular problem.

Frost himself worked in a number of different styles. This in itself creates problems. The media he used range from oils to 'lead' pencil. In his subject-matter he restricted himself to local topography, especially to views in and around Ipswich, and to imagined and observed scenes of the countryside. For our purpose we only need to consider certain of his landscape drawings in pencil and black chalk, those, that is, which relate to drawings we know to be by Constable or which have been attributed to him. Even within this comparatively restricted group however it will be noticed how varied is his approach and how his treatment alters from drawing to drawing. In the *River Scene with Shipping*, for instance

---

* The '*View near Lavenham*' (pl. 82), for instance, was sold at Sotheby's, 13 March 1980 (52) as 'G. Frost'. Another Frost was sold by Sotheby's, 26 March 1975 (223) as 'J. Constable, Aldeburgh Abbey' (repr. R. B. Beckett, 'Constable's Early Drawings', *Art Quarterly*, XVII, 1954, p. 378, fig. 6, as John Constable, *Ecclesiastical Ruin*).

84 George Frost, *River Scene with Shipping*, pencil, 8 × 12$\frac{13}{16}$ (20.3 × 32.6)

85 George Frost, *A Hedgerow*, chalk, 10$\frac{3}{8}$ × 9 (26.3 × 22.9)

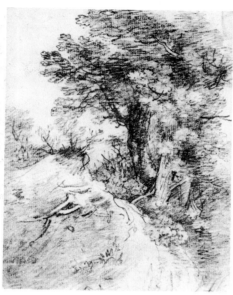

86 George Frost, *Tree Study*, pencil, $7\frac{1}{8} \times 5\frac{5}{8}$ (18.1 × 14.3)

(pl. 84),[10] the emphasis is on plain factual statements; in the more summarily executed sketch, *A Hedgerow* (pl. 85),[11] it is almost entirely on the unifying effect of the broadly massed shadows. In the *Tree Study* (pl. 86)[12] he appears to be chiefly concerned with the rendering of texture and of growth, and in *The Edge of the Wood* (pl. 87)[13] with the harmonizing of the subject into a pictorial composition. The majority of Frosts which appeared on the market in the 1960s were in black chalk, and it is with strongly executed drawings in this medium such as *The Edge of the Wood* that one has come to associate him most readily. But a lighter touch, producing a rather more blonde overall effect, is just as characteristic.

When distinguishing between the drawings of Frost and of Gainsborough or Constable it has been the practice to point up weaknesses in Frost's work and to compare and contrast these with more skilfully or sensitively executed passages in examples by the other two. This system, based on the assumption that the work of a lesser artist will always be inferior to that of a greater one, has its uses but it also has its limitations. One of the disadvantages is that for the comparison to be effective, *perceptibly* weaker work by the inferior artist has to be selected and his better efforts therefore tend to be ignored or put aside. Occasionally, as in the present case, this will defeat itself, and just because they do not exhibit the expected weaknesses examples by the less gifted artist (in this case Frost) will be credited to a more talented one (Constable).* A more reliable

* Other, and grander artists have similarly suffered. One of Perugino's masterpieces, his *Crucifixion with Saints* in the National Gallery of Art, Washington, was wrongly believed to be a youthful work by Raphael until well into the twentieth century, 'not because it resembled his [Raphael's] work in any significant way, but because it was felt to be too good for Perugino'. David Alan Brown, *Raphael and America*, National Gallery of Art, Washington, 1983, pp. 110–11 and n. 6.

[167]

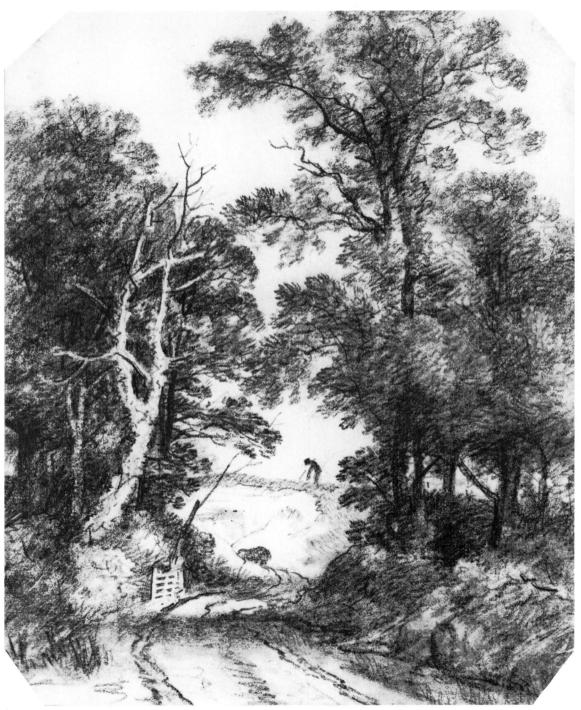

87  George Frost, *The Edge of the Wood,*
chalk, $10\frac{5}{8} \times 8\frac{1}{2}$ (27 × 21.6)

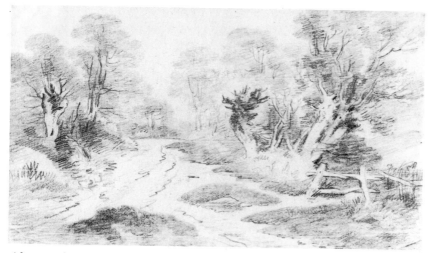

88 George Frost, *A Grassy Track*,
pencil, 8 × 13⅛ (20.3 × 33.3)

aid towards recognition is the identification of characteristics, 'graphological peculiarities', A. E. Popham called them,[14] which typify the hand of one artist and which do not consistently and regularly occur in the work of another, however closely they were associated.

In Frost's drawings there are a number of such recognisable mannerisms, and a few of these can help in distinguishing his work from Constable's. First, there is a general characteristic which may well have reflected an aspect of his psychological make-up, an apparent disinclination to dwell on any one thing or on any one part of a drawing for very long. This expresses itself in a number of ways: in the sheer quantity of sketches produced, many of them very slight; in his restless, rapidity of touch; and, most tellingly, in his liking for what we may conveniently call the vignette.

The *Tree Study* (pl. 86) and the drawing of the hedgerow (pl. 85) are samples of his quick, on-the-spot sketching technique. In the Ipswich albums there are many similar but slighter examples of the notes he made in the countryside. Both studies well illustrate the restless movements of hand and wrist, the varied pace and pressure, the rhythmical flicks and squiggles, and the rapidly scribbled-in shading he employed. In the roots, or branches (or whatever they are) on the bank to the left of centre of the *Tree Study* we have a specimen of a Frost vignette – in this case a detail consisting of little more than a few branches (or roots) sketched in outline and then strengthened by surrounding shading. Further examples are to be seen in *A Grassy Track* (pl. 88),[15] which in fact is a composition of vignettes tenuously linked, a single one, the pollarded tree, to the left, and a loosely-knit group to the right in which each part is seen light or dark, as the case may be, against an opposing dark or light background. Requiring closer examination, but still a recognisable feature is the more closely knit, yet similarly contraposed detailing of the branches among the trees in the *River Scene with Shipping* (pl. 84).

A second Frost characteristic is to be observed in his method of shading with black chalk. *A Hedgerow* (pl. 85) shows the initial 'washes' with which he represented twig and leaf masses, 'washes' often rounded in form which he would overwork with heavier cross-hatching to indicate depth of shadow and on top of which he would particularize branches and the textures of foliage. With a stump or perhaps with his fingers, at various stages it was his habit to soften the edges of the shaded areas or blur the granules of chalk into a smokier tone. In *The Edge of the Wood* (pl. 87) one can see passages that were done at each of these stages.

In the foreground of this last drawing we can also see a third characteristic, a mannerism which almost amounts to a signature in any drawing by Frost featuring a road or track. This is the wriggling zig-zag with which he indicated cart-ruts. Several rather more freely dashed-in examples of this revealing 'tell-tale' may be found in the *Grassy Track* (pl. 88). Finally, occurring rather less often, but a valuable key nevertheless, is a tendency of Frost's to represent a path or track uprearing itself, as it were, in a manner not quite in accordance with one's estimation of the angle of sight, as in pl. 86, the *Tree Study*. These four character-istics — obtuse perspective, snaky ruts, separatism (i.e. the use of vignettes) and a general fidgetiness — are by no means the only 'signals' a Frost drawing emits, but for the few simple identification tests we are going to make they will probably prove sufficient.

At present we do not know enough about Constable's formative years to be able to say exactly how important was the part played by Frost in his develop-ment. But a drawing like the *Mill on the Banks of the River Stour* of 1802 (pl. 83) bears witness that there had recently been a remarkable change in the nature of Constable's experimentation, and as this change was towards a tonalism and free handling of chalk and pencil new to him but characteristic of Frost, it is reasonably safe to assume that their association was in some way or other respon-sible for this change. We shall have a clearer picture of Constable's development when we know who influenced whom, when, and to what extent. To understand this one must be able to distinguish between Constable and Frost, and also between Frost and some of his pupils. This will eventually require a full and detailed enquiry. Here, we shall only be looking at the workings of one of the methods that could be used in such an investigation.

For this, however, we need some sample material. Three Constables, *Mill on the Banks of the River Stour* (pl. 83), his view of Hackney (pl. 89)[16] and a Lake District drawing (pl. 90) with some of the Frosts we have already looked at will serve to represent the polarities. *Track by a Pool* (pl. 91),[17] *View near Langham* (pl. 92),[18] *Figure on a Roadway* (pl. 93),[19] *A Hilly Track through Trees* (pl. 94), *Near Flatford* (pl. 95) and *Dedham Church — a Storm Approaching* (pl. 96)[20] will adequately represent the kind of drawings in need of reappraisal. We have already dwelt on some at least of Frost's more obvious characteristics and mannerisms, the acids, so to speak, we shall be applying in our tests. Constable's characteristics

*George Frost*

89 *Hackney*, 1806; pencil, $4\frac{3}{4} \times 7$ $(12 \times 17.8)$

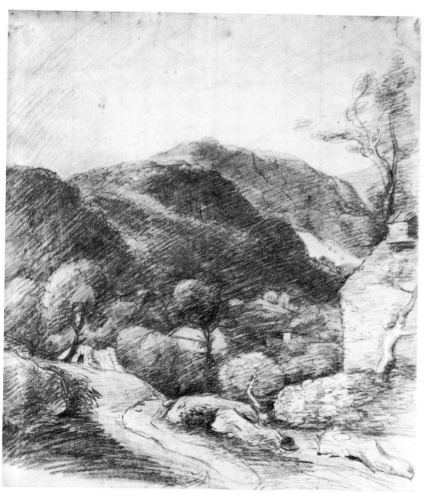

90 *Hamlet in a Lakeland Valley*, 1806; pencil, $16\frac{3}{16} \times 13\frac{5}{8}$ $(41.6 \times 34.6)$

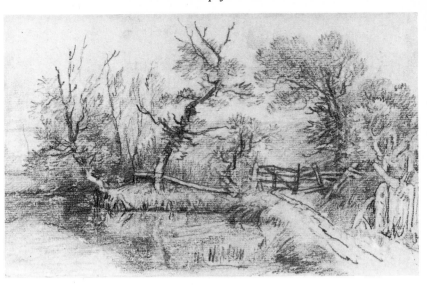

91 George Frost, *Track by a Pool*, pencil and wash, $5\frac{3}{8} \times 8\frac{5}{16}$ (13.7 × 21.2) Here attributed for the first time to Frost.

at this early stage in his career are less easy to identify, but with knowledge of his later work it is possible to point to a few that are not to be found in drawings by Frost. First there is the somewhat intangible but all-important homogeneity which informs Constable's landscape drawings, an integration of forms which sometimes contrasts sharply with the piecemeal handling in a Frost (compare the denser massing of the tree and hedge in the Hackney sketch, pl. 89, with the otherwise similar treatment in Frost's *Hedgerow*, pl. 85). Then, Constable pays greater attention to sculptural form and space or spaces (compare Frost's rather dismissive rendering of the concavities in the little quarry in the *Edge of the Wood*, pl. 87, with Constable's simple depiction of the ditch on the left of his sketch of Hackney). Thirdly, Constable is both less certain and less consistent in his use of line. In his *Mill* (pl. 83) he uses it unobtrusively to contain and reinforce fields of tone, or, as along the foreground shore in this drawing, rather tentatively, in short strokes. In the *Hackney* of 1806, line is hardly used at all. Later that year, in the Lake District pencil drawings he employs a line aqueous, flowing, expressive (pl. 90). But nowhere in his landscape studies do we see anything to match Frost's cursive elegance, the linear sprightliness to be found in drawings such as the *Grassy Track* (pl. 88).

With these few distinguishing characteristics in mind let us now see what results we get when we try them out on drawings that for various reasons, but chiefly on stylistic grounds, have been attributed to Constable. Pl. 91 is of a drawing, *Track by a Pool*, which was bought in 1889 (presumably as a Constable) from Shepherd Bros, a firm of dealers, which in 1950 was given to the Fitzwilliam Museum, Cambridge, and which in 1976 was published as a Constable in a catalogue of the Museum's holdings of his drawings and watercolours. It will be observed that the drawing was executed by a restless, nervous hand, working,

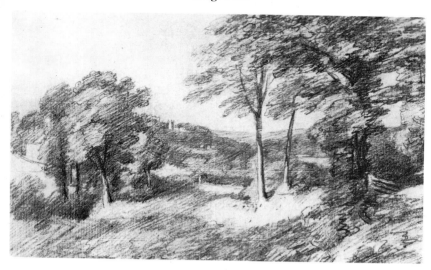

92 *View near Langham*, chalk, $7\frac{3}{4} \times 12$
(19.7 × 30.5)

it would seem, at speed; that it is composed of inter-linked but essentially separate
elements; that trunks, branches and twigs are contraposed light and dark against
their background in a consistent system; that the touch is light and springy;
and finally that along the track itself the ruts are drawn as running zig-zags.
In a note on *Track by a Pool*, the Fitzwilliam catalogue points out that the tech-
nique is 'close to that of Frost'. It is indeed. On spotting the autograph cart-tracks
one is immediately on the alert for other Frost 'peculiarities'. They are plentiful.
And a comparison with the Ipswich *Grassy Track* (pl. 88) produces such a
succession of further similarities that one can hardly be in any doubt about the
authorship of the Fitzwilliam drawing – if the Ipswich sketch is by George
Frost, then this must surely be by him also.

Neither the history nor the whereabouts of the next example, the *View near
Langham* (pl. 92), is at present known, but at least it has the appearance of having
been correctly titled, the distant church and wooded slopes bearing a close resem-
blance to the numerous portrayals of the subject by Constable. After identifying
the scene, one's attention is probably drawn to the bold, contrasting accents and
masses of dark and light, and to the strong, leftward inclination engendered by
the vigorous shading. Other features one notices are the wildly scribbled-in
outlines of foliage and leaf (in the foreground as well as around the shapes of
the trees) and the more judicious, controlled use of outline to give substance
to the trunks of the trees. These are helpful pointers towards an identification,
but by far the most revealing thing about the Langham view is that for all the
energy that went into its making, the drawing achieves unity and cohesion. Now,
if there is a certain degree of homogeneity in some of Frost's slighter sketches,
the *Hedgerow* (pl. 85) for example, it is markedly absent in his larger studies,
which, as we have seen, tend to remain what they essentially are, a sum of
individually observed or conceived parts. Only a steady, controlled release of

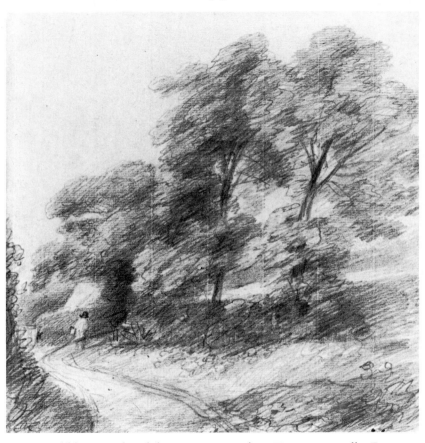

93 *Figure on a Roadway*, pencil, $8\frac{1}{2} \times 7\frac{1}{2}$ (21.6 × 19)

power could have produced the *View near Langham*. Temperamentally, Frost was quite unsuited for sustained endeavour; Constable, on the other hand, was cap-able of working at high pressure for long periods at a stretch. When it last surfaced, in 1949, the Langham drawing was thought to be by Constable. Was this not perhaps correct? Possibly the next drawing up for reappraisal will help us to decide.

At first glance *Figure on a Roadway* (pl. 93) – acquired by the National Gallery of Canada, Ottawa, as a Constable in 1973 – might be mistaken for a Frost. The subject is one he might well have chosen; he often hatched his shading similarly at an angle throughout. But there the resemblance ends. Frost is more conventional in his use of the pencil-point. We would never find him working in the midst of such a storm of wriggling outlines and frantic shading. Neither the sweeping lines of the branches and tree-trunks nor the gentler flow of the lines along the roadway are his. It was not his way either to sacrifice fidelity of detail, colour and texture in this manner for the sake of such simple, generalised statements about landscape forms. It is just such features, however, and evidence of just such a sacrifice that we find in Constable's Lake District pencil drawings

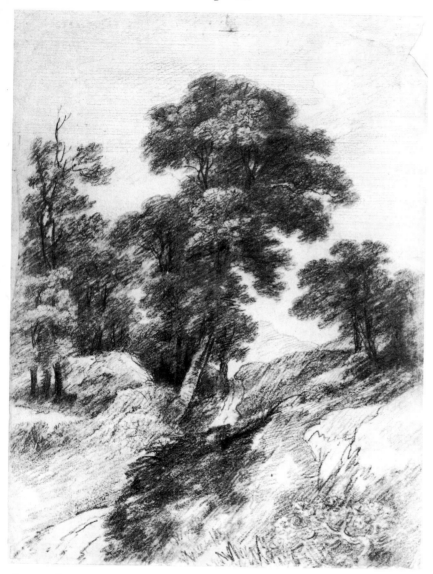

94 George Frost, *Hilly Track through Trees*, chalk, $17\frac{1}{8} \times 12\frac{1}{2}$ (43.5 × 31.8)

of 1806. Compare *Figure on a Roadway* with pl. 90, *A Hamlet in a Lakeland Valley.* The tracks are almost identical. In both, over scribbled and flowing outlines the pencil-point shades unceasingly to and fro, all the time modelling form, yet at the same time maintaining a sense of unity. In the treatment of the trees the latter differs only in the extent to which the process of simplification has been carried. The authenticity of the Lakeland view can hardly be questioned. It must therefore follow that the Ottawa drawing is by Constable also. And what of the *View near Langham*? How does that now stand? We saw it bore a close resemblance to the *Figure on a Roadway*. Now that the attribution of that drawing

[175]

appears to have been correct, is the degree of resemblance not proof enough that this too is by Constable?

When tested for Frost characteristics neither of the two preceding drawings came up with a convincing positive. The next one, *Hilly Track through Trees* (pl. 94), is very different. At every hand familiar 'signatures' abound: the stunted tree in the bottom right-hand corner – a classic Frost vignette; the spiky outlines of the grass and of the edge of the bank just above; the zig-zags running up the track (partly obscured by what looks like a dark bush); the steep curves of the track itself; the blurred tree-silhouettes, softened with finger or stump. All are passages of a kind we have seen in Frost. And the *Hilly Track* looks even more like a Frost when it is compared with a drawing of his such as the elegant *Edge of the Wood* (pl. 87). There are typical deft touches in both, in each bare topmost twigs are shown dark against the sky. In both there is a similar decorative play with the contrasting smudged and gritty textures obtainable with chalk and stump. When first recorded in 1937, the *Hilly Track through Trees* was listed as a Constable. Since then it has been catalogued, exhibited, sold at public auction and written about as one.* The original attribution was based solely on internal, i.e. stylistic evidence. It was made not long after the appearance of Holmes's book and those who thought the drawing was by Constable were apparently unaware of the work of George Frost. Stylistic attributions inevitably reflect prevailing knowledge of the subject, and with Frost a recognisable artistic personality it is only to be expected that we would now see the drawing differently. Today, the drawing in appearance being so much more like a Frost than a Constable, it is unlikely that the same attribution would be made.

So far we have managed to arrive at some sort of conclusion about the authorship of the drawings. This hardly seems feasible with our two final examples, *Near Flatford* (pl. 95) and *Dedham Church – a Storm Approaching* (pl. 96). *Near Flatford* was originally one of the Underdown group of drawings. Holmes said he thought it would be rash to determine its topography, but pointed out that the trees had some resemblance to those just below Flatford Mill. If the subject is Flatford, this does not rule out Frost, for drawings by him have survived of both Flatford and East Bergholt.[21] The drawing has characteristics the two men shared. The subject is a simple one, not unlike Frost's hedgerow study (pl. 85), and the loosely rubbed-in, rounded shapes in the trees could also be his, as could some of the branches and twigs. But the simplicity of the image is equally reminiscent of Constable's *Mill* (pl. 83), and the rounded silhouettes of the foliage relate equally to the curious, globular tree-forms to be found in many of his drawings of 1805–6 – in the Lakeland *Hamlet* (pl. 90) for instance. One could continue, but without materially affecting the issue. However closely we look

---

* John Hayes, 'The Drawings of George Frost', *Master Drawings*, IV, No. 2, 1966, p. 167.

96 Unidentified artist, *Dedham Church –
a Storm Approaching*, chalk, 6½ × 7½
(16.5 × 19)

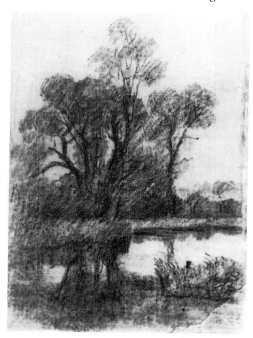

95 John Constable or George Frost,
*Near Flatford*, chalk, 11 × 8 (28 × 20.3)

at it, without partisanship the drawing remains the same – evenly balanced,
as far as labelling is concerned, between Constable and Frost.

*Near Flatford* is an attractive, intriguing work, with no recorded history prior
to its appearance in Holmes's book. Our last is a less interesting drawing, but
with a much more impressive pedigree. *Dedham Church – a Storm Approaching*
(pl. 96) was one of a group of four that came up for public auction in November
1980. The other three were watercolours by Constable of Dedham, Epsom and
Borrowdale, all of high quality and of unquestioned authenticity.[22] This hitherto
unrecorded group had been in the possession of the owner's family for several
generations, having it seems passed out of the Constable family collection in
1888 to a Mr West. This one, *Dedham Church*, is inscribed on the back in pencil,
first 'John Constable' and then, somewhat ambiguously, 'Frost's'. It is a difficult
drawing to place. The subject could well be Dedham, but from what viewpoint?
Apart from the tower, the drawing offers not one topographical clue. The inscrip-
tion on the back cannot be ignored, but how exactly is it to be interpreted?
The medium, black chalk and stump, and the heavily lined paper straightway
suggest Frost or possibly Constable, but how, in terms of either, are we to explain
the messy, rather clumsy execution, the apparent lack of intent? Is it by another
hand? Maybe; but if so how did it fetch up with the other three, and why
'Frost's'? At the sale there seems to have been general agreement that it was
not by Constable, for the watercolours fetched £10,000, £3800 and £5200
respectively, *Dedham Church* only £260. We may not have heard the last of
this perplexing drawing. It deserves a proper explanation.

[177]

# JOHN DUNTHORNE,
# SENIOR

*Born c. 1770. 1793, married Hannah Bird, a widow of East Bergholt. Plumber, painter, glazier,*
*village constable and enthusiastic amateur artist. Lived next door to the Constables and became*
*early painting companion of the son John. 1816, reluctantly, for reasons not fully understood,*
*'as he was determined to continue in his perverse and evil ways',\* Constable broke with him.*
*The friendship was renewed later, in the 1830s. Died 1844.*

Other than the dozen or so letters Constable wrote to Dunthorne, the best record
of their friendship is the account given by Leslie in the early pages of his *Life*.
Constable, he says, 'had formed a close alliance with the only person in the
village who had any love for art, or any pretensions to the character of an artist,
John Dunthorne, a plumber and glazier, who lived in a little cottage close to
the gate of Golding Constable's house. Mr. Dunthorne possessed more intelli-
gence than is often found in the class of life to which he belonged; at that time
he devoted all the leisure his business allowed him, to painting landscapes from
nature, and Constable became the constant companion of his studies. Golding
Constable did not frown on this intimacy, although, he was unwilling that his
son should become a professional artist, and Constable's attempts were made
either in the open air, in the small house of his friend, or in a hired room in
the village.'[1]

Some indication of the seriousness with which Constable and Dunthorne
pursued their studies together in the open air may be obtained from a marginal

* JC to Maria Bicknell, 2 February 1816: 'My acquaintance with Dunthorne has as you know
for a long time given me uneasiness — and it was encreased by what you told me when I was
last with you — I have made a great struggle with myself — I have given the best advice in my
power for some time past — but as he was determined to continue in his perverse and evil ways
— I was determined not to countenance them by being seen with him — accordingly I begged
Mr Travis [the local surgeon, a frequent go-between in the village] to send for him and tell him
my fixed determination — which is that he does never come to this house without being sent
for on his business & that I should never call upon him — without he chooses to alter his conduct,
both at home and abroad — but he is so bent on his folly that I see no probability of any change'
(JCC II, p. 171).

note made by David Lucas in his copy of Leslie's *Life*. 'Both', he wrote, 'were very methodical in their practice taking with them into the fields their easels and painted one view only for a certain time each day when the shadows from objects had changed their position the sketching was postponed untill the same hour, the following day.'[2] Constable's surviving letters to Dunthorne, most of them written between 1799 and 1803, show how close at that time the two men were in their understanding of landscape painting and the technical problems involved. In the correspondence there are also occasional references to their sketching and to Dunthorne's own work. In 1799 Constable wrote from London that on his return he hoped to see some of the drawings Dunthorne had been making from nature. The following spring he wrote, 'This fine weather almost makes me melancholy; it recalls so forcibly every scene we have visited and drawn together.'[3] And in the only surviving letter from Dunthorne, of 21 March 1802, he mentions earlier letters in which he had something to tell Constable of what he 'had been doing in the art'.[4]

In January 1937 there was held at the Albert Hall, Colchester, an exhibition of paintings by two distantly related pairs of fathers and sons, the John Dunthornes of East Bergholt and the James Dunthornes of Colchester.* In all, there were twenty-eight pictures on view, fifteen of which were by the Bergholt Dunthornes. Included among the exhibits were a letter from Dunthorne senior to Constable and a violoncello made by him.† Andrew Shirley evidently saw the exhibition, for he lists the paintings shown by the Bergholt Dunthornes and comments on the style of the first four pictures, suggesting that they were likely to be by the father as they echoed too early a style of Constable's to have been painted by the son.[5] It is likely that the four paintings, 'Country Scene', two tree studies, and 'The Terrace, East Bergholt', are still in existence.‡ It is also quite possible that other paintings by him, and drawings too perhaps, have survived. To date, only one work has been attributed to the elder Dunthorne, the *Flatford Lock* illustrated in pl. 97.[6] This, however, is a painting of special interest as it brings us very near to Dunthorne as Constable's painting companion, as his man Friday. On 7 September 1814 Constable made a drawing of a newly-built, nearly completed barge in the dry-dock at Flatford. This dock was sited

---

* James Dunthorne the elder (1730–1815), local topographer and portraitist; James Dunthorne the younger (c. 1758–92), artist of semi-caricature and theatrical subjects who kept a print shop in Colchester. In his letter to Constable of 21 March 1802, Dunthorne refers to a letter he had received from Dunthorne of Colchester 'which requests me to assist him to paint some perspective on the wall behind the organ in Hadleigh Church which will be ready to be done in about a fortnight's time. This is a job I should like very well but I am afraid I shall not be well enough to assist him'.

† Dunthorne mentions a violoncello that he had 'nearly finished' in his letter to Constable of 21 March 1802.

‡ These are given in Shirley's list (1937, p. 69) as follows: '*Country Scene*. $11\frac{3}{4} \times 9\frac{7}{8}$ in. W. Hicks, Esq., Colchester. *Study of Trees*. $17\frac{1}{2} \times 13\frac{5}{8}$ in. Mrs F. Clark, Colchester. *Study of Trees*. $11\frac{1}{2} \times 9\frac{3}{8}$ in. J. R. Hicks, Esq., Colchester. *The Terrace, East Bergholt*. $9 \times 13\frac{1}{4}$ in.'.

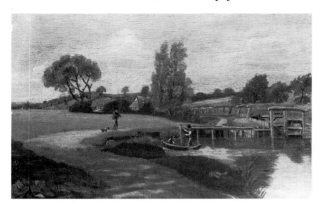

97 John Dunthorne senior, *Flatford Lock*, 1814; oil, 9¼ × 14⅛ (23.5 × 35.9)

on the further bank and just downstream from the cottage to be seen in Dun-thorne's picture. That autumn Constable painted his well-known picture of the subject, *Boat-building*, a painting that, he told Leslie, was executed entirely in the open air. Dunthorne's rather smaller picture of Flatford Lock is dated October of that year. The angle of the shadows in the two pictures indicates that they were painted at about the same time of day. One cannot be certain that Constable and Dunthorne were together, within hailing-distance that is, when they painted their two pictures, but it seems very likely that they were.

At present there is little more to be said about the work of Dunthorne the elder. We still have to find the four paintings mentioned by Shirley. Until these and perhaps other examples by Dunthorne have been identified it would perhaps be advisable to keep an open mind about some of the weaker oil sketches of Bergholt and Stour valley subjects that have been called 'early Constable'.

# THE REVEREND JOHN FISHER, ARCHDEACON OF BERKSHIRE

*Born 1788; died 25 August 1832. Educated at Charterhouse (of which his father was Master) and Christ's College, Cambridge, where he took his degree in 1810. Ordained, May 1812. Acted as domestic chaplain to his uncle, Dr Fisher, Bishop of Salisbury. 1813, granted licence to hold vicarage of Osmington with Ringstead, Dorset. Married Mary Cookson, daughter of Dr William Cookson, Canon of Windsor, 3 May 1816. Fisher's friendship with Constable began in 1811 when the artist stayed in Salisbury at the Palace with the Bishop and his wife. 6 December 1817, Fisher installed Archdeacon of Berkshire. Succeeded to office of Canon Residential and took up residence in Leydenhall, the only house in the Close for canons. By gifts, also licensed to hold vicarage of Gillingham, Dorset. When health began to fail, was taken to Boulogne for change of air. Died suddenly, leaving widow and young family. Constable stayed with Fisher at Salisbury or Gillingham in 1820, 1821, 1823 and 1829; in 1821 he accompanied Fisher on one of his Berkshire Visitations. Fisher visited or stayed with Constable in London on a number of occasions. Constable's correspondence with Fisher and his family was extensive; more than two hundred letters are documented.*

The story of Constable's friendship with John Fisher is a feature of Leslie's *Life*, but the greater part of their correspondence was unknown until R. B. Beckett published his pioneer work, *John Constable and the Fishers; the Record of a Friendship*, in 1952. This was re-issued, with some additional material, in 1968 as Vol. VI of *John Constable's Correspondence*. A few more letters were published in the eighth volume of the series, *Further Documents and Correspondence*. For Constable, his friendship with Fisher was of inestimable value, a fact he frequently acknowledged in his letters to the Archdeacon. In one he talks of it as 'the pride, the honour and the grand stimulus' of his life.[1] In another, he pays this tribute:

> Beleive — my very dear Fisher — I should almost faint by the way when I am standing before my large canvasses was I not cheered and encouraged by your friendship and approbation. I now fear (for my family's sake) I shall never be a popular artist — a Gentleman and Ladies painter — but I am spared making a fool of myself — and your hand stretched forth teaches me to value my own natural dignity of mind (if I may say so) above all things. This is of more consequence than Gentlemen and Ladies can well imagine.[2]

[181]

Fisher played a variety of roles during their twenty years of friendship. He officiated at Constable's marriage and entertained the newly-wedded couple on their honeymoon for several weeks at Osmington. He bought the first two six-foot canvases that Constable exhibited at the Academy, *The White Horse* (1819, pl. 5) and *Stratford Mill* (1821, pl. 2). He and his wife stood godparents to two of the Constables' children and gave the family much-needed holidays in the country. No man did more to help Constable with the anxieties that burdened him; when necessary, no one spoke more sharply to him, nor administered more skilfully a well-deserved rebuke. Possessed of a mind better equipped academically, Fisher was also able to provide Constable with the intellectual stimulus that was lacking in his rather limited circle of artist friends. In their correspondence Constable unbuttoned as to no one else, and some of the most moving passages in the literature of art are to be found in his letters to the Archdeacon. They shared a love of nature, of course, and this was one of their strongest bonds. Fisher too had an eye for landscape and there are a number of colourful descriptive passages in his published letters. From Osmington, 28 September 1820:

> This season of the year with its volumes of rolling clouds ⟨. . .⟩ throws the finest effects ⟨of⟩ over this beautiful country. A large black misty cloud hung to day over the Sea & Portland. The Island could be but just discerned. The smoke of Weymouth was blown off towards Portland & was illuminated by the Western Sun & relieved by the dark cloud. As I rode home a complete arch of a rainbow came down to my very feet: I saw my dog running through it.[3]

From the same place, 1 October 1822:

> The day before yesterday we had a calm with a clear sky. The NE wind had blown off all the atmosphere & every thing came sharp close upon the eye. The sea was smooth & a pale white. The hulls of the vessels came off sharp black spots: you might see the men & the small rigging from the shore. Portland was a deep plum color & close to the eye.[4]

Black, pale white, deep plum; it is colour and a vivid sense of place Fisher also captures in a letter of 8 April 1825:

> I rode yesterday out of the white atmosphere of Bath into the green village of Bath-Easton; & found myself by instinct at the *mill*, surrounded by weirs, backwaters nets & willows, with a smell of weeds, & flowing water, & flour in my nostrils. I need not say that the scene brought you to my mind, & produced this letter.[5]

John Fisher has been given full credit for his support of Constable, not least by Geoffrey Grigson in the fine preface he wrote for Beckett's *Constable and the Fishers*. But so far little attention has been paid to Fisher as a sketching companion, and as an artist in his own right he has been almost completely overlooked. We need to look no further than the Correspondence, no further in fact than Fisher's very first long letter to Constable for evidence both of their sketching

together and of Fisher working out of doors on his own. In the letter (dated 8 May 1812), Fisher tries to coax Constable down to Salisbury again with a description of the kind of life they will lead. 'We will rise', he says, 'with the Sun, breakfast & then out for the rest of the day – if we tire of drawing we can read or bathe & then home at nightfall to a *short* dinner . . . I think the life of Arcadian or Utopian felicity will tempt you, so e'en come & try it.' Further on he writes thus of himself: 'I took out a few colours the other evening & drew & coloured a landscape on the spot & really I am pleased with it. It is rough of course – but it satisfies in some measure my eye. But tho I am paying myself the compliment – I owe this pleasure to you – You fairly coached me & taught me to look at nature with clearer eyes than I before possessed –'.[6] In this case it looks as though watercolours had served for colouring the landscape, but Fisher, we know, also used oils. In 1816 he spoke of having 'brushes paints & canvases in abundance' at Osmington if Constable decided to spend his honeymoon there. Some time later, when staying with his parents in London, Fisher wanted to copy an Osmington view in a sketchbook he had of Constable's and sent a messenger round requesting the loan of 'a few skins of paint: flake white: blue: naples yellow: vandyke brown: brown pink: brown oker a phial of boiled oil & another of linseed oil'.[7] Constable, it seems, had no need to bring his paints when coming to stay at Salisbury. 'I have a painting apparatus', Fisher assured him in the summer of 1819, 'Brushes clean & pallet set, Colours fresh ground every morning &c &c'.[8] A letter written three years later promises both oil paints and watercolours if Constable can spare time for a visit. Water-colours and drawings by Fisher have survived and are known – we shall be discussing these shortly – but his oils present something of a problem. The letters tell us he had paints, brushes and canvas both at Osmington and Salisbury. We know that he used them; colours would only be ground afresh each morning if they were going to be used. He talks of copying one of Constable's Osmington drawings in oils and later, in another letter, of painting and of bringing what he has done up to town for Constable's inspection.[9] But where, we would like to know, are his oil copies after Constable, and where are his own landscape oil paintings? Many of his drawings are undoubtedly lost – the earliest known are dated 1820 – so it is reasonable to suppose that a proportion of his oils at any rate are lost also. At the same time three of his sketchbooks have survived, containing all told some sixty or so drawings and it seems unlikely that none of the oils should have done so. To date, none has been identified. If there are any still in existence it is probable that some at least are to be found in some sub-Constable stratum or among works attributed to Constable, paintings of Salisbury, Osmington or Gillingham, the three main areas where the two men spent their time together in the country.

A possible candidate for a Fisher attribution is *Osmington: a View to the Village from the Footpath near the Mill* (pl. 98), an oil painting at the Yale Center that was for some time thought to be by Constable. The provenance is right for

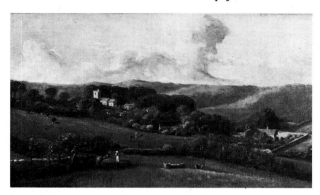

98 ?John Fisher, *Osmington: a View to the Village*, oil, $5\frac{3}{4}$ × 10 (14.6 × 25.4). Whoever this is by, it is not the work of John Constable, to whom it was attributed for many years.

99 John Fisher, *View of Salisbury*, 1820; pencil and watercolour, $5\frac{1}{2}$ × 9 (14 × 22.8)

a painting by Fisher, it had come by descent to a member of the family from the Archdeacon himself. The subject is certainly Osmington and the work is obviously not by Constable. So far so good. But the case does not remain clear. We do not know how Fisher handled oil paint but his pencil sketches and watercolours are executed with great delicacy, and although oil as a medium invites bolder treatment there is a clumsiness in the brushwork of the Osmington view which one would not expect to see in an oil by Fisher. Further doubts are raised by a closely related pencil drawing, a rendering of the same scene, with animals, figures and clouds almost identical.[10] Stylistically this differs as much from drawings known to be by Fisher as the oil does from one's notion of how he might have painted. For the time being the authorship of both must remain uncertain.

While Fisher as an oil painter is at present known only through his letters we have a fair idea of him as a watercolourist and draughtsman as there are more than a dozen of his original drawings in three sketchbooks which have

100 John Fisher, *Osmington Church and Village*, pencil, $3\frac{5}{8} \times 4\frac{1}{2}$ (9.3 × 11.5)

come to light in recent years.* All are of the Salisbury or Osmington areas. Four are initialled or signed; two are dated. The examples we illustrate (pls 99–101) show him to have been a careful, sensitive draughtsman with a keen eye and a feeling for cool clear sunlight. Most often he appears to have worked in pencil on the spot and then washed in the colour later at home. Only one of the watercolours, a view from the vicarage window at Osmington,† was executed mainly with the brush. The rest are essentially tinted drawings. Besides these sketches of Fisher's and several pages of drawings by other, sometimes childish hands, the sketchbooks together contain a sizeable number of copies, mostly from drawings by Constable.

We have already heard of Fisher wanting to copy an Osmington view from a sketchbook of Constable's in his possession. There are several references in the Correspondence to the borrowing and returning of such sketchbooks. In

* The first sketchbook appeared on the market in 1976 and was shown as No. 346a in the 'Friends and Followers' section of the Constable bicentenary exhibition at the Tate Gallery (1976). The supplement to the second edition of the catalogue included a note on the sketchbook and reproduced two of the drawings in it, both by Fisher: a pencil and watercolour sketch from the window of his rectory at Osmington and a copy of Constable's *Preston Church* (V & A, R.153). The second sketchbook was brought to the Tate during the exhibition by a collateral descendant, Mr David Fisher. The third came to light some two years later. For convenience, the books will be named, in the order they appeared, after the subjects of the drawings on the first page of each, i.e. 'Osmington', 'Portland' and 'Salisbury'. 'Portland' is now in the Henry E. Huntington Library and Art Gallery.

† 'Salisbury' sketchbook.

101  John Fisher, *View from Leydenhall*,
watercolour, $5\frac{5}{8} \times 5\frac{1}{2}$ (14.3 × 14)

1820 Fisher wrote to say that his wife would like to be entrusted with a sketchbook to copy if Constable would dare to lend it to her.[11] Constable apparently obliged. From Bath, in 1824, a rather bored Fisher wrote to ask whether Constable would be afraid to send one of his new sketchbooks by the Bath coach: 'We are sadly at a loss for employment; and copying the leaves of your mind is a great source of amusement to my wife'.[12] 'Your sisters', Constable replied, 'have borrowed ("for a friend") such of my sketchbooks as you have not had'; instead, he posted off a dozen of his Brighton oil sketches – 'perhaps the sight of the sea may cheer Mrs F – they were done on the lid of my box on my knees as usual'.[13] A year later, in 1826, Constable wrote to say he was 'greatly distressed' for a sketch⁄book or two in Fisher's possession, the 'title papers' of the two small ones being 'the Bridge at Oxford – & the shoar opposite Gravesend or Woolwich'.* Fisher admitted to possessing a large and a small one, and duly sent them off to Constable on the coach.

The twenty or so copies in the three sketchbooks, with a few stray ones that have turned up, would seem to be the fruits of such borrowings. Most of the

---

* 1 February 1826 (JCC VI, p. 189). Fisher took Constable with him on a Visitation of Berk⁄shire in 1821. They ended up at Oxford. The bridge at Oxford 'title paper' must have been drawn on that trip, so we should perhaps be on the lookout for copies of the drawings Constable made along the banks of the Kennet and Avon and the upper Thames when he accompanied Fisher on his rounds. If by 'the shoar opposite Gravesend' Constable meant the area around Hadleigh Castle, there may also be copies of the drawings in the sketchbook Constable used on the occasion of his visit there in June 1814. To date, none from this $3\frac{1}{4} \times 4\frac{3}{8}$ inch book has been identified.

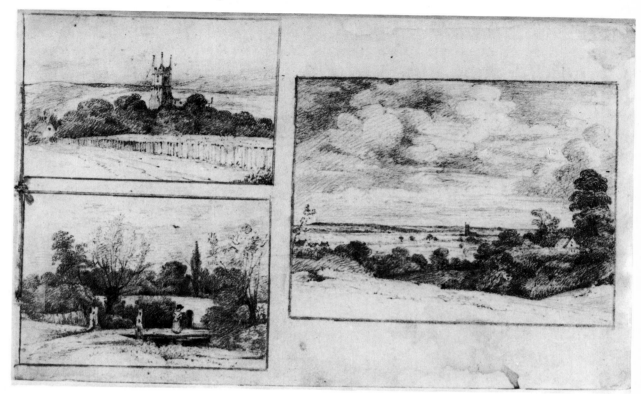

copies are of known drawings by Constable. Six are from the sketchbooks he used in 1813 and 1814 which have survived almost intact (pl. 102). Others are from sketchbooks, now dismembered, he used in 1816, 1817 and 1820.* In style and character the copies vary quite a lot from book to book (as of course do the originals) but most of them share certain characteristics. All in the sketch-books are drawn within a ruled pencil border (see pls 102 & 104). In size they

102 John Fisher, three copies on one page after drawings in Constable's 1813 sketchbook; pencil, $5\frac{1}{2} \times 9\frac{3}{16}$ ($14 \times 23.3$)

* In all there are twenty-two copies of known Constable drawings and three of unknown ones.

'Osmington' contains copies of: *Netley Abbey, with Southampton Water in the Background* (V & A, R.150); *Netley Abbey, the Exterior Seen amid Trees* (R.148); *Preston Church, near Weymouth*, d. 21 November 1816 (R.153); *The Breakwater at Harwich, with Ships on the Beach*, d. 1 September 1815 (R.144); the same, from the opposite direction, d. 1 September 1815 (Henry E. Huntington Library and Art Gallery).

'Portland' contains copies of five drawings from the 1813 sketchbook, V & A, R.121: p. 42 (d. 30 July), p. 57 (d. 14 August), p. 65 (26 September), p. 39 and p. 49; also copies of *Netley Abbey, the East Window*, d. 11 October 1816 (R.147), *Approach to a Lane, East Bergholt*, d. 25 July 1817 (R.156), *St Mary-ad-Murum Church, Colchester*, 9 August ?1817 (R.180), *Reapers, Summer Evening*, d. 15 August 1817 (Private Collection), *Mistley*, d. 20 August 1817 (Louvre RF 32148), *River Scene at Mistley, Essex*, 1817 (R.181), *Salisbury from Harnham Hill*, 23 July 1820 (V & A, no Reynolds number).

'Salisbury' contains copies of *Weston Shore, Southampton*, d. 12 October 1816 (Hornby Album, sold Lawrence, Crewkerne, 19 April 1979, No. 8), *Greenstead Windmill*, d. 26 July 1816 (Hornby Album No. 3), and the same seen from the opposite direction, d. 27 July 1816 (Hornby Library, Liverpool, No. B62-13).

103 *Osmington Bay and Portland Bill,*
1816; pencil, $4\frac{1}{2} \times 7\frac{1}{8}$ ($11.5 \times 18.1$)

105 John Fisher after John Constable,
*God's House Gate, Southampton*, pencil,
$3\frac{3}{8} \times 4\frac{1}{2}$ (8.6 × 11.4) to drawn border.
Pls. 105–6 are further copies of missing
Constable drawings.

tally very closely with the originals. In every case the copyist has endeavoured
to make an accurate and faithful rendering of Constable's pencil work. Most
have descriptive titles written below – 'Harwich', 'Netley Abbey' or 'Osmington
Mills'. An inscription under a drawing of Osmington Bay (pl. 104)[14] enables
it to be identified as a copy of an hitherto unknown Constable, a drawing that
with *Osmington Bay and Portland Bill* (pl. 103) in the V & A[15] once formed a
panorama, spread across two open pages of Constable's sketchbook. The inscrip-
tion under the copy runs: 'These views join & form the harbour at Osmington
Mills'. A juxtaposition of the two drawings shows clearly the follow-on from
one to the other: the sweep of shore; the line of rocks jutting out from the left-
into the right-hand drawing; even the shaded cloud masses, broken only by
the margins of the two drawings. Two further drawings appear to be copies
of hitherto unknown Constables: a Southampton subject, *God's House Gate*

104 John Fisher after John Constable, *Osmington Bay*, pencil, $4\frac{5}{8} \times 7\frac{3}{16}$ (11.7 × 18.2) to drawn border. Fisher's copy of the missing Constable that formed a panorama with the drawing seen in pl. 103.

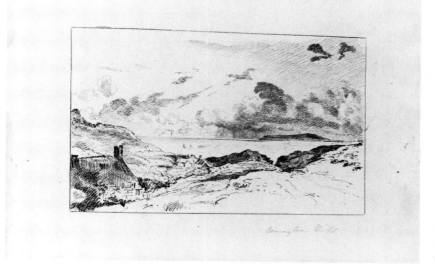

106 John Fisher after John Constable, *Osmington Mills*, pencil, $4\frac{1}{2} \times 7\frac{3}{16}$ (11.4 × 18.2) to drawn border

(pl. 105)[16] and *Osmington Mills*, a view with Portland in the distance from the road above the little harbour (pl. 106).[17]

Until quite recently one of the sketchbooks ('Salisbury') contained two original drawings by Constable, a pencil sketch of Binfield church dated 7 December 1816, and an example of *his* work as copyist or pasticheur, a pencil drawing in the Dutch or Flemish manner inscribed 'July 1829. Salisbury Close'.* Two copies from one of the books were at one time also thought to be originals by

* Christie's, 18 June 1980, lot 41, *Binfield Church*, lot 40, *A Wooded Coastal Landscape with a Figure Approaching a House.*

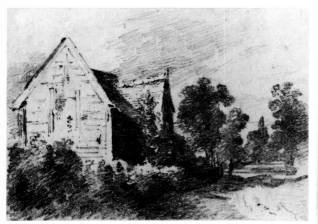

107 John Fisher after John Constable,
*Barn and Road*, pencil, $3\frac{1}{4} \times 4\frac{1}{2}$
(8.3 × 11.4)

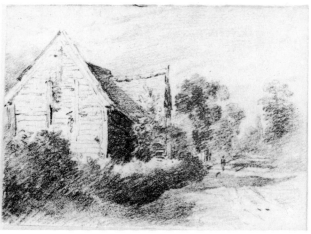

108  *Barn and Road*, pencil, $3\frac{1}{4} \times 4\frac{5}{16}$
(8.3 × 11)

Constable and were in fact exhibited as such.* One of these was the *Barn and Road* (pl. 107). In this case the error was understandable as the original was a little known drawing in the family collection and the copy is remarkable for a high degree of fidelity. When placed side by side, however, as they are seen here (pls 107–8), there are perceptible and instructive differences to be noted quite apart from the fact that the copy was drawn with a blunter pencil. The copyist lacks versatility. In the original each shaky, horizontal edge of the boards that clad the barn's end wall is individually seen and expressed; the same lines in the copy are more alike and more often than not end with a sudden increase of pressure or with a dot. The handling of the pencil in the copy is also less resourceful in the depiction of the hedge and trees where the transition from shading to the particularization of foliage is less well managed. In addition, the copyist cannot match Constable's understanding of practical matters. Constable profiles a section across the rough track with the delicately drawn nearer edge of the shadow cast by the barn. The copyist exaggerates the irregularities of the shadow, does not with equal care feel with the pencil/point over each rut in turn and consequently renders a much less convincing account of the receding lane.

The 'Salisbury' sketchbook contains three initialled copies by Fisher, one of a Constable, two after Antoine Waterloo. The inscriptions on the two Dutch scenes run: 'J.F 1822. Copy of Waterloo.' and 'J.F. 1822. a bad copy of a good Waterloo'. The Constable copy is similarly initialled, 'J.F.', just outside the ruled margin in the bottom left/hand corner. When first seen, this was not known

* *A Miscellany of English and Continental Drawings*, Colnaghi's, December 1976: 25, *Landscape with a Windmill in the Distance*, a copy of *Landscape with Windmill*, d. 6 October, p. 75 in the 1814 sketchbook (V & A, R.132); 28, *Landscape with a Cottage by a Road*, a copy of *Barn and Road* (Constable family collection).

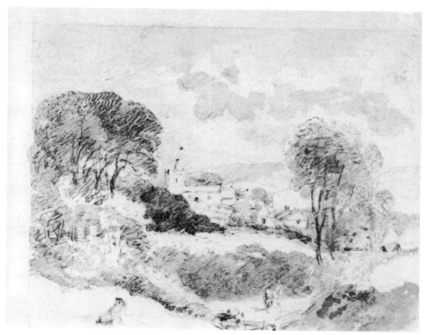

109 John Constable or John Fisher, *Osmington Church*, pencil and wash, $4 \times 4\frac{7}{8}$ (10.1 × 12.4)

to be a copy as the original, in itself an unusual work, had not then come to light. On the mount beneath his drawing Fisher had written 'Southampton'. This subsequently helped to confirm that the original was a view of Weston Shore, just north of Netley Abbey, where Constable made a number of drawings on his honeymoon. This and the other Southampton copy have been tinted with washes of pale colour. Neither the three drawn on one sheet from different pages of Constable's 1813 sketchbook (pl. 102), nor any of the other copies have been so treated.

The three sketchbooks answer some of the questions raised by the Correspondence – from them we have at least learnt something of Fisher as a draughtsman and copyist – but they also create problems of their own, in particular problems of authorship. A pencil and wash drawing of Osmington church and village is a case in point (pl. 109). Prior to its appearance at auction in 1980[18] this was in the 'Salisbury' sketchbook, which had also contained two Constable drawings, the copy or pastiche just mentioned (inscribed 'July 1829. Salisbury Close') and a delicate pencil sketch of Binfield church dated 7 December 1816. Is the Osmington drawing by Constable also, or is it by Fisher inspired by Constable? or is it yet another Fisher copy of a Constable original? All the known copies in the sketchbooks are enclosed within ruled margins. This is so framed, but only on two sides. In manner, in the light, free handling of the pencil, it is similar to other drawings by Constable of this year – the *Binfield Church*, for example. On the other hand, there is very little pencilling which could not be the work of Fisher in a bouyant mood. The monochrome wash

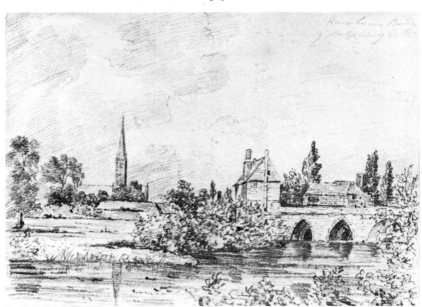

110 Dorothea Fisher after John Constable, *Harnham Bridge*, pencil, $5\frac{5}{8} \times 7\frac{3}{4}$ (14.3 × 19.7). A copy of the drawing seen in pl. 111, by the Bishop of Salisbury's elder daughter, a Constable pupil.

is no help; neither Constable nor Fisher were much in the habit of using the medium at this time.

An additional hazard when attempting to assign some of the work in the sketchbooks is the fact that John Fisher was not the only member of his household to copy Constable's drawings and paintings. Fisher's wife Mary had been taught when a girl at her home in Binfield by a drawing master from the Military School at Marlow, William Sawrey Gilpin.[19] On two occasions, as we have seen, Fisher had asked Constable to lend sketchbooks so that Mary could, as he put it, 'copy the leaves of your mind'. None of her work has so far been identified but the style of the sketchbook copies is by no means consistent, and some of them could well be by her.

We know rather more about the work of another Fisher copyist, Constable's best documented pupil Dorothea, the elder of the Bishop of Salisbury's two daughters. There are a number of references to her painting lessons and to the copies she made both in her father's letters to Constable and in her own. The lessons began in 1818 when she was a young lady of twenty. Pupils in those days learnt by copying. Constable loaned Dorothea some of his own copies to work from – first a Claude and then a Teniers. While staying with Sir George Beaumont at Coleorton in 1823 Constable copied two more of Sir George's Claudes. Fisher heard of this and wrote to say he was impatient to see them. 'The Bishop', he added, 'is delighted at the thoughts of Dolly [Dorothea] "having additional opportunities of improving her style by copying so perfect a master"'.[20] In his reply Constable said he doubted if Sir George would like 'to have these little Claudes mauled, mangled, smeared & begrimed by a Young Lady – but

[192]

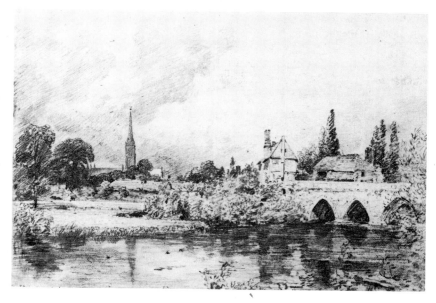

111 *Harnham Bridge*, 1820; pencil, $6\frac{1}{8} \times 9\frac{1}{16}$ (15.6 × 23)

I will say nothing about it. I shall send them away when the lady arrives'.[21] When the time came, unwilling to have her 'maul' one of his new Claudes, Constable instead gave the young lady one of his own paintings to copy, a view at Coleorton. Dorothea writes for advice about this: 'what', she asks, 'are the Colors I am to use in my sky of the picture you were kind enough to lend me, of Sir G. Beaumonts place'.[22] A painting Constable had done at Gillingham when staying with the Archdeacon in September 1823 was the next work lent to Dolly for her to copy. In mid-May 1824 he was summoned 'by order of Miss D.F.' to see the result of her labours. Constable's duties as drawing master to the Bishop's daughter were not confined to teaching. As well as furnishing prepared canvases and the necessary painting equipment and setting her painting box in order he was expected to varnish her copies for her when completed and to arrange for them to be framed. On 29 June 1824 her *Gillingham*, 'retouched a little' by him[23] (how much, one wonders?), was taken round with its frame to Seymour Street, the Bishop's London residence, by the artist's young assistant Johnny Dunthorne. After sending the money for the frame Miss Fisher does not appear again in the story. Perhaps marriage to her Mr John Pike occupied her time.

*Gillingham Bridge*, the original from which Dorothea made her copy, is now in the Tate.[24] Her painting is presumably the larger version of the subject which was sold by a Fisher descendant at Sotheby's in 1957 and is now in an American private collection.[25] The whereabouts of her other copies is not at present known.

The recent identification of a small group of drawings by Dorothea suggests that the oil copies, with two other oils mentioned in the Correspondence, represent only a part of her output. The drawings, three in number, are all copies of known

drawings by Constable, pencil sketches of the Salisbury area he made in the summer of 1820 when staying with Fisher.* Each copy is inscribed in Dorothea's recognisable hand. Her inscription on one of the drawings, 'Downton Church Wiltshire', was in fact of some service, as the church in the original (V & A, Reynolds 1973, No. 201) had not previously been identified. A comparison of her *Harnham Bridge* with Constable's drawing, a particularly fine example of his painterly handling of the pencil (pls 110–11), reveals most plainly the copyist's limitations: her failure to appreciate the fractional yet critical changes of angle along the water's edge and to note the way Constable represented the spire's watery image; her insensitivity to the tonal values in the original, to the contrasting passages of sunlight and shadow. But such side-by-side comparisons are bound to reveal shortcomings in a copy. A fairer test is to judge a drawing in isolation, when the original is not at hand. Dorothea's copies are not without their merits; nor are they lacking in character. She draws boldly, without hesitation in a distinctive staccato manner, and manages to capture something of the spirit of the originals. All her known copies have in their time been mistaken for Constables. If some of her own work comes to light it will be interesting to see how much she had learnt from her studies, whether she too had learnt 'to look at nature with clearer eyes'.

* The three Constable drawings copied by Dorothea Fisher are *Harnham Bridge* (BM, 1910-2-12-228), *Fisherton Bridge, Salisbury* (Cornwall County Museum and Art Gallery, Truro, De Pass Collection No. 234) and *Downton Church, Wiltshire*, a church and graveyard (V & A, R.201).

# JOHN DUNTHORNE,
## JUNIOR

*Born 1798, East Bergholt; son of John Dunthorne, Senior (see pp. 178–80.) As a boy worked for Constable, grinding colours for him, etc. at Bergholt. Carried out a number of tasks for Constable and came to him in London as an assistant finally in May 1824. September 1825, joined Constable again after a visit to Suffolk and worked for him for the next four years. Left London from time to time to paint portraits and execute various commissions. 1827, exhibited for first time at RA, gave address as 4 Grafton Street, Fitzroy Square. Showed one work each year until 1832. Exhibited also at the BI. By 1830 had established himself successfully as picture-cleaner and restorer. Died 2 November 1832.*

Constable had known the younger John Dunthorne since he was a child. The boy is first mentioned in a letter Constable wrote to Maria Bicknell on 22 June 1812. 'My neighbour Dunthorne is thriving in the world – and his family are growing up delightfully – one of his little boys (my namesake) has been grinding colors for me all day – he is a clever little fellow and draws nicely all of "his own head"'.[1] Constable had wanted Johnny to join him as an assistant in 1814, 'I am rather desirous of having him now', he wrote to the father, 'for I think he may be usefull to stimulate me to work, by setting my palate &c, &c. – which you know is a great help and keeps one cheerfull'.[2] But that year, possibly through the intervention of Mrs Constable who did not approve of the idea, Johnny then only spent a short while with Constable in London. Over the next few years he managed to be of service several times while still at East Bergholt; notably in 1821, when he made an outline drawing of a harvest waggon to help Constable with his current work, *The Hay-Wain* (pl. 3). Letters from Bergholt tell of Johnny's activities as an artist: his sketches are 'nicely done'; he paints 'a pretty picture of the "dear old House"'[3] (Constable's birthplace) for Mary Constable.

When Johnny Dunthorne finally came to Charlotte Street as Constable's assistant in May 1824 it was perhaps the busiest period of Constable's career and there was plenty to do. Much of the work was of a humble nature, preparing the paints, getting the palette ready, squaring up, tracing etc., but it was not

long before he was putting in outlines, and within a few months, when Constable needed to replicate a painting, a portrait for instance, the job of beginning the work was turned over to his assistant. By December 1824 Constable was able to report that Johnny could 'copy any of my pictures beautifully'.[4] At times the Correspondence brings us tantalisingly close to the work as practised in the Charlotte Street studio. 1 October 1825: 'we do a deal of painting not going out. I am getting my dead horses off my hands – as fast as I can.'[5] 31st: 'am at work getting in the large picture of the Waterloo – on the Real canvas – &c, &c. of an Eveng we are busy with setting my portfolios in order'.[6] 6 December: 'John has done all he can to his large lock – now we are on the large Thames. I have sent him from the Stour to the Thames'.[7] 12th: 'So dark we had a candle on the table at 10 – in the morning could not paint but it does not ⟨. . .⟩ signify as we are on the intricate outline of the Waterloo.'[8] And in a letter to Fisher the following February (1826): 'John Dunthorne has taken my place at the easil while I hasten to write to you'.[9]

Two quite separate problems are created by the work of the younger Dunthorne. Firstly, paintings known to be by Constable of the period 1824 to c. 1829, especially when there is more than one version of the subject, may have been painted in part by his young assistant. Secondly, certain paintings attributable or attributed to Constable of Suffolk or Stour valley subjects, could be the work of Johnny Dunthorne before he joined Constable in London or during one of his subsequent return visits to Bergholt.

It is not known how far Constable permitted his assistant to carry a painting before taking over himself. Obviously, this would have varied, but the way Johnny had taken Constable's place at the easel while the latter wrote his letter to Fisher suggests that at certain stages at any rate they could work interchangeably. From a marginal note by Lucas alongside a reference of Leslie's to *The Lock* (pl. 22) we gather that sometimes Dunthorne was allowed to advance a replica quite some way towards completion. 'The. upright Lock', Lucas wrote, 'there are two pictures of this subject one of which was copied in a great degree by Mr Dunthorn and worked on by Mr C afterwards. but it was not comparable with the first painting for. vigeour and richness'.[10] The original 'upright Lock' was exhibited at the Academy in 1824 and was bought on the opening day by James Morrison, a highly successful haberdasher and entrepreneur. The picture Dunthorne worked on is now generally thought to be the version bought by Charles Birch at the 1838 studio sale (see p. 45).[11] There are other subjects in the replication of which Dunthorne could have been employed. He might well have lent a hand with the versions of *Harwich Lighthouse*[12] and *Yarmouth Jetty*,[13] for instance. There are three of each subject – six paintings in all – and it is perhaps suggestive of a production line of some sort that all six exhibit almost exactly the same sun-lit, cloudy formations. A large part of Dunthorne's training with Constable would of course have consisted of making copies. No such apprentice work is known. There has survived however an interesting painting

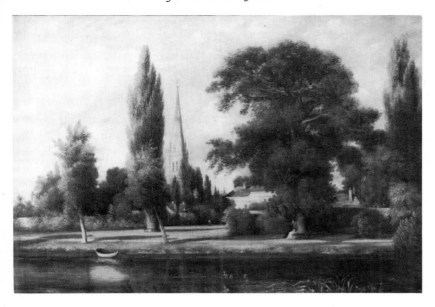

112 John Dunthorne junior, *Salisbury Cathedral and Archdeacon Fisher's House from across the Avon*, oil, 21 × 30 (53.3 × 76.2)

by him of Salisbury. Constable himself referred to the work in a letter to Fisher of 26 August 1827. 'John Dunthorne', he wrote, 'has compleated a very pretty picture of your lawn & prebendal house, with the great alder & cathedral'.[14] Though based on Constable's freely painted oil sketch in the National Gallery, *Salisbury Cathedral and Archdeacon Fisher's House from across the Avon*,[15] Dun-thorne's painting is no copy (pl. 112). Rather, one supposes it to represent his idea of how a finished, a highly finished painting of the scene should look. There is hardly a more dashing, animated work by Constable than the original. It is perhaps to his credit that Dunthorne makes no attempt to emulate this, that instead he goes patiently to work painting leaf by minute leaf, creating in the end a scene stilled – almost, a work of the imagination.

There does not seem to be any need to doubt the name of the artist responsible for the next two paintings illustrated, the *Country Lane*, a view of the Stour valley from the Flatford/East Bergholt road (pl. 113) and *The Rainbow* (pl. 114). The stretcher of the first is inscribed 'This painting by John Dunthorne to be kept in the HICKS family';* 'J^no Dunthorne' is written on the stretcher of the second. There is also a label on the back of the latter which says that the painting was given to the Revd Charles Green, curate of East Bergholt, by 'a man named Dunthorn who was Constable's constant companion', and that the picture was painted in 1829. It has been assumed that the younger Dunthorne painted both. This is probably correct. They are close enough in feeling to be by the same hand, the *Country Lane* being presumably the earlier, and both have features

* W. Hicks and J. R. Hicks, both of Colchester, were owners of pictures by the Dunthornes loaned for exhibition at Colchester in 1937.

[197]

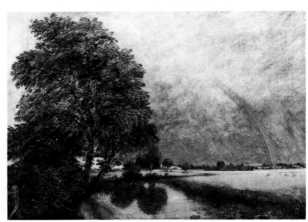

113  John Dunthorne junior, *A Country Lane*, oil, 9¼ × 13³⁄₁₆ (23.5 × 33.5)

114  John Dunthorne junior, *The Rainbow*, oil, 10⅛ × 14⅛ (25.7 × 35.9)

in common with the Salisbury picture (pl. 112). But with so little to go on, at present we should perhaps exercise a little caution and regard the attribution as provisional.

Dr Charles Rhyne has recently suggested[16] that *A Wooded Stream* (pl. 115), a painting hitherto attributed to Constable, should also be considered as a possible work by the younger Dunthorne. Stylistically this makes sense. At first sight the painting looks like an early Constable, one of the studies he is known to have made around 1802. The subject, a branch of the Stour from a point just below the toll-bridge, with Dedham church in the distance downstream, is one he might well have chosen. The composition could be his; even the sluice in the foreground, prominently placed and so carefully observed, invites thoughts of Constable. But the idea of Constable as author cannot be entertained for long when one begins to look at the work more closely. The soft, blurred shapes underlying the foliage and the minutely painted leaves are not his; nor are the very tall, stem-like trunks of some of the trees. In Constable's work of no period do we find such needle-sharp detailing unsupported by graded, larger forms. The only documented painting by Dunthorne, on the other hand, the *Salisbury Cathedral and Archdeacon Fisher's House from across the Avon* (pl. 112), contains plenty that matches: soft furry shapes over-painted with delicate foliage; a liking for vertical elongation and the same curious stillness. During a holiday at Bergholt in the summer of 1825 Dunthorne apparently addressed himself with his paint-box to the scenes Constable loved. In a letter to their brother, Abram and Mary Constable wrote enthusiastically about the results. 'J.D. has painted some very pretty studies indeed. he is wonderfully improved within a Year', reported Abram.[17] 'You will be pleased', wrote Mary, 'with the pretty views J D has taken of your favorite haunts "in these parts"'.[18] One can imagine the *Wooded Stream* having been painted on that holiday. Perhaps it was.

We shall need further material before we have anything like a working corpus

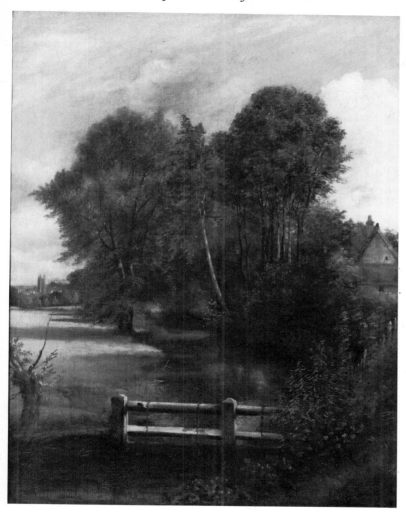

115 John Dunthorne junior, *A Wooded Stream*, oil, $18\frac{1}{4} \times 14$ (46.3 × 35.6.) Only recently reattributed to Constable's one-time assistant.

of paintings by young John Dunthorne. But in the meantime the four paintings discussed briefly here – the *Salisbury Cathedral* (an undoubted Dunthorne the Younger), the *Country Lane* and *The Rainbow* (both Dunthornes and probably the work of the son) and the *Wooded Stream* – can serve as a nucleus.*

* When on the lookout for possible paintings by the younger Dunthorne, we should keep in mind the works he is known to have exhibited. At the RA: 1827, 'Glade in a wood'; 1828, 'Landscape, after a shower'; 1829, 'Landscape'; 1830, 'A cottage'; 1831, 'Landscape, – harvest'; 1832, 'Landscape'. At the BI: 1828, 'Landscape; Summer', frame 27 × 31 in.; 1830, 'Landscape', frame 38 × 70 in.; 1832, 'Landscape', frame 39 × 46 in. The Dunthornes exhibited at Colchester in 1937 which Shirley thought might be by the father are listed above, p. 179n.‡ The remaining Dunthorne landscapes, as listed by Shirley, were: 'Hay Scene', $11 \times 9\frac{1}{2}$ in., Col. H. Gooch; 'Bergholt Street', $10 \times 12$ in., A. Gooch; 'A Weir', $9\frac{5}{8} \times 13\frac{1}{2}$ in., A. Gooch; 'A Lane, East Bergholt', $13\frac{7}{8} \times 11\frac{3}{4}$ in., Mrs F. Clark; 'A Cottage, Walton-on-Naze', $7\frac{1}{4} \times 9\frac{7}{8}$ in., Miss Waller; 'River Scene', $10 \times 12$ in., J. R. Hicks; 'A Ford', $7\frac{1}{2} \times 9\frac{3}{4}$ in., Mrs F. Clark.

There is one further aspect of the Dunthorne/Constable relationship which ought to be given a little attention. Dunthorne copied Constable, but it seems Constable also copied Dunthorne. We have already referred to a drawing young Dunthorne made of a harvest waggon for Constable in 1821. The first certain reference to *The Hay-Wain* is to be found in a letter from Fisher to Constable dated 14 February 1821, 'how thrives the "hay wain"?', but by then Constable had evidently been at work on the picture for some time. There is an implicit mention of it in a letter Abram Constable wrote in answer to one he had received from his brother on 28 January. 'I am glad to have your account', he writes, 'of your picture's going [?on] well for the Exhibition  I think it will turn out well'.[19] At the end of his letter Abram says young Dunthorne is very well but that 'old Dunthorne has been very ill with some abscess in his side'. On 25 February Abram wrote again, this time to say that their sister Martha was coming to London 'on Monday next, by when I shall take the opportunity of sending you John Dunthornes outlines of a Scrave* or harvest Waggon I hope it will answer the desired end  he had a very cold job but the old Gentleman urged him forward saying he was sure you must want it as the time drew near fast† I hope you will have your picture ready but from what I saw I have faint hopes of it, there appear'd everything to do'.[20] There are several points of interest here, but in our context the most important one is that, when under pressure at any rate, to get the information he needed for a painting Constable was prepared to make use of another's drawing, in this case an outline sketch by young Dunthorne, an untrained twenty-three-year-old.

Although in later life Constable confessed that Suffolk was never absent from his thoughts,‡ after his marriage it is remarkable how seldom he revisited Bergholt and the scenes he had known since boyhood. It is furthermore remarkable that all his large paintings of that area, many of them his best-known pictures, were painted entirely from recollection with the aid of oil and pencil sketches made in years gone by. Sometimes, as in the case of *The Hay-Wain*, he found himself embarrassed for lack of the material he needed. During the period Dunthorne worked as Constable's studio assistant he may have been able to help quite often with such details. On a return trip from Suffolk in 1825 he brought a moorhen with him, a bird Constable was painting at the time into his current main picture, *The Leaping Horse* (pl. 23).[21] The 'pretty views' he took back may also have been of service, reminders, if nothing more, of the favourite haunts.

---

* Defined as a word used in Essex for a light harvest waggon (ed. Joseph Wright, *The English Dialect Dictionary*, 1904). Mr C. A. Brooks, who kindly supplied the above, was told by Mr John Eagle of Walton-on-Naze, Essex, that the word was still used (1980) in those parts and that 'we've still got one or two on the farm'.

† Almost certainly the elder Dunthorne. What other 'old Gentleman' at Bergholt would have known Constable's needs at this time?

‡ 'a County very dear to us all – and from which my mind is never absent', JC to the Revd Henry Scott Trimmer, 6 June 1833 (unpublished letter, Royal Academy of Arts, Jupp Catalogues, vol. 7, p. 63).

Devoted to Constable since childhood, Dunthorne even managed to serve him posthumously. In 1835, in the weeks preceding sending-in day Constable was working on *The Valley Farm* (pl. 26), his main painting for that year's Academy. On the right-hand side of this upright composition, in front of the main mass of trees, there stands an ash, almost the height of the picture. Most of the anatomy of the tree derives from a drawing approximately the same size, which in turn appears to have been enlarged from a much smaller but highly detailed pencil study (pl. 31); most of the anatomy that is, but not all, for the highest-reaching branch of the tree in the painting, an important feature, is additional and appears in neither drawing. On 14 February Constable wrote to his old friend the elder Dunthorne: 'If you can lend me two or three of poor John's studies of the ashes in the town meadow, and a study of plants that grew in the lane below, Mr Coleman's, near the spouts which ran into the pond, I will take great care of them, and send them safe back to you soon. I am about an ash or two now.'[22]

The 'ash or two' on which Constable said he was engaged must have been the tree or trees in *The Valley Farm*, and it must have been the need for help with the painting of these that prompted him to write for young John's studies. If, in the end, Constable did make use of them, presumably it would have been to help him with the large, additional branch we have observed in the painting. The rest, as has been said, derives from the full-size drawing enlarged from a pencil study, both of which are in the V & A. None of Dunthorne's studies of the ash trees in the town meadow* appears to have survived. It is possible, however, just possible, that the other study Constable wrote for, the study of the plants in the lane below Mr Coleman's, has survived.

In the collection left to the V & A by Isabel Constable there is an oil study, *Plants Growing near a Wall* (pl. 116). On the back is a partially erased inscription: 'Minna Dec 27th 47'.[23] Holmes dated this study 1826. Reynolds assigns it to the period c. 1820–30, for reasons given in his catalogue entry for another plant study in the collection, *Study of Foliage* (pl. 117), a work he compares with similar studies Isabel gave to the British Museum, one of which is dated 'Brighton July 24th 1828'. Dr Hoozee, in his *L'opera completa di Constable*, classifies *Plants Growing near a Wall* as a doubtful Constable and in view of the inscription attributes the study to the artist's eldest daughter, Maria Louisa. The inscription, as we now know, refers to the share-out among Constable's four surviving children that took place in the winter of 1847–8 (see pp. 61–2). Minna must have chosen the plant study with the other works she selected that winter as her share of the collection, and her name on the back therefore has nothing to do with the authorship of the work. With her out of the running as author, does the attribution automatically revert to Constable, or was Hoozee initially

---

* One of the water-meadows near Flatford is marked 'East Bergholt Town' on the 1817 East Bergholt Enclosure Award map. There are three more fields so described quite near Golding Constable's property behind the family home.

116 ?John Dunthorne junior, *Plants Growing near a Wall*, oil, 12 × 9¾ (30.5 × 24.8). One of the very few works among Isabel Constable's bequests to have been doubted. First queried by Dr Hoozee in 1979.

justified in doubting it? In our view he was — fully justified. A direct comparison will perhaps make this plain.

Pl. 117 shows the other V & A study of plants, *Study of Foliage*, a Constable of undoubted authenticity. Superficially, the two studies have a certain amount in common. Each portrays a modest group of growing plants; in each a large-leafed specimen predominates. The resemblance, however, does not stand up to further examination. In the *Study of Foliage* there is present a keen understanding of plant structure, of small-scale engineering: semi-rigid stems supporting a spread of umbrella-like, crinkly leaves. There is little evidence of such interest in the other study, *Plants Growing near a Wall* (pl. 116), where neither the structural relationship of stem to leaf nor the small weight of the leaves themselves have received much attention. A strong directional light strikes across the leaves in the former study, boldly shaping the contours and in places catching the plant's

117 *Study of Foliage*, oil, $6 \times 9\frac{1}{2}$ (15.2 × 24.2)

deckled edges. In pl. 116 direct light is absent and the forms of the leaves are less dramatically and much less convincingly modelled. Contrasting attitudes are also reflected in the representation of profile in the two studies. In the *Study of Foliage* the edges of the leaves have received a wide range of treatment, some are defined with abrupt, sharp touches, some with swift, flickering movements of the brush, while others are blurred and almost lost against the background. In the other study the edges are more closely defined, and are drawn quite differently, with flowing, repeated, wavy motions of the brush. Differences of handling, to our mind, also rule out any possibility that the two studies are by the same artist. Constable's mature brushwork is characterised by vigour and spontaneity, and by an almost total lack of repeated rhythms or touches. This is splendidly exemplified in the *Study of Foliage*. Nowhere in *Plants Growing near a Wall* is there to be seen handling of this kind. Instead, we have gentle, weaving sweeps of the brush; light, repeated touches; and a marked preference for neat execution and conventional notation.

Now, if the studies are not by the same hand, and the first (pl. 117) is by Constable, who then was responsible for the other? It does not look like the work of either Lionel or Alfred, nor presumably can it be by Isabel (who was a painter of flowers), as it was she herself who bequeathed it with the hundreds of her father's works to the Museum. It may, of course, be by some hitherto

[203]

unknown hand. But among those whom we know worked close to Constable a likely candidate is John Dunthorne the Younger, and as we have documentation for such a study by him (though not specifically an oil), the 'study of plants that grew in the lane below Mr Coleman's, near the spouts which ran into the pond', there is just a chance that *Plants Growing near a Wall* is the study in question, the study Constable asked the elder Dunthorne to send him.

Unfortunately there is a limited amount of further available evidence, for or against. The 'Mr Coleman' Constable talked of is almost certainly the William Coleman who owned a number of fields in the eastern corner of Bergholt parish, and several of these fields were bordered by lanes.[24] Presumably, the 'spouts which ran into the pond' were associated with the drainage of the fields, and a brick wall or embankment, such as the one in the study (pl. 116), could well have been part of such a system. The large, curly-leafed plants in the study are quite like the burdocks or docks which Constable liked to paint in his foregrounds. On the other hand, they do not match those which in the end he painted in *The Valley Farm* (pl. 26). There is also the question of the 'studies' he wrote for, the studies of the ashes as well as the plant study. Would these have been in oil or pencil? We can be reasonably certain that *Plants Growing near a Wall* is not by Constable; but, for lack of further evidence, at present it can only remain a possibility that the study is the work of the younger Dunthorne.

# FREDERICK WATERS WATTS

*Born 7 October 1800, in Bath ( ? ). Father may have been in the Royal Navy; mother, a daughter of Ambrose Eyre, M.A., Rector of Leverington, Isle of Ely, nephew of Edmund Keene (1714–1781), Bishop of Ely. Is said to have studied at the Academy Schools and to have won several medals (a William Watts, aged seventeen in 1817, silver medalist in 1819, 1820 and 1821, is registered in the RA records). Exhibited RA, 1821–1860 (seventy-six works); BI, 1823–1862 (108 works); Society of British Artists 1825–1838 (seventy-one works). Lived all his working life in the Hampstead area. Painted almost entirely landscape subjects. The areas where he worked included Hampstead and parts of Middlesex, the southern and south-western counties, Scotland, Wales and the border counties, Lancashire and Derbyshire, France (two Rouen subjects exhibited). Married twice; by the first wife two sons and three daughters, none of whom were believed to be alive in 1911. Is said to have given up painting for the last ten years of his life. Died at No. 11 Lawn Road, Hampstead, 4 July 1870.*

On 13 February 1911 there appeared in the *Daily Telegraph* a letter from Ernest E. Leggatt of Leggatt Brothers asking for information about 'an eminent artist named Frederick W. Watts, who from 1821 down to 1860 was a regular Academy exhibitor of oil paintings representing landscapes in the United Kingdom'. 'His pictures', the writer continued, 'which are fairly numerous, are broadly and brilliantly treated in a style that shows the strong influence of John Constable R.A. . . . Not a word of biography of this talented artist exists at present, reference to the British Museum even failing to yield any information as to the years of his birth and death'.* Leggatt was writing in the hope that some of the family were still living and could help him in the matter. He received a reply straightway from the artist's widow, Mrs Julia Watts, living at St Leonards-on-Sea. In her letter Mrs Watts gave a few basic facts about her late husband and in a second one supplied a few more. Some of these (here published for the first time) have been included in the biographical summary above. Mrs Watts was then still in possession of a few of her husband's oil paintings and 'some beautiful ⟨oil⟩ water colors, as well as a true Copy of Constable's Corn field & a large one

* Permission for the publication of the newspaper cutting and Mrs Watts's letters has been kindly given by the owners, Messrs Leggatt Brothers.

of Hobema's etc'.* Her husband, she said, 'was & had an humble opinion of his works & having ceased to paint for 10 years before his death, may be the reason that his name is so little before the public'. In her second letter she gave details of Watts's family. 'His father', she said, 'I have understook [sic] was in the Navy, & I possess his sword'. Leggatt had asked whether Watts was related to Constable, the latter's mother having been a Miss Ann Watts before her marriage. Mrs Watts replied that though 'often known as Constable's pupil' her husband was not related to him in any way.

Mrs Watts's letters add a little to our limited knowledge of Watts. The lists of works he exhibited at the RA, BI and the Society of British Artists can also tell us something. From them (and from a few inscribed oil sketches) we can get some idea of his working holidays: Wales and the Welsh border counties in the earlier 'twenties; Hampshire (for quite some time apparently on the banks of the Itchin) in 1829; a Derbyshire tour and probably several visits to Devon in the 'thirties. From the lists we can also see that in the first half of his life as an exhibitor the greater number of his paintings are of named, topographical subjects: 'View on the estate of Sir J. Hawkins, Bart at Ketston [?Keston Park], near Bath' (RA, 1823), 'Goodrick Ferry, on the Wye' (BI, 1824), 'Distant view of Shanklin, Isle of Wight' (RA, 1837). Later the titling becomes less specific in character: 'A Water Mill' (RA, 1849), or 'River Scene with Barges' (BI, 1855).† Both the sizes of his pictures and his prices appear to have been moderate. There is only one six-foot frame listed among his BI exhibits and the most he was asking at those shows in the 'fifties and 'sixties was £30.

A large number of Watts's oil landscape studies on board have survived. Many are quite small; $4\frac{1}{2} \times 6\frac{3}{4}$ inches or thereabouts was a favourite size. He appears to have painted from nature on these little boards as readily as some artists drew in their sketchbooks. Although his choice of subject-matter was varied, his technique and his mood in these studies changes hardly at all. Almost always he is to be found in rural areas; seldom far from hamlet or farm cottage. The tonal rendering of natural appearances characteristic of his oil sketches may be seen also in his earlier exhibition paintings, works meticulously finished with a Hobbema-like attention to detail such as the example reproduced here (pl. 118).‡

Watts is probably best known for the paintings he did towards the end of his working life; paintings of waterways, cottages in wooded valleys, water- and windmills, scenes of rural life observed so keenly in the small oil sketches, but

* Watts also appears to have made a copy of Constable's *Leaping Horse*. A 'Jumping Horse' by him was sold by Leggatt's in 1941.

† Flatford, Dedham or East Bergholt have frequently been incorporated into the titles of works by Watts. No Suffolk or Essex subject was exhibited by Watts as such in his lifetime and there is no evidence that he visited either county.

‡ Until quite recently this work was attributed to Constable. It was correctly attributed, however, when it appeared at Sotheby's Madison Avenue Galleries, New York, 27 May 1982 (20).

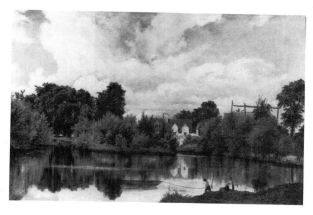

118 F. W. Watts, *Pond and Haystack*, oil, 21 × 32 (53.3 × 81.3). At one time thought to be an exceptionally fine Constable.

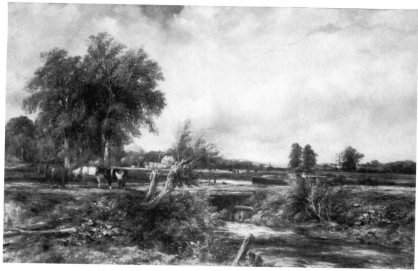

119 F. W. Watts, '*Dedham Lock*', oil, 37 × 57 (94 × 144.8)

now rendered less sharply, expressive, if at all, of a mood pensive and wistful. In 1859, not long before he gave up painting, Watts told James P. Ley of Bideford (who appears to have asked about two pictures by Watts in his possession) a little about his working methods. Of a lock scene Watts said he thought it was composed from sketches made on the river Itchin, but that it was 'in fact more [of] the character of the Country generally'. Another he said he knew to be 'composed from Sketches in my possession no actual View in fact'.[1] It is among the works of these, his later years, that one finds Watts has borrowed most heavily from Constable. Two scenes in particular he exploited almost unashamedly, the lock at Flatford and the stretch of the Stour depicted in *The Leaping Horse* (pl. 23); this, as far as we know, without ever having visited Constable country. The possibilities of re-composing these scenes were of course endless. Some of Watt's variants have been close enough to be mistaken for

[207]

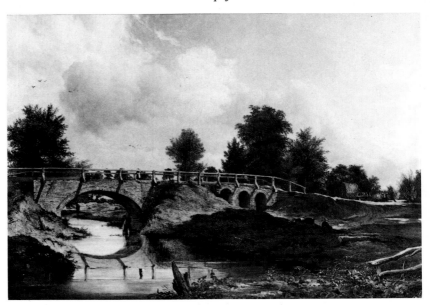

120 F. W. Watts, *Hendon Bridge ('Bridge over the Stour')*, oil, 18 × 25 (45.7 × 63.5)

Constables.* Others, when correctly attributed, have nevertheless been given mis-leading titles. The so-called *Dedham Lock* (pl. 119), with its sensation of *déjà vu*, is a fair example of Watt's borrowing. Here, only slightly re-arranged, are to be seen several elements from Constable's *Leaping Horse*: a barge (though of a type never seen on the Stour), tow-horses, a sluice (not a lock, as the title suggests), a distant church (the tower not Dedham's), a pollarded willow placed to balance a larger mass of trees the other side of the water.

Mrs Watts had said that her husband was 'often known as Constable's pupil'. In more recent works of reference — his name does not appear at all in the earlier ones, Redgrave, Bryan or the DNB — Watts is termed a follower of Constable. It is extremely unlikely that he ever received tuition from Constable in any form, but he was undoubtedly much influenced by the older man and though there is no record of an acquaintanceship of any kind Constable certainly knew of Watts and it is not impossible that they met. In the Academy catalogue of 1821 (the first year he exhibited) Watts gave his address as High Street, Hampstead. Constable had been a summer resident there since 1819. They painted similar scenes on the Heath; one of Watts's views, with Harrow in the distance, was for many years thought to be by Constable.[2] In the 1820s Watts exhibited 'Child's Hill, Hampstead; Harrow in the distance' and a number of views of the countryside around Hendon which was relatively close by. One of these was called 'An old bridge at Hendon'. Pl. 120 is of a picture at present titled *The Bridge over the Stour*. This could well be the exhibit just mentioned, for it is in fact of a bridge at Hendon. We know this because there is a drawing

* A *Leaping Horse* variant, rather closer to the original than pl. 119, was mistakenly introduced as a Constable among the plates for the Mayne (1951) edition of Leslie's *Life* (pl. 38).

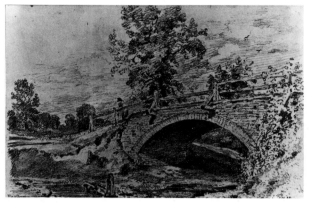

121 *Bridge at Hendon*, 1820; pencil, $6\frac{1}{4} \times 9\frac{1}{4}$ (16 × 23.5)

by Constable inscribed 'Hendon 8 Oct. 1820' of the main arch of the same bridge taken from a different viewpoint, but agreeing even to the two rotting stumps below, one on the bank the other in the stream (pl. 121).

There is a long history of confusion over the work of Constable and Watts. It began in Constable's lifetime when one of his paintings came up for auction and was bought in for a derisory fifty shillings as there had been doubts as to its authenticity. 'I have seen many who were in the room', Constable said, explaining what had happened, 'and it was considered Watts's, and at least not certain, if mine'.* By the 1890s paintings by Watts, attributed to Constable, were entering major collections. *The Cottage*, sold in Paris as a Constable in May 1873, was acquired by the Louvre. In 1897 a Watts then titled *The Old Bridge*, a view of the same bridge at Hendon, was given to the Metropolitan Museum in New York by George A. Hearn as a Constable and for many years was exhibited as such.† A painting called 'The Bridge Farm – East Bergholt' in Watt's early manner, a view of a bridge uncommonly like the one at Hendon, was exhibited as a Constable at the Guildhall in 1899.‡ Some, certainly, became

* JC to Charles Boner, 19 July 1833 (JCC V, p. 164). The painting was the *Helmingham Dell* exhibited at the BI in 1833 although painted in 1825–6 (pl. 32). It is now in the J. G. Johnson Collection at Philadelphia. Following the death of its owner, and without Constable's knowledge, the work was included in Christie's sale on 29 June 1833 but arrived too late to be catalogued. See Tate Gallery 1976, No. 295 for details of the incident. As recounted on pp. 77–8 above, the painting was the subject of further confusion in 1874.

† Pl. 120 could well be the RA exhibit 'An old bridge at Hendon' but, in view of the more self-conscious, complex composition and the similarity of title, the Metropolitan 'Old Bridge' seems the likelier candidate.

‡ This picture was later included in the Turner-Constable-Bonington exhibition at the Boston Museum of Fine Arts, 1946 (125). According to an advertisement cut from the *Burlington Magazine* (issue not identified), the work 'is often described as having been painted in 1916 [sic], but the Boston catalogue plausibly suggests an earlier date. There is also some doubt about the subject. The scene certainly does not take place in the immediate neighbourhood of Constable's native village, but it may be along the river past Flatford Mill. The topography of Constable's pictures', the writer all too truthfully observes, 'is badly in need of detailed study, considering that false titles have in the course of time, become attached to his Suffolk and other landscapes'. Another view of the bridge at Hendon is in the J. G. Johnson Collection, Philadelphia.

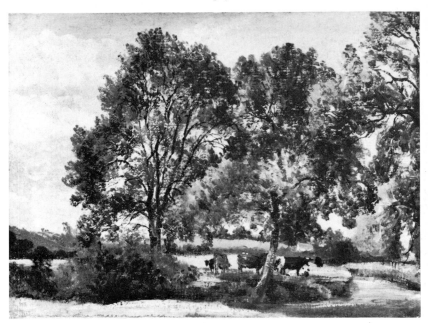

122 F. W. Watts, *Meadow Scene with Trees and Cattle*, oil, $10\frac{1}{4} \times 13\frac{3}{4}$ ($26 \times 35$). Shown at the Tate in 1976 as the work of an 'Unknown Imitator of Constable'. Here attributed for the first time to Watts.

aware of the confusion. In an article on the Louvre's British paintings in the *Burlington Magazine* for March 1907, P. M. Turner questioned the authenticity of the work titled *The Cottage*. A reproduction of the painting, reattributed to Watts, appeared shortly after in another art journal. 'Even in England', it was observed in the accompanying note, 'the pictures of Frederick W. Watts are still mistaken for those of Constable, but any one who chooses to make a close examination of one or two works by the lesser artist ought never to be mistaken as to the difference between them'. In a footnote, the writer tells of six works by Watts that had recently appeared in the sale-rooms. 'Of these one was labelled "Old Crome"; a second, a large and important work, was sold as a Constable, two more had forged signatures of Constable, while only two were rightly described.'[3]

Between the two wars some of Watts's studies from nature, works of a less formal character, had found their way as Constables into various collections (pl. 122) – Lord Lee of Fareham owned several – but it was not until the later 1940s that the smaller oil sketches arrived on the market in any numbers. When they did so, if originally sold as the work of Watts, many as they changed hands were re-named and bought, apparently without question, as Constables. Occasionally one comes upon a reproduction of one of these Watts sketches attributed to Constable in the advertisement pages of art journals of the 'fifties and 'sixties. More recently, as the prices of Watts's larger paintings soared, his work became increasingly sought after and the little oil sketches were less often marketed under false colours. In 1973 Colnaghi's showed a large and varied group of these charming little works in their November exhibition of English

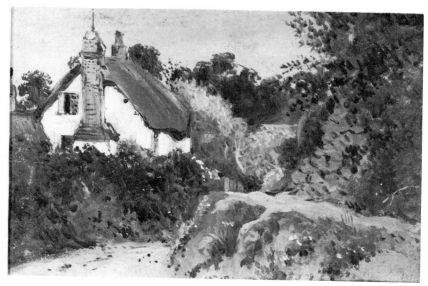

123 F. W. Watts, *Cottages at Heavitree,* oil, $4\frac{1}{4} \times 6\frac{5}{8}$ (10.8 × 16.8)

drawings and paintings. Spinks bought a group of seven similar sketches at Christie's in October 1981 (pl. 123),* and the following month five from the Mellon collection were sold at Sotheby's.† All were correctly attributed to Watts.

During his working life Watts appears to have modified his style of painting quite a bit for his exhibition works. But as he only occasionally dated an oil sketch, and most of those inscribed seem to have been done around 1830, it is not as yet possible to follow any sort of development in the work he did outdoors. Most of the oil sketches one sees around are entirely consistent in style. Seldom does he pay much attention to changes in the light or to the states of the weather. In his open-air studies the passing shower has long passed. Possessing a keen eye and a natural feeling for tonal interval, he is able to work with a comparatively limited palette. The paint he applies rather dryly, in deft, effective touches, often in dots and dabs of a colour several tones darker or lighter than the layer beneath. This very characteristic crisp handling at times produces a pattern of touches not unlike the markings on the wings of certain butterflies, the Tortoiseshell for example. When a few oil sketches like the *Cottages at Heavitree* (pl. 123) are seen together as a group his style becomes readily distinguishable. In the future there should be much less danger of confusing his work with Constable's.

* Christie's, 23 October 1981 (42), including views at Broadclyst and Heavitree near Exeter, Totnes, Bishopstoke and Banstead.
† Sotheby's, 18 November 1981 (1, 2, and 199), including a view at Littlehampton near Totnes and three tree studies, two dated September 1829, in Knole Park and at Tadworth.

# WILLIAM GEORGE JENNINGS

*Born 1763. Gentleman amateur; Honorary Exhibitor at RA, 1797–1806, showing views in Surrey, Sussex, the Lake District and Wales; also Honorary Exhibitor at Society of British Artists 1830 ('Scene near Perugia'). Friend of Constable from at least 1826, when Maria told her husband 'old Mr. Jennings called'. In the 1830s bought two paintings from Constable and discussed with him his lectures and the letterpress to* English Landscape. *His wife, Caroline Mary, died 1827. Jennings himself died 16 July 1854 at his house in Guilford Street near Russell Square; at some time he also lived at Braishfield House, Hants.*

Until recently Jennings was known chiefly through his few surviving letters to Constable.[1] These were all written in 1835–6 and deal, among other matters, with Jennings's purchase of the *Hampstead Heath with a Rainbow* which is now in the Tate Gallery.[2] Constable told his Arundel namesake that the work had been 'painted for a very old friend – an amateur who well knows how to appreciate it'[3] and Jennings's enthusiastic letters about the painting suggest that Constable was not mistaken. 'Your beautiful Picture now hangs in my Drawing room to the utter anihilation of my own daubs', Jennings told Constable in November 1836,[4] while in another letter he wrote of becoming 'a Painter from studying it'.[5] But there was little in the idealized, classicising landscapes by Jennings that turned up occasionally in the sale-rooms to suggest that he did in fact learn much from Constable's example.

In December 1981, however, an exhibition was mounted at the Krios Gallery in London of some two hundred watercolours and oil sketches by Jennings, imaginary scenes as well as views around London, which his descendant Karen Addenbrooke had unearthed. Many carried overtones of Gainsborough, Varley and others but there were some that pointed to Jennings's friendship with Constable, including oil sketches of Hampstead Heath which had a superficial resemblance to Constable's. Perhaps most interesting of all were two copies after Constable,* one in oil (pl. 124) after his watercolour of *Old Houses on Harnham*

---

* Not identified as such in the exhibition, these were respectively Nos 118, 'A riverside village with figures at the water's edge' and 154, 'Figures on a windswept path'.

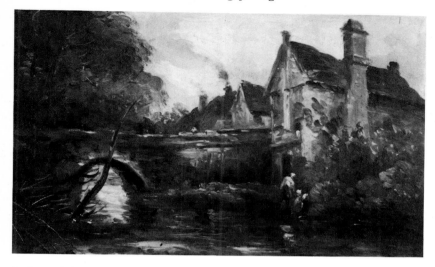

124 W. G. Jennings after John Constable, *Old Houses on Harnham Bridge*, oil, $5\frac{1}{2} \times 8$ ($14 \times 20.3$)

*Bridge, Salisbury*,[6] which Constable painted in 1821 but retouched ten years later, and the other loosely based on an East Bergholt oil study, *A Country Road with Trees and Figures*,[7] or more closely copied from a lost study of the same scene (Jennings disposes the figures differently and extends the composition on the right). Jennings's copy of the *Harnham Bridge* shows that he did not really understand the design of the original and was unable to recreate the tension of its drawing. Constable's forceful lines break down into Picturesque irregularities. One is reminded of the relaxed picture Jennings gives of himself in his letters: 'I saunter about with my camp stool & when tired sit down & sketch in my hasty imperfect manner — I am amuzed & benefitted by the balmy air, & that for me is enough'.[8] But it is conceivable that, seen in isolation, such a work might be mistaken for an original Constable. The possibility that lost sketches by Constable may be recorded in Jennings's works should also be born in mind.

# GEORGE CONSTABLE
## OF ARUNDEL

*Born 1792, Arundel. No relation to John Constable, the artist. Prosperous brewer and maltster of Sefton House, Arundel. By his wife, Frances, neé Coote (d. 1864 aged 70), had eight children. Collector and amateur artist. 13 December 1832, first letter to John Constable. More than a score of their letters have survived; some of John Constable's to the brewer contain important information about his state of mind and works in progress. The artist paid two visits to Arundel, the first, with his eldest son, in July 1834; the second (with his two eldest children) in July 1835; children paid further visits to Arundel after his death. 1837, George Constable became mayor of Arundel. Died 1878. Eldest son, George Sefton Constable (d. 1896 aged 78), also an amateur painter.*

Constable numbered several amateurs among his circle of friends in later years; almost, he seems to have preferred their company to that of professional artists. His friendship with George Constable of Arundel began in December 1832 when the brewer wrote a flattering note to enquire about the price of the *English Landscape*. A regular correspondence followed. Constable's visits to Arundel proved a great stimulus; some of his finest late watercolours and drawings are of the West Sussex countryside. George Constable probably accompanied the artist on his sketching expeditions, but nothing is known of the work he did outdoors. In May 1835 he told Constable he had been 'making a few Sketches of local interest' for a young woman who was leaving shortly for Tasmania. 'At all opportunities', he said, 'I am hard at work sketching, and am more than ever delighted with its charms'.[1] Constable may have introduced him to the habit of working in the open the previous July when he was down in Sussex. Later, in April 1836, when business began to make greater demands on his time, the brewer had to forsake his easel. 'I am obliged, for the present', he wrote, 'to give up painting, I must endeavour to earn money & purchase pictures, for really it will be quite impossible to live without art'.[2]

George Constable had been collecting work by living artists for some time. In Harriet DeWint's lists of purchasers of her husband's works 'Constable' or 'Mr Constable' is shown as having bought four paintings, the first in 1832; and in 1833 Peter DeWint wrote to say that he was about to send George Con-

stable 'the Rainbow, as it has been much admired by Artists'.[3] William Havell was also patronised by George Constable and he too is known to have worked in the area. John Constable, however, was not greatly impressed by his host's taste in art, and wrote somewhat scornfully of the 'many enormous pieces of stained paper by Copley Feilding, as well as of poor Robson, and Havell, and some "oils" by Wm. Daniel' he saw around him in the drawing-room of Sefton House.[4] It was not George Constable's fault, though, that there was not hanging in the drawing-room at least one example of Constable's own work, a version of his *Salisbury Cathedral from the Bishop's Grounds* (see pl. 14). In December 1833 Constable declined an offer for the painting he had received from the brewer: 'I have not an idea that I shall be able to part with the Salisbury', he wrote, 'the price will of necessity be a very large one, for the time expended on it was enormous for its size. I am also unwilling to part with any of my standard pictures – they being all points with me in my practice, and will much regulate my future productions, should I do any more large works'.[5] George Constable did not give up hope of possessing the painting. 'Respecting one of your pictures', he replied, 'I shall certainly do my utmost to possess what I think your best in some respects, the "Salisbury Cathedral"; but more on this subject when I have the pleasure of seeing you. Could you without much trouble enclose me a bit of your sparkling colour to copy, I should be more than I can express obliged'.[6]

Among the oils by 'Arundel' Constable still with his descendants there are three copies of Constable subjects, Dedham mill, the mill-stream at Flatford, and a windmill at Brighton (pl. 24). All three are painted from David Lucas engravings. It is not known if Constable obliged with a bit of sparkling colour. If he was not able to, it might account for the dark, not in the least sparkling

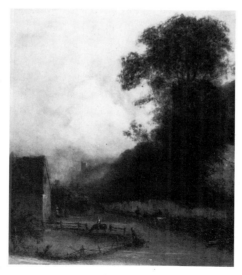

125 George Constable, *Arundel*, oil, $29\frac{1}{2} \times 24\frac{13}{16}$ (75 × 63)

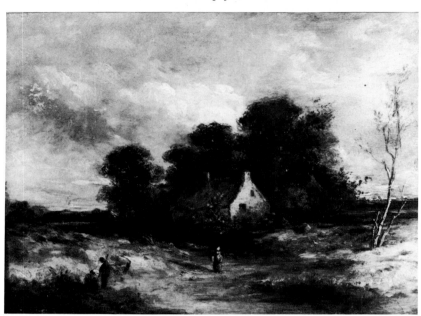

126 George Constable, *Landscape with Cottage and Figures*, oil, 9⅞ × 13 (25 × 33). For many years works such as this found their way into Sussex antique shops and galleries carrying attributions to John Constable.

appearance of the three copies and of the other paintings by George Constable in the family collection, in none of which are there more than a few touches of primary colour to enliven the low-toned greens and browns and the cloudy skies. Pls 125–6 illustrate two kinds of paintings George Constable appears to have favoured: the local view, studied in some detail (pl. 125), and the loosely painted compositional sketch of nowhere in particular (pl. 126). It is in these sketches that he appears to have tried hardest to capture Constable's late, highly individual style of painting. The theme (if that is not too grand a word) to which George Constable constantly returns in these rather slight works is one of rural nostalgia; the subject, unenclosed heathland with cottagers and their dwellings, the latter often placed against trees thickly grouped, with a solitary spindly tree to offset the dark mass behind. Most are well, if perhaps over-decorously composed. All so far seen have been executed in a confident, breezy style, with skies occasionally palette-knifed in, and with contrasting textures of paint – moist impasto thickly applied for the lights, loosely-brushed, thin washes of transparent paint for the half-tones, heavily stained darks.

These pseudo-John Constables were produced by the brewer, it seems, in some numbers. Examples have not infrequently changed hands. Sometimes this has resulted in a change of attribution. With two unrelated artists bearing the same name, there is bound to be confusion. If there is a stylistic resemblance the confusion increases in a direct ratio to the artists' inequality of merit and inevitably, if there is a change, the move will be away from the lesser to the greater name – in this case from George to John Constable. In the earlier years of this century many of George Constable's paintings were so promoted. It is

unlikely that an oil sketch by Constable will ever be found masquerading as a painting by his friend, the Arundel brewer.

The text of C. R. Leslie's letter of August 1844 to Minna and Isabel, written when he heard they were contemplating another visit to Arundel, and telling them of the spurious Constables 'Mr Geo. Constable' had been marketing, is given on p. 42. There is little one can add to what has been said about this perplexing document and its contents. There just remain the unanswered questions. What caused George Constable, so recently mayor of Arundel, a man with generations of successful business practice behind him, to behave as he did? How could he attempt to pass spurious Constables as genuine works by his friend? And how could he then try to press the sales home with reiterated assurances that he had seen the artist paint them? We shall probably never know.

# THOMAS CHURCHYARD

*Born 22 January 1798 at Melton, near Woodbridge, Suffolk, where his father was butcher and grazier. Educated at Dedham Grammar School (where Constable had completed his schooling). Settled in Woodbridge and became county court lawyer. Married Harriet, née Hailes, by whom he had three sons and seven daughters. Became prolific amateur watercolourist and landscape painter. Exhibited five times at Norwich (Norfolk and Suffolk Institution, of which he was an Honorary Member); at the RA, 1831; and at the Society of British Artists, 1830– 33. An ardent collector of English painting. Three close friends were Bernard Barton, the Quaker poet (1784–1849), Edward FitzGerald (1809–83), and Revd George Crabbe, son of the poet. Died 1865.\**

In the introduction he wrote for an exhibition of work by Thomas Churchyard held at the Nicholson Gallery, St James's Place, in 1940, Andrew Shirley said that Constable and Crome 'were personal friends' of the artist. Churchyard greatly admired the work of both (he owned and also copied their paintings) but so far as Constable is concerned no evidence has been found to support Shirley's statement. We have no knowledge of direct contact between him and Churchyard.

As an artist, though an amateur, Churchyard is familiar to present-day collec- tors, especially those with an interest in the area in Suffolk around Woodbridge and the River Deben, the country he painted so happily. Since the sale after the death of his last surviving daughter in 1927 there has been a plentiful supply of his work on the market. His output was prodigious; his use of media wide- ranging. Best known are his oils and watercolours. For us, however, it is his pen and wash drawings that are of particular interest. Landscape was the main subject of his drawings and paintings, but he had an eye for incident, for the life of the country and sea-shore, and he frequently depicts work going on in the fields or among the boats on the river. Details also delighted him: hedgerow plants, a bird's nest, a colony of snails or a dead weasel. Somewhat perplexing

\* For much of the information in this section we are indebted to Denis Thomas's *Thomas Churchyard of Woodbridge*, 1966. He has also generously advised us on a number of points.

127 Thomas Churchyard, *Willy Lott's House*, watercolour, $6 \times 9\frac{1}{2}$ (15.2 × 24.1)

is Churchyard's stylistic range. On many sides there are to be seen examples authentic in origin but in manner seemingly inconsistent with the main body of his work. We are mainly concerned with the question of Churchyard and Constable's work being confused, but there are obviously problems for those wishing to identify the former's own work.* A helpful guide is the fact that many of his drawings and paintings are inscribed with the name of the particular daughter who inherited them. In a number of cases he pencilled his initials in the corner or margin of a drawing, but he seems to have been unwilling to sign in full (the initials 'T.C.', it should be noted, can quite easily be altered to 'J.C.'). Denis Thomas states that Churchyard usually took care to sign his copies of work by other artists 'with his distinctive flourish of initials' on the back of the canvas or stretcher.[1]

His eye for transient incident and effect enabled Churchyard to paint a great many charming works — more in watercolour, perhaps, than in oil. In water-colour his style was especially easy, fluent and unmannered. But like the work of many an amateur, though often pleasing Churchyard's painting has a limited appeal as it not infrequently lacks depth, depth of feeling as well as of perception. This was recognised by his friend Bernard Barton. 'I am just such a poet as my neighbour Tom Churchyard is an artist', he wrote. 'He will dash you off slight and careless sketches by the dozen, or score, but for touching, retouching, or finishing, that is quite another affair, and has to wait, if it ever be done at all. Of course we are a couple of lazy slovenly artistes, for our want of pains, but as the old proverb has it, "There is no making a silken Purse out of a Sow's ear".'[2] It is this slightness, the amateur's shallowness of intent, that dis-tinguishes his work most clearly from that of Constable, the artist he most admired. Pl. 127, *Willy Lott's House*, exhibits something of both his charm and his superficiality. It also shows him at the very heart of the Constable country years before it became a national shrine. Flatford was only one of the places

* Numerous works by the daughters and a son, Charles, were among the items in the sale of 1927. 'Many of the weaker and more slapdash "Churchyards" now in circulation are not the father's work but the children's'; Thomas, op. cit., p. 10.

with Constable associations painted by Churchyard: East Bergholt, Dedham, The Grove at Hampstead, he visited in person to sketch. Apparently in much the same spirit, he also painted Arundel Castle and Salisbury, but as there is no evidence he ever went to either Sussex or Wiltshire just how he managed this, unless he was making copies, is not at all clear.

It is not known if Churchyard ever met Constable; nor is it known when he became aware he had crossed Constable's tracks. He may have heard of him locally when a schoolboy in Dedham. He may have read about him in the *Ipswich Journal*, which often reprinted items from the London papers of local interest. In his capacity as a practising lawyer he would have undoubtedly met people such as James Pulham, the Woodbridge solicitor, who were well acquainted with Constable. Whatever the link, he was certainly in close touch with events in the period immediately following the artist's death in 1837. A memorandum in his hand, to be published in a forthcoming biography of Churchyard,[3] records a conversation he had with John Charles and Golding Constable when they visited Woodbridge just a few days after John Constable's death. '11th April', the note commences, 'young John Constable and his uncle Golding called and described to me the last hours of Constable . . .', etc. As he owned a catalogue of Foster's Constable sale of 1838 with the prices noted down* it is possible he was in attendance on that occasion. By some, notably his friend Edward FitzGerald the poet, he was considered a great judge of Constable, and able to tell whether a work was genuine. It is in a letter from FitzGerald (dated 11 April 1844, from – of all places – Charlotte Street) that we find an early reference to Churchyard as a collector of Constables.

In the sale following Churchyard's death there were four paintings by Constable listed in the catalogue: 'Willy Lott's House' (24 × 20); 'Flatford Mill' (16 × 13); 'Bergholt Heath' (19 × 12); and 'View at Dedham' (25 × 18). 'Bergholt Heath' is very possibly the painting later mistitled 'Highgate' that he is known to have owned (see p. 72). It has been suggested that the Leeds oil study by Constable for the *Stour Valley and Dedham Village* (pl. 52) was owned by him and that a copy of this sketch of Constable's is his work.[4] If the measurements were a little closer, 'View at Dedham' in his sale would have been a likely candidate for this painting. At one time he owned a smaller *Willy Lott's House*, the oil sketch now at Ipswich, which he appears to have bought at C. R. Leslie's sale in 1860. A copy by him of this is in the collection of Mr Peter Folkard, who also owns a Churchyard copy of one of Constable's oil sketches of Flatford Mill from the lock. Other Constables may have passed through his hands; among the copies he made there is listed a *Parham Mill, Gillingham* as well as a *Glebe Farm*. There were also works by Constable, drawings it seems, among collections of his own work inherited by the daughters.

* This catalogue, with a copy of Leslie's *Life of Constable* (interleaved with watercolour sketches) and a copy of J. T. Smith's *Remarks on Rural Scenery*, were among the books listed in the catalogue of the 1927 sale; Thomas, op. cit., p. 21.

128 Thomas Churchyard, *A River Valley*, oil, $6\frac{11}{16} \times 8\frac{7}{8}$ (17 × 22.5). Reattributed here to Churchyard for the first time.

129 Thomas Churchyard, *The Valley of the Deben*, oil, 6 × 9 (15.2 × 22.9)

Apart from the group of drawings to which we refer below, there is not a body of work by Churchyard, as there is with some artists, that has been mistakenly attributed to Constable. Although Churchyard's debt to Constable often calls for comment, and indeed is not infrequently found to be a good selling point, it is now only rarely in the London art market that they are confused, as was the case with *River Valley* (pl. 128). This is not to say that the occasional collector or dealer does not from time to time secretly nurse the hope that one of his Churchyards will eventually prove to be by the greater artist. Pl. 129, *The Valley of the Deben*, an oil sketch sold by Christie's in 1972 as a Churchyard[5] and as such bought by Spinks, is an example of the kind of painting by him that, out of context and with no previous attribution, might easily start a train

[221]

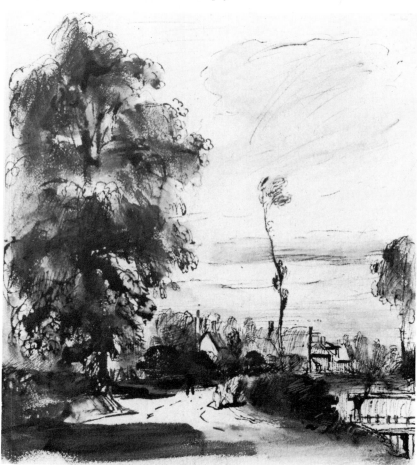

130 Thomas Churchyard, *A Country Lane with Cottages ('A Village near Dedham')*, pen and wash, $6\frac{3}{8} \times 5\frac{3}{8}$ (16.2 × 13.6). For many years attributed to Constable; more recently the name of Thomas Creswick has been suggested.

of thought leading off in the direction of Constable. Holmes, surprisingly enough, on one occasion appears to have been misled in just such a way, in his case by a watercolour. One of the smaller plates in his book on Constable of 1902 reproduces a watercolour entitled '*A Distant View of Woodford*' which is stated to be of 1830 and in the possession of Arthur Kay.[6] The attribution is plainly wrong. The subject, a harvest field with a church, windmill and rooftops among trees beyond, is not unlike some of Churchyard's views of Woodbridge. By misreading, or wrongful transcription, Woodbridge could easily have become Woodford. The present whereabouts of the original is not known. From the sepia reproduction alone one cannot be certain it is a Churchyard, but topographical verification might very well prove it to be one.

In his later years Constable produced a number of forceful compositions in sepia wash or pen and wash, studies usually based on scenes he knew or had previously drawn. Some of these are amongst his most memorable images. Pen and sepia wash was also much used by Churchyard, both for sketching and

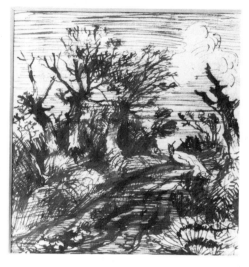

131 Thomas Churchyard, *A Lane*, pen and wash, 6 × 5¼ (15.2 × 13.3)

composing. Three of his drawings of this type were shown as Constables at the Wildenstein centenary exhibition in 1937; one, No. 157, was catalogued as '*A Village near Dedham*' (pl. 130), a misleading and entirely fictitious title.* Apart from the bold use of the brush, the drawing has little in common with one of Constable's late productions, but once an attribution of this kind has been established it is not easily changed, and the drawing had survived as a Constable when it entered the Mellon collection in 1962. Neither of the other two Churchyard drawings exhibited as Constables at the Wildenstein show has surfaced yet, but the more recent history of another Churchyard (pl. 131), similarly executed in pen and wash, shows that the precedent established by the three in 1937 has survived. This drawing was bought by the omnivorous collector L. G. Duke at Bonham's in 1955, with other drawings in a parcel, for £1. In Duke's catalogue (No. D.3129) it is entered fully as a Constable. It was more recently seen at a sale at Christie's (20 January 1980, lot 13) catalogued rather more cautiously as 'J. Constable, Drawing of a Lane', and sold as one of two drawings in the lot. As a Churchyard, it is a drawing any modest collector would be pleased to possess.

* The other two drawings were catalogued as: No. 158, 'Landscape, Church and Cottages   Pen and Sepia 3⅝ × 4″, 1829'; and No. 159, 'View of a Church   Pen and Sepia 4½″ × 3¾″, 1829'.

# LIONEL BICKNELL
# CONSTABLE

*Born 2 January 1828, 6 Well Walk, Hampstead. Godparents: Charles Jones (Admiralty),*
*C. R. Leslie, Mrs Jane Anne Inglis (née Mason). 23 November 1828, death of his mother.*
*31 March 1837, death of his father. Educated: c. 1838, at a school at East Sheen; 1841–*
*c. 1844, 'Mr Stoton's', Wimbledon; 1847–8, F. S. Cary's School of Design (Sass's*
*Academy). Lived most of his life with his sisters Maria Louisa (Minna) and Isabel and with*
*his brother Alfred (until his death by drowning in 1853) at 16 Cunningham Place, St John's*
*Wood. Exhibited RA 1849–55\* and BI 1850.† September to December 1850, tour of United*
*States. Various sketching holidays and expeditions are recorded: 1846 (June) Suffolk, (July)*
*Ashcott near Glastonbury, Somerset; 1849 (May) Elstree, (August) Brighton; 1850 (July)*
*Cornwall; 1852, Sidmouth; Dorset. He is also known to have visited Scotland, Lancashire,*
*the Lakes, Kent, Wiltshire and other southern counties, and, several times, Suffolk. Died 20*
*June 1887, at 64 Hamilton Terrace, St John's Wood. Appears to have painted very little*
*after Alfred's death. Subsequent interests, photography, carpentry, yachting and his pets.*

In 1954 there was held in Ipswich and London *An Exhibition of the Works of*
*The Constable Family – Five Generations.* The exhibits had been lent by the artist's
great-grandson, Col. J. H. Constable, and by other members of the family. At
Ipswich seventy-four drawings and paintings by John Constable from the family
collection were shown. Others represented were Charles Golding, Isabel, Alfred
Abram and Lionel Bicknell, the artist's children, Hugh Golding, Charles Gold-
ing's son, and Arrahenua Ella, Hugh's daughter. The fifth generation was
represented by Col. Constable's two sons, John Charles Philip and Richard
Golding, then twenty-six and twenty-two years of age respectively. Of the second
generation, there were eighty-four watercolours and drawings by Charles Gold-
ing, nineteen watercolours and oils by Isabel (all flower- or feather-studies), nine

* 1849; 40, Landscape; 358, 'A view near Twyford'. 1850: 14, 'Landscape'; 516, 'A stormy
day'; 630, 'Tottenham Park'; 975, 'An ash tree'. 1851: 13, 'On the coast of Cornwall'; 1039,
'Entrance to Looe harbour, Cornwall'. 1852: 1129, 'Falls of the Tummell, Inverness-shire'; 1293,
'View on the Thames, near Pangbourne, Berkshire'. 1853: 729, 'A study' (under 'Drawings
and Miniatures'). 1855: 271, 'A barn, in Sussex'; 1358, 'Entrance to a wood'.
† 342, 'Evening', size with frame 16 × 20 in.

works by Alfred, and thirty-nine drawings, watercolours and oils by Lionel.* Between 1855, when Lionel showed for the last time at the RA, and 1976, when a few examples by him were included in the Constable Bicentenary Exhibition at the Tate, this was the only time works by him on public view had been correctly acknowledged and catalogued. In the intervening years a great many of his oil sketches, watercolours and drawings had been seen at loan exhibitions, in public and private collections, at dealers' galleries and at the sale-rooms, but only in the *Five Generations* showing were examples of his work correctly listed as his. On all the other occasions his drawings and paintings had been mistakenly attributed to his father, to John Constable.

In 1978, the present writers published an exploratory article entitled 'Which Constable?' in the *Burlington Magazine*.[1] The main purpose of the article was to discuss the authorship of some oil paintings and drawings which had hitherto been attributed to John Constable, and to offer reasons for thinking they were more probably the work of Lionel Constable. The ready and widespread acceptance of the suggested reattributions was encouraging, but it was also a measure of the prevailing uncertainty about the extent of the Constable oeuvre. The idea in this case proved a welcome one, as it answered in a positive manner a number of nagging and rather awkward questions, and because it permitted well-known and much admired pictures such as the Tate Gallery's '*Near Stoke-by-Nayland*' (pl. 44) to remain Constables, to stay in the family, as it were, requiring only a change of christian names. In all, ten paintings were reattributed to Lionel Constable. After the publication of this article it was possible to extend the list and eventually, with some thirty oils that could reasonably be attributed to Lionel, it was thought there was a sufficient number for a small exhibition.

In February, 1982, therefore, little short of a hundred years after his death, the Tate Gallery gave Lionel Constable his first one-man show. Held in the gallery next to the permanent Constable collection, the exhibition displayed oil paintings, watercolours, drawings and engravings by Lionel and also a selection of his photographs – in all, fifty-eight items. It was a useful exhibition. A room-full of his work made it possible to compare paintings that had not been seen together before, to assess the rightfulness of some of the attributions (before 1978 all but five of the thirty-three oils on display had been attributed to John Constable), and to obtain a clearer idea of Lionel's capabilities as an artist. All things considered, in such august surroundings, with some of his father's finest works next door, Lionel came out of it surprisingly well. There were several lessons to be learnt from the exhibition. One was that with knowledge of paintings by Lionel not included in the show, knowing of others not as yet attributed to him, and with little idea so far of the capabilities of his brother Alfred, it would be premature to attempt a full assessment of Lionel as an artist. Here,

* After Ipswich, a smaller version of *The Constable Family – Five Generations* was shown at the South London Art Gallery, Camberwell and subsequently in Sunderland, Middlesbrough, Birkenhead, Southsea, Worcester, Leamington and Blackpool.

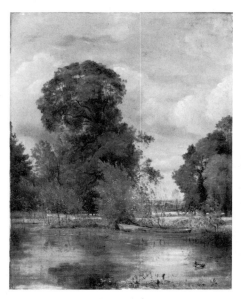

132  Lionel Constable, *Tottenham Park*, exh. 1850; oil, $18\frac{1}{4} \times 14\frac{1}{8}$ (46.4 × 35.9)

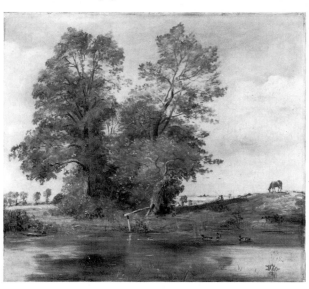

133  Lionel Constable, *On the Brent*, oil, $12\frac{1}{8} \times 13\frac{1}{4}$ (30.8 × 33.7)

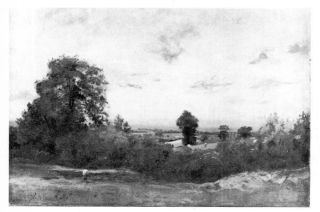

134  Lionel Constable, *Hampstead Heath ('View near Dedham')*, oil, $13\frac{1}{2} \times 16\frac{1}{2}$ (34.3 × 41.9)

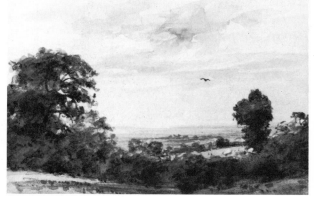

135  Lionel Constable, page from dismembered sketchbook, 1849; watercolour, $3\frac{3}{8} \times 4\frac{13}{16}$ (8.6 × 12.2)

therefore, we only intend to offer some observations on his subject matter, his methods of working and his mode of painting, and to comment on certain distinguishing features in his style of handling.

The scale on which Lionel worked was modest. The largest painting known to be by him, a view of Hampstead Heath, is only $14\frac{3}{4} \times 18\frac{3}{4}$ inches;[2] the smaller dimension of the majority averages ten inches or under. The larger paintings are on canvas; most of the smaller ones on board or paper, the latter a support John Constable favoured for his oil sketches. Like his father, Lionel liked a

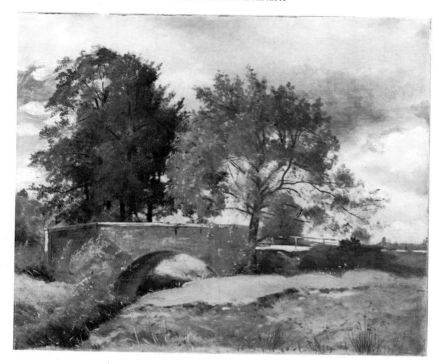

136 Lionel Constable, *A Bridge on the Mole*, oil, $9\frac{15}{16} \times 11\frac{15}{16}$ (25.4 × 30.3)

137 Lionel Constable, photograph of the site depicted in pl. 136; salt print, $5\frac{9}{16} \times 8\frac{11}{16}$ (14.1 × 22). The discovery in 1976 of this and other photographs taken by Lionel led to the reassessment of a number of works previously attributed to John Constable.

coloured ground of some sort to paint on. In many cases he used a reddish-brown one, not unlike the colour with which his father prepared *his* painting surfaces, but rather yellower and not so dark. Sometimes Lionel began differently, on a white ground with two colours – it might be blue and green – thinly scumbled over the main areas that were to be sky and land. With a bright but partly clouded sky, quite often he would scumble blue over parts only and then brush his clouds in softly while the blue was still wet. Most of the sketches were executed with the paint applied as thinly as possible. Small touches of colour to represent individual leaves or stems, a feature of Lionel's technique, were put in with

the paint only slightly thicker than the previous layer. Hardly ever did he use a heavy impasto.

Some of Lionel's pictures, landscapes such as *Tottenham Park* (pl. 132) and *On the Brent* (pl. 133), appear to have been painted in the studio; others, the coastal scenes for example (pl. 45), show every sign of having been done on the spot. Between these not so distant extremes we have studies such as *On the Sid near Sidmouth* (pl. 47) which, one feels, could have been painted either before or away from the motif. It is evident that both drawings and his own photographs provided him with material for his pictures. At least four of the views in a sketch-book he used in 1849* were selected as subjects for paintings. The Smith College, so-called *View near Dedham* (pl. 134) is in fact derived from three of the 1849 studies, a watercolour (pl. 135) and two pencil drawings, all taken from the same spot on Hampstead Heath. The *Bridge on the Mole* (pl. 136), of which there are two versions, closely resembles one of the two photographs Lionel took of the scene (pl. 137) – in some parts the detailing is identical. In another case, *The Way to the Farm*,[3] he appears to have photographed and painted the subject, but from almost opposite viewpoints.

Although Lionel often chose to paint subjects similar to his father's, he rarely worked in the same places, Hampstead being the chief exception. Nor did he share his father's intense attachment to a few localities. Lionel appears to have been at home wherever he found himself – from Cornwall to Scotland – and as a result it is not always easy to identify the subjects of his pictures, especially when recognisable topographical features are often absent. A number of his paint-ings, because they were thought to be by his father, have been given fictitious titles, '*Dedham Water Meadows*' (pl. 138), '*On the Stour*', '*Near Dedham*' etc. Com-paratively little in his choice of subject-matter does Lionel seem to have been conscious of current fashionable notions about landscape. Almost the only exam-ple of a traditional picturesque subject is the work he exhibited at the RA in 1852, *The Falls of the Tummel*,[4] an uncharacteristic work and one of his less successful efforts. Most of the scenes he painted are viewed at some distance from human habitation, but in selecting his subjects he seems to have been guided neither by a desire to proclaim remote isolation nor by the opposite contemporary taste for cosy rural subjects. If he places himself thus, a little apart, it would seem to be less for reasons of sentiment than for matter-of-fact practicability, it being easier to work if there were a few fields between him and the labouring life of the countryside. Skies are a noticeable feature in Lionel's paintings, some of which, with horizons placed low down, are really little more than sky-studies. Early morning and evening effects, as well as the rain squalls so beloved by his father, are almost entirely absent from Lionel's *oeuvre* as it at present stands.

---

* This dismembered sketchbook of thirty-three pages in the Staatliche Museen, East Berlin is described (and some pages from it illustrated) in Tate Gallery 1982, pp. 10, 97–100.

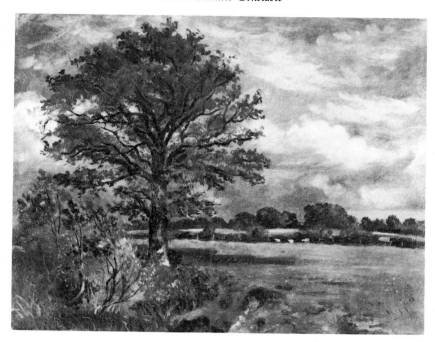

138 Lionel Constable, '*Dedham Water Meadows*', oil, $9\frac{1}{16} \times 11\frac{13}{16}$ (23 × 30)

The Smith College *Hampstead Heath* (pl. 134) is one of the very few to depict an evening sky.

Much of Lionel's charm derives from his sense of colour. Most of his paintings are light in key and of a pleasing freshness. Certain colours are peculiarly his own: a range of pinky-mauves; pale yellowy khaki, for dried grass foregrounds; an intense cerulean blue in the skies; stones and rocks frequently purply-grey and black. The oft-told story of Constable laying down a violin on Sir George Beaumont's lawn to prove grass was green not brown, has encouraged us to think of him perhaps overmuch as a painter of greens. For most of his working life, especially in the later years, Constable was in fact relatively sparing in his use of the colour, and in particular of the lighter greens of spring (a season he most often spent working feverishly at his easel endeavouring to finish his Academy exhibits). But there was a period, for a couple of years before his marriage and for a few afterwards, a time of happiness and great promise, when Constable did see relatively brilliant colours in nature, radiant blues and fresh 'tints and colours of the *living* foliage'.[5] Lionel was greatly, one is tempted to say almost exclusively influenced by his father's art, and it appears to have been the work of this short period, of paintings with lighter and more intense ranges of colour that influenced him most, pictures such as the Tate Gallery's *Salt Box*[6] and the *View from Archdeacon Fisher's House* now in the V & A[7] (a work he had chosen for himself at the sharing-out in 1848), that influenced him most. Several times he painted views from the higher terrain at Hampstead, in intention views not unlike the *Salt Box* or even the more brilliant *Hampstead Heath*[8] in

the Fitzwilliam Museum, Cambridge, and more than once he attempted the blue-green shadows his father had so successfully captured at the bedroom window of Fisher's house in Salisbury Close. Although he also owned the late, mannered watercolour of Willy Lott's house in the British Museum (now known as the *Farmhouse near the Water's Edge*)[9] and possibly others like it, there is no evidence to suggest that Constable's work of his last years, the palette-knifed, white-bespeckled oils subsequently to be so imitated and forged by others, were of much practical interest to Lionel.

In his choice of subject, his use of colour and in his handling, Lionel at times comes quite close to the elder Constable. He is less like his father in his sense of design, in the way he selected his views and composed his material. Working in the middle of the nineteenth century, perhaps with an eye accustomed to the lens's image, Lionel had a more direct, less academic, perhaps a more innocent approach to pictorial design.

Temperamently, father and son were also unlike, and this makes for further perceptible differences in their work. At times Lionel's handling resembles his father's, in the way he painted his skies for instance, but in general their brushwork is very different. In the painted surfaces of Constable's pictures, whether he was exercising maximum control or painting freely and boldly, there is almost always evidence of his strength and passionate nature, each touch of paint is a record of power released or in some degree held in check. Lionel, of a gentler and less impulsive disposition, had quite a different feel for the application of paint. His strokes or dabs of the brush are light and soft, his touches of pigment crisp, sharp and delicate. This lightness of touch led to the development by Lionel of a technique peculiarly his own.

Another picture by his father Lionel chose for himself in the 1848 share-out and kept to the end of his life was the *Admiral's House, Hampstead* (pl. 139), now in the Tate Gallery. Though parts of this picture are carefully and precisely delineated, a feature of the work is its breezy spontaneous character and the vigour of much of the brushwork. In the middle foreground on the far side of the pond, there are two small trees. In each the delicate airy foliage is expressed by means of a veritable fountain of tiny strokes and touches. Constable painted leaves in this way, with small, tonally gradated touches angled and widely spaced to suggest low-density 'see through' foliage, in several of his pictures, notably *The Hay-Wain* (pl. 3). Lionel used a scatter of such touches habitually for foliage, but he also adapted it for the rendering of other forms of foreground or nearby vegetation, for grass-stems and seed-heads, for reeds, briars and for scrub of all kinds. Prime examples of this very distinctive technique of Lionel's may be observed in *On the Sid near Sidmouth* (pl. 47) and *The Source of the Brett* (pl. 140). In these and in a number of other paintings by him there is to be found represented a plant form with a drooping head shaped like an italic 'f' and with additional comma-like touches on either side, a calligraphic-style symbol which has become tantamount to a recognisable Lionelian signature.[10] A quite different characteristic

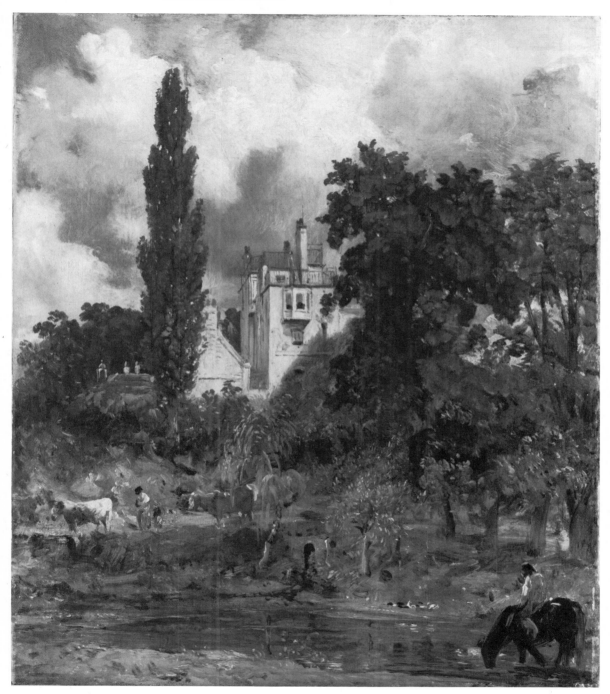

139 *Admiral's House, Hampstead,*
*c.* 1820–25; oil, $14 \times 11\frac{7}{8}$ (35.6 × 30.2)

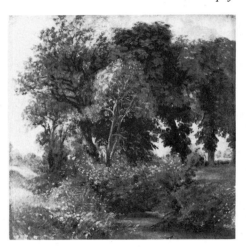

140 Lionel Constable, *The Source of the Brett*, oil, $10\frac{5}{8} \times 10\frac{1}{4}$ (27 × 26)

in his handling was the way he often rendered the lower branches of a tree as a kind of radial system, generally with a stiffer, broader brush. Other characteristics emerge. He tends to be repetitious. The three mowers in the Tate Gallery's '*Near Stoke-by-Nayland*' (pl. 44) are closely grouped and in a similar posture, like toy farm-hands in a nursery set of farm animals. The mole-hills in the same picture are also alike, and seem to have been placed in position rather than to have appeared from below ground. Lionel lacked his father's almost instinctive feeling for random spacing and interval, and his trees are therefore often to be seen standing awkwardly in rows, military fashion. A more serious limitation is his poor understanding of structure and of three-dimensional form. The branches of his trees seldom convey a sense of the weight they bear; though delightfully painted, his clouds do not hang convincingly one in front of the other; it is the more superficial aspects of rocks that he paints, the cracks and striations, hardly at all is he concerned with their bulk and mass.

One of the purposes of the exhibition at the Tate was to bring together for comparison a few paintings, erstwhile John Constables, which could not be attributed so confidently to Lionel. This small group, seven in all,[11] was representative of a much larger one, a group consisting of paintings previously attributed to John Constable, which, though stylistically not altogether consistent, were now thought to be by one or another of the two youngest sons. In one respect the experiment proved inconclusive. Very little further did it bring us towards a desired aim, the recognition of the work of Alfred, the elder of the two.

Alfred is, in fact, something of an embarrassment. Through his letters, especially from those he wrote in the summer of 1846, one gets to know him quite well. He is outgoing, amusing, carefree and excited about painting. From where he was staying at Higham in the Stour valley, he talks of his room having become quite a gallery of pictures; already, at the age of nineteen, he was talking of pictures intended for the Academy. The following year, 1847, he had a work

accepted by the R.A. Though titled just 'Landscape' in the catalogue, we know from Jane Anne Luard's letter (see p. 60) that it contained trees and grass in sunlight and a shady road, that she thought it 'as sweet & true to nature' as it could possibly be and that she admired it for 'that particular out of door look which is of inestimable value'. Alfred continued to exhibit at the Academy and only failed to show once (1849) between 1847 and 1853, the year of his death. Four of the pictures he showed were of subjects or places on the coast. Two were named: 'Hythe Church, Kent' (1852) and 'On the Devonshire coast' (1853).* From the Correspondence Alfred seems to have received just as much encouragement to study art, and to have been considered no less of an artist. All this we know, yet, for us, as a painter, he barely exists. To date, only two paintings have been ascribed to him: a rather dull landscape in the family collection and an equally inconclusive oil study of a thatched cottage which is inscribed on the back of the frame, 'Cottage in the parish of Wenham Magna, Suffolk painted by Alfred Constable (son of John Constable R.A.) about the year 1848–9'.[12] It is a tantalizing situation: on the one hand an artist about whom quite a lot is known; on the other at least a couple of dozen paintings awaiting ascription. Until the appearance of more work by Alfred of undoubted authenticity, regretfully things have to remain, somewhat cryptically, thus.

At present we know Lionel as a draughtsman and watercolourist much as we know him as an oil painter, as the author of a group of fully authenticated works to which others can be stylistically related with a certain degree of confidence, and as the possible author of an uncertain number of further works, to some of which Alfred (or in this case, Charles Golding too) may eventually be able to lay claim. The majority of drawings traditionally ascribed to Lionel are still in the family collection. In the *Five Generations* exhibition of 1954, thirty-seven drawings and a sketchbook of Dorsetshire pencil sketches were listed as Lionel's. Most of these can be identified in the collection today; many have inscriptions or ascriptions which fully confirm the traditional family attributions. This is the hard core essential for subsequent attributions; it is to these that we should refer when attempting to identify Lionel's work elsewhere.

Over the years a considerable number of drawings as well as paintings by the Constable children have found their way on the market, almost always attributed to their father. A proportion of those that had infiltrated public and private collections has been identified as their work.† Some of these are by Lionel and have been accepted as his, notably the Berlin sketchbook of 1849 (pl. 135).

* Alfred's other exhibited works were: 1848, 'Landscape'; 1850, 'Morning on the coast' and 'A sketch'; 1851, 'A fisherman's cottage'; 1852, 'Landscape'.

† On 18 November 1971 an album from the Ridley-Colborne collection was sold at Sotheby's. It contained original drawings by Constable, Frost and other unidentified hands, and thirty or so by the younger Constables, presumably Lionel and Alfred. These last were later put back into the rooms and sold as drawings by Constable's sons. In no time a few were back on the market again, attributed to John Constable and marked up at John Constable prices.

141  Lionel Constable, *Brighton Beach*, 1845; pencil, $3\frac{1}{2} \times 5\frac{1}{4}$ (8.9 × 13.3)

But in general, until we know him better, it is going to be a hard task distinguishing between Lionel's drawings, especially his more boyish efforts, and those of his brother Alfred.

All but one of the drawings by Lionel we reproduce here are from the family collection. The first (pl. 141), inscribed 'Oct. 18 45' and on the back 'Brighton morning   Lar [i.e. Lionel]', is one of three pencil studies of beached vessels he made that month. The second is inscribed 'Shoreham Oct 20 evening'; the third, 'Oct. 25. 1845'. All are carefully and deliberately drawn, without fuss. In the one we illustrate (pl. 141), the end of Brighton pier is just discernible, beyond the stern of the furthest boat. Pl. 142, *A Harvest Field*, '⟨July⟩ Aug! 1846', was shown at the Tate in 1976.[13] Lionel was staying at Ashcott in Somerset when he made this drawing (see pp. 57–9) and at the time he and Alfred were writing to each other regularly about their work. Lionel sent his brother a pencil sketch done on the spot of a Somersetshire windmill; Alfred thought very highly of this, 'I must tell you that the pencilling of the mill you sent me is very beautiful you seem to have quite the power of the pencil   the sky is so beautiful   how well it will paint   do make a sketch of it'. In manner this drawing of Lionel's, the *Harvest Field*, is remarkably close to his father's pencil sketches of 1814, to one of his studies for *View on the Stour*, for instance (pl. 143). Pl. 144, *The Corner of a Field*, inscribed 'Oct 13th 47 evening', shows up some of Lionel's weaknesses, his rather poor grasp of structure and his idiosyncratic but not altogether satisfactory formula for foliage. The *Rocky Cove* (pl. 145) was drawn during his visit to Cornwall in 1850; *Rame Head* (pl. 45) was done on the same trip. In the family collection there are two further Cornish pencil sketches. One is inscribed on the back of the mount, 'Cheese Ring. Cornwall. July 19th 1850'. Both are of gigantic piles of eroded rock. Both are drawn strongly and firmly, like the *Rocky Cove*, with a soft pencil, producing a rather gritty texture in the more lightly shaded areas. In the Huntington Art Gallery there is a similar but rather better drawing by Lionel of a typical, steep-sided Cornish or Devonshire valley inscribed 'Evening July' (pl. 146). Titled 'On the Wiltshire Downs', this has twice been exhibited as a John Constable.[14] Two of the water-

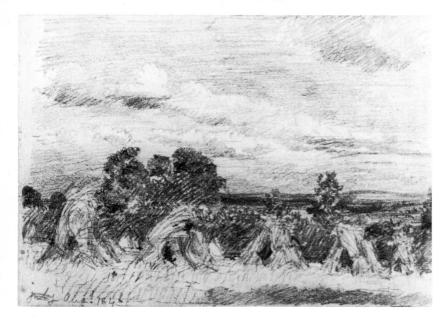

142 Lionel Constable, *A Harvest Field*, 1846; pencil, $4\frac{5}{8} \times 6\frac{3}{8}$ (11.7 × 16.2)

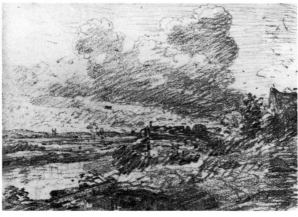

143 Study in John Constable's 1814 sketchbook used for *View on the Stour* (pl. 4); pencil, $3\frac{1}{8} \times 4\frac{1}{4}$ (8 × 10.8)

colours Lionel made on his tour of Scotland in 1851 are known,[15] so for lack of a firmer identification it has been assumed that pl. 147 is also a *Scottish Scene*. In the family collection there is a double-spread pencil study of the subject. The blotchiness of the sky in the *Scottish Scene*, due to retouching while the first washes were still wet, is to be seen in some of Lionel's other watercolours.

The attribution of the drawing shown in pl. 148, a copy of a pencil sketch, *A Lane near East Bergholt* dated 25 July 1817, by John Constable (pl. 149), is not based solely on slight weaknesses of understanding on the part of the copyist and the similarity of the shading to the gritty pencil work already noted in Lionel's Cornish drawings of 1850. In the exhibition *Five Generations* the copy is listed as a Lionel Constable, 'The Cornfield Lane, East Bergholt', though with the

[235]

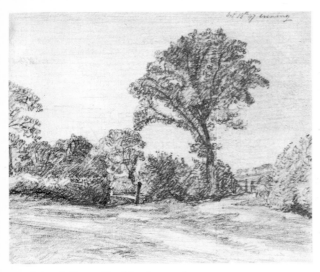

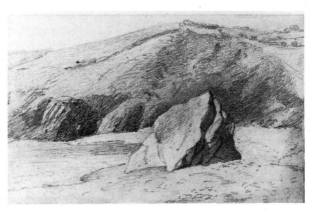

145 Lionel Constable, *Rocky Cove, Cornwall*, 1850; pencil, $4\frac{5}{8} \times 7\frac{3}{16}$ ($11.7 \times 18.2$)

144 Lionel Constable, *The Corner of a Field*, 1847; pencil, $4\frac{3}{8} \times 5\frac{1}{8}$ ($11.1 \times 13$)

146 Lionel Constable, *Cornish Valley*, 1850; pencil, $4\frac{5}{8} \times 7\frac{1}{8}$ ($11.7 \times 18.2$)

precautionary rider: 'May be by John Constable, R.A.'. If this drawing is by Lionel, as we strongly suspect, we should be on the look-out for other equally skilful copies by him, for it is unlikely that this is the only one he made. For good measure, and as an exercise in connoisseurship, we also illustrate a copy from *A Lane near East Bergholt* by John Fisher (pl. 150). The three hands are distinguishable but, it perhaps will be agreed, not readily, at a glance.

Thirty-seven drawings by Lionel were shown at the *Five Generations* exhibition; Alfred was represented by only eight. As a painter he is elusive; he is hardly

147 Lionel Constable, *Scottish Scene( ? )*, ? 1851; watercolour, $6\frac{7}{8} \times 9\frac{7}{8}$ (17.5 × 25.1)

less so as a draughtsman. In an introductory note in the catalogue of the exhibition it is stated that 'of John Constable's sons, he was probably the one most likely to follow his father'. R. B. Beckett appears to have based his assessment of Alfred on this statement and on a reading of some of Charles Golding's letters. 'Alfred', he says, 'inherited more of Constable's artistic genius than any other member of the family, and some of his pencil drawings might easily be mistaken for those of his father'. Quite erroneously, Beckett has Lionel 'living for many years in one of the East Bergholt cottages which had inspired his father. Like Alfred', Beckett continues, 'to whom he was greatly attached and with whom he had spent much time sketching, he took to art at an early age and exhibited thirteen landscapes at the Royal Academy between 1849 and 1855; but he had not the same talent'.[16]

There are at present barely half-a-dozen drawings in the family collection that can confidently be attributed to Alfred. None of these shows more than average talent. The watercolour reproduced here (pl. 151), *In the Garden of Gandish House, East Bergholt* – inscribed 'Bottom of Aunt Mary's garden whilst Clarky was taking his weed [i.e. having a smoke]   John Garwood told me this was very good' – is a fair example of his landscape painting in watercolour. He was better at ships.

Charles Golding's drawings and watercolours of Egypt, of the Persian Gulf, where he spent so many years, and of India are of the greatest interest, but it is not our intention to reproduce any as they are only remotely connected with our story. Both he and Alfred were competent marine draughtsman. Pl. 152, *Sunset Hawl-down*, initialled 'C.G.C.' on the back, reflects something of his life-long love of ships and the sea.

[237]

148 Lionel Constable after John Constable, *A Lane near East Bergholt*, pencil, $3\frac{3}{4} \times 7\frac{1}{8}$ (9.5 × 18.1). It is not difficult to spot a copy (pls. 148, 150) when it can be placed alongside the original (pl. 149) but out of context it is much less easy to identify.

149 *A Lane near East Bergholt*, 1817; pencil, $4\frac{1}{2} \times 7\frac{3}{8}$ (11.5 × 18.6)

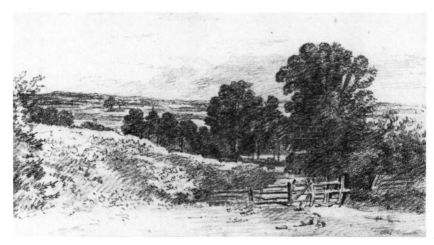

150 John Fisher after John Constable, *A Lane Near East Bergholt*, pencil, $4\frac{1}{2} \times 7\frac{1}{2}$ (11.5 × 19) to drawn border

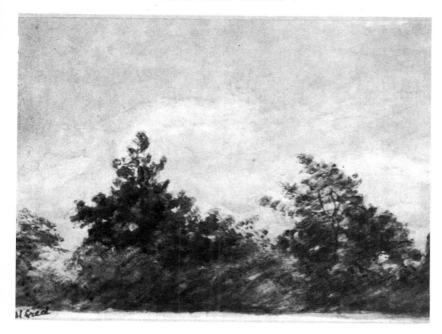

151 Alfred Constable, *In the Garden of Gandish House, East Bergholt*, watercolour, $3\frac{1}{2} \times 4\frac{3}{8}$ (8.9 × 11.1)

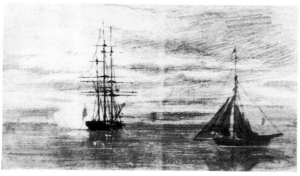

152 Charles Golding Constable, *Sunset Hawl-down*, watercolour and pencil, $4\frac{1}{8} \times 6\frac{1}{8}$ (10.5 × 15.5)

From her letters his daughter Ella, who married I. B. A. Mackinnon, appears to have inherited the Constables' feeling for art and she often talks of making sketches. In a letter to her brother Hugh, written in June 1887 from Colchester, where she and her aunt Isabel had gone to stay with the Inglis, she writes: '. . . pray excuse my remarking I am in the habit of doing a little more than the Kate Greenaways you only credit me with. Tomorrow I begin a sketch at the back of the house here & I have a few sketches at home [Hamilton Terrace], of course I am nothing very grand but I try my humble best in a mad sort of way.' But as an artist, however humble, to us Ella is quite unknown.

On p. 101 we quoted from Hugh Constable's autobiographical and family notes which he titled 'Rambling Tales'. He had been talking of paintings by Alfred and Lionel in the Salting collection. 'My wife', he went on, 'who has

copied John, Alfred, & Lionel's pictures so that it is nearly impossible to tell the originals knows each style directly but either the wonderful critics dont know or else something else'. Two of Eleanor May Constable's copies (as we said in a note, p. 101) are still with the family. For one, a *Branch Hill Pond*, it is said the dealer Cahn offered £800, no questions asked. The other is an excellent copy of John Constable's *Elder Tree*, now in Dublin. We shall leave the location of more of her work to future 'wonderful critics' who do know.

# JAMES WEBB

*Born 1825. Landscape and seascape painter, chiefly of British, French, Dutch and German subjects. Exhibited RA, 1853–88, BI, 1852–67, Society of British Artists 1851–1888/9, and elsewhere, giving London addresses. Died 1895.*

Under his own name Webb was a prolific landscape and marine artist with a particular liking, it would seem, for Continental estuary and coastal scenes of a kind made popular by Clarkson Stanfield. Such pictures are usually clearly signed and dated and would not in any case be mistaken for the work of Constable. But Webb is also said to have been one of the chief sources of imitation Constables and Turners in the second half of the nineteenth century. In this role he has already figured several times in part one of our book. John Absolon, it may be remembered, privately identified Webb as the artist responsible for the three 'Grand Rural Landscapes' which Foster's attempted to sell as Constables in 1869 and which Captain Constable and others exposed before the sale could take place (see p. 75 above). After Webb's death Charles Holmes identified two 'Constables' in the Orrock sale at Christie's on 4 June 1904 as his work: lot 68 as a copy after *The Glebe Farm* and lot 71 as a small copy of *Stratford Mill*.[1] The following year Holmes spotted Webb again in James Staats Forbes's collection (see p. 102 above).

It seems to have been widely known that Webb was responsible for imitation Constables but according to M. H. Spielmann, writing in 1904, 'no one ever cared to challenge him on a charge which was openly talked of and universally believed'.[2] Only after his death was Webb publicly named as a forger. By then the evidence against him was thought to be conclusive. Holmes wrote with complete assurance on the question, perhaps because – as we mentioned in part one – he had discovered 'several signed works by [Webb] in a private collection at Oxford, with a technique identical in many respects with the imitations'.[3] Percy Moore Turner seems to have been equally certain about Webb's imitations. In 1907 he had the following to say about a copy of *The Glebe Farm* entitled 'The Rainbow' (pl. 153), which had been presented to the Louvre as an authen-

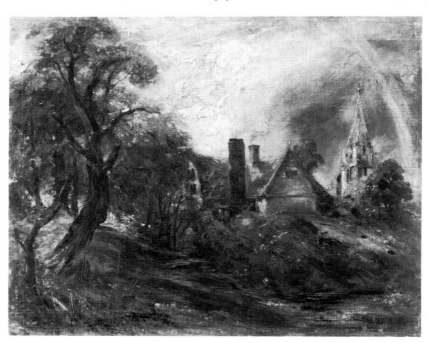

153 ? James Webb after John Constable, *The Glebe Farm*, oil, 19$\frac{11}{16}$ × 25$\frac{9}{16}$

tic Constable in 1873 and which was probably derived from an early state of Lucas's mezzotint rather than the finished painting (pl. 13):

> the flat and opaque brushwork of the church on the hill, and the sky, are character-istic traits of that able and prolific forger of Constable and Turner – James Webb. The work is, however, in a measure clever, and closely approaches Constable in parts – especially in the trees. It was always on the aesthetic side that Webb failed. When painting a landscape in his own manner he is by no means a painter to be despised . . . But his manner changes when he is working in imitation of Constable or Turner. He is endeavouring all the time to catch the trick of the brush, the breadth and sureness of handling, and consequently he is easily detected by the abject failure of the clouds and sky.[4]

Turner was writing in the *Burlington Magazine* and Charles Holmes, then co-editor of the magazine, presumably agreed with his reattribution of the Louvre painting. If Turner was correct, an almost identical *Glebe Farm* copy at the Castle Museum, Norwich (No. 216.948) can also be given to Webb.* We have not yet identified any of the imitations which Holmes attributed to him. A *Salisbury Cathedral from the Bishop's Grounds* in the Montreal Museum of Fine Arts, a copy of a large sketch now at Ottawa,[5] has recently been put forward[6] as a possible Webb on the grounds that it once belonged to James Orrock who was said

---

* This possibility does not appear to have occurred to Turner himself: it was he who, with Andrew Shirley's backing, sold the picture to Norwich in 1948 as a genuine Constable.

by Holmes to possess Webb imitations. Holmes did not, in fact, specifically mention this painting, which was already in Canada by 1890, but it appears to have features in common with the Louvre copy. A very similar *Salisbury Cathedral* copy is in the Laing Art Gallery, Newcastle-upon-Tyne (see p. 103 above). It would be possible to extend the list of such copies but at present the only basis for attributing them to James Webb seems to be P. M. Turner's statement that the Louvre painting was by him. Even if some of the works Holmes called Webb can be identified, we shall still lack first-hand evidence of his authorship.

Knowledge of other nineteenth-century Constable forgers and imitators is even less certain and we have not felt justified in devoting separate sections to any of them. We can, however, bring together the few names that have been mentioned in this connection.

Willcock, an artist employed to make copies in the 1840s by the collector–dealer Samuel Archbutt, is discussed on p. 41 above, where his possible identification with George Burrell Willcock (1811–52) is suggested. The latter's own paintings are known but no Constable imitations by him have been identified.

Joseph Paul (1804–87) is frequently mentioned in early twentieth-century accounts of Constable and Norwich school forgeries,[7] though his christian name is sometimes incorrectly given as Robert.[8] He exhibited at Norwich in the 1820s and 1830s and then, according to these accounts, fled to London, where he and his sons produced imitations of Crome and other Norwich artists, Constable and Canaletto. But there appears to be little or no contemporary documentation of these activities. As an example of the sort of Constable imitation which has been attributed to him we reproduce in pl. 154 a pastiche of *Salisbury Cathedral from the Meadows* (pl. 9) which was sold as by Joseph Paul at Sotheby's Belgravia on 20 April 1982 (208). As well as changing the format of Constable's original, this adds on the left the cows from *The Valley Farm* (pl. 26) and in the foreground some young anglers of a kind seen in several of Constable's large canvases.

Shirley mentions an Italian artist of uncertain name, Quenini or Chianini, who, he was told, based paintings on Constable's oil sketches and watercolours.[9] And according to Sydney Key, a lawsuit in 1915 exposed the activities of a Bath shopkeeper called Warren, who had produced 'three hundred sketches', apparently in the manner of Constable.[10] More recently, Tom Keating has been exposed, or perhaps over-exposed.[11]

In most cases no name at all is available and the student is obliged to invent his own if he wants to classify groups of similar works: thus, Master of the Red Signature, Master of the Cabbage Leaves, and so on. The extent and range of early Constable imitations, however, almost defies classification. Everything is possible, from hasty sketches of trees writhing under tortured skies (pl. 155) to elaborately painted but nonsensical compositions of rivers, locks and mills: nightmare versions of familiar Flatford in which there is something not quite

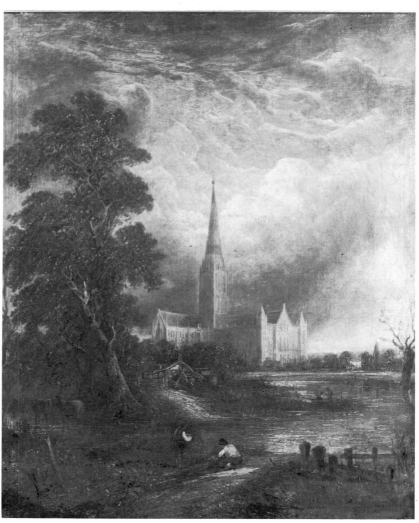

154 ? Joseph Paul after John Constable, *Salisbury Cathedral from the Meadows*, oil, 50 × 40 (127 × 101.5)

right about the perspective or the water level and out-of-scale lock gates tower over dwarf bargees. A special brand of crazy writing sometimes accompanies such works in sale or exhibition catalogues. The caption to a painting exhibited in 1895 tells us that the subject is Hampstead Heath and that Dedham Church can be seen in the distance.

There are also many works by unidentified artists which do not in the least resemble Constable's but which have nevertheless attracted 'his' signature. It may be worth repeating the sort of advice Sir Charles Holmes gave on this point in 1902. Constable signed only a few of his exhibition canvases, some of the drawings and watercolours he presented to friends, and some of his portraits. The presence of a signature, therefore, usually indicates that a work is *not* by Constable. A few early oil sketches are dated on the front but more frequently

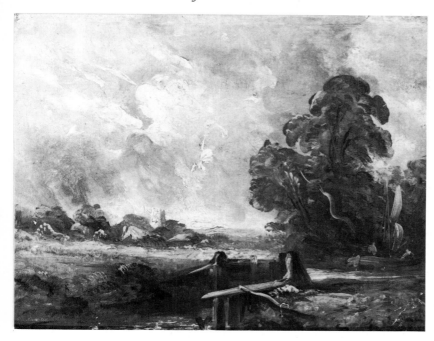

155 Unknown imitator of Constable, *The Lock*, oil, $8\frac{1}{2} \times 11$ (21.5 × 28)

information about date, weather, place, etc. is given, if at all, on the back, either in Constable's own hand or sometimes transcribed in a later hand if the work has been relined or the original support otherwise reinforced (e.g. paper mounted on canvas or board). Drawings are frequently inscribed with place and date on the front.

There is clearly a good deal of work to be done on the question of Constable imitations, if anyone has the stomach for it. The nature of the material, however, makes it unlikely that much hard information will ever be available.

# NOTES

PART ONE

CHAPTER ONE

1  Leslie 1843, p. 113, 1951, p. 265.
2  C. R. Leslie, ed. Tom Taylor, *Autobiographical Recollections*, 1860, I, p. 158.
3  Leslie 1843, p. 114, 1951, p. 266.
4  JC to John Fisher, 28 November 1826 (JCC VI, p. 228).
5  JC to John Fisher, 26 August 1827 (JCC VI, p. 230).
6  JC to C. R. Leslie, 4 November 1831 (JCC III, p. 50).
7  Constable family collection.
8  Leslie 1843, Preface.
9  C. R. Leslie to JCC, 18 May 1837.
10  A copy of the printed circular is with the Beckett Papers at the Tate Gallery.
11  Leslie 1843, pp. 127-8, 1951, pp. 267-8.
12  JC to John Fisher, 8 April 1826 (JCC VI, p. 217).
13  Andrew Robertson to C. R. Leslie, 21 August 1837 (JCC IV, p. 308).
14  A manuscript list of the subscribers and their subscriptions is in the National Gallery's dossier on the painting.
15  C. R. Leslie to JCC, 10 December 1837.
16  JCC IV, p. 94.
17  Tate Gallery; Parris 1981, No. 32; Tate Gallery 1976, No. 247.
18  Details of prices and buyers at this sale are taken from marked copies of the catalogue in the family collection.
19  According to an annotation by JCC in his copy of the sale catalogue (family collection).
20  Details of this sale are taken from the copy of the catalogue in the V & A library, which appears to have been marked up by Foster's themselves.
21  Reynolds 1973, No. 137; Tate Gallery 1976, No. 132.
22  See n. 17.
23  Tate Gallery 1976, No. 330.
24  Tate Gallery 1976, No. 253.
25  Tate Gallery 1976, No. 201.
26  W. T. Whitley, *Art in England 1821-1837*, 1930, p. 189.

## CHAPTER TWO

1 MLC to AAC, ? September 1838.
2 JCC V, p. 203.
3 CGC to JCC, 10 September 1839, from Bombay.
4 CGC to MLC, 17 March 1840, from Karachi.
5 CGC to MLC, July 1842.
6 CGC to MLC, 1 October 1842, from Bombay.
7 CGC to IC, 2 January 1843, from Bombay.
8 AAC to LBC, n.d. (1843).
9 AAC to LBC, 4 March 1843.
10 CGC to MLC, 1 May 1843, from Bombay.
11 CGC to AAC, 1 October 1844, from Bombay.
12 C. R. Leslie, ed. Tom Taylor, *Autobiographical Recollections*, 1860, I, p. 64.
13 John Fisher to JC, 27 September 1826 (JCC VI, p. 226).
14 Abram Constable to MLC, 16 February 1862 (JCC I, p. 314).
15 C. R. Leslie, ed. Tom Taylor, *Autobiographical Recollections*, 1860, II, p. 253.
16 ibid., p. 256.
17 ibid., p. 259.
18 Leslie 1843, p. 126, 1951, p. 284.
19 Leslie 1843, p. 126, 1951, p. 285.
20 Private Collection; see JC:FDC, pp. 249–52.
21 JC:FDC, p. 248.
22 *Athenaeum*, No. 849, 3 February 1844, p. 103.
23 C. R. Leslie, ed. Tom Taylor, *Autobiographical Recollections*, 1860, I, p. lxxxvii.
24 F. M. Redgrave, *Richard Redgrave, C.B., R.A.*, 1891, p. 56.
25 Richard and Samuel Redgrave, *A Century of Painters of the English School*, 1866, II, p. 346.
26 Ed. R. M. Kettle, *Memoirs and Letters of Charles Boner*, 1871, I, pp. 13, 17.
27 CGC to MLC, postmarked 5 April 1844.
28 JCC IV, p. 441.

## CHAPTER THREE

1 *Art-Union*, 1845, p. 291.
2 *Art-Journal*, 1855, p. 163.
3 *Art-Union*, 1839, p. 104.
4 *Art-Journal*, 1855, p. 164.
5 See *Art-Journal*, 1848, p. 33 for forgeries of Müller and Etty, and 1855, pp. 161–2 for forgeries of the other artists mentioned.
6 Preface to the specimen of the *Life* (JC:FDC, p. 250).
7 C. R. Leslie to Francis Darby, 22 May 1843 (JC:FDC, pp. 248–9).
8 Leslie 1843, p. 122.
9 Leslie 1845, pp. 306–7, 1951, p. 279.
10 Leslie 1896, p. xiv.
11 *Art-Union*, 1845, p. 319.
12 Private Collection; Tate Gallery 1976, No. 312.
13 *Art-Union*, 1845, p. 294.

14 *Art-Union*, 1848, p. 295, where a long account of the case is given.

15 JCC V, pp. 38–9.

16 Shirley 1930, No. 4, based on V & A, Reynolds 1973, No. 310.

17 Leslie 1843, p. 86, 1951, p. 214.

18 Leslie 1896, p. xiv and R. C. Leslie, 'With Charles Robert Leslie, R.A.', *Temple Bar*, CVII, 1896, pp. 362–3.

19 Three versions of the composition survive: Tate Gallery 1976, Nos 213–15; see also Parris 1981, No. 26.

20 Private Collection; Tate Gallery 1976, No. 137.

21 C. R. Leslie to James Lennox, 10 March 1848, quoted in the catalogue of the New York Public Library sale, Parke-Bernet, New York, 17 October 1956 under lot 41.

22 *Branch Hill Pond, Hampstead Heath, with a Boy Sitting on a Bank*, Tate Gallery; Parris 1981, No. 29.

23 *Art-Journal*, 1857, p. 90.

24 Christie's own copy of the 1849 sale catalogue is annotated to show that the picture was delivered to Rought on Taunton's instructions on 2 June.

25 *Agnew's 1817–1967*, 1967, p. 17, where the receipted bill is reproduced.

26 Henry Vaughan, manuscript volume 'The Hay-Wain and other Pictures by John Constable R.A.' (National Gallery library), quoted in Reynolds 1973, under No. 209.

27 See n. 12.

28 *Art-Journal*, 1855, p. 65.

29 Yale Center for British Art; Hoozee 1979, No. 408.

30 Glasgow Art Gallery; Martin Butlin and Evelyn Joll, *The Paintings of J. M. W. Turner*, 1977, No. 374.

31 National Gallery of Victoria, Melbourne; *Sir Edwin Landseer*, Tate Gallery 1982, No. 139.

32 Private Collection; *Sir Edwin Landseer*, Tate Gallery 1982, No. 125.

33 See n. 12.

34 See Ch. 1, n. 23.

35 Tom Taylor, *Handbook to the Pictures in the International Exhibition*, 1862, p. 93.

36 Tate Gallery; Parris 1981, No. 36.

37 Tate Gallery; ibid., No. 38.

38 V & A; Reynolds 1973, No. 184; Tate Gallery 1976, No. 180.

39 V & A; ibid., No. 301; Tate Gallery 1976, No. 254.

40 V & A; ibid., No. 323; Tate Gallery 1976, No. 188.

41 *Water-Meadows near Salisbury*; Shirley 1937, pl. 113; a view towards Harnham Ridge: see Parris 1981, p. 138.

42 *Art-Journal*, 1855, pp. 9–12.

43 Ed. E. T. Cook and Alexander Wedderburn, *The Works of John Ruskin*, 1903–12, III, pp. 44–5.

44 ibid., III, p. 191.

45 ibid., III, p. 603.

46 C. R. Leslie, *A Hand-Book for Young Painters*, 1855, p. 267.

47 ibid., p. 275.

48 ibid., p. 276.

49 *The Works of John Ruskin*, XIV, p. 39.

50  ibid., V, p. 423.

51  Shirley 1930, No. 20.

52  ibid., No. 12.

53  Lady Lever Art Gallery, Port Sunlight; Andrew Wilton, *The Life and Work of J. M. W. Turner*, 1979, No. 788.

54  *The Works of John Ruskin*, V, pp. 162–4.

55  ibid., V. p. 172.

56  Shirley 1930, No. 27.

57  *The Works of John Ruskin*, VI, p. 101.

58  ibid., XVI, p. 415.

59  ibid., XXII, pp. 58–9.

60  C. R. Leslie, *A Hand-Book for Young Painters*, 1855, p. 275.

61  *The Works of John Ruskin*, V, p. 423.

62  ibid., XIV, p. 141; see also pp. 253–4.

63  Reprinted in W. M. Rossetti, *Fine Art, Chiefly Contemporary*, 1867, p. 155.

64  W. Holman Hunt, *Pre-Raphaelitism and the Pre-Raphaelite Brotherhood*, 1905, I, p. 42, II, pp. 491–2.

65  Ed. Virginia Surtees, *The Diary of Ford Madox Brown*, 1981, p. 132 (12 April 1855).

66  Allen Staley, *The Pre-Raphaelite Landscape*, 1973, p. 136.

67  *Philip Gilbert Hamerton, An Autobiography 1834–1858 And a Memoir by his Wife 1858–1894*, 1897, pp. 148–9.

68  P. G. Hamerton, *Thoughts about Art*, 1873, p. 315 (article on Leslie first published 1866).

69  ibid., p. 316.

70  *Revue des Deux Mondes*, 15 July 1854, p. 309.

71  *Revue Universelle des Arts*, January 1857, pp. 289–302.

72  See Delacroix to Silvestre, 31 December 1858; Ed. André Joubin, *Correspondance Générale d'Eugène Delacroix*, 1938, IV, p. 60.

73  Pierre Miquel, *Le Paysage français au XIX$^e$ siècle*, 1975, II, p. 198.

74  ibid., pp. 198–9.

75  Richard and Samuel Redgrave, *A Century of Painters of the English School*, 1866, II, p. 390.

76  Reynolds 1973, No. 323.

77  ibid., No. 301.

78  Redgrave, op. cit., II, p. 391.

79  ibid., pp. 394–5.

80  ibid., pp. 387–8.

81  P. G. Hamerton, 'Constable', *Portfolio*, 1873, p. 119.

## CHAPTER FOUR

1  AAC to LBC, 28 June, 22 July, 8 August, 20 October 1843.

2  See West Suffolk Record Office, Stour Navigation Papers: Order Book, River Stour, 1824–61, EE 501 5097, pp. 113, 116, 122.

3  ibid., pp. 149–50, etc.

4  CGC to IC, 2 January 1842.

5  See *East Anglian Miscellany*, Part IV, 1934, p. 77.

6   CGC to MLC, 17 November 1844.

7   Presumably the Tate Gallery picture: pl. 12.

8   AAC to LBC, n.d., the first of his letters from Higham in 1846.

9   AAC to LBC, 4 August 1846.

10   CGC to MLC, 25 August 1846.

11   CGC to MLC, 24 April 1847.

12   Jane Ann Luard (née Inglis) to AAC, postmarked Colchester 9 December 1847.

13   CGC to MLC, 1 January 1847.

14   CGC to MLC, 19 June 1847.

15   See Ch. 3, n. 19.

16   See JCC V, pp. 168—9.

17   Peter Spencer to CGC and AAC, 29 September 1849.

18   Mary Constable to MLC, 17 May 1850.

19   Constable family collection; Tate Gallery 1982, Nos 48a—b.

20   CGC to AAC, 23 October 1852.

21   Constable family collection.

22   Leslie 1896, pp. 263—4.

23   See Tate Gallery 1982, No. 57—69 for examples.

24   CGC to MLC, 22 May 1857.

25   CGC to MLC, 12—18 January 1863, from Florence.

26   Constable family collection.

## CHAPTER FIVE

1   Ed. R, M. Kettle, *Memoirs and Letters of Charles Boner*, 1871, I, p. 14.

2   ibid., p. 15.

3   JC to J. T. Smith, 18 August 1799 (JCC II, p. 16).

4   Reynolds 1973, Nos 17—20.

5   With Spink & Son Ltd. 1979; Hoozee 1979, No. 180.

6   Tate Gallery; Parris 1981, No. 10.

7   ibid., No. 9.

8   ibid., No. 28.

9   ibid., No. 4; Tate Gallery 1976, No. 87.

10   ibid., No. 24.

11   Henry Vaughan to LBC, 21 March 1874 and CGC to LBC, 21 April 1874.

12   CGC Diary, 26 January 1875.

13   Yale Center for British Art; Tate Gallery 1976, No. 121.

14   Tate Gallery 1976, No. 294.

15   V & A; Reynolds 1973, No. 359; Tate Gallery 1976, No. 311.

16   Frederick Wedmore, 'Constable 1776—1837', *L'Art*, 1878, II, pp. 169—79; the text was reprinted in Wedmore's *Studies in English Art*, 1880.

17   Henry E. Huntington Library and Art Gallery, from the Ingram Collection.

18   Private Collection; Tate Gallery 1976, No. 315.

19   Allan Cunningham, *The Lives of the Most Eminent British Painters . . . Annotated and Continued to the Present Time by Mrs Charles Heaton*, 1880, III, p. 200.

20   Hoozee 1979, No. 616.

21   ibid., No. 438.

22   George Redford, *Art Sales*, 1888, I, p. 175.

23  ibid., p. 177.
24  M. H. Spielmann, 'Art Forgeries and Counterfeits: A General Survey – VII', *Magazine of Art*, 1904, p. 78.
25  *Art-Journal*, 1874, p. 132.
26  Ed. Thomas Landseer, *Life and Letters of William Bewick (Artist)*, 1871, II, p. 143.
27  JCC V, p. 215.
28  Hoozee 1979, No. 564.
29  Tate Gallery; Parris 1981, No. 49.
30  Hugh Golding Constable, manuscript notes made in the early 1930s and headed 'Rambling "Tales of Grandpapa"', contained in an exercise book used by his son, J. H. Constable, in 1915 for 'Fair Notes in Electricity and Magnetism' (Constable family collection).

## CHAPTER SIX

1  Principal Registry of the Family Division, Somerset House.
2  Public Record Office, Entry Books of Decrees and Orders, Chancery Division, J 15/1464 f. 1889 (C. 1880 c. 1621).
3  The documents relating to the loan quoted in this chapter can be found on Mrs A. M. Constable's file at the V & A. The works themselves are listed in *Loans to the South Kensington Museum 1877–1891*, pp. 28–33.
4  Hoozee 1979, No. 532.
5  Ernest Chesneau, trans. Lucy N. Etherington, *The English School of Painting*, 1884, p. 142.
6  Nos 19–40, 111–13, 115–18 in the list published in *Loans to the South Kensington Museum 1877–1891*, pp. 28–33.
7  Details of the Edinburgh loan are recorded in the Royal Scottish Museum's Loan Register under No. 86.
8  Parris 1981, No. 40.
9  We are grateful to Mr A. B. Parry for drawing the catalogue of this exhibition to our notice.
10  National Gallery of Victoria, Melbourne; Hoozee 1979, No. 442.
11  Private Collection; Tate Gallery 1976, No. VI.
12  Yale Center for British Art; Tate Gallery 1976, No. 243.
13  Anon., 'The Constable Family', *Spectator*, 15 September 1888, pp. 1256–8.
14  Minna's and Lionel's Wills are in the Principal Registry of the Family Division, Somerset House.
15  H. G. Constable, 'Rambling Tales' (see Ch. 5, no. 30).
16  Letter in National Gallery archive.
17  Tate Gallery; Parris 1981, No. 19; Tate Gallery 1976, No. 186.
18  Tate Gallery; ibid., No. 6; Tate Gallery 1976, No. VII.
19  Tate Gallery; repr. Parris 1981, frontispiece.
20  Tate Gallery; ibid., No. 25; Tate Gallery 1976, No. 221.
21  See Reynolds 1973, p. 3 for Isabel's letter to Thompson and for details of the miscellaneous items in the gift.
22  We have consulted the copy of the Will preserved in the Constable family collection.
23  Tate Gallery 1976, No. 330.
24  Tate Gallery; Parris 1981, No. 42; Tate Gallery 1976, No. 334.
25  Tate Gallery; ibid., No. 18; Tate Gallery 1976, No. 179.

26 Reynolds 1973, No. 223; Tate Gallery 1976, No. 203.
27 ibid., No. 288; Tate Gallery 1976, No. 246.
28 ibid., No. 359; Tate Gallery 1976, No. 311.
29 ibid., No. 395; Tate Gallery 1976, No. 331.
30 Tate Gallery; *Sir Edwin Landseer*, Tate Gallery 1982, No. 68.
31 Reynolds 1973, Nos 196–7.
32 ibid., No. 174.
33 'The Constable Pictures', *Standard*, 27 July 1888.
34 Allan Cunningham, *The Lives of the Most Eminent British Painters . . . Annotated and Continued to the Present Time by Mrs Charles Heaton*, 1880, III, pp. 197–8.
35 P. G. Hamerton, 'Constable's Sketches', *Portfolio*, 1890, p. 163.
36 ibid., p. 167.
37 As listed in the copy of her Will in the Constable family collection.
38 Now in an American private collection, this painting (Hoozee 1979, No. 167) has been called 'The Artist's Garden, East Bergholt' but seems more likely to be a view from Fisher's lawn at Leydenhall, Salisbury.
39 R. A. Thompson's two oils descended to Mrs Bell Duckett, who sold them at Morrison, McChlery & Co., Glasgow, 18 March 1960; one of them was the Flatford lock study shown as Tate Gallery 1976, No. 96. Four of Mrs Fenwick's five oil studies were sold at Christie's, 19 November 1982 (44–47); her '*Stoke-by-Nayland*' was sold there on 18 November 1983 (88). For further information on the Fenwick sketches, see L. Parris, 'Some recently discovered oil sketches by John Constable', *Burlington Magazine*, CXXV, 1983, pp. 220–3.
40 Yale Center for British Art; Tate Gallery 1976, No. 243.
41 Private Collection; Tate Gallery 1976, No. 214.
42 See Ch. 1, n. 24.
43 Private Collection; Tate Gallery 1976, No. 96a.
44 Private Collection; Tate Gallery 1976, No. 90.
45 Tate Gallery 1976, No. 268.
46 Shirley 1930, No. 39.
47 ibid., No. 40.
48 *Art Journal*, 1893, p. 222.
49 J. H. Duveen, *The Rise of the House of Duveen*, 1957, p. 90.
50 Holmes 1936, p. 272.
51 J. G. Johnson Collection, Philadelphia; Tate Gallery 1976, No. 92.
52 Roger Fry to J. G. Johnson, 6 May 1909; ed. Denys Sutton, *Letters of Roger Fry*, 1972, I, p. 321.
53 Lord Windsor, *John Constable R.A.*, 1903, p. 209.

## CHAPTER SEVEN

1 Much of the information given here about Constable's grandchildren is taken from a red morocco album of manuscript reminiscences by Hugh Golding Constable, compiled about 1940 (Constable family collection).
2 Catalogue by J. H. Constable of the exhibition *The Constable Family – Five Generations*, Ipswich 1954, p. 10.
3 H. G. Constable's red morocco album: see n. 1.
4 C. L. Eastlake to Ella Mackinnon, 5 December 1888 (National Gallery archive).

5 Unidentified newspaper cutting among a collection of reviews of the exhibition preserved by Leggatt's. Our quotations are taken from this collection.

6 Tate Gallery 1982, No. 21.

7 Private Collection; ibid., No. 14.

8 J. G. Johnson Collection, Philadelphia; ibid., No. 20. An alternative candidate for No. 71 in Leggatt's exhibition has recently come to light: a sketch sold by Phillips, Edinburgh, 2 December 1983 (85), which bears the 1899 exhibition label inscribed with the same title, 'Cottage on the Stour'.

9 Hoozee 1979, No. 690.

10 Yale Center for British Art; Tate Gallery 1982, No. 8.

11 Tate Gallery; Parris 1981, No. 54; Tate Gallery 1982, No. 51.

12 Private Collection; Tate Gallery 1982, No. 15.

13 See Ch. 5, n. 30.

14 Sold at Sotheby's, 18 March 1964 (145); Hoozee 1979, No. 650.

15 Sold at Christie's, 18 November 1960 (88); ibid., No. 643.

16 Tate Gallery; Parris 1981, No. 45; Tate Gallery 1982, No. 22.

17 C. J. Holmes, 'Notes on Some Recently-Exhibited Pictures of the British School', *Burlington Magazine*, VII, 1905, p. 328.

18 Byron Webber, *James Orrock, R.I. Painter, Connoisseur, Collector*, 1903, II, p. 155.

19 James Orrock, 'Constable', *Art Journal*, 1895, pp. 369–70.

20 C. J. Holmes, 'Notes on Mr Orrock's English Pictures', *Burlington Magazine*, V, 1904, p. 414.

21 For further information about Orrock's dealings with Leverhulme, see Edward Morris's essay in the catalogue of the exhibition *Lord Leverhulme*, Royal Academy 1980.

22 Hoozee 1979, No. 682.

23 *Athenaeum*, No. 3403, 14 January 1893, p. 60.

24 ibid., No. 3405, 28 January 1893, p. 128.

25 Sold Christie's, 28 January 1983 (132).

26 Leslie 1896, pp. xii–xiii.

27 ibid., p. xiv.

## CHAPTER EIGHT

1 Holmes 1936, p. 156.

2 ibid., p. 190.

3 C. J. Holmes, *Constable*, 1901, p. 8.

4 ibid., p. 11.

5 V & A; Reynolds 1973, Nos 21–32.

6 ibid., No. 37.

7 ibid., Nos 72–94.

8 C. J. Holmes, *Constable*, 1901, p. v.

9 Holmes 1902, p. viii.

10 Graham Reynolds, *Victoria and Albert Museum, Catalogue of the Constable Collection*, 1960, p. 9.

11 See Ch. 1, n. 17.

12 Holmes 1902, p. 71.

13 ibid., p. 241.

14 ibid., p. 115.

15 ibid., p. 126.

16 ibid., p. 175.

17 See his *Notes on the Science of Picture-Making*, 1909, which is based on the lectures.

18 Holmes 1902, p. 237.

19 Holmes 1936, p. 210.

20 C. J. Holmes, 'Constable's *Dedham Vale*, 1811', *Burlington Magazine*, XII, 1907, pp. 74–7.

21 C. J. Holmes, 'Some Constable Puzzles', *Burlington Magazine*, XIII, 1908, pp. 286–7.

22 Holmes 1936, p. 207.

23 Private Collection; Tate Gallery 1976, No. 78.

24 M. Sturge Henderson, *Constable*, 1905, p. 185.

25 Percy Lindley, *A Drive through the Constable Country*, p. 2. The Tate Gallery library has a copy marked 'Rough Proof' which appears to have been sent to the Gallery in May 1902.

26 ibid., p. 13.

27 ibid., p. 15.

28 T. West Carnie, *In Quaint East Anglia*, 1899, pp. 21–2.

29 C. J. Holmes, 'Constable's "English Landscape Scenery"', *Dome*, VI, 1900, pp. 203–29.

30 C. J. Holmes, *Constable*, 1901, p. 22.

31 Frederick Wedmore, 'Constable's "Landscape"', *Nineteenth Century*, LIV, 1903, pp. 1013–9.

32 Frederick Wedmore, *Constable: Lucas: with a Descriptive Catalogue of the Prints they did between them*, 1904, p. 26.

33 ibid., p. 31.

34 We are grateful to Mr Osbert Barnard for discussing this point with us and for showing us examples of such false proofs.

35 Now called *Stormy Afternoon*; Tate Gallery 1982, No. 56.

36 See Ch. 5, n. 9.

37 Tate Gallery; Parris 1981, No. 38.

38 Tate Gallery; ibid., No. 47.

39 National Gallery; Hoozee 1979, No. 280.

40 National Gallery; ibid., No. 433.

41 Tate Gallery; Parris 1981, No. 13; Tate Gallery 1976, No. 143.

42 Frick Collection, New York; Hoozee 1979, No. 468.

43 Hoozee 1979, No. 564.

44 ibid., No. 657.

45 ibid., No. 562.

46 Tate Gallery 1976, No. 239.

47 Reported in *Morning Post*, 1 October 1913.

48 Tate Gallery; Parris 1981, No. 1.

49 Hoozee 1979, No. 7.

50 Tate Gallery; Parris 1981, No. 8.

51 See Ch. 6, n. 25.

52 See Ch. 6, n. 16.

53 See Ch. 6, n. 24.

54 See Ch. 1, n. 17.
55 Holmes 1936, p. 207.
56 Private Collection; Hoozee 1979, No. 192.
57 Tate Gallery 1976, No. 187.
58 See Ch. 1, n. 21.
59 James Orrock, 'Constable', *Art Journal*, 1895, p. 369.
60 C. J. Holmes, 'Constable's "English Landscape Scenery"', *Dome*, VI, 1900, p. 228.
61 See n. 50.
62 E. V. Lucas, *John Constable the Painter*, 1924, p. 67.
63 Percy Moore Turner, 'The Representation of the British School in the Louvre', *Burlington Magazine*, X, 1907, pp. 341–2.
64 Tate Gallery 1976, No. 202.
65 Hoozee 1979, No. 265.
66 ibid., No. 460.
67 See Ch. 7, n. 22.

## CHAPTER NINE

1 Shirley 1930, p. 1.
2 Hon. Andrew Shirley, 'John Constable and "The Nude"', *Connoisseur*, XCI, 1933, pp. 213–9.
3 H. Isherwood Kay, 'The Hay Wain', *Burlington Magazine*, LXII, 1933, p. 281.
4 P. G. Hamerton, 'Constable's Sketches', *Portfolio*, 1890, p. 166.
5 Parris 1981, No. 11.
6 Tate Gallery; Parris 1981, No. 10.
7 E. V. Lucas, *John Constable the Painter*, 1924, pp. 67–8.
8 C. J. Holmes, *Constable*, 1901, pp. 23, 25.
9 Hoozee 1979, No. 426.
10 Julius Meier-Graefe, translated by Florence Simmonds and George W. Chrystal, *Modern Art, Being a Contribution to a New System of Aesthetics*, 1908, I, p. 129.
11 ibid., p. 130.
12 Kenneth Clark, 'Constable, Prophet of Impressionism', *Listener*, XVII, No. 430, 7 April 1937, p. 636; the article is reprinted in *Art in England*, ed. R. S. Lambert, 1938, pp. 35–42.
13 Julius Meier-Graefe, *Modern Art*, 1908, I, p. 128.
14 C. J. Holmes, *Constable Gainsborough and Lucas*, 1921, Postscript.
15 Clive Bell, *Landmarks in Nineteenth-Century Painting*, 1927, p. 40.
16 Roger Fry, *Reflections on British Painting*, 1934, p. 136.
17 ibid., pp. 140–1.
18 R. H. Wilenski, *English Painting*, 1933, p. 219.
19 Kenneth Clark, *John Constable, The Hay Wain*, The Gallery Books No. 5, 1944, p. 8.
20 Ed. Peter Leslie, *The Letters of John Constable, R.A. to C. R. Leslie, R.A.*, 1931, p. xxii.
21 C. J. Holmes, 'Constable's *Hadleigh Castle*', *Burlington Magazine*, LXVII, 1936, p. 107.
22 Shirley 1937, p. lxi.
23 ibid., pl. 54.

24 Shirley 1930, No. 26.
25 Ashmolean Museum, Oxford; Hon. Andrew Shirley, *John Constable, R.A.*, 1944, pl. 154.
26 V & A; Reynolds 1973, No. 100.
27 Private Collection; Tate Gallery 1982, No. 15.
28 See Ch. 7, n. 16.
29 See Ch. 7, n. 6.
30 Shirley 1937, p. lxiv.
31 Hon. Andrew Shirley, 'Constable's Early and Middle Periods', *Burlington Magazine*, LXX, 1937, p. 274.
32 Tate Gallery 1976, No. 41.
33 Hoozee 1979, No. 69.
34 *Apollo*, XXV, 1937, pp. 295—6.
35 Private Collection; Tate Gallery 1976, No. 27.
36 Private Collection; Hoozee 1979, No. 124.
37 National Gallery of Victoria, Melbourne; Tate Gallery 1976, No. 146.
38 Private Collection; Tate Gallery 1976, No. 166.

## CHAPTER TEN

1 JCC III, p. 93.
2 See Ch. 1, n. 23.
3 JCC I, p. 273.
4 Private Collection; Tate Gallery 1976, No. 296.
5 JC to C. R. Leslie, n.d., ? March 1833 (JCC III, p. 97).
6 JC to CGC, 27 March 1833 (JCC V, p. 150).
7 JC to George Constable, 17 April 1833 (JCC V, p. 12).
8 No. 128, 'A Cottage in a Field of Corn', frame 34 × 30 in.
9 Shirley 1937, p. 101.
10 ibid., p. 101.
11 Leslie 1951, p. 71, n. 7.
12 See Reynolds 1973, No. 352 (first published 1960).
13 ibid., No. 145.
14 JCC IV, p. 166.
15 JCC IV, p. 165.
16 Nos. 297 and 136.
17 Information communicated by a member of the family.
18 JC to C. R. Leslie, 21 June 1835 (JCC III, p. 126).
19 JC to C. R. Leslie, 2 March 1833 (JCC III, p. 94).
20 Leslie 1843, p. 132, 1951, p. 294.
21 Fitzwilliam Museum, Cambridge; Tate Gallery 1976, No. 152.

## PART TWO

### SMITH

1 R. Gunnis, *Dictionary of British Sculptors*, 1968, p. 276.
2 JCC II, p. 16.
3 Reynolds 1973, Nos. 2–5, 7–13.
4 Harold Day, *Constable Drawings*, 1975, pls. 117–8.
5 Photograph in Witt Library; for a pencil study of the subject, see Tate Gallery 1976, No. 36.
6 Whitworth Art Gallery, University of Manchester (Tate Gallery 1976, No. 22) and V & A (Reynolds 1973, Nos 16a, 16b, 16c).
7 Charles Rhyne, 'Constable Drawings and Watercolors in the Collections of Mr and Mrs Paul Mellon and the Yale Center for British Art. Part I. Authentic Works', *Master Drawings*, XXIX, No. 2, 1981, No. 2, pl. 1.
8 Fleming-Williams 1976, fig. 5.

### BEAUMONT

1 Leslie 1843, p. 4, 1951, p. 5.
2 See Ch. 9, n. 35.
3 Reynolds 1973, Nos 21–32a.
4 *The Times*, 1 May 1953.
5 Private Collection; Shirley 1937, pl. 85a.
6 Ashmolean Museum, Oxford; Harold Day, *Constable Drawings*, 1975, pl. 72.

### REINAGLE

1 Letter inserted in the Lord Lee of Fareham Volume, an extra-illustrated copy of the 1843 edition of Leslie's *Life* (Department of Rare Books, Yale Center for British Art).
2 Farington Diary, 9 March 1801.
3 JC to John Dunthorne senr., 1801 (JCC II, p. 26).
4 ibid.
5 Dennis H. B. Neale, Woodbridge, 9 November 1971 (31–44). We have Graham Reynolds to thank for information which enabled one of us to attend this sale.

### FROST

1 C. J. Holmes, *Constable Gainsborough and Lucas*, 1921, p. 20.
2 *Stour Valley*, Shirley 1937, pl. 23.
3 Mary Woodall, *Gainsborough's Landscape Drawings*, 1939, p. 91.
4 John Hayes, 'The Drawings of George Frost', *Master Drawings*, IV, No. 2, 1966, pp. 163–8, plates 24–32.
5 JCC I, pp. 168, 196–7, 201; JCC II, pp. 37–8.
6 Reynolds 1973, No. 38; inscribed '3 Octr. Noon 1802'.
7 Hayes, op. cit., 1966, pl. 30; formerly on the London art market.

8   ibid., p. 167.

9   For the two drawings see Tate Gallery 1976, Nos 38–9.

10   Royal Academy of Arts, Jupp Catalogues, vol. 8, p. 27, where it is incorrectly attributed to William Frost.

11   Ipswich Museum, 1912–28–119.

12   Ipswich Museum, 1917–23–64.

13   Ipswich Museum, 1917–23–62.

14   A. E. Popham, *Catalogue of the Drawings of Parmigianino*, 1971, I, p. 5.

15   Ipswich Museum, 1917–23–56.

16   Musée du Louvre, Paris, sketchbook RF 8700, p. 6; inscribed on verso 'Thursday 10 July Hackney. 1806'.

17   Fitzwilliam Museum, Cambridge; Reg Gadney, *John Constable . . . A Catalogue of Drawings and Watercolours . . . in the Fitzwilliam Museum . . .*, 1976, No. 3.

18   Fine Art Society, London 1949.

19   National Gallery of Canada, Ottawa, 1973–18–11; inscribed 'JC'; watermark JOSEPH COLES 1795.

20   Sotheby's, 13 November 1980 (97); watermark 1795.

21   *Flatford Mill*, Courtauld Institute of Art, No. 2744; *East Bergholt Church*, Ipswich Museum, 1917–23–15.

22   Sotheby's, 13 November 1980: lot 100, *View of Dedham looking towards Langham Church*, inscribed on verso 'Given to Mr. West by Ella N. Constable & brothers (grand-daughter of John Constable, R.A.) Aug 30 88 1888'; lot 98, *Epsom Common*, inscribed on verso 'Epsom Book 1806 Aug Constable'; lot 99, *Borrowdale by Moonlight*.

### DUNTHORNE Senior

1   Leslie 1843, p. 2; quoted here from 1845, pp. 3–4, 1951, p. 3.

2   JC: FDC, p. 54.

3   JCC II, p. 24.

4   JCC II, p. 30.

5   Shirley 1937, p. 69.

6   Inscribed on verso 'Oct 1814 John Dunthorn'.

### FISHER

1   JC to John Fisher, 30 September 1823 (JCC VI, p. 132).

2   JC to John Fisher, 1821 (JCC VI, p. 63).

3   JCC VI, p. 58.

4   JC: FDC, p. 118.

5   JCC VI, pp. 195–6.

6   JCC VI, p. 15.

7   Postmarked 29 May 1818 (JCC VI, p. 36).

8   2 July 1819 (JCC VI, p. 44).

9   15 December 1817 (JCC VI, p. 34).

10   Private Collection; photograph in Witt Library.

11   11 September 1820 (JCC VI, p. 57).

12   21 November 1824 (JCC VI, p. 184).

13    5 January 1825 (JCC VI, p. 189).
14    'Osmington' sketchbook.
15    V & A; Reynolds 1973, No. 151.
16    'Salisbury' sketchbook.
17    'Osmington' sketchbook.
18    Christie's, 18 June 1980 (43), attributed to John Fisher.
19    Farington Diary, 16 January 1808.
20    12 December 1823 (JCC VI, p. 145).
21    16 December 1823 (JCC VI, p. 146).
22    Probably February 1824 (JCC VI, p. 153).
23    JC to Maria Constable, 29 June 1824 (JCC II, p. 346).
24    Parris 1981, No. 25; Tate Gallery 1976, No. 221.
25    Parris 1981, p. 104, fig. 1.

## DUNTHORNE Junior

1    JCC II, p. 79.
2    JCC I, p. 101.
3    Mary Constable to JC, 8 May 1824 (JCC I, p. 209).
4    JC to Golding Constable, 3 December 1824 (JC:FDC, p. 75).
5    JC to Maria Constable (JCC II, p. 397).
6    id., JCC II, p. 407.
7    id., JCC II, p. 416.
8    id., JCC II, p. 421.
9    1 February 1826 (JCC VI, p. 214).
10   JC:FDC, p. 58.
11   See Ch. 3, n. 12.
12   See Tate Gallery 1976, Nos 178–9; also Parris 1981, No. 18.
13   See Ch. 3, n. 19.
14   JCC VI, p. 232.
15   See Ch. 8, n. 39.
16   Orally, in discussion with one of the authors.
17   Abram Constable to JC, September 1825 (JCC I, p. 221).
18   Mary Constable to JC, September 1825 (JCC I, p. 222).
19   JCC I, p. 191.
20   JCC I, p. 193.
21   Mary Constable to JC, 2 May 1825 (JCC I, p. 221).
22   JCC I, p. 287.
23   See C. M. Kauffmann and John Murdoch, 'Which Constable?', *Burlington Magazine*, CXXII, 1980, p. 436, where this re-reading of the inscription is given.
24   To be seen on the East Bergholt Enclosure Award map of 1817.

## WATTS

1    Letter in the Tate Gallery archive.
2    Ex coll. Lord Lee of Fareham; Tate Gallery 1976, No. 347 (as Watts).
3    We have not identified the source of this item, which is known to us only from a cutting.

## JENNINGS

1   JCC V, pp. 47–53.
2   See Ch. 6, n. 24.
3   JC to George Constable, 16 September 1836 (JCC V, p. 35).
4   JCC V, pp. 52–3.
5   Jennings to JC, August 1836 (letter in Constable family collection; not in JCC but partially published in Parris 1981, p. 164).
6   V & A; Reynolds 1973, No. 240; Tate Gallery 1976, No. 284.
7   ibid., No. 329.
8   Jennings to JC, 12 August 1836 (JCC V, p. 50).

## GEORGE CONSTABLE

1   JCC V, p. 21.
2   JCC V, p. 31.
3   Harriet de Wint's lists and the letter, of 13 February 1833, are in the collection of the City of Lincoln Libraries, Museum and Art Gallery.
4   JC to C. R. Leslie, 16 July 1834 (JCC III, p. 111).
5   JCC V, p. 14.
6   JCC V, p. 15.

## CHURCHYARD

1   See Denis Thomas, *Thomas Churchyard of Woodbridge*, 1966, pp. 11–12.
2   Ed. Alfred McKinley and Annabelle Burdick Terhune, *The Letters of Edward FitzGerald*, 1980, I, p. 29.
3   By Wallace Morfey, to whom we are most grateful for this advance information.
4   See Harold Day, *East Anglian Painters*, I, 1967, p. 112; the copy after the Leeds sketch is reproduced on p. 119.
5   Christie's, 17 February 1972 (298).
6   Holmes 1902, p. 204; on p. 249 Holmes lists this as a watercolour of 1830 and gives the measurements, $6 \times 7\frac{3}{4}$ inches.

## LIONEL CONSTABLE

1    CXX, 1978, pp. 566–79.
2    Private Collection; Tate Gallery 1982, No. 13; previously known as 'Vale of Dedham'.
3    Private Collection; Tate Gallery 1982, No. 15.
4    Constable family collection; Tate Gallery 1982, No. 5.
5    Letterpress to 'Spring' in *English Landscape* (Shirley 1930, p. 250).
6    See Ch. 6, n. 17.
7    V & A; Reynolds 1973, No. 320; a work at present dated 1829 but which could well have been painted earlier, in 1820 for instance.
8    See Ch. 8, n. 57.
9    See Ch. 5, n. 14.
10   See Tate Gallery 1982, pp. 16–17, figs i–iv for examples.

11　Tate Gallery 1982, Nos 28–33.

12　Both works are reproduced in Parris and Fleming-Williams, 'Which Constable?', *Burlington Magazine*, CXX, 1978, p. 569, figs 11–12.

13　Tate Gallery 1976, No. 343.

14　*Three Centuries of British Water-Colours and Drawings*, Arts Council, London 1951, No. 23; *John Constable Drawings & Sketches*, Henry E. Huntington Library and Art Gallery, San Marino, California 1961, No. 19, 'ca. 1815'.

15　See Tate Gallery 1982, No. 49.

16　JCC V, p. 209.

## WEBB

1　C. J. Holmes, 'Notes on Mr Orrock's English Pictures', *Burlington Magazine*, V, 1904, p. 416.

2　M. H. Spielmann, 'Art Forgeries and Counterfeits: A General Survey – VII', *Magazine of Art*, 1904, p. 78.

3　Holmes 1936, pp. 209–10.

4　P. M. Turner, 'The Representation of the British School in the Louvre', *Burlington Magazine*, X, 1907, p. 341.

5　See Graham Reynolds, *John Constable, Salisbury Cathedral from the Bishop's Grounds* (Masterpieces in the National Gallery of Canada No. 10), 1977.

6　In the catalogue of the exhibition *L'Art du Connaisseur/The Art of Connoisseurship*, Montreal Museum of Fine Arts 1978–9, where the copy was No. XVI and the Ottawa painting No. XV.

7　See, for example, H. S. Theobald, *Crome's Etchings*, 1906, p. 10; Holmes 1936, p. 209; and Shirley 1937, p. lxxxiv.

8　On this point, see Miklos Rajnai, 'Robert Paul the non-existant painter', Paul Mellon Foundation 'Notes on British Art' No. 10, *Apollo*, LXXXVII, April 1968.

9　Shirley 1937, p. lxxxiv.

10　Sydney Key, *John Constable, His Life and Work*, 1948, p. 105.

11　See Tom Keating, Geraldine Norman and Frank Norman, *The Fake's Progress*, 1977, Geraldine Norman, *The Tom Keating Catalogue*, 1977, and catalogue of Christie's South Kensington sale, 12 December 1983 (*Paintings, Watercolours and Drawings by Tom Keating*).

# INDEX

[263]